COAST
THE JOURNEY CONTINUES

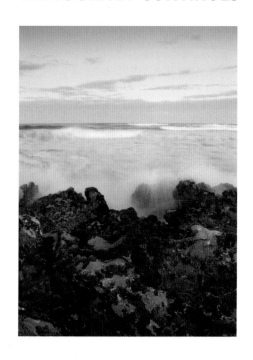

COAST

THE JOURNEY CONTINUES

BBC BOOKS

CHRISTOPHER SOMERVILLE

SANDY BEACH AND CLIFF AT
BURTON BRADSTOCK, DORSET

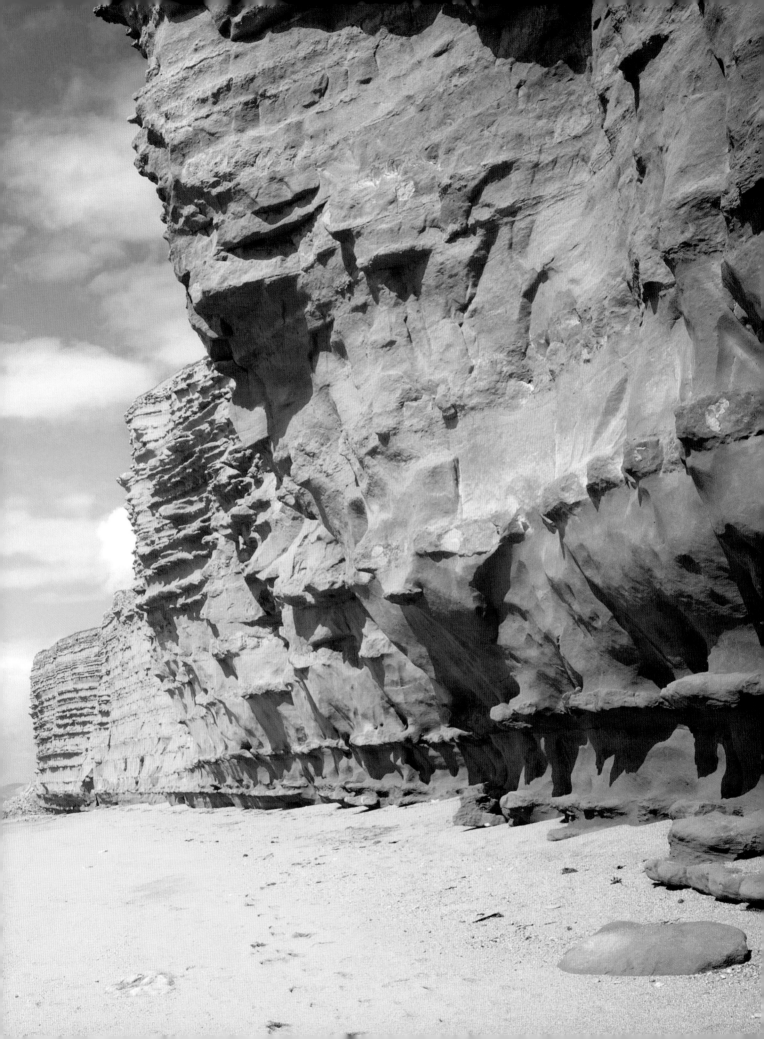

SEALS BASKING ON A BEACH, SCOTLAND

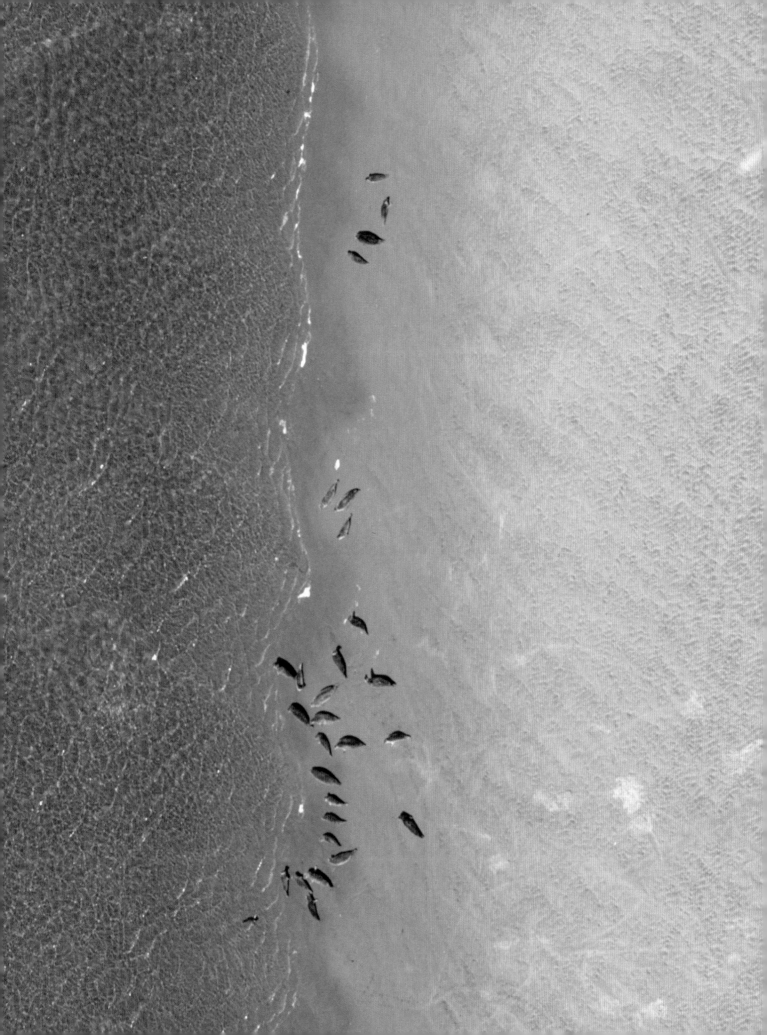

Foreword

The Hebrides: the words speak to me of the wild, the edge –
somewhere half-forgotten or half-remembered. They hold the
essence of what our coast means to me. Some of them are
empty places, abandoned by all but the seabirds. Many of the
folk who left made new homes in places as far apart as Canada
and New Zealand. To this day their descendants sing songs
promising that their hearts are Highland. When the passions
run high the tears they shed are salt water, of course, like the
seas that separate them from their ancestral homes.

Our coast has always cast an everlasting spell on those who
live there, those who visit, and those forced to leave it behind
forever when life gets too hard. It is the job of *Coast* to go in
search of those and other stories: rediscovering places
overlooked and forgotten by people, but remembered by the
sea and the sky.

There's only one word to describe how I felt at the end of
our first journey round the coast – bereft. Sounds a bit
melodramatic? Maybe, but it's the truth. The coast had opened
up like a marvellous book: characters, stories, unforgettable
images, and I didn't want to stop. So when BBC2 said they
wanted us to go back out again we were thrilled. The story of
our coastline is far too great, too grand, we agreed, to be told
in one series of programmes or contained in a single volume.

And the best news of all: we've already embarked on our next
journey. Promising further excitement, adventure and
discovery, the third series of *Coast* is coming your way soon.

NEIL OLIVER

SERIES PRESENTER ON *COAST*

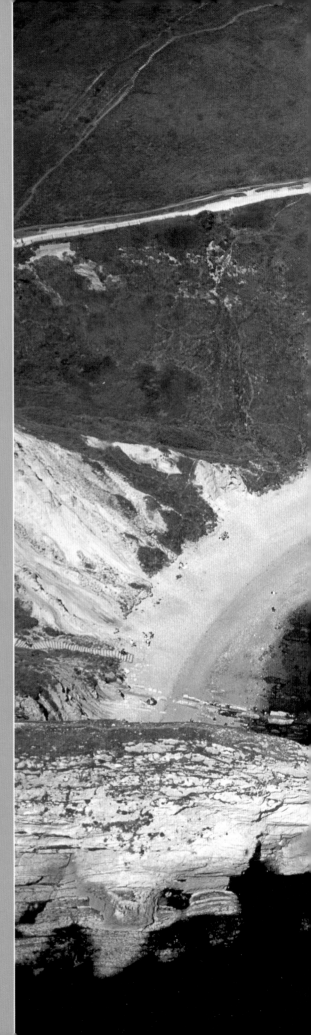

ST OSWALD'S BAY,
DORSET

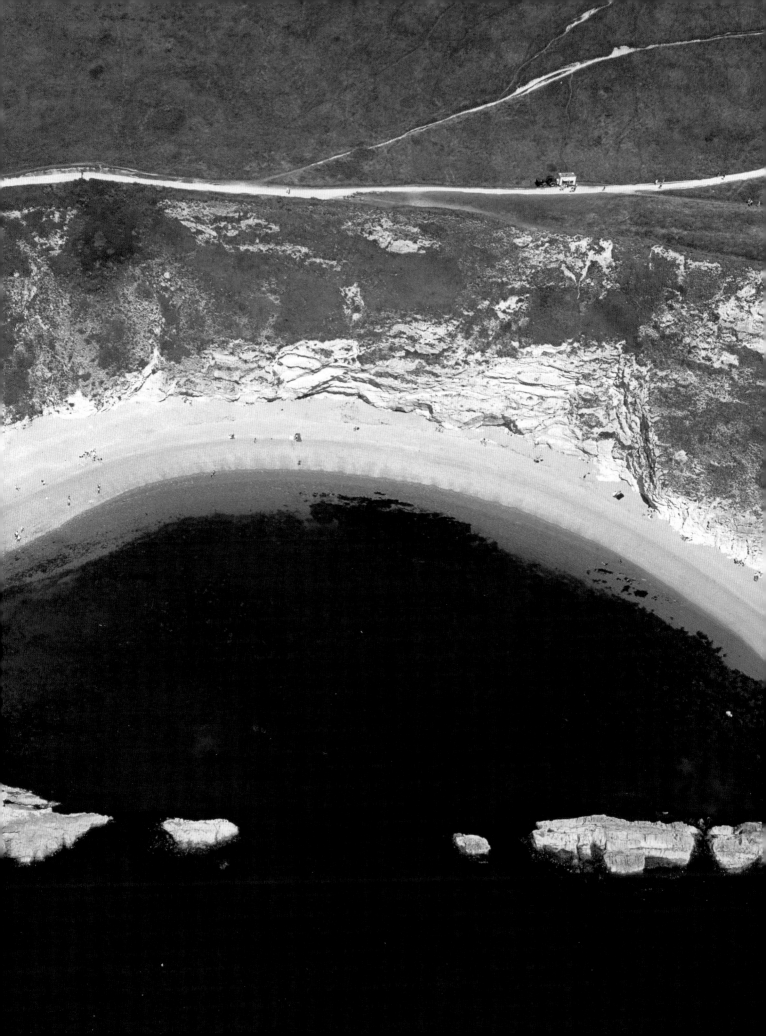

HOLYWELL BAY, CORNWALL

Introduction

So – we are off again! After the tremendous success of the first book and series of *Coast*, here is a new and completely different journey. This book takes 16 separate sections of the coast and explores them in detail, with its nose right up against the rocks and sands. Themes as fascinating and widely contrasting as ground-breaking inventions, earth-quaking explosions, heroes and saints, villains and devils, the heart of the city and the edge of the world – all are taken for a rollercoaster ride around the shores of these most extraordinary islands of ours.

The coasts of Britain and Ireland are packed full of tales and here is a whole treasure-house of them – yarns of the smugglers of *Moonfleet* and the golden walls of Lyonesse, as well as real-life stories about hurricanes and shipwrecks, famous adventurers on the trail of death or glory, eccentrics, half-crazed hermits outfacing the weather on a barren Irish rock, invaders bringing fire and sword ashore from dragon-headed ships, and immigrants arriving suitcase in hand at Tilbury docks to help build a new Britain.

From the towering chalk cliffs of Beachy Head to the moody marshes of the Humber Estuary and from the wind-whipped stone walls of the Aran Islands to the flowery machair of the Western Isles, these are the savage and glorious coasts of Britain and Ireland – and *Coast: The Journey Continues* takes you right there.

Christopher Somerville

CHRISTOPHER SOMERVILLE

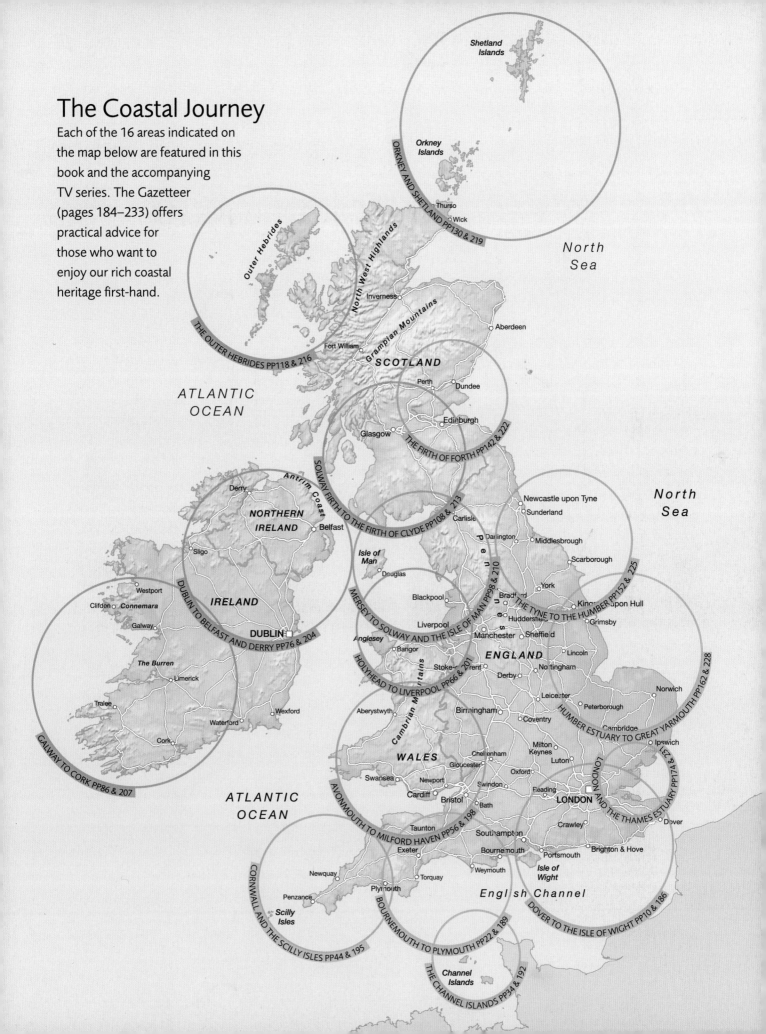

The Coastal Journey

Each of the 16 areas indicated on the map below are featured in this book and the accompanying TV series. The Gazetteer (pages 184–233) offers practical advice for those who want to enjoy our rich coastal heritage first-hand.

Shetland Islands

Orkney Islands

ORKNEY AND SHETLAND PP130 & 219

Thurso

Wick

North Sea

Outer Hebrides

North West Highlands

THE OUTER HEBRIDES PP118 & 216

Inverness

Aberdeen

Grampian Mountains

SCOTLAND

Fort William

Perth

Dundee

ATLANTIC OCEAN

Glasgow

Edinburgh

THE FIRTH OF FORTH PP142 & 222

SOLWAY FIRTH TO THE FIRTH OF CLYDE PP108 & 213

Derry

Antrim Coast

NORTHERN IRELAND

Belfast

Carlisle

Newcastle upon Tyne

Sunderland

North Sea

Darlington

Middlesbrough

Sligo

Pennines

Scarborough

IRELAND

Isle of Man

Douglas

York

THE TYNE TO THE HUMBER PP152 & 225

Westport

DUBLIN TO BELFAST AND DERRY PP76 & 204

Kingston upon Hull

Clifden

Connemara

Galway

Blackpool

Bradford

Grimsby

Liverpool

Huddersfield

DUBLIN

MERSEY TO SOLWAY AND THE ISLE OF MAN PP98 & 210

Manchester

Sheffield

The Burren

Anglesey

ENGLAND

Lincoln

Limerick

Bangor

HOLYHEAD TO LIVERPOOL PP66 & 201

Stoke-on-Trent

Nottingham

Norwich

Tralee

Cambrian Mountains

Derby

HUMBER ESTUARY TO GREAT YARMOUTH PP162 & 228

Waterford

Wexford

Leicester

Peterborough

Ipswich

Cork

Aberystwyth

Birmingham

Coventry

Cambridge

GALWAY TO CORK PP86 & 207

WALES

Cheltenham

Milton Keynes

Luton

LONDON AND THE THAMES ESTUARY PP174 & 228

Gloucester

Oxford

Swansea

Newport

Swindon

Reading

LONDON

Cardiff

Bristol

Bath

ATLANTIC OCEAN

AVONMOUTH TO MILFORD HAVEN PP56 & 198

Taunton

Southampton

Crawley

Brighton & Hove

Dover

Exeter

Bournemouth

Portsmouth

Newquay

Torquay

Weymouth

Isle of Wight

Penzance

Plymouth

English Channel

DOVER TO THE ISLE OF WIGHT PP10 & 186

Scilly Isles

CORNWALL AND THE SCILLY ISLES PP44 & 195

BOURNEMOUTH TO PLYMOUTH PP22 & 189

Channel Islands

THE CHANNEL ISLANDS PP34 & 192

The Chalk Coast

DOVER TO THE ISLE OF WIGHT

There is no more magnificent sight anywhere along the coasts of southern Britain than the mighty white ramparts of the chalk cliffs. The White Cliffs of Dover, Shakespeare Cliff and Beachy Head, the Seven Sisters, Tennyson Down and The Needles – they rear skywards from jade-green or turquoise waves, shining like celestial beacons in the sharp south-coast sunshine, or sulking in the ghostly grey of sea mists. The towering white cliffs – like giant teeth bared in defiance – have a majestic force and symbolic power entirely appropriate for a coastline that's survived the ravages of wild weather, erosion from the sea and violent attacks from enemies across the Channel. These chalk cliffs have exerted a remarkable influence over the lives, wellbeing and social development of generations of people living locally for tens of thousands of years.

The actual length of coastline that the chalk cliffs occupy is surprisingly small, considering their fame. Their line runs in three great ripples along the coast. The largest stretch starts at Kent's Isle of Thanet and goes round the corner of the Straits of Dover to Folkestone, where it dips to the flat green apron of Romney Marsh and the giant shingle spit of Dungeness; the next section runs from Beachy Head to Brighton, where it declines into the level West Sussex shore; finally, a line of chalk cliffs extends across the widest part of the 'waist' of the Isle of Wight, off the Hampshire coast.

THE RED-AND-WHITE-STRIPED lighthouse that guards the foot of Beachy Head is over 150 feet tall, but it stands dwarfed by the towering wall of chalk that looms at its back. The magnificent 530-foot rampart of Beachy Head is Britain's highest chalk cliff.

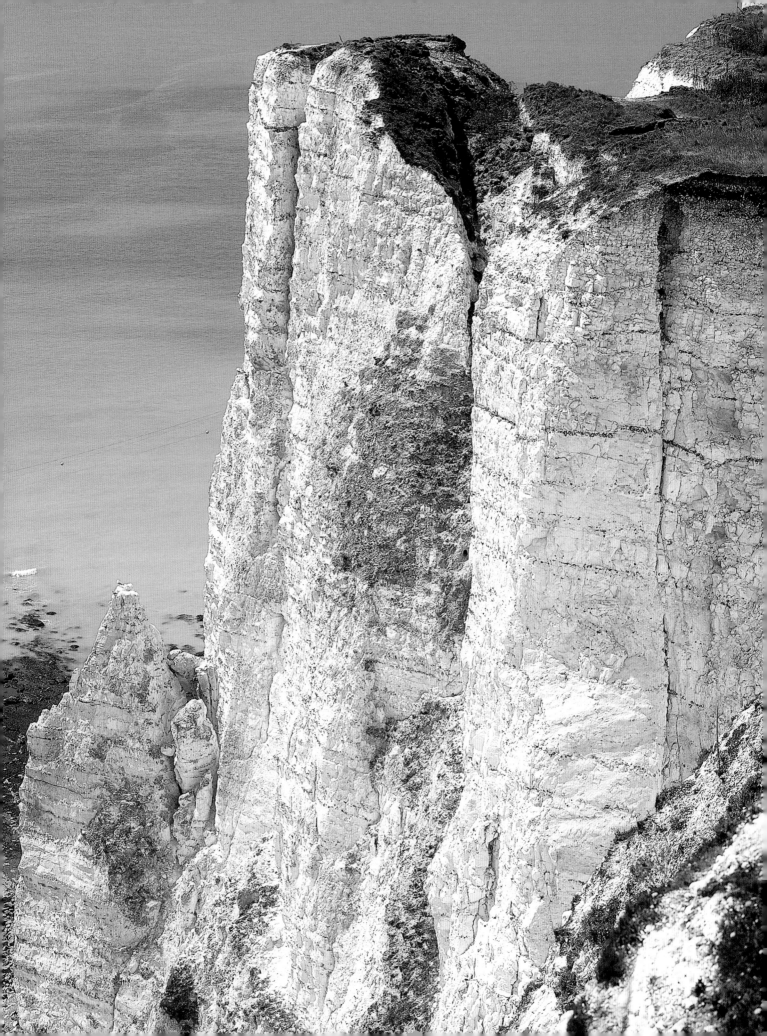

What is chalk? It is hard to believe, but this great wedge of material inserted into the body of southern England – a rock as crumbly and white as Sussex Slipcote cheese, yet strong enough to form cliffs nearly 600 feet tall – is entirely composed of algae and the shells and skeletal remains of tiny plankton. These creatures, mostly of microscopic size, once lived in the warm, tropical Great Chalk Sea, whose shallow waters covered most of Britain and north-west Europe some 60–80 million years ago. When you consider that the chalk deposits at their greatest height around the Isle of Wight are over 1700 feet thick, the picture is of a mind-bogglingly enormous number of minute shells and skeletons drifting down to settle, one on top of another, on that ancient seabed.

The human – or proto-human – shinbone that was unearthed at Boxgrove Quarry in West Sussex in May 1994 (see box, facing page), to great excitement and controversy in the archaeological world, suggested that humans have inhabited these chalky coastal areas for about half a million years. Small wonder, because chalk benefits humans in so many different ways. Chalky soil is fertile and easy to work, which means it is good for agriculture. Water in chalk country is sweet and pure, thanks to the long filtration that rainwater undergoes as it sinks gradually from the high downs through hundreds of feet of permeable chalk. It also forms rolling country – a fast-draining and open terrain that is easy to travel around, because the trackways and valley bottoms don't flood. You can burn chalk in a kiln to produce lime for the fertilizing of acid land, or you can roast it with clay and powder it to make cement.

Perhaps the most important aspect of this landscape to our ancestors was not the chalk itself, however, but the dark treasure of flint contained within it. As sponges and other marine life of the Great Chalk Sea died and dissolved, their skeletons produced crystals of silica that coalesced to form layers of flint, in nodules or in sheets. These layers are easily seen as thin dark lines, dozens of them in parallel, running horizontally along the faces of the chalk cliffs. Some visionary among our primitive ancestors made the imaginative leap to grasp and unleash the properties of flint, a step that had a dramatic impact on human development. A major discovery was that flints could be struck together to produce fire – the element that separates humans from beasts. Warmth and light were now available whenever

and wherever the flint-carrier chose to create them. This remarkable, almost magical substance was also used for tool-making: it could be flaked into a blade that was light enough to fly through the air at the tip of an arrow, and was sharp enough to slice through a wild boar's hide and muscle to strike his vital organs, yet was hard enough not to shatter on its way there. In addition, it was useful when bartering with people from flintless regions for precious items such as gold or fine pottery.

EXPOSED AT LOW TIDE, the Isle of Thanet's limestone 'pavements' lie hollowed with hundreds of tidal rock pools. These pavements are the remnants of previous lines of soft chalk cliffs, which have been ground down and eroded away over time by wind, weather and the inexorable power of countless tides.

BOXGROVE MAN

The shinbone of our very venerable ancestor, known as Boxgrove Man, was dug from Boxgrove Quarry near Chichester in May 1994. Boxgrove Man had a splendid physique for his era, being well over 6 feet tall. He was probably a member of the species *Homo heidelbergensis*, a hunter–gatherer skilled in the making and use of stone tools; and, judging by the state of his teeth, he may well have suffered from raging toothache. As for how long ago he lived, experts are divided: many think it could be around 500,000 years ago, making him one of the very first ancestors of modern man to inhabit the empty, silent land of Britain.

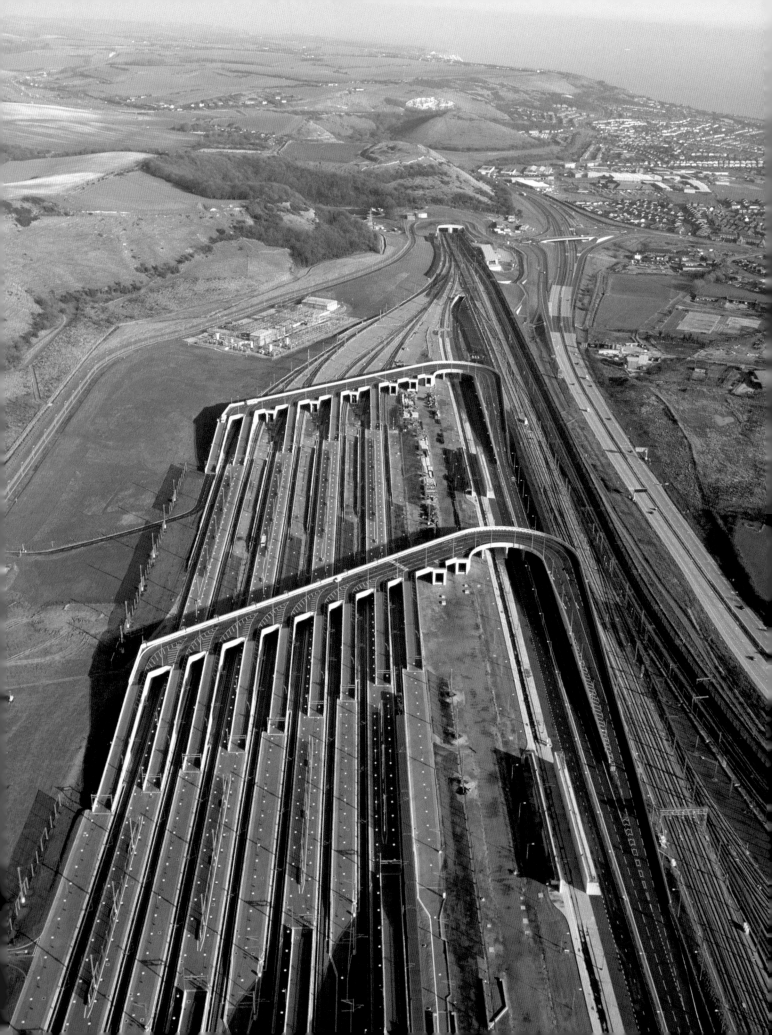

It might be too fanciful to claim that the chalk country is a nursery for visionary notions, but certainly some of the brightest and best ideas, as well as some of the most bizarre, have come to fruition or disaster along this white-walled coast. One of the greatest engineering feats ever accomplished, and one of the longest in gestation, was the 31-mile-long Channel Tunnel under the Straits of Dover, between Folkestone on the English Coast and Sangatte in France. It is the second longest railway tunnel in the world, with a length of 23 miles beneath the sea. The idea of a travel link between England and France that would do away with the time-consuming, weather-dependent, sometimes dangerous and often sick-making sea crossing had been mooted as long ago as 1751. Tentative starts were made in 1881, 1919 and 1974, but soaring costs, the pussy-footing of governments and the dire warnings of military chiefs meant that each attempt came to a grinding halt. But the Channel Tunnel made such good sense, and was such an irresistibly grand challenge, that political will finally stiffened to the point.

In 1987–8 digging began in earnest on both sides of the English Channel. The statistics were comparable to those of the most ambitious Victorian railway schemes – 13,000 people worked on the tunnel and 140 million cubic feet of chalk were excavated on the UK side alone. The French

AN EXTRAORDINARY PATTERNING was created in the coastal country around Folkestone during the building of the Channel Tunnel in the late 1980s. Like the furrows left by a giant's plough, hundreds of lines of new road and railway tracks seamed the ancient landscape.

and British tunnellers broke through to each other under the sea on 1 December 1990. In May 1994, the great triple-tunnel system came into operation, cutting the crossing time by more than half. But the newly forged physical link with the Continent represented more than just an increase in convenience for travellers. It stood as a symbol of the close cultural, historical and political ties that bind our island nation to those of mainland Europe. As a bold and successful technological adventure, it represented a triumph of which Isambard Kingdom Brunel or any of the other great engineers would have been proud.

The lozenge-shaped Isle of Wight is an island of two distinct halves – the northern segment is composed of younger sand, clay and limestone, while the southern half is made up of older greensand, mudstone and sandstone. The meat in the middle of this geological sandwich is a great lateral ridge of chalk that pokes out at the eastern extremity of the island to form the blunt-nosed Foreland promontory, and tapers at the western tip into Tennyson Down and The Needles, a promontory that consists of three detached, blade-shaped white chalk stacks that emerge dramatically from the sea. It was here, at the Old Battery – a spectacular cliff-top site overlooking The Needles – that laboratories and gantries were set up in the mid-1950s to test the Black Knight rocket, a missile which, it was hoped, would help Britain towards

possessing her own credible nuclear deterrent. More than 200 people were employed on the Black Knight project at the top-secret site. Towards the end of the 1960s, it became apparent that an independent British nuclear weapon was unaffordable, and work switched to the related Black Arrow, a missile intended to carry Britain's Prospero satellite into space. This it duly did in 1971, from a launch site at Woomera in South Australia – even though the project had been deemed too expensive and cancelled three months previously. Prospero still circles the Earth, intermittently transmitting, forgotten by all but a small and dedicated band of admirers. Meanwhile, the bare concrete foundations of a few buildings are all that is left at the Old Battery to bear witness to Britain's abortive attempt to compete in the great international Space Race.

Another visionary project associated with the chalk country, though of a completely different stamp, was the futuristic seaside resort of Hastings. By the early twentieth century, Brighton and Eastbourne were the most popular of the chalk-coast resorts, with Hastings a poor third. When borough engineer and architect Sydney Little decided to change that pecking order in the 1930s, Hastings and its neighbouring resort of St Leonards-on-Sea got the mother of all makeovers. Inspired by the grand vision of Mr Little – soon dubbed the 'Concrete King' – the town shed much of its genteel Victorian architecture in favour of such wide-screen Art Deco monuments as a magnificent open-air lido, or swimming pool, with tiered seating for 2500 (this later became a grand ice rink), bathers' beach chalets, a cliff-sized block of flats shaped like an ocean liner, a pioneering double-decker car park, and a two-tiered promenade known as Bottle Alley because of its decorative mosaics of broken glass. The bill for such vast aspirations topped £3 million, a giant sum in those days. Of the Concrete King's seaside empire, only fragments remain intact today and Sydney Little's futuristic designs have been supplanted by those of other architects, equally vulnerable to the long tides of history.

ONE OF THE MOST STRIKING FEATS of Art Deco architecture in the realm of Sydney Little, the 'Concrete King' of Hastings, was this curvilinear 1930s seafront block of flats in St Leonards-on-Sea. Designed to reflect the grandeur of an ocean liner, the building was named Marine Court – but locals soon dubbed it 'Monstrosity Mansions'.

ON A DUSKY SUMMER'S EVENING in the Isle of Wight, the long, convex curve of Tennyson Down rises to the slender shape of the Tennyson Monument. This ornamental stone cross, which is carved with neo-Celtic interlacing, stands 480 feet above the sea, in a beautiful spot where the nineteenth-century Poet Laureate Alfred Lord Tennyson loved to linger.

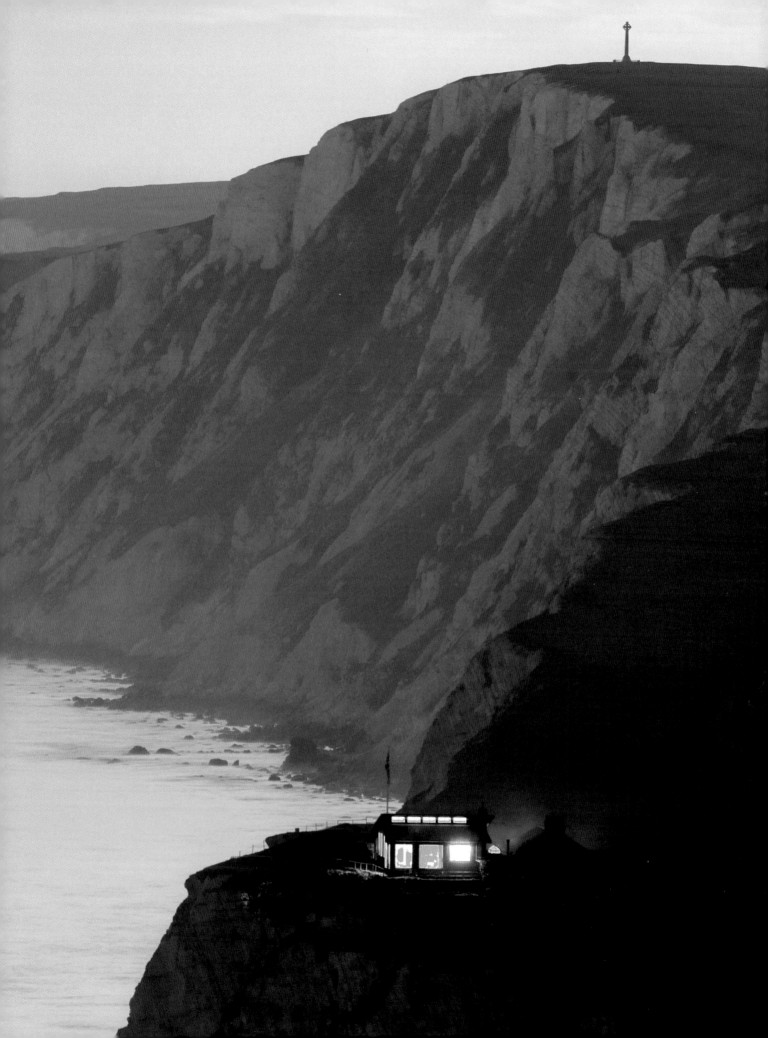

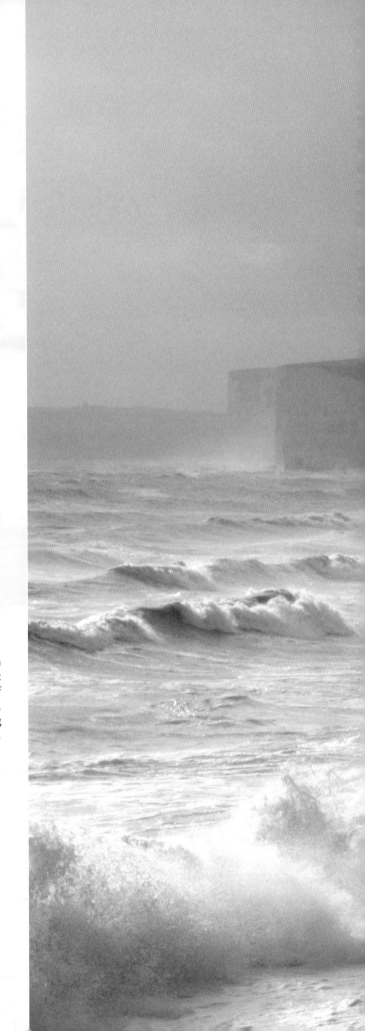

The survival of the chalk cliffs of the south coast could be at stake if global warming produces a substantial increase in rainfall and stormy weather. Rain sluices chalk away; it freezes in the cracks and expands, breaking off chunks. Also highly destructive are storm waves, which hollow out the feet of the cliffs so that the overhanging chalk is liable to fall. In addition, the thump of waves against cliffs can violently compress pockets of air trapped in the chalk, producing mini-explosions that blast away chunks of cliff face. Some experts predict that the very organisms whose shells and skeletons formed the chalk may themselves pollute the seas. Locked up in their skeletons is a great deal of carbon dioxide, the greenhouse gas produced by living organisms. When dissolved in seawater, the released carbon dioxide forms a weak carbonic acid, which tends to decompose calcium carbonate, the material from which corals and marine shells are made. If carbon dioxide levels greatly increase in the atmosphere, the oceans could acidify to the point where they might struggle to sustain marine life. Our decisions about pollution and production of greenhouse gases over the next few years are crucial. The great shelf of chalk that has nourished and sustained man through all these millennia is now reliant on us for its own continued existence.

THE TREMENDOUS CHALK CLIFFS of the Seven Sisters, rising to 253 feet on the East Sussex coast, look like an impregnable white wall. But a combination of rough weather, foreshore erosion and violent waves, exacerbated by the effects of climate change, is causing these cliffs to collapse at an ever-increasing rate.

I've walked the coastal path a few times, glimpsing France through the haze. But it's another presence that looms strongest as you look out over the grey waves – the great mass of Britain itself, spreading out behind you.

NEIL OLIVER, SERIES PRESENTER

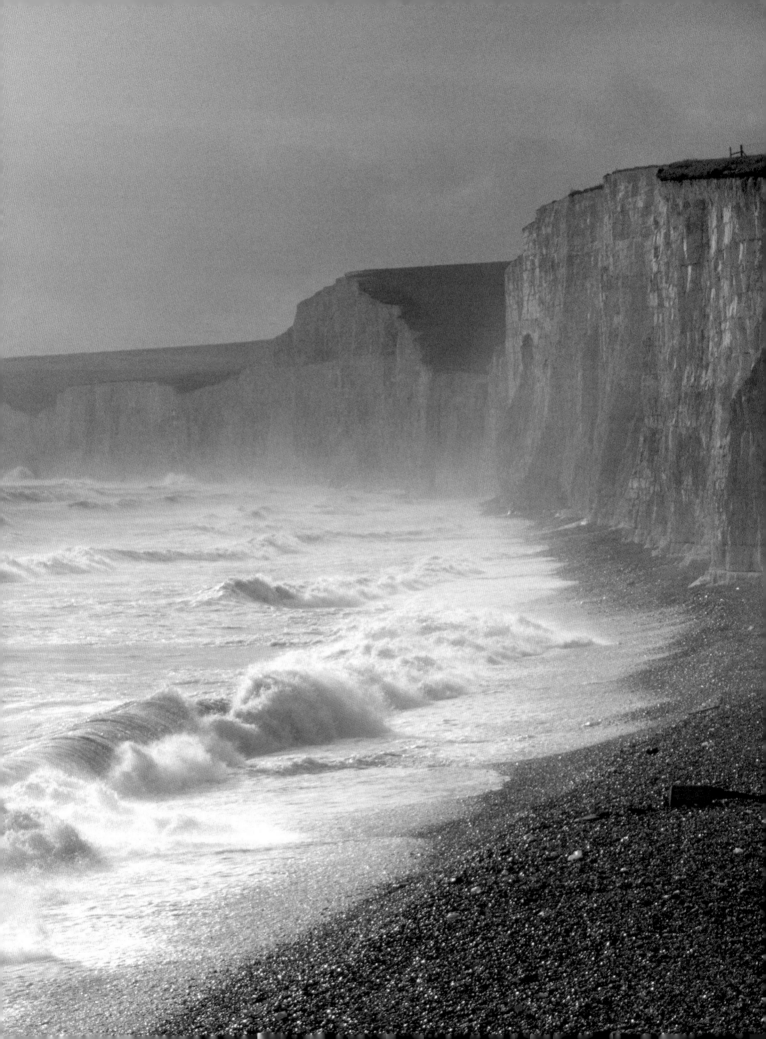

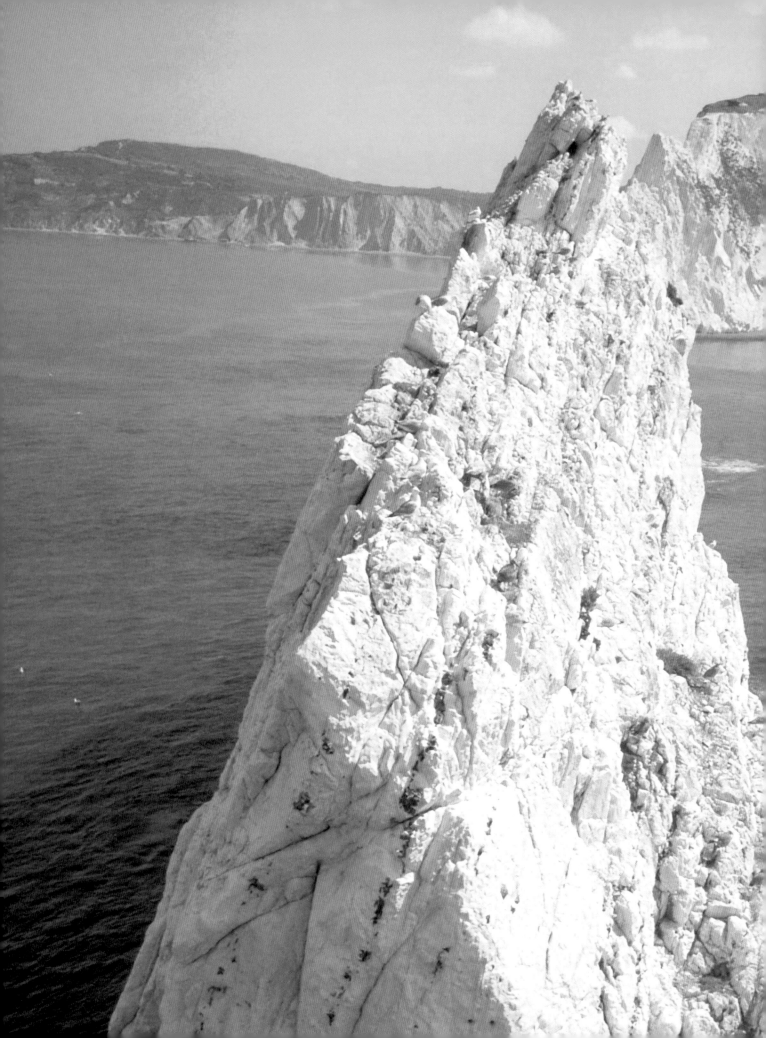

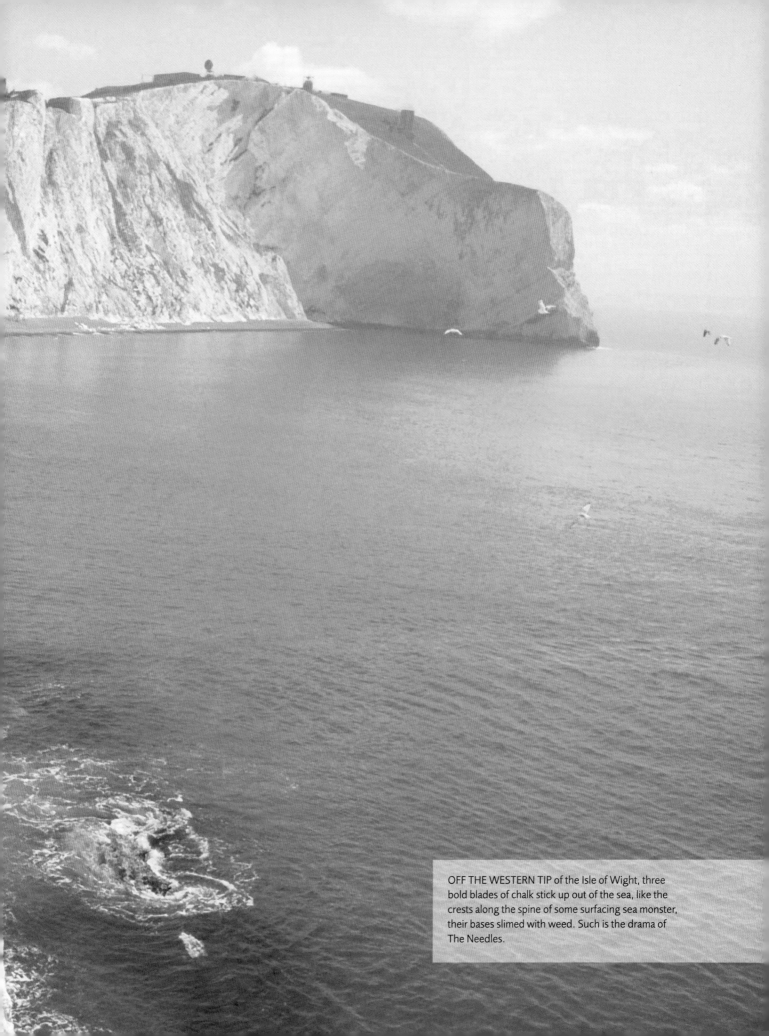

OFF THE WESTERN TIP of the Isle of Wight, three bold blades of chalk stick up out of the sea, like the crests along the spine of some surfacing sea monster, their bases slimed with weed. Such is the drama of The Needles.

The English Riviera

BOURNEMOUTH TO PLYMOUTH

The most exclusive piece of real estate in Britain – that in many ways describes the coast that stretches in an elegant series of curves from Bournemouth westward to Plymouth. Bournemouth and Poole, Weymouth and Lyme Regis, Seaton and Sidmouth, Torquay and Brixham, Dartmouth and Salcombe – these names breathe the very air of safe and comfortable seaside holidays, of fossiling and cream teas, of easy living in balmy weather. Yet the British coast is rarely as tame as it looks from a hotel window. Along the beautiful and seemingly benign coast of Dorset and Devon, rocks and rough weather can bite as hard as anywhere. For the fishermen, sailors, villagers and quarrymen working here, the living has never been easy.

Previously a remote and impoverished region, this stretch of coast received a big shot in the arm in financial terms in the early nineteenth century, when well-heeled Britons accustomed to foreign adventures found that they could no longer travel in the occupied countries of Napoleon's Europe. They looked around for an agreeable domestic substitute for the Swiss mountains, the Italian lakes and the shores of the Mediterranean, and they found it in the flowery cliffs and sheltered coves of Dorset and Devon. The English Riviera was close enough to make for easy travel, the climate was sunny and mild, and everyone spoke the language. Best of all, for eyes newly opened by the burgeoning Romantic movement, the tumbled rocks and mineral-streaked cliffs gave a thrilling dash of exoticism to the landscape.

TORQUAY CAME TO prosperity in the eighteenth century as a base for the families of Royal Naval officers. The *Fawlty Towers* team made the town infamous in the 1970s, but now this handsome seaside resort is returning to favour as a destination for lovers of fine Victorian architecture in a sylvan setting.

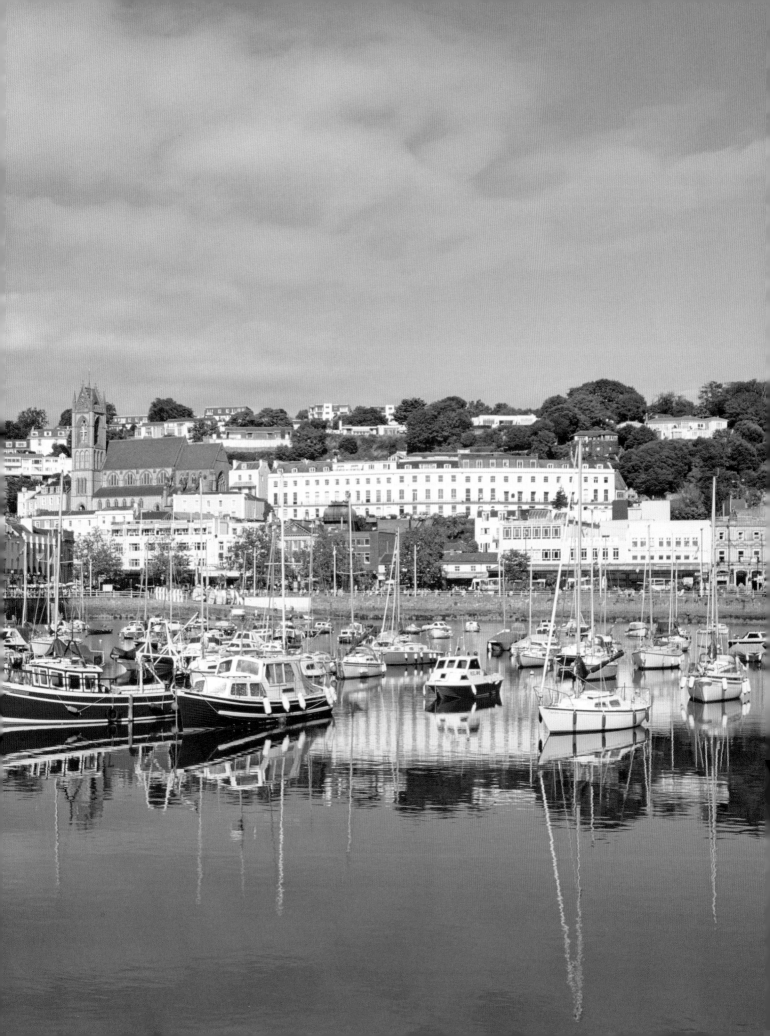

Bournemouth makes a fine starting point to the westward journey, and the story of its development is by and large that of most seaside resorts along the Dorset–Devon coast. The tiny fishing and smuggling hamlets that were here before the town came into being were located on a sheltered curve of coast, amid steep wooded valleys called 'chines' and cliffs as colourful as the yellow-and-white strata of nearby Barton and Highcliffe. At first, Bournemouth was a highly exclusive resort for the upper classes, who would not tolerate anything as vulgar as a shop in the vicinity – all their requirements were brought to them in their own residences. Gradually, the town became more developed. Beautiful gardens were planted, elegant promenades appeared, and a daily coach service was set up in 1840. By the time the railway finally arrived in the town in 1870, bringing with it an influx of day-trippers and less well-off holiday-makers, the exclusivity of Bournemouth had already diminished.

Other sizeable resorts along this coastline got their commercial starts in different ways. King George III ensured the success of Weymouth, 30 miles west of Bournemouth, when he repaired to the town on some 14 separate occasions between 1789 and 1805, in the hope of a sea-bathing cure for the hereditary blood disorder, porphyria, which was tormenting him with symptoms akin to madness. Torquay and neighbouring Paignton, destined for prosperity as genteel health resorts during the nineteenth century, first developed during the Napoleonic Wars as places where the wives and families of Royal Navy personnel could meet the men of

BOURNEMOUTH boasts some very fine sandy beaches, and the delights of Poole Harbour and the Dorset coast and hinterland are nearby. Today, the once-exclusive resort has reinvented itself as a conference centre, but it also continues to fulfil the role of a classic English seaside holiday town.

the Channel Fleet, which was based in Torbay. The coming of the railway to Torquay in 1848 and to Weymouth in 1857 heralded great expansion of these resorts, as well as a dilution of their extreme gentility.

The heyday of Bournemouth, Weymouth, Torquay and Paignton as large, popular seaside resorts was at hand. For a century or so, they were filled to the brim with British holiday-makers. However, their fortunes turned in the 1970s – Britain's heavy-industry economy collapsed and private car ownership increased. The British were no

longer taking the train to specific seaside resorts but were touring the country by car. Cheap package holidays enabled more people to travel abroad. Although all traditional seaside resorts went through a downturn at this time, the resorts of the English Riviera suffered less than their northern counterparts, such as Blackpool and Scarborough, largely because they never relied on trippers from big local manufacturing centres. They enjoy better weather, too, and more diverse scenery. Torquay and Paignton have struggled, but now find themselves on the 'short break' agenda of better-off holiday-makers, thanks largely to their fine Victorian architecture, wooded setting and beautiful beaches, many of which have been awarded the Blue Flag for their cleanliness and suitability for bathing. Weymouth ticks along, as it has done for the past two centuries, on its local trade. And Bournemouth has reinvented itself as a conference centre of international repute, as well as retaining the upper end of the senior citizens' holiday trade. Those flowery promenades, those well-kept gardens and terraces, that easy-on-the-eye scenery – all remain popular to this day.

TOP SPOTS ■ BOURNEMOUTH TO PLYMOUTH
Abbotsbury Swannery p.190 - Bournemouth p.190
Brixham p.190 - Cobb breakwater pp.190–1

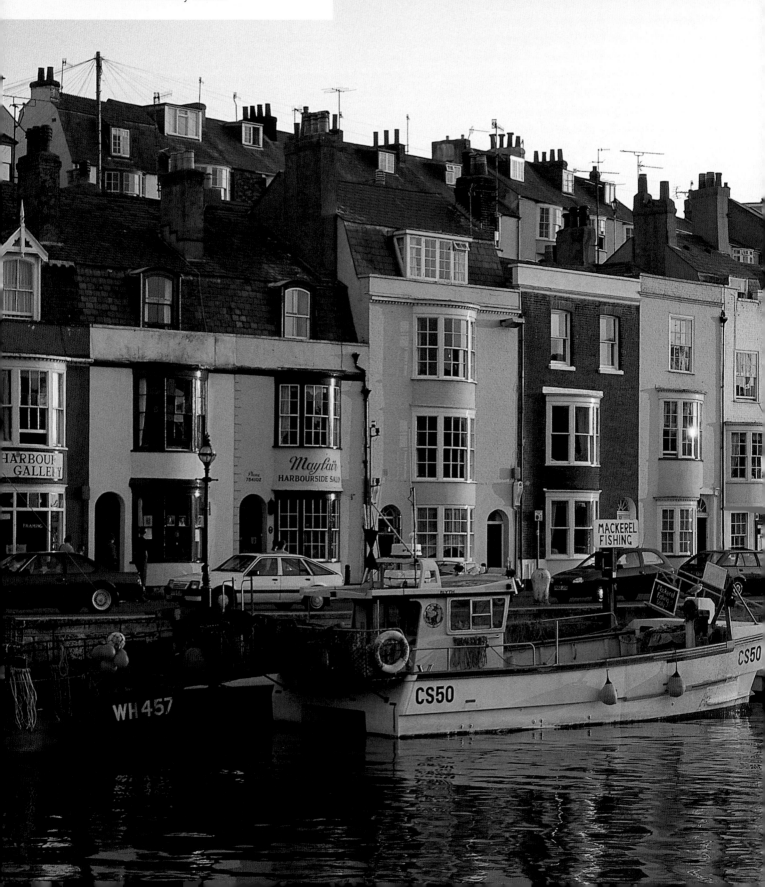

WEYMOUTH'S QUAYSIDE in the evening, with the sunset lighting up the handsome Georgian bow fronts of the houses. King George III's favourite resort, the mid-Dorset town and its sheltered bay are perennial favourites with local holiday-makers.

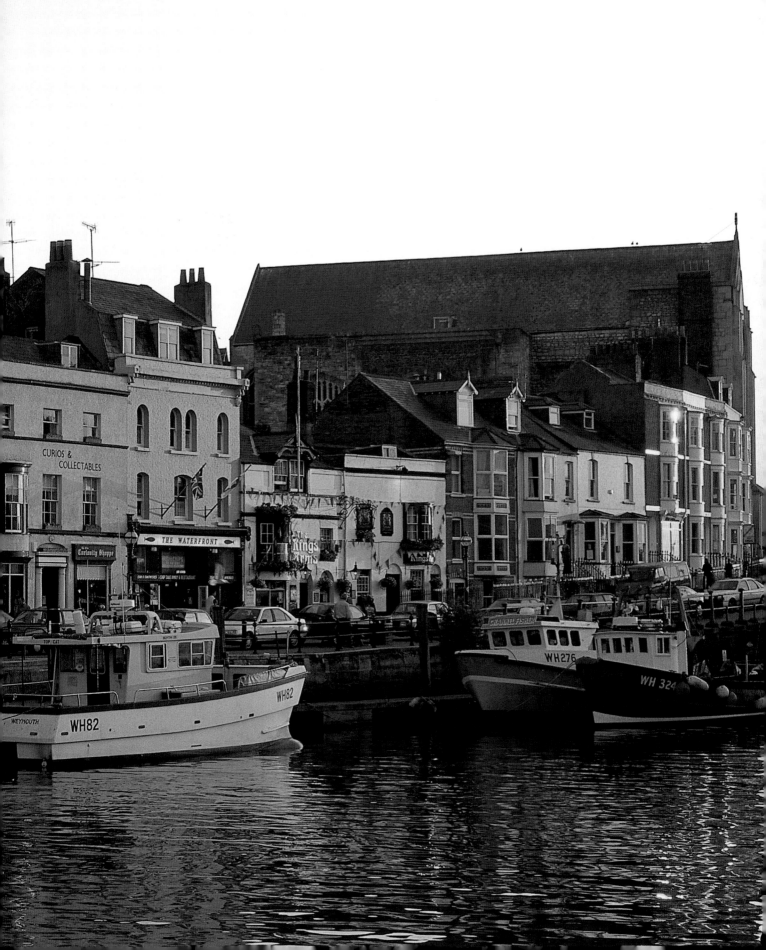

The smaller towns and villages of this coast make up a fascinating mosaic. Some were prosperous through commerce long before the eighteenth-century seaside boom got under way – for example, Brixham with its famous fishing fleet, Dartmouth and its sheltered anchorage, and Poole with its wonderful harbour and strong transatlantic trade links that filled the town with handsome merchants' houses, at a time when Bournemouth was not even a twinkle in a jaded duchess's eye. Today, money continues to stick like glue to this favoured part of the coast; the small settlement of Sandbanks, on a peninsula in Poole Harbour, is one of Britain's most expensive places to buy property.

Swanage and Lyme Regis, on the Dorset coast, became modest resorts in their own right, and still retain that status. So do the Devon villages of Seaton, Sidmouth and Budleigh Salterton to the east of the Exe estuary, and Dawlish and Salcombe further west. Many of these smaller Riviera resorts have their own unique selling points. Across Studland Bay from Bournemouth, Swanage boasts extravagant architecture, based on pieces salvaged from London during the nineteenth century by stone merchants John Mowlem and George Burt. This

SANDBANKS is a highly exclusive peninsular enclave in Poole Harbour. The peninsula may enjoy the even greater exclusivity of becoming an island if sea levels continue to rise.

uncle-and-nephew team were dismantling the capital in order to rebuild it in Portland stone, and among the scrap stone items they proudly installed in their native town were the Wellington Clock Tower from London Bridge, the frontage of the seventeenth-century Mercers' Hall (doing duty as the façade of Swanage Town Hall) and George Burt's wonderfully overblown residence of Purbeck House, made up of bits and pieces from several grand London buildings. Sidmouth has its sparkling Folk Week in the height of summer, a festival of traditional music second to none; Salcombe, in and around the sheltered waters of the Salcombe Estuary at the southern tip of Devon's South Hams district, is a rower's, diver's and small-boat sailor's paradise.

EVERY JUNE, the Torbay fishing town of Brixham hosts a trawler race, a chance for these stubby little sea harvesters – many 'dressed overall' in flags and sparkling in a new coat of paint – to show off their paces and manoeuvrability as they charge twice round Torbay.

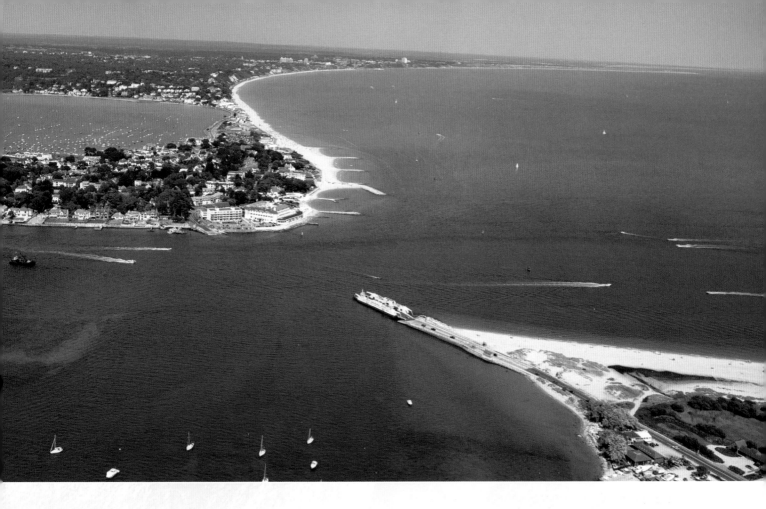

Lyme Regis, on the Dorset–Devon border, is famous above all for fossils. It was here, around 1811, that palaeontologist Mary Anning (1799–1847) and her brother Joseph unearthed the first-known skeleton of ichthyosaurus, the prehistoric fish lizard. Today, the tottering cliffs of shale and blue lias clay east and west of the town continue to yield extraordinary numbers of fossils – particularly ammonites and belemnites – in their frequent falls and slides. Lyme is situated in the middle of one of the most unstable pieces of coast in Europe, a slippery geological sandwich in which a top layer of 100-million-year-old greensand and chalk lies uneasily on top of a greasy skid mat of grey Jurassic marine clay. The whole of the Dorset coast, together with a large slice of Devon's most easterly cliffs, is known as the 'Jurassic Coast', in recognition of its richness in fossil remains and the folded, contorted rock strata that stand exposed by cliff falls all along its length.

A GIANT AMMONITE, too large and heavy for even the most assiduous collector to remove, lies among the rocks under Ware Cleeves, to the west of Lyme Regis, mecca of fossil hunters along the Jurassic Coast.

TOP SPOTS ■ BOURNEMOUTH TO PLYMOUTH
Dartmouth p.190 - Durlston Country Park p.191 - Isle of Portland p.190 - Jurassic Coast p.191 - Lyme Regis p.190

Tough times along the Dorset–Devon coast were common in the not-so-distant past. Most of the difficulties of everyday life were founded on the unstable geology that cut off the area from the outside world – it inhibited road building, blocked up beaches and choked harbour outlets. Until the seaside boom, Lyme Regis was dirt-poor, owing to the isolation imposed by the steep, dangerous hills that hemmed it in and made it a difficult and dangerous place to get to. Many of the region's inhabitants turned to smuggling as a way of making a living, and the Dorset and East Devon coasts became one of Britain's most notorious contraband areas, with plenty of lonely beaches and coves to land the goods, and dozens of remote heaths, woods and farms just inland to serve as secure hides for the illicit cargoes of duty-free tobacco, brandy and lace.

John Meade Falkner set his 1898 smuggling classic *Moonfleet* in and around the villages along the brackish lagoon of the Fleet, which lies behind the great 12-mile shingle bank of Chesil Beach. For sailors, this has always been a deadly coast. Chesil Beach has been the scene of shipwrecks and deaths without number. So many wreck victims were pounded and drowned on

Chesil in the eighteenth and nineteenth centuries that they fill two large graveyards around All Saints Church at Wyke Regis, near Weymouth. The worst disaster of all fell on 18 November 1795, when three military transports came to grief in the bay with the loss of over 1000 soldiers and crew members. Walking the crunching, slippery pebble ridge of Chesil Beach, one sees exactly why a shipwrecked sailor cast up on the water's edge had so little hope of rescue. Each wave rushes up the beach in a white collar of foam, then drags back in a vicious undertow with a hiss and a seething sigh of rolled pebbles. Ships and men would be revolved in the breakers, cast up and dragged back time and again, until there were only shattered remains left of either.

THE SHINGLE BANK of Chesil Beach stretches 18 miles along the Dorset coast, lying between the Isle of Portland and the village of Abbotsbury. The seas of Lyme Bay wash its outer rim, and the calm waters of the Fleet lagoon shelter inside its protective arm.

Some of the houses in the Sandbanks peninsula in Poole Harbour are certainly striking – and all of them worth a mint. But look out to sea and you can't help but be reminded that the landscapes and the views here are free – and also priceless.

NEIL OLIVER, SERIES PRESENTER

Sea disasters are dramatic events by their very nature, and many of the shipwrecks that occurred here are well documented. But more prosaic and less notorious were the everyday hardships of the labourers on the lonely starveacre farms of Thomas Hardy's Dorset, and of the men who quarried the freestone of the district at daily risk of their lives. The bleak quarrying landscapes of the Isle of Purbeck and the Isle of Portland – all geometric ledges and harsh downfalls of stark white boulders – are still there to be seen, and some of the quarries continue in operation, although the quarrymen work in considerably better conditions these days.

LIKE DEEPLY ERODED sea cliffs, the buttresses of quarried oolitic limestone, known as freestone, that surround the Isle of Portland drop sheer to a sloping scree of shattered and discarded rock. Quarrying used to be a highly dangerous occupation in this area.

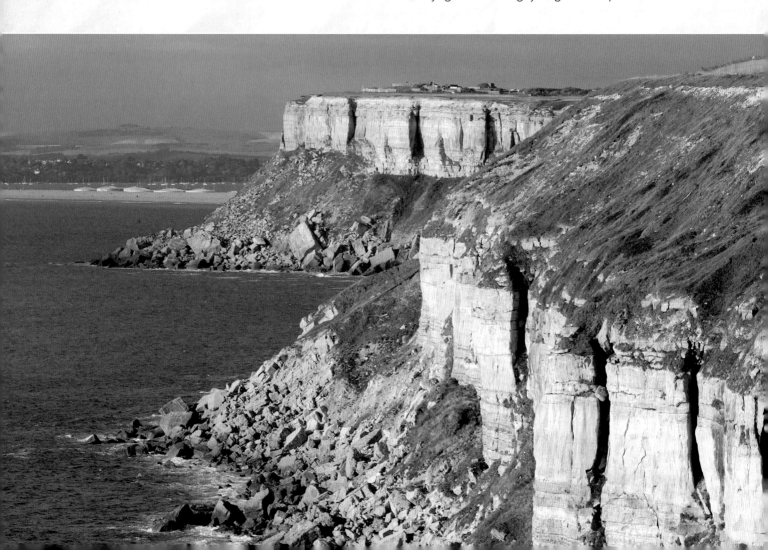

Peaceful holidays and wild sea catastrophes, gentility and brutality, glorious scenery and austere industrial landscapes – variety and contrast are the keynotes of the English Riviera. As a coda to the whole many-faceted journey stands the old seaport city of Plymouth, on the border of Devon and Cornwall. The sea approach is dramatic in itself, passing the slender, mile-long arm of the great Plymouth breakwater, running up the Sound to pass Drake's Island, and taking in the views of the seventeenth-century Royal Citadel, Plymouth Hoe and the impressive walls of the Royal William Victualling Yard.

Plymouth suffered badly in the twentieth century, from German bombing during the Second World War and from inappropriate planning and building thereafter. Yet the waterfront remains one of the most impressive and historic in Britain. It was from Plymouth that Sir Francis Drake set sail to beat off the Spanish Armada on 19 July 1588, and from here that the Pilgrim Fathers headed out in *Mayflower* on 6 September 1620 to found the first successful British colony in the New World, 3000 miles to the west. On 12 July 1776 Plymouth saw Captain James Cook, Britain's greatest navigator–explorer, leave on his third and fatal voyage to America and Hawaii; and on 28 May 1967 the city welcomed home Francis Chichester, pioneering round-the-world solo yachtsman, who was knighted by the Queen at Greenwich with Sir Francis Drake's own sword. It was fitting that Plymouth should be Chichester's final destination – a brave reminder of the noble seafaring heritage of this remarkable stretch of coast.

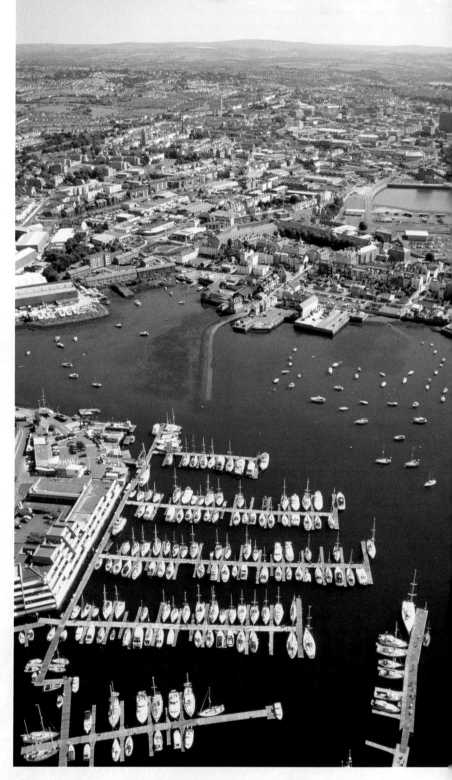

PLEASURE BOATS tie up at Plymouth's marina jetties these days, but the waterside city on the Devon–Cornwall border has seen more business-like craft set sail in past centuries – notably Sir Francis Drake in his flagship *Revenge* to confront the Spanish Armada in 1588, and Captain James Cook in *Resolution* on his last voyage in 1776.

Gateway to the Continent

THE CHANNEL ISLANDS

Jersey, Guernsey, Alderney and their even smaller neighbours of Sark and Herm – these green and compact islands, situated in the English Channel just a few miles off the Normandy coast of France, lie right on the front line of history. For centuries, British sailors and smugglers, military men, merchants and adventurers have seen the Channel Islands as a gateway to Europe and the wider world. In their location as doorkeepers to the Continent, they have acted as a filter through which most tides of the region's richly eventful past have flowed – an age-long history of confrontation, compromise and co-operation between Britain and the European mainland.

Each of these British islands is very much a self-governing, proudly independent parliamentary democracy, answerable not to the British Parliament but directly to the Crown. Councils of legislature, known as 'States', administer Jersey, Guernsey and Alderney, while Sark has its Council of Chief Pleas (its own island parliament) and its Seigneur – some consider him Europe's last feudal lord. Culturally and linguistically, France has a very strong influence on all the islands. Bearing in mind that these islands seem to have such a lot in common, an outsider might well think they would be as close-knit as a Guernsey sweater, 'us against the world', but nothing could be further from the truth. Although

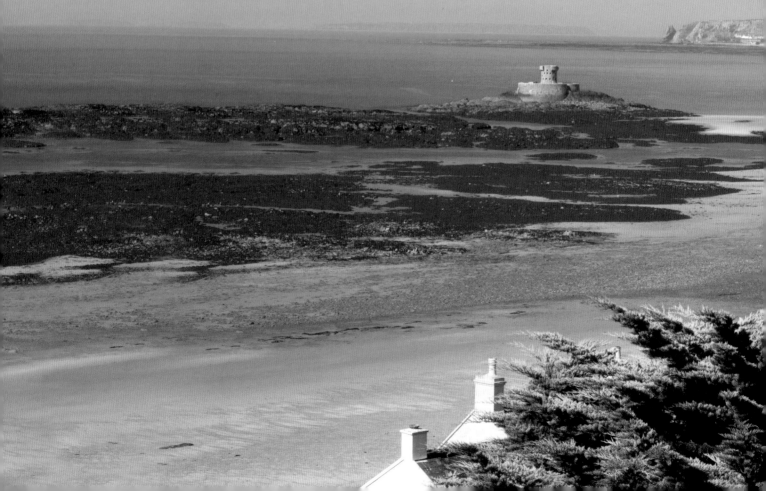

the little archipelago exists under the common
name of the Channel Islands, and its component
islands owe allegiance to the British Crown, they
don't necessarily agree about anything else, and
each island has its own strong identity.

THE BEAUTIFUL BEACH at St Ouen's on Jersey's west coast – a
5-mile stretch of glorious sand – is superb for surfing, blokarting,
sailboarding, riding and running, and for the simple pleasures of
building sandcastles and fossicking in rock pools.

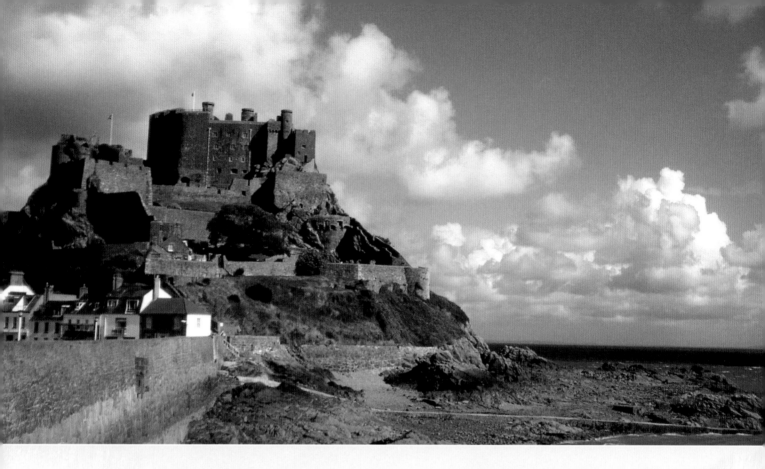

Like many island cultures, the Channel Islands have a very strong sense of their own identity. Each island is quite different – part French, part English, but also reflecting their own distinctive character and heritage.

MARK HORTON, PRESENTER

The largest of the Channel Islands, at 9 by 5 miles, Jersey is only one-third of the size of Rutland, the United Kingdom's smallest county. You could stroll around the island's perimeter comfortably in a couple of days, and a cyclist can ride from one side to the other in half an hour. Yet there's a complex variety of landscape, custom and history packed into this little block of land. Jersey is shaped like an eastward-charging bull, head menacingly lowered, tail twitched high. Beneath the belly and around the backside, it's all long sandy beaches; along the bent

spine and under the jowls, it's cliffs and rocks. As for the interior, good land is at a premium in such a small island, and Jersey's has been worked over the centuries into a very high state of agricultural productivity. Jersey's aspect of green fertility is the first thing that strikes anyone looking down at the island from the air. From cider apples to early flowers, and cattle grazing to Jersey Royal potatoes, the islanders have coaxed a succession of rich crops out of their slip of land. More recently, they have focused on cultivating international business, fertilizing the plot with tax breaks and favourable conditions, nurturing the growth of financial services and business entrepreneurs, and harvesting an excellent income.

Like the other Channel Islands, Jersey lies in shallow water with a big tidal range – you appreciate just how large it is when you join Jerseyman and marine biologist Andrew Syvret on one of his memorable 'moon walks', from La Rocque across the low-tide rocks for a mile or more to the lonely tidal

JERSEY'S great medieval stronghold of Mont Orgueil dominates Gorey Harbour from its high rocky promontory. The castle was initially built as a Norman fortress in the early thirteenth century. After gunpowder was introduced to European warfare, later additions turned it into a mighty cannon-proof citadel.

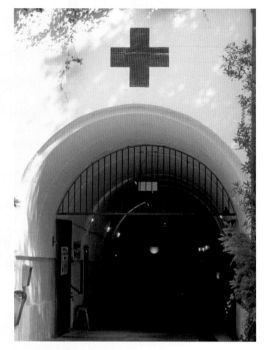

THE ARCHED ENTRANCE to the Jersey War Tunnels leads into a labyrinth of underground passages that hold displays about the German Occupation of Jersey and the building of the subterranean artillery barracks-turned-casualty clearing station by slave labour.

outpost of Seymour Tower. 'At high water,' Andrew points out, 'Jersey measures 45 square miles; but at low water the island swells to twice that size, thanks to the 40-foot rise and fall of our tides.' This 'other island' that emerges at low tide is a moody, harsh and wholly fascinating world in itself, a dark plateau of knobby black and orange rock ridges and pinnacles, of vast rock pools and spillways, sucking sands and shell carpets, where sharp-eyed wanderers may spot the iridescent, ear-shaped shellfish known as ormers – a Jersey delicacy.

The presence of Seymour Tower, a stark, lonely fortification, tells you of Jersey's vulnerability to invasion from the sea from Viking times onwards. Seymour Tower was built as a defensive measure in 1782, the year after an abortive French invasion of the island was bravely repulsed in what became known as the Battle of Jersey. From the tower you gaze north to a truly tremendous stronghold on a mighty crag, the castle of Mont Orgueil. It was founded at the north end of the Royal Bay of Grouville, facing the French coast, in 1204, the year King John of England lost

Normandy to King Philippe-Auguste of France. The Channel Islanders decided to remain loyal to the English Crown, and found themselves on the front line between two warring nations. Other strongholds and castles settled around the Jersey shores in the following centuries, generally guarding against French attack.

By far the most widespread signs of fortification these days are the concrete bunkers, observation towers and gun emplacements, which were left over from the 1940–5 Occupation by German forces. The Occupation is still vividly remembered on Jersey and movingly commemorated in the Jersey War Tunnels, sited in a labyrinth of subterranean bunkers built by the Germans in the centre of the island with the use of slave labour. The castles and the Second World War fortifications are also great attractions, and it's this side of the island economy that is now being revived, after decades of complacency that led to a big downturn in visitor numbers. With the cultivation of fun activities such as sailing, blokarting, cycling, walking and ecologically based expeditions, Jersey is trying hard to build an outdoor style of modern tourism, something that nearby Guernsey is also keen to promote.

TOP SPOTS ■ THE CHANNEL ISLANDS

PORTELET BAY, one of Jersey's most beautiful spots, where cliff paths lead up from the lichen-coloured rocks of the shore through green scrub and trees – one of the many lovely sections of the island's 30-mile coastal footpath network.

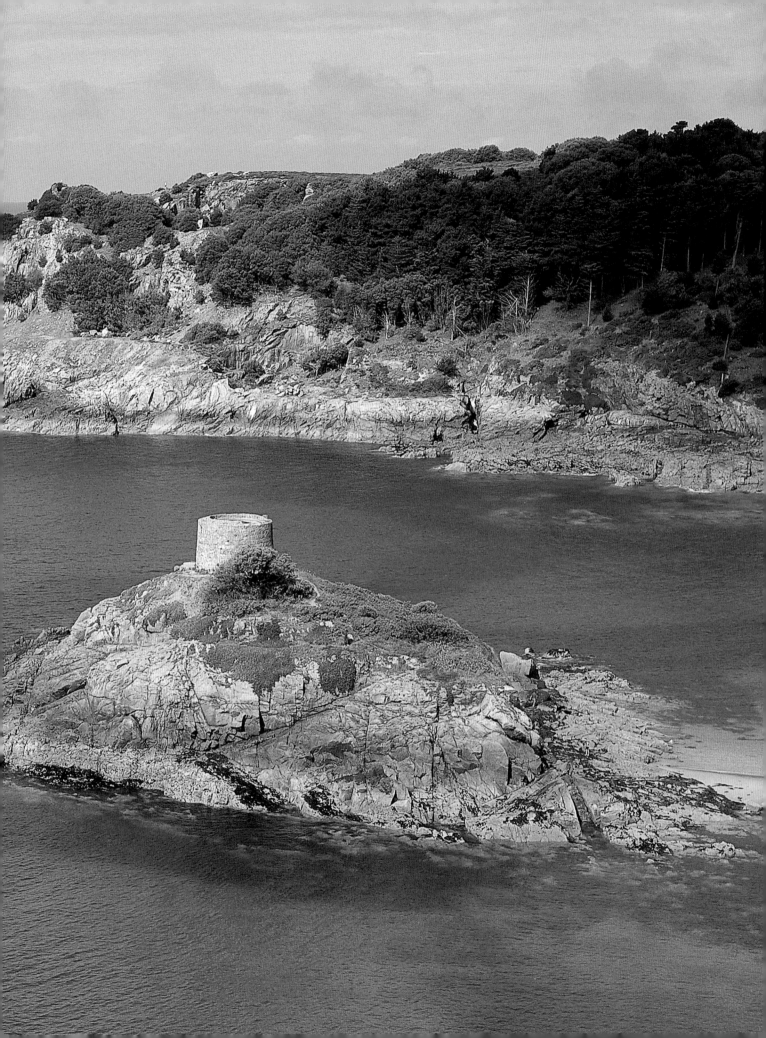

BACKED by a strong sea wall, a scatter of stone buildings and a round eighteenth-century defensive tower, Guernsey's secluded little cove of Fermain Bay between its wooded headlands is a beauty. Cars are banned, so you have to walk down to the bay – another factor that has helped Fermain preserve its lovely tranquil atmosphere.

There's little love lost between Jersey and her slightly smaller north-westerly neighbour, Guernsey. Jerseymen call Guernseymen 'donkeys'; and to return the favour, Jersey people are known in Guernsey as 'crapauds', or toads. Guernsey is 7 miles long and 4 miles wide, and takes the shape of a right-angled triangle, its upright back stiffly presented to the Cotentin Peninsula of Normandy. This eastern flank, with the capital ferry town of St Peter Port in the middle, is rocky and rugged, as is the southern side. By contrast, it's the sloping western face of the island that is full of

fabulous sandy beaches – Portelet, Le Crocq du Sud, Rocquaine Bay and L'Erée Bay in the south-west, then ten more beautiful scoops of sand, separated by headlands, that stretch right up to the northernmost tip of the island. The history of Guernsey is neatly sewn up in the ten panels of the Guernsey Tapestry, which is on view in the Dorey Centre, St Peter Port. As with the other Channel Islands, it is a centuries-old tale of invasions, resistance and dogged perseverance in the face of hardship. During the Second World War, Guernsey was occupied from 30 June 1940 until 9 May 1945, leaving a legacy of grim fortifications all over the island.

Like Jersey, Guernsey works its limited land hard for early flowers and for dairying, and the coast is the base for a fishing fleet of small boats that catch all kinds of white fish and shellfish in the warm and relatively unpolluted waters around the island. Guernsey celebrates this close connection with the sea each summer with a week-long seafood and maritime festival, the Fete d'la Mair. In fact Guernsey has become 'festival island' in recent years, part of a drive to encourage more upmarket tourism – there are flower festivals, a folk festival, an ale festival, a Victor Hugo International Music Festival, and walking festivals in spring and autumn. Genuine Guernsey knitwear, made from oiled wool to traditional patterns and finished by hand in Guernsey houses, is still a premium product. However, tourism and knitwear alone would never bring the prosperity that Guernsey enjoys: that is maintained by the incentive-driven welcome the island offers companies dealing in offshore finance, trust funds and insurance.

Alderney, out on its own to the north-east of Guernsey, resembles an open-mouthed little dragon flying eastwards towards the French coast, which is only 9 miles away. This peaceful slip of green land, just 3 miles long and half as wide, is a holiday destination for those who want to escape from the rest of the world, especially for strollers and gazers with plenty of time to admire the island's rare wildlife. Here you can find the delicate yellow-spotted rockrose and the tiny pale purple sand crocus with its curly leaves, as well as a strange breed of hedgehog with pale spines and none of the species' customary fleas. Alderney also puts on several festivals during the year, notably a wildlife week towards the end of May.

Of the three larger Channel Islands, Alderney is the most remote and peaceful; paradoxically, it has by far the most sombre wartime Occupation record, for it was on Alderney that the Germans established Lager Sylt. This was a brutal SS concentration camp for Eastern European slave labourers, hundreds of whom were worked, beaten, starved and shot to death there. Remnants of the camp are still to be seen at Val L'Emauve, near the south coast.

Of the other four inhabited Channel Islands, Sark is the best known – a delightful slip of a place a couple of miles east of Guernsey, where there are no motor cars. The island gardens are fabulous, especially around La Seigneurie, the home of the island's 'feudal ruler' known as the Seigneur (representative of the British Sovereign), who is entitled to apply a number of arcane laws concerning imprisonment and suchlike – but rarely does. The wild flowers in spring on Sark are something to gasp at.

THE NORTH-WEST COAST of Alderney, which has been sculpted by tides and storms into a series of semi-circular sandy bays interspersed with rocky headlands, has been so deeply indented by the wild Channel weather that you can see clear from one side of the island to the other.

ROCK STACKS, reefs and islets guard the rugged cliffs of the island of Sark, a quiet green haven for nature and man alike, where visitors walk or bicycle on sandy tracks from one gorgeous beach and promontory to the next. Sark is known for its beautiful wild flowers, and the gardens of La Seigneurie are also a great attraction.

TOP SPOTS ■ THE CHANNEL ISLANDS
Jersey p.193 - Jersey War Tunnels p.193 - Jethou p.193
Mont Orgueil Castle p.193 - Reefs p.194 - Sark p.193

A little north-west of Sark lies Herm, 1½ miles long and ½ mile wide, also car-free, and possessed of a wonderful beach of shell sand. Between Herm and Sark are two tiny bijou islands, neither of them open to the public. Brecqhou is the very private property of brothers David and Frederick Barclay, newspaper and property magnates, who would like to declare independence from Brecqhou's 'parent' island of Sark. Nearby Jethou has had a succession of tenants holding sway from its single house.

Two more remarkable sites in the Channel Islands include the lonely reefs of Les Écréhous and Les Minquiers. Les Écréhous lie 6 miles off the north-eastern tip of Jersey and about the same distance from Cap de Carteret on the Normandy coast. Les Minquiers (known by Jerseymen as 'The Minkies') are positioned about 12 miles south of Jersey. Intrepid sea-kayakers paddle out to the reefs, and yachtsmen sometimes visit. Les Écréhous and Les Minquiers see very few other visitors, apart from fishermen and the owners of the handful of houses on each reef. Although high tide at Les Minquiers hides all but nine blobs of islets, at extreme low water as many as 25 square miles of rocks and rock pools are uncovered – a wonderland for visitors. These two reefs are the ultimate Channel Islands experience for those bold and determined enough to try to reach them.

A REMARKABLE VIEW of the lonely reef of Les Écréhous, off Jersey's main island, with the handful of quarrymen's and fishermen's houses huddled together as if for protection from the rising tide.

A Land Apart

CORNWALL AND THE SCILLY ISLES

Nowhere in mainland Britain feels so much a place apart as Cornwall. When the Cornish speak of the 'land across the Tamar', the sons and daughters of Britain's westernmost county are referring not to Cornwall (known in the Cornish anthem as 'Bro Goth Agan Tasow', the 'Beloved Land of our Sires'), but to the rest of Britain – that odd and vaguely hostile appendage to the east. Cornwall is not quite an island – the River Tamar fails by a mere 4 miles to cut the Beloved Land off from its neighbouring county of Devon – but it might as well be. The Cornish have always rejoiced in their Cornishness and done things their way, wresting a living out of a landscape that appears harsh, salt-blasted and barren, yet which hides enormous riches.

Every development in Cornish history has been shaped and moulded by the county's remoteness and by the proximity of the sea. When Britain found herself at war with France in 1689, trade and communications with the wider world were disrupted by land (closure of the French borders) and by sea (vigorous aggression by French privateers). However, Cornwall's ports were sufficiently far from the French coast to be less vulnerable than other British havens, making the county a useful strategic point for naval operations.

GLEAMING IN THE SUNLIGHT as it passes beneath Isambard Kingdom Brunel's great Royal Albert Bridge near Plymouth, the River Tamar marks the boundary between the granite 'land apart' of Cornwall and the rest of the British Isles.

Falmouth had a particularly important role to play in the war with France. Tucked into a sheltered cranny of the southern Cornish coast, with the vast natural harbour of Carrick Roads at its back, Falmouth was a logical choice as a gathering place for fast, lightly armed boats, known as 'packets', which could transport bullion, important persons and messages, and could outsail – and outfight, if need be – any enemy vessel. So the famed Falmouth Packet service came into being, an express maritime communications and delivery operation that continued for nearly 200 years.

Falmouth became the most cosmopolitan port in Britain, with two dozen foreign consulates, Swedish chandlers, shipwrights from Russia, a dozen languages to be heard every day in the streets and wonderful gardens full of exotic blooms grown from seeds from the four corners of the world. The coming of the railways and of more peaceful times in Europe saw the Falmouth Packet service wither and

ARRESTATION DU DOCTEUR CRIPPEN ET DE MISS LE NEVE SUR LE PONT DU «MONTROSE»

DR CRIPPEN ON BOARD

In 1910, with radio equipment installed on most cruise liners, Guglielmo Marconi's invention helped to capture wife-murderer Dr Crippen. The doctor, on the run with his lover Ethel Le Neve, who was disguised as a boy, had sailed from Liverpool for Canada on board the Canadian Pacific liner SS *Montrose*. The captain was suspicious and sent a wireless message from the mid-Atlantic to Scotland Yard: 'Have strong suspicion that Crippen London cellar murderer and accomplice are amongst saloon passengers. Moustache shaved off, growing a beard. Accomplice dressed as a boy; voice, manner and build undoubtedly a girl.' The pair were arrested and Crippen was hanged.

CHIEF INSPECTOR Walter Dew slips the 'darbies' on to the wrists of Dr Crippen, saying: 'Good afternoon, Dr Crippen, remember me? I'm Inspector Dew with Scotland Yard.'

NEAT LINES of yachts crowd the margins of Carrick Roads at Falmouth. For two centuries this was the most important and prosperous port in Britain, thanks to the success of its far-famed international delivery service by the fast and reliable Falmouth Packet boats.

Diving the wrecks that litter the Cornish coast, one can really marvel at how nature encroaches and then takes over the crushed wreckage of a once-great ship. Where many lives were once lost, new life takes hold – this is the never-ending cycle of the sea.

MIRANDA KRESTOVNIKOFF, PRESENTER

die by the mid-nineteenth century, but it left a well-established little town that was conveniently placed to capitalize on the tourist industry. Today, Carrick Roads harbour sees more sails than it has for decades, albeit those of sailing-school dinghies and private yachts.

The Cornish coast has been the setting for numerous shipwrecks down the centuries. Winters are stormy in the face of the open Atlantic, many of the safe havens are hard to enter, and the actual structure of the coast is deceptive and deadly. Cliffs, sea stacks, rocks and reefs – these fierce black teeth of granite have chewed up more men and ships than any records can name or number. One particularly memorable disaster is the wreck of Admiral Sir Cloudesley Shovell's fleet on the Western Rocks of the Scilly Isles in thick fog on 22 October 1707, when nearly 2000 men drowned because of a navigational error.

The southward-jutting promontory of the Lizard Peninsula terminates in a spectacular display of coloured cliffs at Kynance Cove, just west of mainland Britain's most southerly point. The serpentine rock,

iridescent in pinks, greens and blues takes on a beautiful glow when polished, as if lit from within. The Lizard has seen more than its share of shipwrecks, a legacy of its situation out in the fairway of the Channel. That exposed position, out and away from any other land, made the Lizard ideal for the radio experiments of Guglielmo Marconi, Italian physicist, at the beginning of the twentieth century. Back then, many people thought that radio waves couldn't bend with the curvature of the earth, and would shoot off into space. But Marconi was convinced that radio signals could be sent across the Atlantic. On 12 December 1901, his colleagues transmitted a Morse signal from Poldhu Point, near Mullion Cove on the west side of the Lizard Peninsula, to the scientist who was waiting in Newfoundland. The world's first transatlantic message was rather prosaic: dot-dot-dot ('S'). Marconi's reply was equally unemotional: dot-dash-dot ('R').

A couple of miles from Land's End, Porthcurno is another place out on the edge of things. It was here, in 1870, that the first telegraph cables linking Britain with India were brought ashore. If stormy weather scours away enough sand in Porthcurno Cove, you may still see the old cables vanishing into the sea.

More romantically, legend has it that the fabled Land of Lyonesse lies buried in the Atlantic, not far from this stretch of coast – a Cornish Atlantis with fabulous golden palaces which was overwhelmed by the sea. One sole horseman, Trevillian, was said to have survived the catastrophe, galloping hell-for-leather for Land's End as great waves battered down the towers and roared after him over the ruins. What is the truth about this walled city in the sea? Could the sighting of the towers of Lyonesse be a folk memory of glimpsing the hilltops of the Isles of Scilly on the horizon, 28 miles to the south-west? The islands were always a place of magic and reverence, the Isles of the Dead, where important people were taken for burial. Unsentimental science confirms that the Isles of Scilly have the densest concentration of archaeological sites throughout Britain – 239 scheduled monuments in an area of 6 square miles. This is testament, maybe, to the Neolithic belief that the dead should go west towards the setting sun. Many of the Bronze Age burials lie in intertidal areas between the islands, suggesting that the Scillies were once all part of the same large land mass. The islands we see now are only the highest hilltops of a coherent piece of land that was still intact and very heavily populated in the Bronze Age.

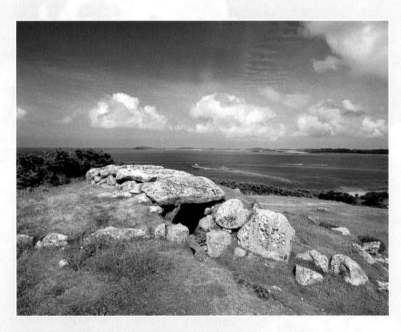

HIGH ON THE SCILLONIAN HILLTOP of Halangy Down, at the north-west end of St Mary's, the stone burial chamber of Bants Carn (perhaps 5000 years old, maybe much older) looks down on a Romano-British village of the Iron Age, complete with huts, corn kilns and ancient field systems.

CROMWELL'S CASTLE was built during the seventeenth century, when the threat of invasion by the Dutch was very real. It was constructed in Tresco Harbour, to prevent any enemy fleet from anchoring there and using the Scilly Isles as a naval base.

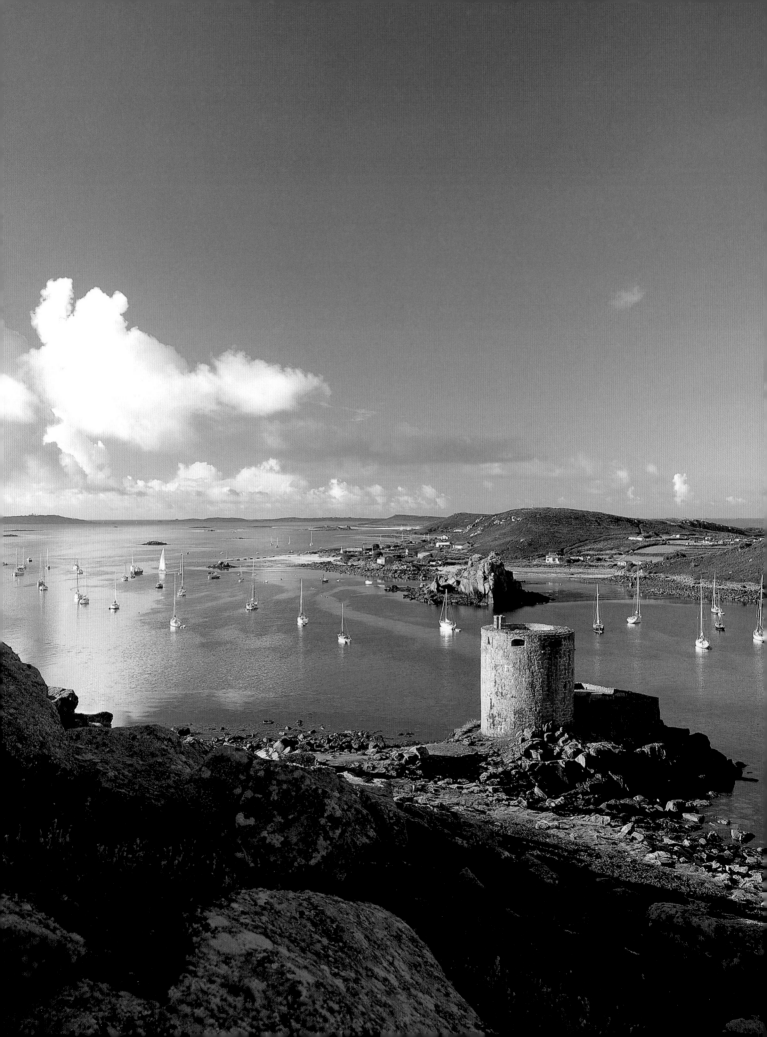

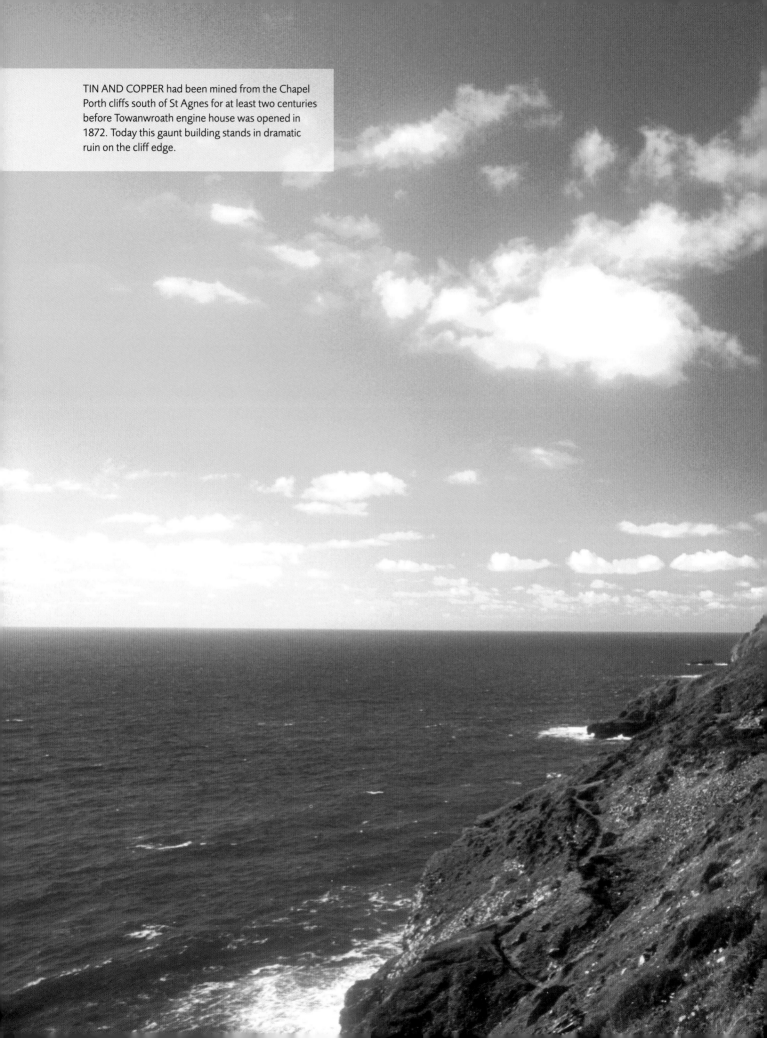

TIN AND COPPER had been mined from the Chapel Porth cliffs south of St Agnes for at least two centuries before Towanwroath engine house was opened in 1872. Today this gaunt building stands in dramatic ruin on the cliff edge.

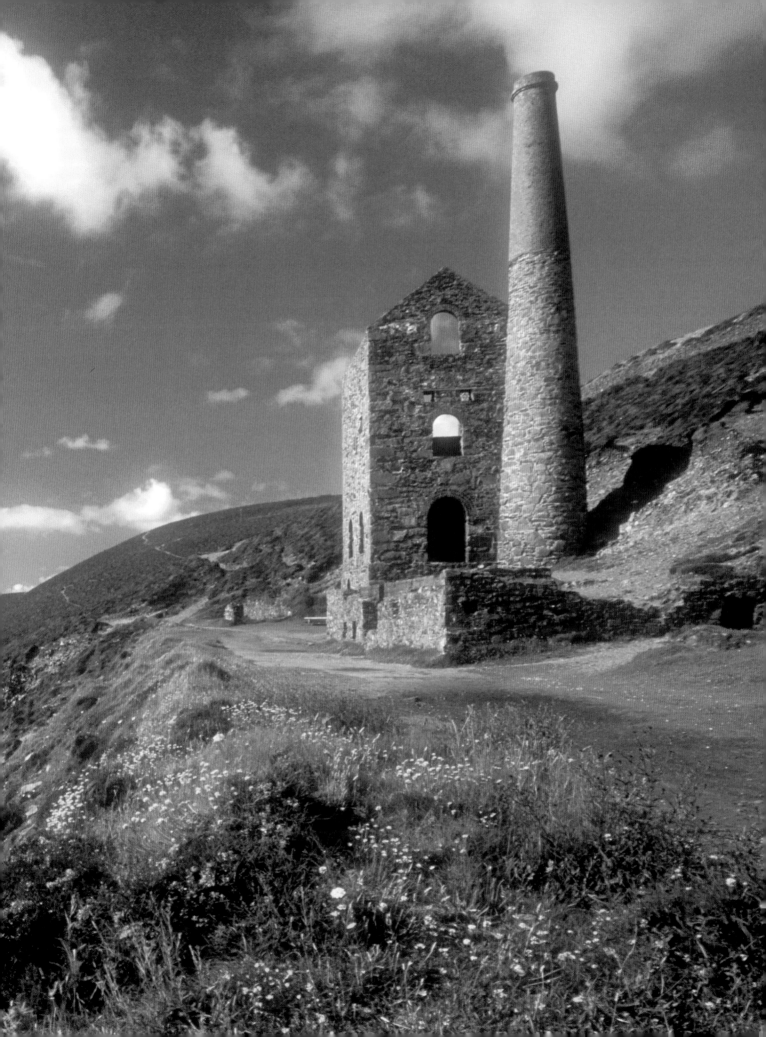

The landscape of Cornwall sparks imaginations in a very particular way. In the early twentieth century, the charming little fishing town of St Ives, set between several curves of beach and headland, attracted a bohemian and dynamic crowd of artists. Sculptor Barbara Hepworth, painter Ben Nicholson and potter Bernard Leach were among the incomers who responded to the clear light, the juxtaposition of hard and soft shapes, and the interplay between sea, sky and land forms. However, the power and simplicity of the Cornish coast was captured at its purest (rather than in the style of a well-trained outsider) in the flattened, sombre, unselfconscious style of self-taught painter Alfred Wallis (1855–1942), a local fisherman who took up painting when he retired from his trade in 1925.

The seas that Wallis knew as a working fisherman seemed a never-ending resource, teeming as they were with pilchards, herring and other fish. However, by the late twentieth century there was a disastrous decline, putting the Cornish fishing industry into real trouble. A local conservation initiative, voluntarily agreed by the area's fishermen in 1997, established a 'no-take zone' for lobster and crab in the waters around St Agnes. It proved so successful in helping stocks recover that in 2004 they were able to increase landing limits from 120 to 190 tons. It's a gratifying chink of light in what sometimes seems like a one-way tunnel of doom and gloom.

Cornish fishermen may be feeling the pinch today, but Cornish tin-miners are a vanished breed. The cliffs at St Agnes hold several

of those gaunt, ruined engine houses that are so characteristic of west Cornwall's tin-mining landscape. Cornwall's special geology means that the bones of the county are loaded with tin ores. For more than 2000 years they yielded a living, but they couldn't last forever against outside competition. The tin industry finally died in the 1990s, but it had been terminally sick for more than a hundred years. In the late nineteenth century, nearly half the county's men left for the New World, where their mining skills and experience were needed and appreciated.

Emigration from the impoverished and remote villages of Cornwall had in fact been going on apace since the eighteenth century. In 1841 Padstow was surpassed only by

PADSTOW'S quay is a leisure area these days, with superb restaurants, tourist shops and yacht berths; but for hundreds of years this was one of the most vibrant commercial ports in the West Country, with a large fishing fleet and trade connections across the Atlantic.

IN THIS LITTLE WOODEN HUT on the north Cornish cliffs, the eccentric, forthright Reverend Robert Stephen Hawker, Vicar of Morwenstow from 1834 for more than 40 years, would sit, meditate and write poetry while smoking opium in his pipe.

Parson Robert Stephen Hawker of Morwenstow, just inside the borders of north Cornwall, was a good man and an effective minister in one of the roughest smuggling and wreck-plundering parishes in the county. He was also one of the nineteenth-century's true eccentrics. When he was 20 he married a lady of 41; when he was 60, a girl of 20. He built a parsonage with chimneys shaped like local church towers. He would dress as a mermaid with a seaweed wig, wear a pink hat and sea boots, smoke opium for inspiration and pinch babies as he baptized them to let the devil out with a scream. The parson was a fine poet, too. Inspired by the story of Cornish-born Bishop Jonathan Trelawny (imprisoned by King James II for sedition in 1688), Parson Hawker's great 'Song of the Western Men' echoes not just the determination of honest lads to see a prisoner set free, but a typically defiant 'us-against-the-rest' attitude that, for better or worse, has more or less defined Cornwall down the ages:

A good sword and a trusty hand! A merry heart and true!
King James's men shall understand what Cornish lads can do!
And have they fixed the where and when? And shall Trelawny die?
Here's twenty thousand Cornish men will know the reason why!

Liverpool and London in the number of people embarking for Canada. Padstow ships would take emigrants to Quebec or Prince Edward Island, returning to Cornwall a couple of months later with a cargo of North American timber. In each decade from 1861 to 1901, one in five Cornishmen emigrated – three times the average for England and Wales. In the 60 years between 1841 and 1901, Cornwall lost a quarter of a million of its people to emigration. No county, let alone isolated and hard-edged Cornwall, could bear such a human drain unscathed. It was lucky indeed that the Romantic movement opened the eyes of the holiday-making public to the beauty and grandeur of just the kind of dramatic, rugged scenery that Cornwall possessed in such abundance.

TOP SPOTS ■ CORNWALL AND THE SCILLY ISLES
Porthcurno p.196 - St Agnes p.196 - St Ives p.196
St Martin's p.196 - St Mary's p.196 - Tresco p.197

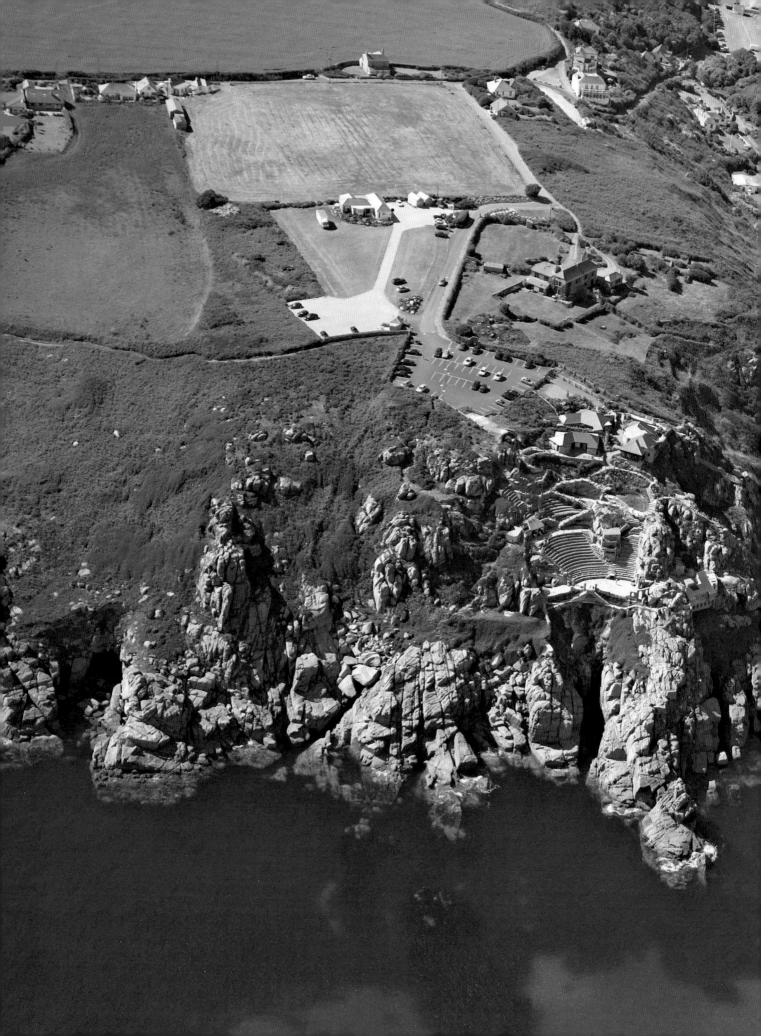

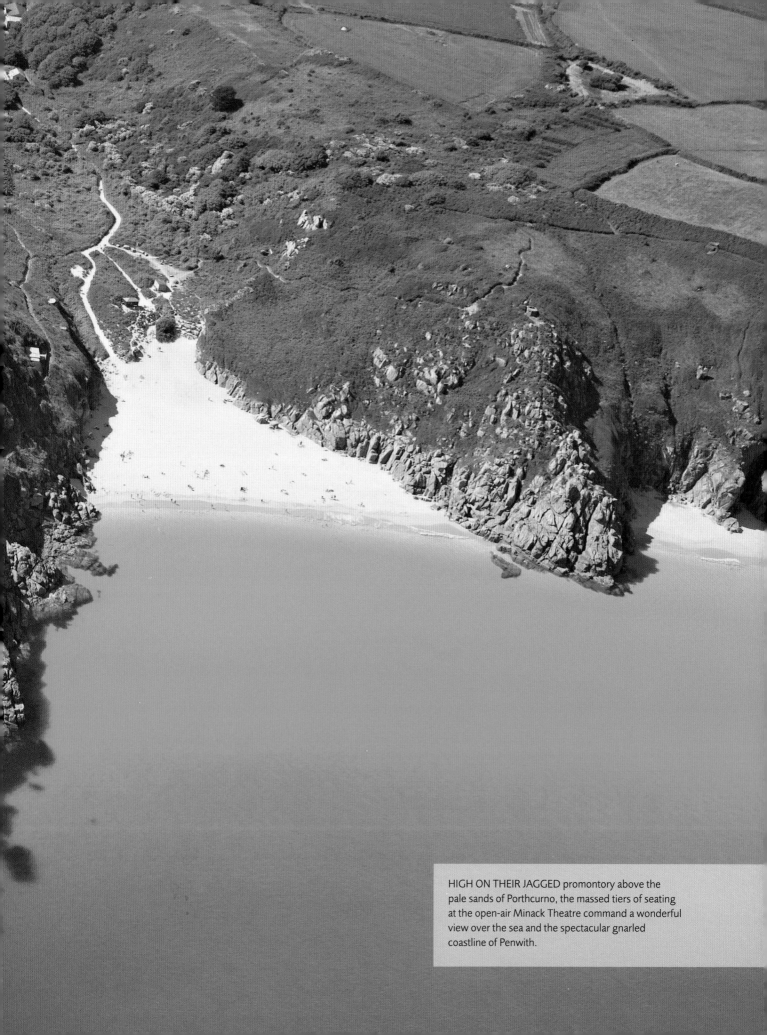

HIGH ON THEIR JAGGED promontory above the pale sands of Porthcurno, the massed tiers of seating at the open-air Minack Theatre command a wonderful view over the sea and the spectacular gnarled coastline of Penwith.

From the Valleys to the Docks

AVONMOUTH TO MILFORD HAVEN

The Severn Estuary, the greatest tidal waterway in Britain, is 30 miles wide as it flows between Swansea and Ilfracombe; yet even there, where it is known as the Bristol Channel, it has not yet made its final widening to embrace the Atlantic. Fresh water and salt water mix vigorously in the estuary in all directions. As well as water flowing to and from the sea, there is also sideways and vertical activity – whirlpools and rip currents, particularly just upstream of the Severn bridges – and an advance and retreat of estuarine wildlife with the twice-daily tides.

It is small wonder that human activity along the estuary has mirrored the tides in the ebb and flow of commerce around Newport, Cardiff, Swansea, Barry, Port Talbot, Llanelli and Milford Haven – a string of working ports and harbours along the Welsh flank of the Severn Estuary, and a vital hub for heavyweight imports and exports up until the last century.

Before commerce got underway, the outside world arrived on these shores haphazardly, sometimes violently. The Vikings raided the area and some of them settled, leaving a scatter of northern names – Steep Holm, Flat Holm, Swansea ('Sweyne's island'). In the Middle Ages international commercial links became firmly established. The 'Newport Ship' – a fifteenth-century merchant vessel some 80 feet long, unearthed from the banks of the River Usk in 2002 – contained Portuguese pottery, coins and pieces of cork, evidence of a lively trade with the Continent. But the area really came into its own in commercial terms in the eighteenth century, when the nascent Industrial Revolution set its characteristic seal of prosperity side by side with poverty, grime, pollution and vast social change.

THE SECOND Severn Crossing bridge, which opened downstream of its elder sister in 1996, shines at sunset in a beautiful suit of lights, its twin towers strung like Welsh harps or the rigging of a great sailing ship.

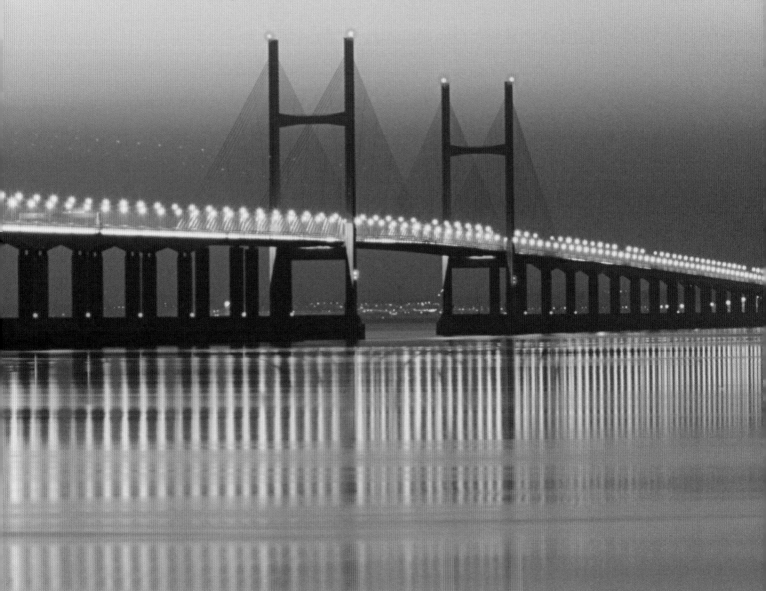

It was the narrow, ribboning valleys in the hills just inland, so rich in iron ore and steam coal, that were the making of the coastal towns. Dowlais Ironworks, founded at Merthyr Tydfil in 1759, grew to become the greatest ironworks in the world, producing almost 100,000 tons of iron annually in its mid-nineteenth-century heyday. By 1831, the town's population had topped 60,000 – more people than lived in Newport, Cardiff and Swansea combined. The twin valleys of Rhondda Fach and Rhondda Fawr developed more than 60 coal pits and saw their population rocket from 3000 in 1860 to more than 160,000 just before the First World War, when production was a staggering 8,716,867 tons. But before all those unbelievable tonnages of iron and coal could be of value as exports and earn their keep, they had to be transported to the coast.

Newport, the farthest upriver of the coastal settlements, was free of the duties that more seaward towns had to pay. Helped by this tax break, the coal owners and dock landlords of Newport prospered, and their town swelled. As ironworks and coal pits opened by the hundred in the Welsh Valleys – catering for the Moloch-like demands of the Industrial Revolution – Newport became a central point for iron, coal and steel exports. These initially arrived by barge and horse-drawn cart, and were later carried seaward from the Valleys by railways.

UNDER THE HIGH, grassy heads of the hills around Cwm Rhondda, long terraces of housing for the pitmen and their families were built wherever a few feet of level land could be found. This contrast between industrial and rural was always a striking feature of the Welsh Valleys in their coal-mining heyday.

Newport's docks expanded, rail tracks proliferated, and the town sprawled out into the countryside and along the shore. In 1801 Newport's population was 6657; in 1901 it was 79,342; in 2001, nearly 140,000 – figures that tell their own tale. However, the twentieth century struck the town some dire blows: wartime bombing, the closure of the coal port, the end of the shipbuilding and steelmaking industries, and the destruction of the old town centre as a result of insensitive planning.

Around neighbouring Cardiff, the Bute family were all-powerful owners of land, ironworks and coal mines. The 2nd Marquess invested massively in developing the docks at Cardiff in the 1840s, and soon had what amounted to a fantastically lucrative monopoly on the export of coal and iron. Cardiff Docks and those at Barry, just along the coast, became the busiest coal docks in the world. Cardiff's resultant population explosion was even more dramatic than Newport's – a little over 6000 in 1801 had swollen to 172,629 by the start of the twentieth century, and to more than 3 million at the turn of the millennium.

THE 2ND MARQUESS OF BUTE owned thousands of acres of land in the South Wales Valleys behind Cardiff. During the Industrial Revolution, the Bute family became very rich on the profits from the minerals under their land and through exercising a monopoly on transporting and exporting coal and iron. Under this regime, the waterfront at Barry (pictured here with its giant bow-legged cranes around 1910) became part of the busiest coal dock system in the world.

TOP SPOTS ■ AVONMOUTH TO MILFORD HAVEN
Barry Island and Docks p.199 - Big Pit p.199 - Blaenavon Ironworks Museum p.199 - Burry Port p.199 - Cardiff Bay p.199

Some of the indignities inflicted on Newport by the twentieth century were also visited on Cardiff. However, as the seat of local and eventually national government, Cardiff had more money and clout, and the collapse of the coal, iron and shipping industries did not sound a death knell for the city. Instead, the old tidal basin of Cardiff Bay has been barred off from the estuary, and the derelict waterfront has been revamped into a vibrant area of housing, entertainment and light industry. People choose to stroll, eat, work and live in a district they would have gone out of their way to avoid only 30 years ago. There are still reminders of Cardiff's commercial links to the sea and the wider world, however – for example, the beautiful wooden Norwegian Church, built in 1868 for the many Norwegian seamen who worked ships to Cardiff with cargoes of softwood timber. The author Roald Dahl was baptized here in 1916; like many other foreigners, his Norwegian father Harald, a ship broker and coal exporter, had settled in the dock area of Butetown in the 1880s, to be near the source of his business.

Although Barry Docks are much diminished from their coal heyday, they are still in operation and exert the fascination of all working docks. Steam railway enthusiasts remember the adjacent Woodham's scrapyard, where the great behemoths of steam locomotives came in the 1960s to await dissolution under the cutter's torch, or salvation at the hands of various steam-railway preservation societies. For many years their rusting corpses rotted among the weeds of this elephant's graveyard. Today, though, all are long gone from Woodham's.

LIKE A LITTLE SLICE OF SCANDINAVIA transported to South Wales, the lovely weatherboarded Norwegian Church on Harbour Drive in Cardiff Bay – now in use as an Arts Centre – was built in 1868 so that Norwegian seamen far from home could attend church services in their own Lutheran faith and Norse language.

A 'QUEEN OF THE IRON ROAD' – her boiler door swinging wide, her funnel and buffers cannibalized for another more salvageable locomotive – lies rusting among the weeds in Woodham's scrapyard alongside Barry Docks as she awaits the cutter's torch – a poignant image from the 1970s.

The third great industrial settlement along this stretch of coast, Swansea, grew prosperous on the copper industry. During the Industrial Revolution, copper and other ores were taken from the West Country and South America to Swansea for smelting. By the nineteenth century, the city was known as 'Copperopolis': 90 per cent of the world's copper was smelted in the area around the River Tawe in the Lower Swansea Valley and exported through the recently developed docks. Other mineral-processing industries also settled here, namely those of zinc, silver and brass. Along with commercial success came environmental degradation. Copper smoke contained arsenic and sulphur; it stunted trees, withered crops, poisoned pastures and killed people. In 1883 the average life expectancy of someone living and working in the Lower Swansea Valley was 24 years.

In the twentieth century, most visitors thought that the area was so vilely polluted with the detritus of mineral processing that it could never be decontaminated. However, a great local clean-up, initiated in the 1960s, has taken place. The poisoned ground has been scoured, and

SWANSEA'S DOCKS AND BAY AREA were heavily bombed during the Second World War but these days bars, restaurants, clubs and shops line the revitalized waterfront. There are also several excellent museums around the docks, such as the National Waterfront Museum, the Dylan Thomas Centre and the Swansea Museum.

trees, shrubs and flowers planted. There are sports and community halls, shops and a burst of new small industries. Settling ponds through which polluted water once flowed have become fishing lakes and long-disused railway tracks have provided the basis for footpaths. And down along the waterfront and the docks, a whole new city is stretching its arms among bars, restaurants, clubs, shops and museums. Some think that Swansea, rather than Cardiff, should be the seat of government and the capital city of Wales. Certainly, the city has seen major improvements in the past few decades, and its history equals that of Cardiff in terms of richness and variety.

TOP SPOTS ■ AVONMOUTH TO MILFORD HAVEN
Dylan Thomas Centre p.199 - Gower Peninsula p.199
Milford Haven p.199 - National Museum p.199

Lucky Swansea! The Gower floats like a forgotten island beyond the city's western suburbs. And it has one of the most sublime coastal hikes in the UK: 50 miles of velvety strands and jagged capes, with the ghost of Dylan Thomas for company.

NICHOLAS CRANE, PRESENTER

Three other industrial towns in the area are of commercial importance. Port Talbot, just east of Swansea, still has its massive Margam Steelworks, in full view of every driver on the M4 motorway. On the other side of Swansea is Llanelli, whose huge-scale processing of Cornish tin ore once earned it the nickname of 'Tinopolis'. Much further west lies the great deep-water harbour of Milford Haven, with its oil refineries and storage depots. Milford Haven currently imports about 20 per cent of the UK's fossil fuel oil, and will soon be receiving some 30 per cent of the country's gas needs in the form of liquefied natural gas (LNG). Milford Haven is not merely the scene of dinosaur energy technologies, however. Just offshore floats the Milford Haven Wave Dragon tidal

DWARFED BY the elongated hulk of a tanker and the chimneys and silos of an oil terminal, sailing boats skim the sheltered waters of Milford Haven.

BRAVE SWIMMERS take the icy plunge into the sea off Cefn Sidan beach during Llanelli's annual Walrus Dip, which takes place on Boxing Day. Started in 1993, the dip raises money for local charities through sponsorship of the bold participants – many of them sallying into the sea in fancy dress.

energy converter, a brave stab at harnessing the energy of the tremendous Severn Estuary tides to provide power for up to 3000 homes. It's a prototype, a whisper of the energy commerce of the future that may well supplant oil, gas and nuclear power.

The power of the Severn's tidal range – 40 feet in certain seasons, the second largest in the world – has been something that dwellers around the estuary have learned to fear and respect. Over the centuries, huge tides have sometimes arrived unheralded, with devastating consequences, as in the case of the giant high tide of 30 January 1607 – a tsunami, some think – which struck the estuary, drowned more than 2000 people and swept away whole villages. The tides of the Severn have lost none of their power. The lifeboats stationed along the estuary are often called into action, and it was during a rescue on 24 August 2004 that Aileen Jones, helmsman of the Porthcawl lifeboat, earned the bronze medal of the Royal National Lifeboat Institution – the first

such accolade to a woman for well over 100 years. Another brave and resourceful woman is also remembered along this stretch of coast – the slightly built Amelia Earhart, the first woman to fly the Atlantic, who landed on 18 June 1928 on Burry Port sands near Llanelli.

Away from the industrial centres there are many delights and surprises along this coast. The cream of the crop is the delectable Gower Peninsula west of Swansea. The Gower offers breathtaking beaches, tangled flowery lanes and local delicacies such as laverbread (dried seaweed) and cockles from beneath the ribbed sands of Penclawdd. Something more, too – a sense of a place that has always remained disengaged from the tides of industrial sound and fury that transformed this stretch of coast.

TOP SPOTS ■ AVONMOUTH TO MILFORD HAVEN
Porthcawl p.199 - Rhondda Heritage Park p.199
Swansea p.199 - Welsh Miners' Museum p.200

RANKS OF WAVES, their forward edges lacy with foam, march in on the beautiful clean sands of Three Cliffs Bay, a double cove in the southern cliffs of the Gower Peninsula. The Gower is one of the outstanding beauty spots of South Wales.

The Sea of Innovation

HOLYHEAD TO LIVERPOOL

How often have we seen them flash into being around the coasts of Britain, those moments of inspiration that spin us headlong forward into the future? The daring notion of a tunnel under the Straits of Dover, the invention of a rocket-powered line that could be shot from the shore to a ship in distress, the foghorn, Guglielmo Marconi and his radio signals, submarine telegraphy, transatlantic flight…the list goes on and on. For a section of coast that exemplifies this Nelson touch, the spark of genius that fires the breakthrough, one need look no further than the 100 miles that separate Holyhead, on the seaward tip of Anglesey's Holy Island in north-west Wales, and the great Atlantic port of Liverpool.

This is a most beautiful piece of coast, starting in the west with the island of Anglesey, whose green farmland and tall cliffs trend north-west to the 719-foot-high Holyhead Mountain on Holy Island – the highest point on Anglesey. The Menai Strait, which separates Anglesey from the Welsh mainland, is fringed by sand and mud flats, thronged with seabirds and laden with shellfish – mussels in particular. The shellfish, in their huge sea-floor beds, thrive on the rich diet of nutrients mixed up and distributed by the fast-flowing tides and swirling currents of the narrow Strait. Mussel culture and production is an important business locally. The sand flats and powerful tides of the Strait may provide a living for mussel farmers and good pickings for wading birds, but they presented a formidable barrier to travellers before Thomas Telford spanned the narrows with the first road bridge in 1826. It was Robert Stephenson who brought the railway across in 1850 by means of his graceful tubular Britannia Bridge.

THE LONELY LIGHTHOUSE on the promontory of South Stack shines a light that can be seen for 28 miles. The 91-foot tower was built in 1809, to warn ships making a passage between Dublin and Liverpool to steer well clear of the deadly reefs and cliffs of Anglesey's north coast.

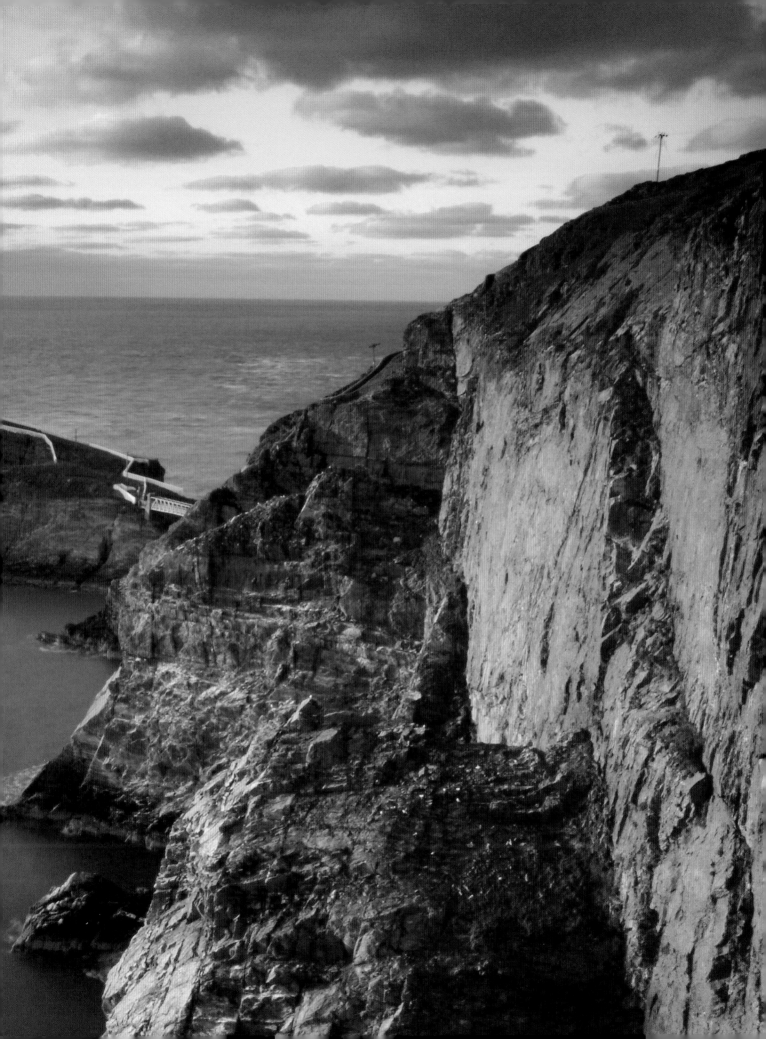

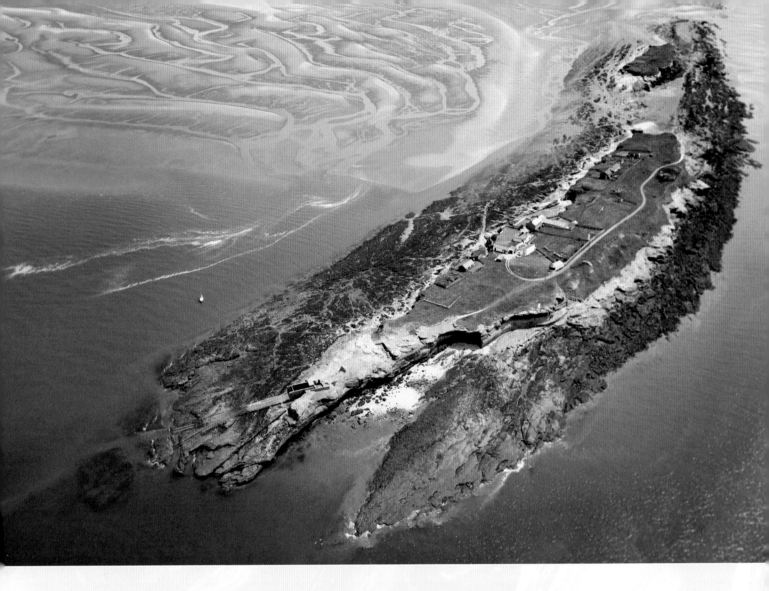

For centuries, sailing ships played a vital role in the world's commerce. Everything of size and value, and everybody of importance and purpose, was carried by ship. However, until the early nineteenth century there was no reliable way to communicate messages between shore and ship except by using flag codes, which were hard to decipher in adverse weather conditions and all too easy to misinterpret. The consequences could be dire. In the 1820s the Liverpool Dock Trustees – spurred on by a keen naval surveyor, Lieutenant B.L. Watson – had the bright idea of adapting a military invention, the optical telegraph, so that messages to and from the trade's commercial base in Liverpool could be exchanged with ships as they passed Holyhead Mountain. As the out-bound or inbound landfall for the transatlantic and Irish trade, Holyhead was of immense importance at the time.

In 1827 – the year after Telford bridged the Menai Strait – a string of 11 signal stations, each within sight of its

A WONDERFUL GULL'S EYE VIEW of the sandstone island of Hilbre, among the vast sands and tides of the Dee Estuary near Liverpool. You can walk out to Hilbre from West Kirby on the Wirral Peninsula – but beware of getting caught by the incoming sea!

immediate neighbours to the west and east, was set up at high points along the coast between Liverpool and Holyhead Mountain. Every station boasted two tall masts, each equipped with two pairs of pivoted, moveable arms. By setting the arms to agreed positions, coded phrases could be passed down the line in semaphore, to be translated by use of code books. Some 40,000 phrases in total could be signalled by ingenious use of the signal arms. Examples ranged from 'Dismasted and abandoned' (code number 4000) through 'I have lost a rudder' (9586) to the rather dismaying 'Wreckers alongside' (9576). The Liverpool to Holyhead optical telegraph stayed in operation for some 30 years, until the advent of the electric telegraph rendered it obsolete.

From the Menai Strait, the coast
runs east at the feet of the Cambrian
Mountains, passing Conwy's medieval
walled town and storybook castle and the
Victorian seaside resort of Llandudno,
with its promenade and pier. It rounds the
nose-like promontory of the Great Orme,
beyond which the hilly backdrop of
Snowdonia declines and the shoreline
runs into a string of sandy beaches and
popular, cheerful holiday resorts – Colwyn
Bay, Rhyl, Prestatyn. Beyond the lonely
foreland known as the Point of Ayr, the
coast meets the wide mud flats and
sands of the Dee Estuary – classic
birdwatching territory.

CASTLE CONWY was one of the strongholds that King Edward I of England built in the late thirteenth century as part of his famed and feared 'Iron Ring', constructed to bring the turbulent Welsh to heel. Today it frowns out across the River Conwy's estuary as if still meaning business.

THE SHIFTING SANDS, sucking mud flats and strong tides of the Menai Strait were a potentially deadly hazard for travellers between the Welsh mainland and Anglesey before Thomas Telford built his graceful Menai Suspension Bridge in 1826, cutting hours from the Holyhead journey and saving countless lives.

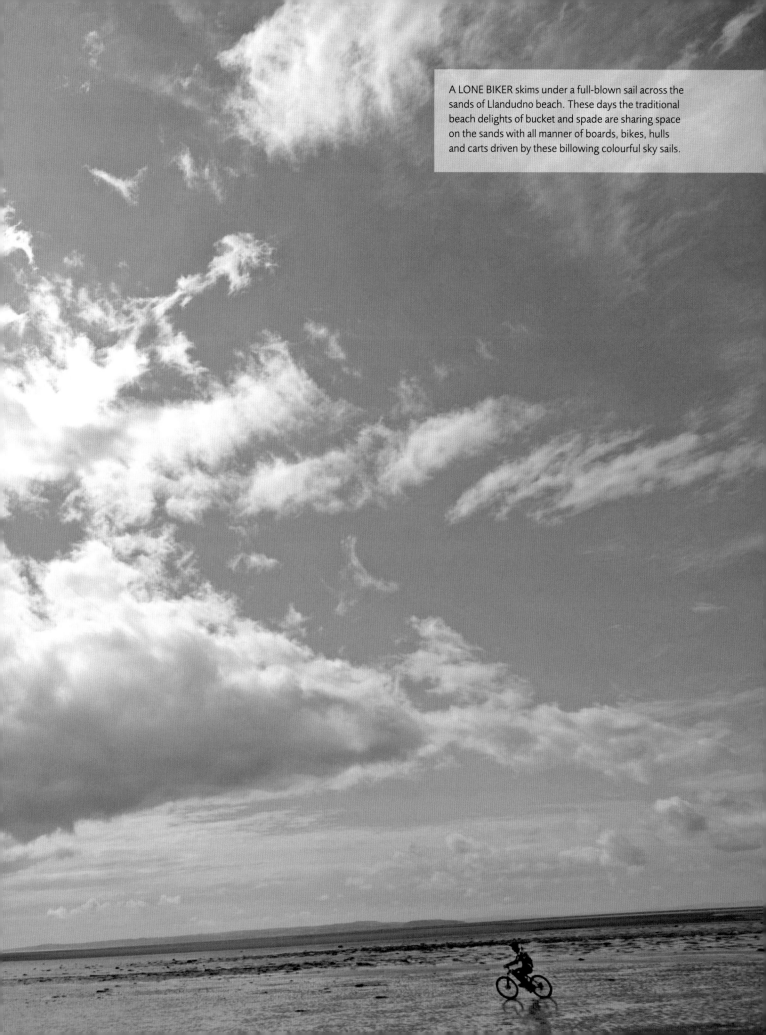

A LONE BIKER skims under a full-blown sail across the sands of Llandudno beach. These days the traditional beach delights of bucket and spade are sharing space on the sands with all manner of boards, bikes, hulls and carts driven by these billowing colourful sky sails.

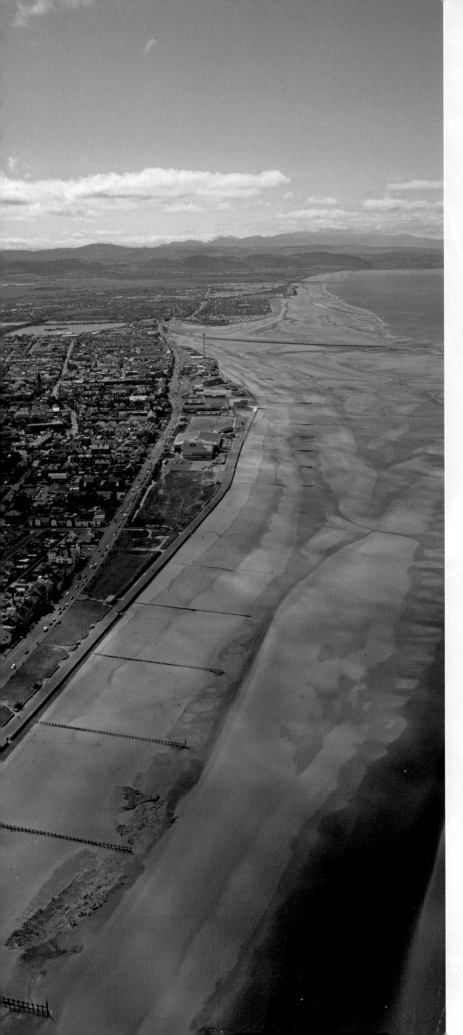

THE RESORT OF RHYL possesses one of the finest beaches along this north-facing coast. It was this beautiful sweep of sand, together with good road and rail connections, that helped turn Rhyl and its neighbouring town of Prestatyn into the premier holiday towns of North Wales.

Another apt name for the stretch of coast between Anglesey and Liverpool Bay would be 'The Sea of Wrecks'. Among the most notorious was the 1831 wreck of the pleasure steamer *Rothsay Castle* off Anglesey, with the loss of 150 lives. Another was the disaster of 25 October 1859, when the steam clipper *Royal Charter*, carrying some 500 souls, was driven ashore in Moelfre Bay by an unheralded hurricane – all but 41 of those on board were lost.

Both these tragedies prompted inventive minds to do something to lessen the likelihood of such shipwrecks. The loss of the *Rothsay Castle* resulted in the building of

PUFFIN ISLAND

Shipwrecks can affect animals as well as humans. When a Dutch ship got into trouble and went down off the eastern point of Anglesey in the 1890s, a swarm of brown rats left the sinking ship and came ashore on Puffin Island. Local people were already harvesting the island's puffins for food, but their depredations were nothing compared to those of the rats. In 1907 the puffin population was reckoned to be upwards of 2000; by the 1990s it was down to 20 pairs. In 1998, the Countryside Council for Wales took action against the unwelcome rodents, so effectively that neither hide nor hair of them has since been seen. The puffins are returning – but slowly. Once bitten…

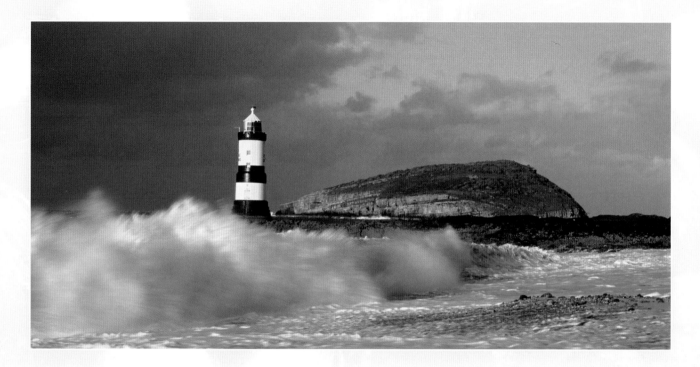

ROUGH SEAS crash around Penmon lighthouse on Black Point, at the eastern tip of Anglesey. The lighthouse was built in 1838 to safeguard the dangerous passage between Anglesey and Puffin Island (seen here in the distance beyond the tower). It was one of several lighthouses built in the area in the early nineteenth century.

Point Lynas lighthouse on the north coast of Anglesey in 1835, followed by Trwyn Du lighthouse on a rock just off Puffin Island in 1838, to safeguard the very dangerous entrance to the Menai Strait. As for the unexpected hurricane that had caused the *Royal Charter* disaster, it stimulated Robert FitzRoy, appointed Meteorological Statist to the Board of Trade, to develop proper practical charts for predicting the weather. From 1860, his predictions were published regularly in *The Times*.

It is not only surface vessels that have been claimed by this coast of North Wales. Two well-known submarine sinkings have also occurred here. *Resurgam* (meaning 'I shall rise again'), Britain's first full-sized steam-powered submarine, sank on 25 February 1880, after getting into difficulties in bad weather while being towed to Portsmouth for the Spithead Review – luckily, her crew had transferred to the towing vessel. Far worse was another submarine accident along this coast – the desperate tragedy in Liverpool Bay on 1 June 1939, when 99 men died after the forward compartments of HM Submarine *Thetis* became flooded during her maiden diving trial. Most of the dead lie together in a mass grave in Maeshyfryd Cemetery, Holyhead.

THIS REMARKABLE archive photograph, taken on 2 June 1939, shows the unrolling of the *Thetis* tragedy. The stricken submarine lies at a steep angle in the waters of Liverpool Bay, bows on the sea floor and stern upraised, as a rescue vessel stands helplessly by. Unseen inside *Thetis*, an escape attempt using deep-sea escape apparatus is being planned – in the end, four men would escape and the other 99 on board would die.

TOP SPOTS ■ HOLYHEAD TO LIVERPOOL
Holyhead p.202 - Holyhead Mountain Heritage
Coast p.203 - Liverpool p.202 - Llandudno p.202

Human ingenuity has put man under the sea and into the air in the past century. Whether it can save him from the disastrous environmental effects of his own restless inventiveness and his insatiable hunger for fuel remains to be seen. The eyes of the world are focusing on sources of renewable energy to combat global warming; and here, along this coastline – windy, shallow and open enough to be an excellent location – wind farms are springing up offshore. At North Hoyle, some 4 to 5 miles off Rhyl and Prestatyn, 30 turbines (each 350 feet tall) have been whirling round since 2003, producing a total of 60 megawatts of power – enough to light 40,000 homes, says operator NPower. Now other wind farms are being planned – one at Rhyl Flats, one at Burbo Bank in the Dee Estuary, and the Daddy of them all at Llandudno Bay, where 240 turbines, 500 feet tall, may soon stand on the horizon some 9 miles offshore. They could produce up to 750 megawatts of power, enough for nearly half a million homes – yet they will intrude on a good section of the seaward view from one of Wales's premier seaside resorts. Whether the vibrations set up by wind turbines can affect the migratory patterns of birds, or whether the giant blades themselves pose a more direct threat to the creatures, are questions we still do not have answers for. The effect of wind farms on human beings, too, whether physiologically or psychologically, is a big debating point.

Innovation and sharp-mindedness do not stop short at the mouth of the River Mersey, of course. Birkenhead, on the western bank of the river, has seen some great innovations in its shipyards – including the building of both *Resurgam* and *Thetis*. The Mersey Railway that tunnelled under the river in 1886, connecting Birkenhead and Liverpool, was one of the world's first railways to travel underwater – a nasty, smoky ride by all accounts. In the mid-1840s, a pioneering move by Birkenhead Commissioners made life vastly more pleasant for the overflowing and generally unhealthy population of the town. Since the beginning of the nineteenth century, the

population of Birkenhead had grown from just over 100 to nearly 10,000, and the Commissioners were desperate to find a means of providing ordinary working people with some fresh air and open space. So in 1843, in what was for the era a really bold and philanthropic move, they engaged the Duke of Devonshire's garden superintendent, Joseph Paxton, to plan a public park to be funded out of public money – the first such park in Britain. Grassland, trees, shrubs, public sports areas for bowls and quoits, sculptures, a refreshment place, a lake, a bandstand and flowerbeds: all these amenities and more were introduced over the following decades. Birkenhead Park became the envy of other towns, and its radical example was soon copied by municipalities up and down the land.

OFFSHORE wind turbines rise from the sea at North Hoyle. Clean and green, or an overhyped eyesore? The debate on wind farms continues, while several more are being planned for these waters off the North Wales coast.

So to Liverpool, teeming city of enterprise and invention. Few of the 'Pool's extraordinary tales are quite as remarkable as the one about the 153 Welsh emigrants, who sailed away from the port in 1865 on board the dilapidated tea clipper *Mimosa* to found a Welsh-language, Welsh-culture colony in Patagonia, 7000 miles away. The 65-day voyage was hellish in its discomfort, the arrival in Patagonia was miserable, and the first attempts to claw a living out of the inhospitable land were harsh and discouraging beyond belief. But the Welsh stuck at it, taming the Lower Chubut Valley – the name they gave to their Patagonian province – into an Eden of productivity. Today, the Welsh-speaking community still survives, and looks back with pride to their tough and determined ancestors who left Liverpool all those years ago.

Stand on the beach at Rhyl and the offshore wind farm of North Hoyle appears, like a mirage, on the horizon. You can just make out the slowly turning blades of the turbines as they catch the light.

ALICE ROBERTS, PRESENTER

THE PANORAMA of central Liverpool sprawls towards the River Mersey and that iconic Pier Head waterfront. Many have crossed the Mersey, but many more in the past two centuries have travelled downriver towards the open sea on board warships, luxury transatlantic liners and crowded emigrant vessels.

A Tale of Three Cities

DUBLIN TO BELFAST AND DERRY

The issue that has divided and united so many, not only throughout Ireland but also across the world – the question of what it means to be Irish – is brought into sharp focus along this stretch of coastline, which spans three important cities. It runs from Dublin, capital of the Irish Republic, northwards to Belfast, principal city of Northern Ireland; then round in a great north-westerly curve to the little walled settlement that unionists know as Londonderry, nationalists as Derry, and humorists as Stroke City (because fence-sitters and offence-avoiders refer to it as Derry-stroke-Londonderry). In these three cities, which are situated along some 300 miles of lough-indented coastline, the question of Irish identity has posed itself down the centuries, often to brilliant and sometimes to bloody effect.

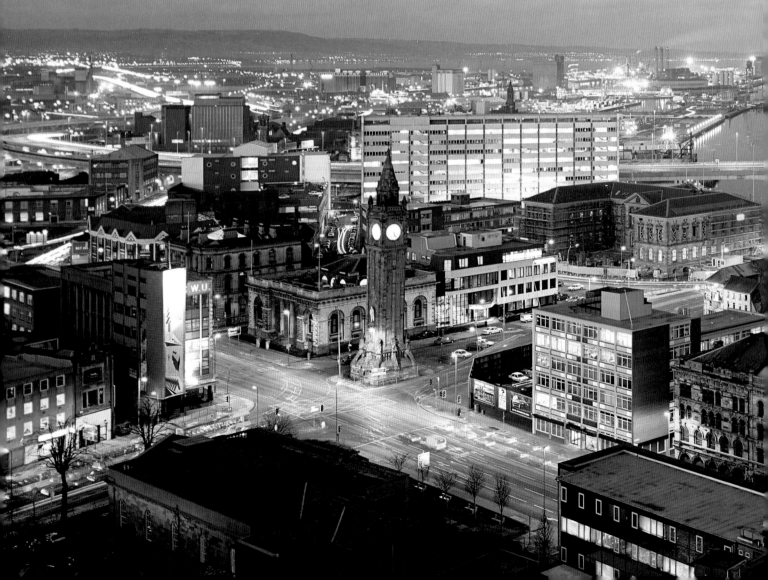

Many incomers and invaders have migrated to Ireland in the past couple of thousand years – Iron Age Celts from central Europe, Dark Ages Vikings from Scandinavia, Norman knights in the early Middle Ages, English and Scottish soldiers, and men of business from Tudor times onwards. With one or two exceptions, each would-be conqueror has become imbued with 'Irishness' over time – a diffuse notion that is wide and deep enough to embrace an otherwise disparate group of peoples. As for the Irishness that is felt by sons and daughters of the Irish diaspora – by Fermanagh women from Illinois and Corkmen from Adelaide, who have never set foot in the native country of their great-great-grandparents – that must surely be the purest and most romantic love of all.

A STRIKING VIEW over the city of Belfast at dusk, looking downriver through the curves of the River Lagan as it winds north from the refurbished waterfront towards Belfast Lough and the sea. Samson and Goliath, the giant yellow cranes that stand as landmarks of the city, rise in the background from the shipyard of Harland & Wolff, where RMS *Titanic* was built in 1909–11.

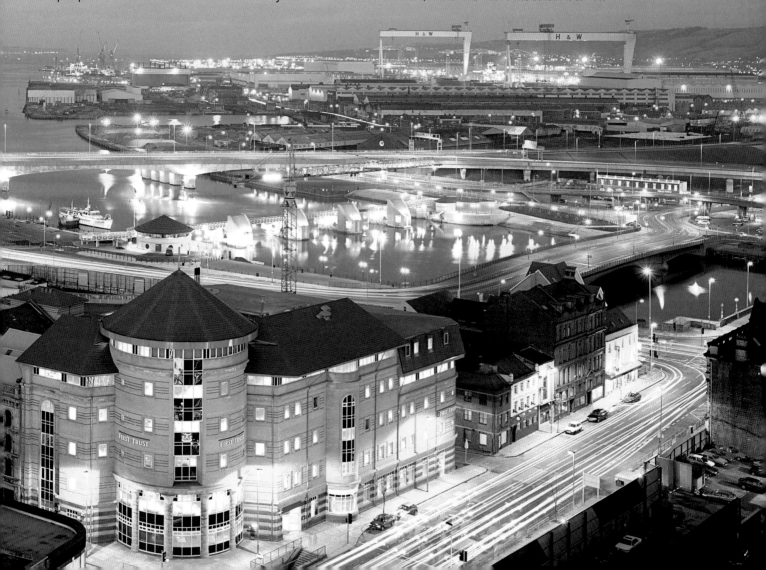

Flying into Ireland from the British mainland, looking out of the windows as the plane banks to run up the County Dublin coast, it's not unusual to hear first-time visitors to Ireland gasp out loud, 'Wow – I never realized Dublin was a seaside town!' Whether it's the whiff of citified self-absorption that modern Dublin gives off to the world in her recent prosperity, or a stranger's sense that history must have laid a hand far too solemn for resort-style fripperies on such a famously artistic and literary city, the fact is that it comes as a shock to be let in on Dublin's Big Secret – that Ireland's great capital and her satellites enjoy a vast sea frontage of 15 miles along Dublin Bay, with many continuous miles of unbroken sandy beaches and many more of bird-haunted mud and sand flats. Looking down from the air at the animated dots that are riders and joggers, walkers, bird-watchers, kite-flyers and swimmers, one sees at once what a tremendous asset such a seafront is to Dublin; and at the same time how the great pincer of Dublin Bay with its sheltered waters and rich hinterland must always have drawn incomers and invaders to the point where Dublin now stands.

A FINE VIEW over Killiney, the 'Millionaire's Row' of outer Dublin, where extravagant mansions in handsomely wooded grounds look out over Killiney Bay, a curve of sea and shore so beautiful that it has been compared to the Bay of Naples.

THE CUSTOMS HOUSE, a noble Georgian civic building on the north bank of the River Liffey, symbolizes the great 'colonial' days of Dublin past as powerfully as the warehouse apartments, chic eating places and plate-glass offices across the river epitomize the new, aspirational Dublin of today.

Dublin was founded in the ninth century by Viking invaders, and the city prospered under its Norse masters for three centuries as a base for trading and raiding. In 1170 the Anglo-Normans arrived in Ireland in a great burst of fire and slaughter, flexing their muscles, building forts and pushing aggressively inland. Their sting was drawn by a century or so of military setbacks, followed by a more gradual social assimilation. By the sixteenth century, the 'hard-core' rump of those who were more Anglo than Irish found themselves dominating merely the city of Dublin and a surrounding strip of land known as 'the Pale', a figurative fence against the wider Irish world.

In 1541 the Tudors arrived, fearful of a neighbour that might be used by Spain and other Roman Catholic countries as the springboard for an invasion of mainland Britain. They asserted the control of the British Crown and Parliament, a situation that would last almost another 400 years. Further centuries of repression followed, especially Oliver Cromwell's punitive expeditions in the mid-seventeenth century – an era of uprisings savagely put down, leading to more rebellion and even harsher suppression under the notorious anti-Catholic Penal Laws.

Dublin lived through it all, to become the second city of the British Empire and to develop a reputation as a centre of rationality and tolerance by the end of the eighteenth century. The Georgian city we enjoy today laid its foundations at this time, creating that special unhurried Dublin atmosphere, which is only now beginning to be corroded by modern impatience.

Dublin also saw some of the worst of the miseries of nineteenth-century Irish emigration. The crisis was sparked off by the political and humanitarian disaster of the Great Famine of 1845–9, in which the potato crop failed in successive years and about a million Gaelic-speaking Irish peasants died of disease and starvation. Before the Famine the population of Ireland was more than 8 million. In the aftermath, hundreds of thousands left the quays of Dublin, Waterford, Cobh and Galway each year in emigrant ships, many of them notoriously crowded and leaky, bound for the New

A SYMBOL OF HOPE

One of the boats that carried emigrants from Ireland to the New World was the barque *Jeannie Johnston*, a well-founded vessel that never lost a passenger. She made 16 Atlantic crossings and carried 2500 emigrants to Baltimore, New York and Quebec between 1847 and 1858. In the millennium year of 2000, Ireland launched the sail-training ship *Jeannie Johnston*, a replica of the original vessel, built and crewed by people from both sides of the Irish border as a symbol of unity and hope.

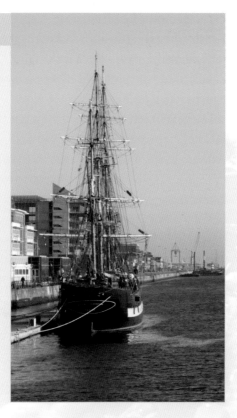

TOP SPOTS ■ DUBLIN TO BELFAST AND DERRY
Belfast p.205 - Bendhu House p.205 - Botanic Gardens p.205
Carlingford p.205 - Carrickfergus p.205 - Derry p.205

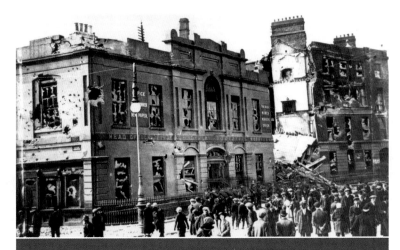

DUBLINERS STAND AND STARE at the wreck of Liberty Hall, damaged by British Army shellfire during the Easter Rising of 1916. The rebels, hoping for backing from 10,000 sympathizers in their bid to establish an Irish Republic, in the event mustered 2000 at best, and were quickly crushed. But it proved a pyrrhic victory for the British Crown.

World. Between 1845 and the 1920s, Ireland lost almost half of its population to emigration – a staggering proportion. The emigrants clung to their Irishness as if to a lifeline: language, customs, music and dance – everything that gave them a sense of identity and community in the strange world they landed in. Cultural isolation and political bitterness were sweetened by yearning for the 'green hills of Ireland', a landscape sprinkled with the fairy-dust of nostalgia. A kind of 'second-remove' Irishness spread down the generations, no less powerful for being half fantasy.

In 1916 Dublin was also to be the setting for the most iconic of all assertions of 'Irishness', the Easter Rising of 1916, the spark that was eventually to touch off the 1919–21 War of Independence that divided Ireland and brought Southern Ireland her longed-for political freedom from Britain.

Yet in its neo-classical architecture, the flavour of its capital-city cultural life and even the language heard on its streets, Dublin remained essentially Anglo-Irish throughout the twentieth century. But it is changing rapidly under the pressures of the modern age, becoming richer and bolder, more cosmopolitan and less 'quaint'. New, tall buildings are rising along the Liffey's old seaward quays. Businesses and money are moving into Dublin, a new immigration to counterbalance the years of emigration out of the city. Trendy young things are delighted to find funky apartments in Temple Bar and on the now cool north side of the Liffey in the heart of town. The newly rich, however, are choosing to move themselves and their families out along that glorious 15-mile coastline of Dublin Bay, into Georgian and Victorian houses at Killiney and Dalkey, to the south of the city, and Sutton and Howth to the north.

THE HA'PENNY BRIDGE across the Liffey is the rendezvous of choice in Dublin. Its official name is Wellington Bridge (it was opened in 1816, the year after the Battle of Waterloo), but Dubliners renamed it after the toll they paid to use it.

MONASTIC PRANK

In medieval times, the university run by the monks of Howth Abbey was the wonder of the western world – so much so that the authorities in Paris, hitherto the academic capital of Europe, became concerned about this new 'rival' and sent spies to Howth to assess the university and to entice the Abbey's students away by offering them places in Paris. The Abbot of Howth, however, got wind of the impending raid. He posted his monks, disguised as dock labourers, all around the harbour. When the Frenchmen landed, the 'labourers' began speaking earnestly to each other on learned topics. The amazed spies returned to France and reported that it was pointless to take offers of education to a place where even the dockers conversed in Latin!

COLIEMORE HARBOUR at Dalkey is a beautiful, peaceful spot on the southern shores of Dublin Bay. Persuasive visitors can sometimes get a local fisherman to run them out to Dalkey Island a few hundred yards offshore, where there is a nineteenth-century Martello tower and cannon battery and the ruins of an ancient church to explore.

TOP SPOTS ■ DUBLIN TO BELFAST AND DERRY
Dublin p.205 - Giant's Causeway p.206 - Lambay Island p.205
Loughs p.206 - Murlough Nature Reserve p.205

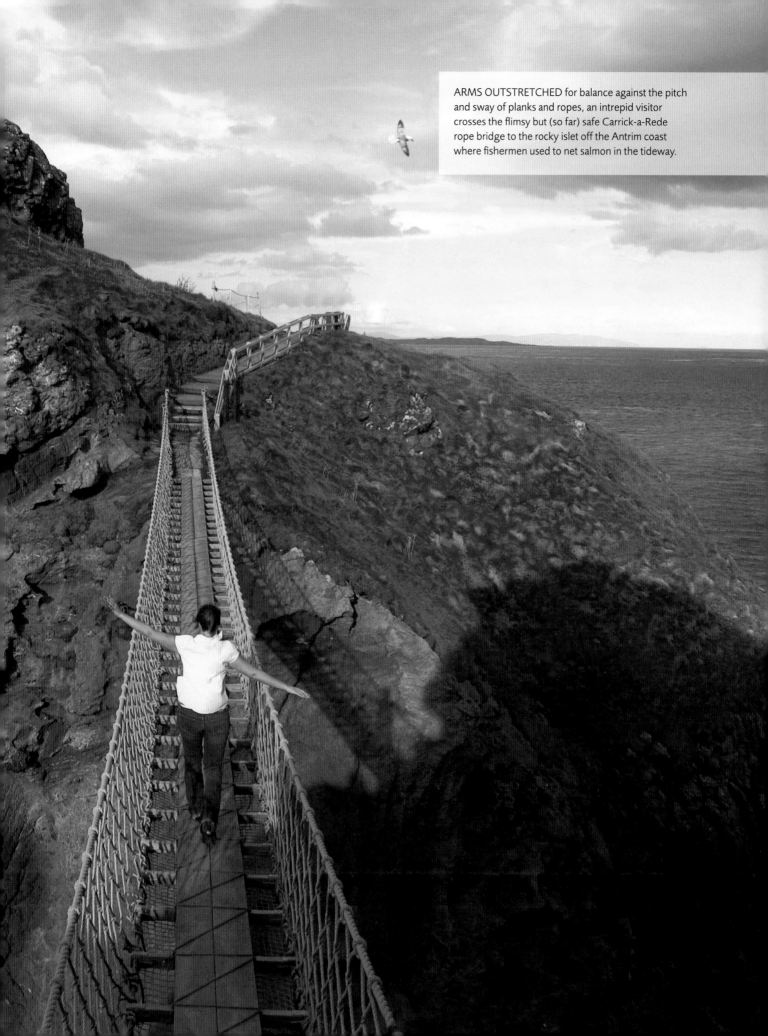

ARMS OUTSTRETCHED for balance against the pitch and sway of planks and ropes, an intrepid visitor crosses the flimsy but (so far) safe Carrick-a-Rede rope bridge to the rocky islet off the Antrim coast where fishermen used to net salmon in the tideway.

Across the border in Northern Ireland, a couple of hundred miles up a coastline deeply hollowed by sea loughs, lies Belfast – by far the youngest and brashest of the Three Cities. Industry, money-making and mercantile solidity seem the order of the day. Yet Belfast is founded not on any sturdy bedrock, but on the sloppiest of sletch or wet clay. 'A poor place to build a city, but a great place to site one,' said wise observers of the rise of Belfast. The inner corner of Belfast Lough was certainly sheltered and well protected, but the tidal nature of the River Lagan and the quakiness of the ground meant endless toil before the dock area and the piled and underpinned buildings could rise and breed prosperity. The crooked floor of St Anne's Cathedral bears witness to the shakiness of what lies beneath, as does the famous tilt to the Albert Memorial Clock Tower, which has shifted some 4 feet since it was raised in 1865. 'Albert has the time – and the inclination!' say the locals.

Belfast was developed by Victorian industrialists; its wealth became rooted in the mass-employment industries of linen and cotton manufacture, rope-making, heavy engineering and shipbuilding, exemplified by Harland & Wolff's yards, where RMS *Titanic* was built in 1909–11 by a workforce numbering some 30,000 men. Belfast is Ireland's one and only proper industrial city. Establishing it took a lot of stubbornness, grit and determination – qualities that still characterize Belfast people today.

The story of Titanic has haunted me since I was a boy. It wouldn't work as fiction because it's unbelievable. But stand on her slipway, feel the bone-chilling wind cut through you, and you glimpse the reality of it all.
NEIL OLIVER, SERIES PRESENTER

FOR TWO centuries Belfast's waterfront prided itself on the sort of heavy engineering epitomized by its Harland & Wolff ship-building yard. Much of the shipyard is likely to be redeveloped as housing and modern business premises.

REACHING OUT across the divide. Such is the symbolism of Maurice Harron's 'Hands Across The Divide' peace statue near Craigavon Bridge, which links Derry's Protestant and Catholic communities on either side of the River Foyle.

A hundred miles north-west along the coast, Derry (you may read 'Londonderry' if you wish) sits snugly at the inner corner of beautiful Lough Foyle. The 'settlement of the sacred oak grove', which grew up on an island here, is Belfast's senior sibling – and in fact predates Dublin, too, by a thousand years or more. A modern city was founded on the site around the turn of the seventeenth century by merchants from London as a well-situated place for trade and defence. The splendid walls they built round their little city between 1613 and 1618 are some of the finest still standing, and the old town centre is full of delightful Georgian and Victorian buildings. Outside the walls, the name of the Bogside district betrays its origins in the swamp that surrounded the original settlement.

During the Second World War, Derry – the most westerly 'home port' available to the British – played an active and vital role in the Battle of the Atlantic, refitting and refuelling units of the Royal Navy and other allied forces in their struggle to get US convoys safely across the Atlantic to Britain in the teeth of opposition by German U-boats. At the end of the war some 60 U-boats came into Derry under surrender, and eventually something approaching that number were sunk in waters north of Northern Ireland as part of a clearing-up exercise known as Operation Deadlight. Their whereabouts on the sea bed have mostly been discovered, and in 2002 an expedition was mounted to explore some of the wrecks lying in their submarine graves, a source of endless wonder and imaginative speculation.

At the Edge of the World

GALWAY TO CORK

The ancient Gaelic city of Galway marks the halfway point in the north–south run of Ireland's ragged, deeply indented west coast. Galway is the focus or powerhouse of the west; the largest city of the region by far, as well as the most influential, forward-looking and optimistic. Today, it's a thriving place with a vibrant university, a good provision of light industry, a lively arts scene and plenty of music and street events – all this based in and around a handsome city centre, where the houses, shops, castle towers and churches of seven centuries jostle each other. In the past it was the jumping-off point for adventurers, emigrants, holy travellers and visionaries with their eyes on the western horizon and what might lie beyond.

The sense of Ireland as a meeting place of different worlds is never stronger than along the west and south-west coasts of the island. So many places here have acted and continue to act as gateways or points of transition, both physical and spiritual – between the Old World and the New, the living and the dead, tradition and progress, past, present and future. It is quite remarkable how many journeys have their beginnings and endings along these bleak and beautiful shores.

DUNGUAIRE CASTLE, sited on an inlet of Galway Bay, was built in the 1520s by the O'Hynes, descendants of the fifth-century High King of Ireland, Niall of the Nine Hostages. Niall is considered to be the greatest Irish king ever to rule; some have styled him the 'Alexander the Great of Ireland'.

The best-known figure of all in the story of the Old World's discovery of the New is that of the Genoese mariner and navigator Christopher Columbus (1451–1506), linked forever to the year of 1492 when he became the first European to make a recorded and authenticated landfall in the Americas. In those days, Galway was one of the last mainland ports of call for anyone leaving western Europe for the wide Atlantic. As a young man in his twenties, Columbus had visited the city in 1477 on the course of a voyage from Lisbon. He was convinced even then that land lay to the west – he was well aware of the power of the Gulf Stream, and he had seen the exotic seeds from 'somewhere out there' that were regularly washed up on western Irish beaches. A couple with oriental features had drifted into Galway Bay, too, as he noted in the margin of one of his books: 'Men have come hither from Cathay in the Orient. Many remarkable things have we seen, particularly at Galway, in Ireland, a man and a woman of most unusual aspect adrift in two boats.' They had been blown to the west coast of Ireland by westerly gales. Columbus became fairly confident as to what he would one day find out there beyond the horizon – either Japan or Cathay (the archaic name for China).

More than 400 years later, two brave pioneers reversed the adventure. John Alcock and Arthur Whitten Brown at least knew that there would be land to crash into on the other side when they took off from Newfoundland in their converted First World War Vickers Vimy bomber on 14 June 1919, hoping to make the first non-stop aerial crossing of the Atlantic. They covered the 1890 miles in 15 hours 57 minutes, through fog, snowstorms and ice, and ended the flight nose-down in Derrygimlagh Bog, at the western tip of Galway's peninsula of Connemara. The epic pioneering flight had its moments: they almost crashed on take-off and twice dropped out of control from 4000 feet to within 50 feet of the sea – so close they could taste salt on their tongues. Their electrically heated leather flying suits stopped working and they almost froze to death. In another episode, ice built up so dangerously on the engines that while Alcock flew the plane through a snowstorm Brown crawled out four times on to the wings to hack the ice away with a knife.

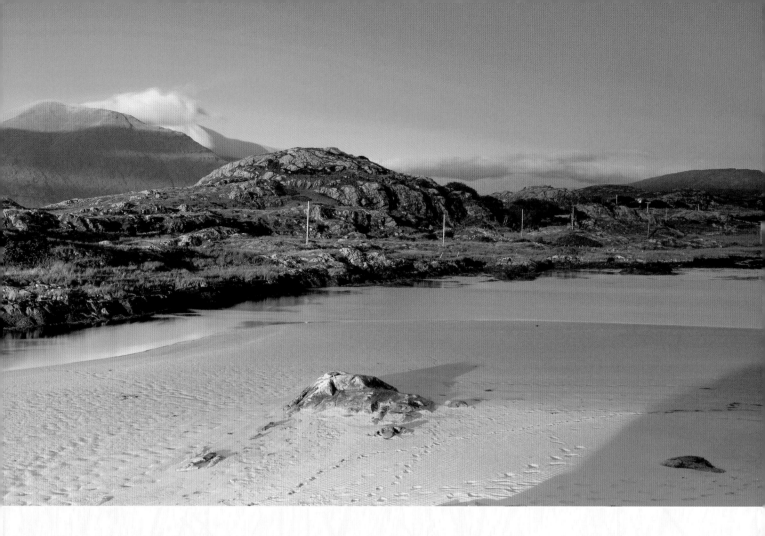

There could not have been a more iconic place than Connemara to witness their triumph. In the late nineteenth century, with the question of Home Rule on everyone's lips and a stirring of nationalism across the country, it was to the boggy and mountainous peninsula of Connemara, with its Gaelic-speaking people and entrenched traditions, that Irish men and women looked for a sense of their roots. Educated folk from the east journeyed out west in search of their own Irishness. Padraic Pearse, one of the architects of the 1916 Easter Rising (see page 80), drew spiritual and political inspiration from this landscape and its people. Artists came to paint 'the soul of Ireland' and marvel at the beauty of the bogs, the hills and the white strands. Connemara was, and still is, a point of connection between the old and the new Ireland, a word that holds sway over the emotions. Much of the peninsula is a Gaeltacht or Irish-speaking area, and youngsters from all over Ireland spend the summer out here, brushing up on their native language and heritage. As for lovers of wild scenery, moody bog land, cloud-capped mountains and curving bays of silken blue water – Connemara is their dream come true.

A WONDERFUL VIEW of Connemara at its most beautiful – the shell-sand strand and low rocky shores, the distant mountains with many contrasting weathers brewing, and amid it all the little whitewashed cottage that tells of a human presence in the wilderness.

The County Clare coast is stunning. In places, emerald green hills descend to picturesque secluded coves; elsewhere, the coast is a strange windswept landcape of bare limestone. At least it looks bare until you peer down the cracks and see a miniaturized woodland abounding in plant life.

ALICE ROBERTS, PRESENTER

TOP SPOTS ■ GALWAY TO CORK

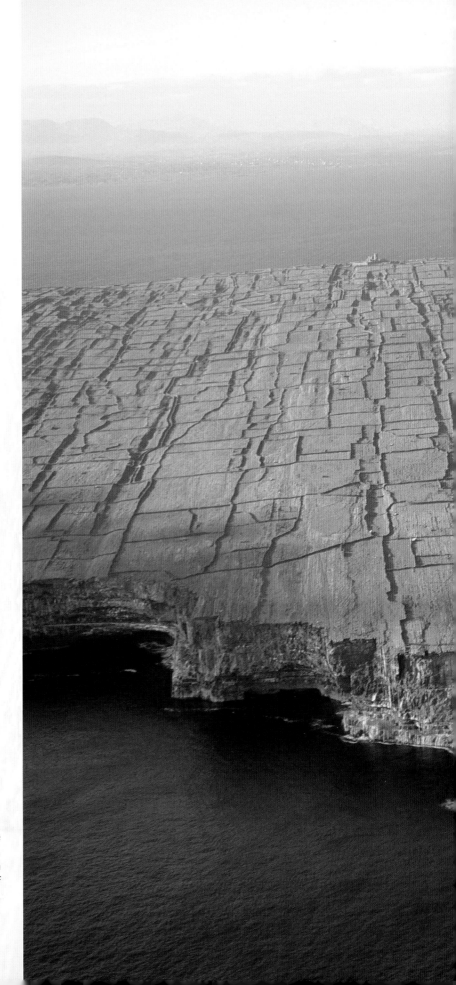

Out to the south, cruising in line astern like a family of sea monsters, lie the three Aran Islands – elongated Inishmore, the largest and most seaward, followed by the wedge-shaped Inishmaan, and the arrow-head of Inisheer, closest to the coast of County Clare. Their landscape is even more rugged and strange than that of mainland Connemara, and they are yet more iconic of old-style Ireland. Though they belong to County Galway, their bedrock is County Clare limestone – smooth, grey and naked, cracked into north–south lines that make the islands look as if their surfaces have been scraped by some giant's currycomb. The fields of soil – created by hand from seaweed, dung and sooty thatch – are littered with ancient churches and standing stones. Each individual field is surrounded by a protective stone wall, which is built so delicately of limestone shards that you can see the sky between every stone, like a stained glass window in greys, whites and blues. People fish from currachs, the traditional light and manoeuvrable black canoes of the west. Irish is the language, especially on Inishmaan, at the centre of the chain, where the oldest inhabitants still wear homespun. And mysterious is the atmosphere, no more pungently than around Inishmore's extraordinary pair of Iron Age forts, the all-but-intact Dún Aengus (Angus's Fort) and the more ruinous Dún Dúchathair (the Black Fort), both perched at the very tip of the island's 300-foot sea-facing cliffs.

THIS STUNNING AERIAL SHOT shows the true essence of the Aran Islands: a rugged block of harsh, windswept limestone rising naked and treeless from the sea, its back seamed with geometrical patterns of gullies and of stone walls enclosing tiny fields, created with infinite care and hard work.

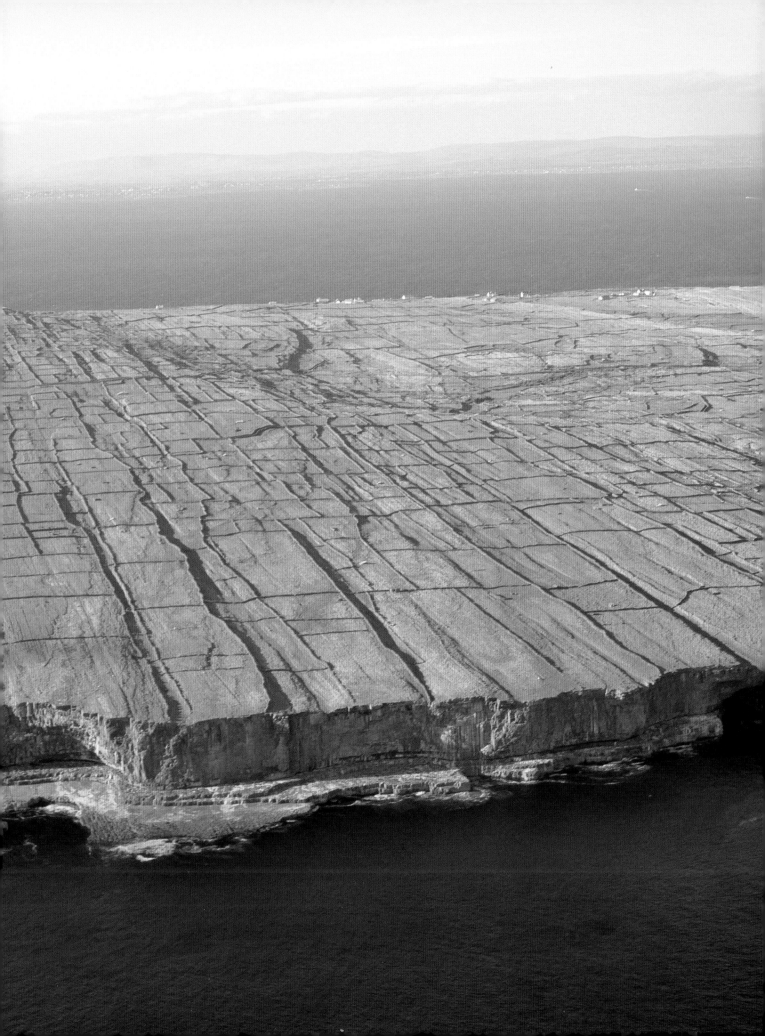

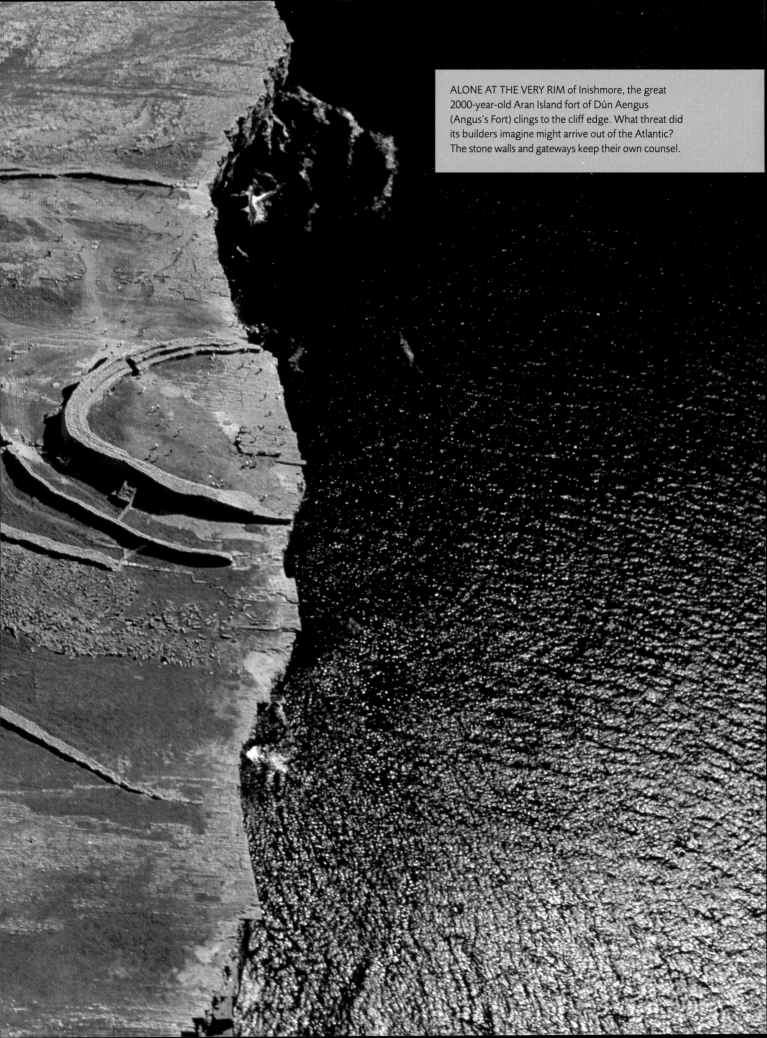

ALONE AT THE VERY RIM of Inishmore, the great 2000-year-old Aran Island fort of Dún Aengus (Angus's Fort) clings to the cliff edge. What threat did its builders imagine might arrive out of the Atlantic? The stone walls and gateways keep their own counsel.

South of Connemara and the Aran Islands is County Clare, the softest and greenest county of the west – all except in the Burren, its northernmost corner. Here one finds a landscape entirely at odds with the rest of the county, a landscape unique in the whole of Ireland. This is karst country, with domed hills of naked limestone pavement, cracked like elephant hide as it was hoisted high from under the sea some 270 million years ago. With its lack of wood, shelter and water, the Burren was never hospitable to man or beast; yet people in the Stone Age lived here and built imposing tombs for their chiefs, such as the 4500-year-old portal dolmen at Poulnabrone and its slightly younger brother, Gleninsheen's splendid wedge tomb. Human population continued in the central Burren for the next 3500 years, and these ancestors left a legacy of the greatest concentration of archaeological remains in the British Isles: a rich strata of churches, tombs, castles, crosses and ring forts. Gaelic culture flourished. In the great stone ring fort of Cahermacnaghten the O'Davoren clan held a medieval law school, respected throughout the land. Such civilized activities came to an end after Oliver Cromwell and his English fire and sword arrived in 1651.

Now the central Burren lies empty, yet it is vigorously alive to anyone with an interest in botany. This is the setting for the richest and strangest of Irish flora, an example of opposing worlds colliding: a place where

WITH A DRAMATIC sense of movement as fluid as a swirling scarf, the slopes of the Burren hills fall in natural terraces to the sea; every nook and cranny of the cracked limestone provides a sheltering place for some plant.

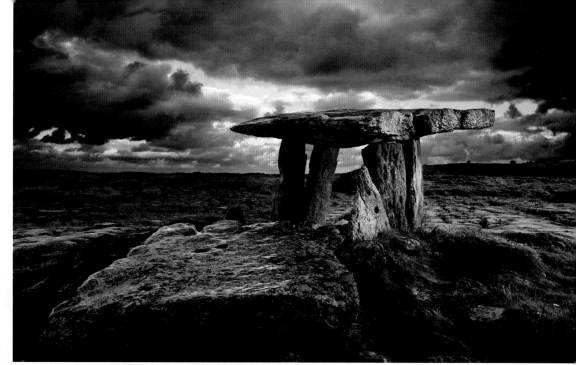

LIKE A MASSIVE STONE TABLE set up for a funeral feast, Poulnabrone's prehistoric portal dolmen tomb stands in the bare limestone landscape of the Burren – one among many archaeological treasures of this open yet mysterious region.

plants that wouldn't normally be found within a thousand miles of each other co-exist happily in neighbouring limestone hollows and on grassy hills and slopes. Acid-loving heather thrives next to lime-loving milkwort; northern upland species, for instance mountain avens, mountain saxifrages and spring gentian, flourish down at sea level side by side with southerners such as hoary rockrose and maidenhair fern. Several factors help to encourage this diversity – an absence of humans, the grazing by cattle so that shading scrub is kept down, the cracks or 'grykes' in the limestone pavement that shelter plants and trap sunlight and rainwater for them; but most of all, the benign presence just offshore of the warm currents of the Gulf Stream. As for an explanation of the presence of so many arctic-alpine species so far south – they are probably refugees from the last Ice Age, their ancestral seeds carried thousands of miles by the southwards-advancing

glaciers, then dropped here towards the end of the Big Freeze, as the melting ice sheets retreated northwards once more.

Incomers and emigrants – the continuing story of Ireland's west coast. Its most dramatic and tragic chapter was written during and after the Great Famine of 1845–9 (see page 79). The Famine was a political, social and human disaster of epic proportions, especially in the west where the land was the poorest, the infrastructure the least developed and the surroundings the harshest in Ireland. Blennerville, on Tralee Bay in County Kerry, became the chief port of emigration for a vast area, thronged with desperate men, women and children crowding on to the emigrant ships. For many, the last sight of their native land was Blennerville's great windmill, still standing today; for others, setting out from Cobh, south of Cork city, it was Fastnet Rock, the southernmost point of Ireland – this was known as 'the Teardrop of Ireland', for its shape and for its symbolism.

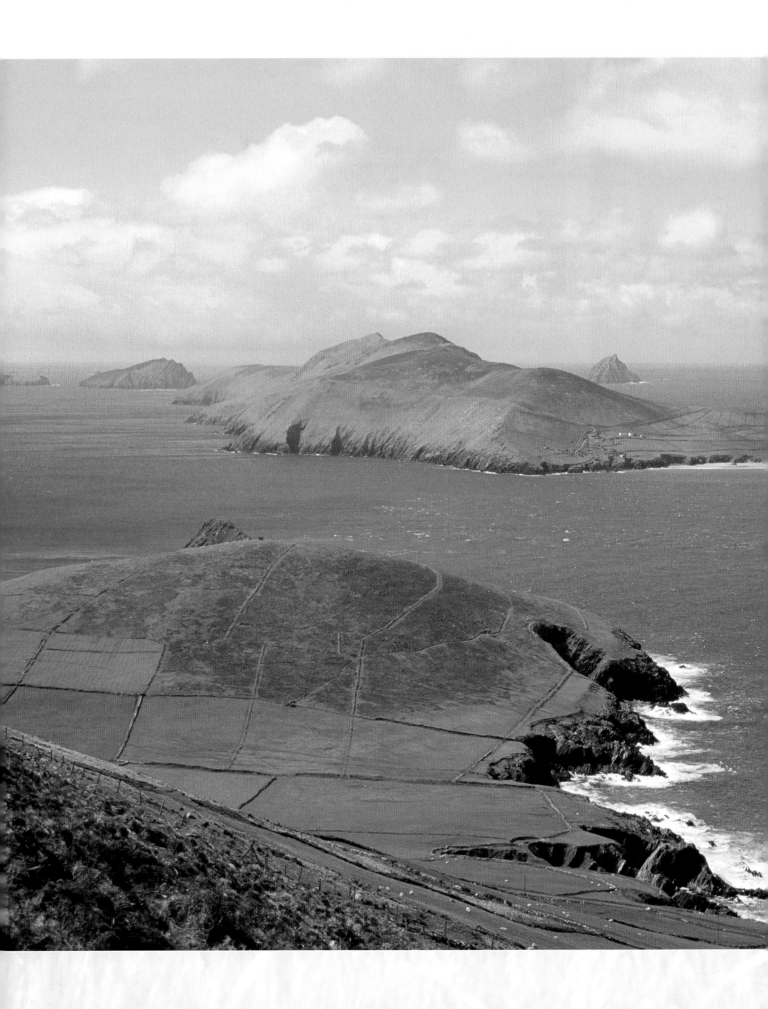

A SPECTACULAR VIEW looking out from the western tip of the Dingle Peninsula, across the turbulent tide race in Blasket Sound to the scattered village of houses on Great Blasket Island. This is the largest island of the archipelago and it was once home to a trio of great twentieth-century writers.

Tralee Bay marks the northern boundary of five rugged peninsulas – Dingle, Iveragh, Beara, Sheep's Head and Mizen. They stick out into the Atlantic from the south-western tip of Ireland like the fingers of a hand opening towards the New World, in friendship or supplication, or perhaps as a mother offering her children to the wide world. The seaward fringe of counties Kerry and Cork lies at the edge of the physical and spiritual Irish worlds. The ancient Celts, observing the tide race and the sunset through the natural arch of Bull Rock, off the tip of the Beara Peninsula, called it Teach nDuinn, the House of Donn, and believed that it marked the spot where Donn – the kingly son of Mil, leader of the Milesians (ancestors of the modern Irish) – fell to his death from the masthead of his ship as the Milesians were invading Ireland. The souls of the dead, they said, would gather at the arch before passing through to Tir Na nOg, the Land of the Young.

On the slopes of Mount Eagle, out at the tip of the Dingle Peninsula, you'll find clusters of round, stone-built clochans, tiny beehive huts where the early Christian hermits shivered and prayed. They looked to find God in hardship and solitude. So did the hermits who established a community out on the pinnacled rock of Skellig Michael, 7 miles off the Kerry coast, amid stormy waters and wild winds. Today's visitor, tossing out on a

BEEHIVE HUTS built with enormous labour by the early Christian hermits who fled the world, the flesh and the Devil to embrace loneliness and hardship on the rocky outpost of Skellig Michael, off the coast of Kerry.

boat from Valentia Island to climb the 544 stone steps and explore the cluster of domed stone huts near the summit, marvels at their bravery and sheer determination.

Among the toughest and most determined of these Christians was Brendan the Navigator, the sixth-century monk who set sail with a few companions in a skin boat from Brandon Creek on the Dingle Peninsula. Did Brendan discover America, as the written account of his seven-year voyage suggests? Certainly, he met volcanoes, icebergs, whales, walruses and Eskimos, and set foot on a beach of white sand. Was a transatlantic crossing feasible in a flimsy currach of leather and wood? Sceptics doubted it down the centuries; then, in 1976–7, Tim Severin (British explorer and navigation scholar) proved it possible by building such a craft and following the saint's wake to landfall in Newfoundland.

TOP SPOTS ■ GALWAY TO CORK
Roaringwater Bay islands p.208 - Skibbereen p.208
Sheep's Head Peninsula p.208 - Skellig p.209 - Tralee p.208

Great Tides and Sands
MERSEY TO SOLWAY AND THE ISLE OF MAN

The iron man, with his salt-streaked cheeks and rusty skin, stares unblinkingly out over Liverpool Bay. Ranged along Crosby Beach at irregular intervals, some on the sands, others up to their knees in the outgoing tide, his 99 identical brothers do likewise. There's a curious intensity about their collective blank-eyed gaze, as if they are watching departing travellers diminish in the distance or scanning the sea for some epoch-making arrival. Together, these

cast-iron scrutineers make up the art installation that its creator, the sculptor Antony Gormley, calls 'Another Place'. November 2006 is their vanishing point, uprooted after a two-year sojourn and installed elsewhere. For anyone who saw them *in situ* on Crosby Beach, however, they will remain in the mind as a touching and disturbing memory, echoing the comings and goings, the departures and arrivals of millennia along this north-western coast of England, the stretch that faces out towards unseen lands 3000 miles away beyond the western horizon.

'ANOTHER PLACE': the body of sculptor Antony Gormley, cast by its owner 100 times in iron, stands on the sands of Crosby Beach, watching the ships passing under the ever-changing cloudscapes of Liverpool Bay.

Connections between the New World and the Old are legion along this shore – religious dissidents and nineteenth-century emigrants quitting the old country for a harder but freer life overseas; slave ships setting out from Carlisle and Whitehaven, on passage to the Caribbean and the Americas via West Africa; stringbag aeroplanes staggering in from pioneering transatlantic flights and Second World War convoys bringing lifesaving supplies. There has long been trade and contact with other places – Roman ships operating from ports at Freckleton on the Ribble Estuary and at Ravenglass on the Cumbrian coast, Vikings sweeping ashore on the Sefton Coast of south-west Lancashire, Norsemen sailing into the Isle of Man, Oliver Cromwell's armies embarking for bloody deeds in Wexford and Drogheda. Then all the incessant bustle of domestic trade and ferry traffic to and from Scotland, Ireland and the Isle of Man; and seaside business, too, with a new style of 'invader' journeying from inland to the developing spas and seaside resorts of the eighteenth and nineteenth centuries.

The strange thing to anyone coming afresh to this stretch of Britain's coastline after learning of its great maritime history is its apparent unsuitability for sea trade. Travelling from south to north, one moves from an impenetrable barrier of dunes and seaward-stretching sands along the dead-flat Sefton Coast into a succession

RARE CREATURES such as the natterjack toad, with its bold yellow spine stripe, and the short-legged sand lizard thrive in the carefully managed dunes at Ainsdale Sand Dunes National Nature Reserve, while the pine woods along the Sefton Coast play host to a big colony of red squirrels, native to Britain but now a declining species.

of estuaries – Ribble, Wyre, Lune, Kent, Leven, Duddon, Esk, Solway. These are not deep, straight estuaries capable of accommodating big ships but shallow and twisting channels, whose rivers are forced to snake tortuously to the open sea through banks of mud and sand. It seems to be a coast without any potential for serious engagement with the sea. However, the many harbours and docks at the estuary mouths and the canals and railway lines that connect them with big towns, such as Preston, Lancaster and Carlisle several miles upriver, bear witness to man's incredible energy and resourcefulness. Down the centuries, humans along this stretch of coast have struggled heroically and ceaselessly against the sea, wresting a living from it while battling against the silt and shifting sands, encroaching mud, and coastline-altering storms. Remedial schemes have been devised and laboriously carried out to restrain the sea, keeping it out of homes yet close to towns; keeping communications open but the sluice-gates shut.

Nature, of course, struggles and survives by other means and with a different agenda. There are species

and prolific grey squirrel. However, the pine trees planted as commercial woodland at Formby Point at the turn of the twentieth century have proved a haven and a form of salvation for red squirrels. Now managed by the National Trust for the benefit of these rare rodents, the conifers of Formby Reserve hold a thriving population of about a thousand.

For the wild birds – the greatest international travellers of all – the vast sands and mud flats of such a vigorously tidal coast simply offer one enormous larder, packed solid with plant and invertebrate food – the ideal place for Arctic Circle breeders to spend milder winters. For birds on passage, the succession of tide flats represents a huge service station just off the aerial freeway, a place to pause and recruit themselves before flying on to their summer destinations.

that would die – literally – rather than move from their one fixed habitat. The great dunes at Formby, Ainsdale and Birkdale on the Sefton Coast form a system 15 miles long, unequalled anywhere in the north of England, a carefully managed and maintained refuge for natterjack toads, sand lizards and other rare animals and plants that can't survive in any other environment. As for red squirrels, their numbers are declining in almost every other part of England through disease, destruction of woodland habitat and competition from the more robust

LAPWINGS PICK OVER the gleaming mud flats of Sunderland Point at the mouth of the Lune Estuary below Lancaster – a windy, moody piece of coast haunted by the piping cries of wading birds. The quiet little hamlet of Sunderland is cut off at each high tide.

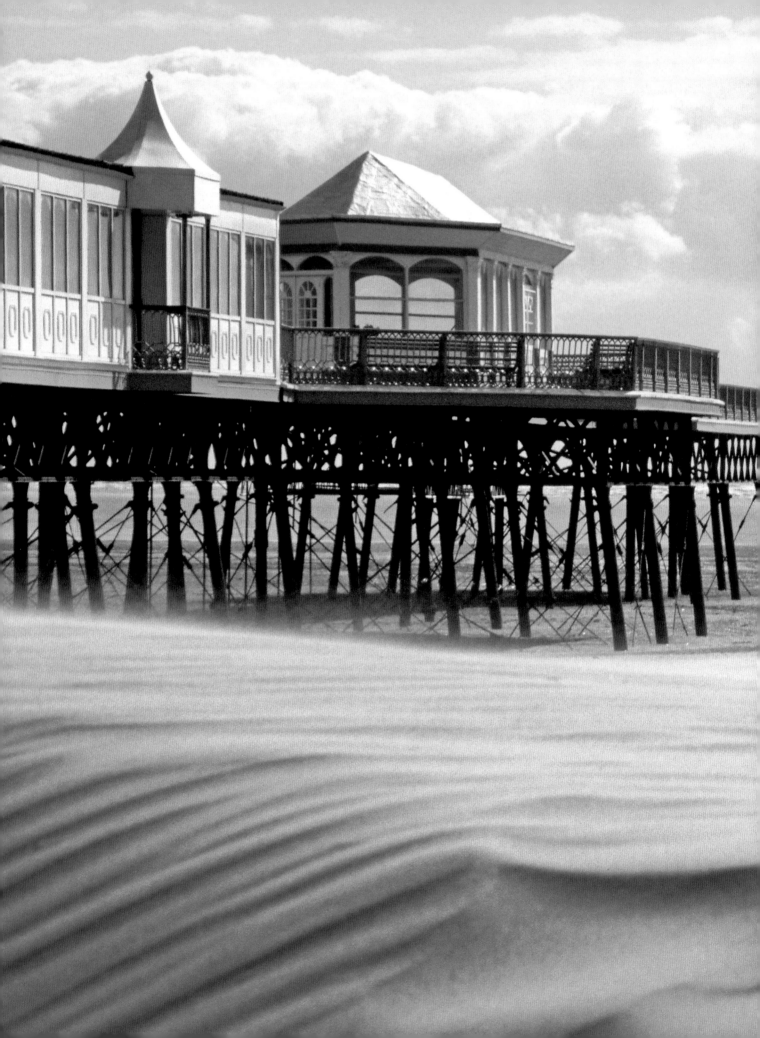

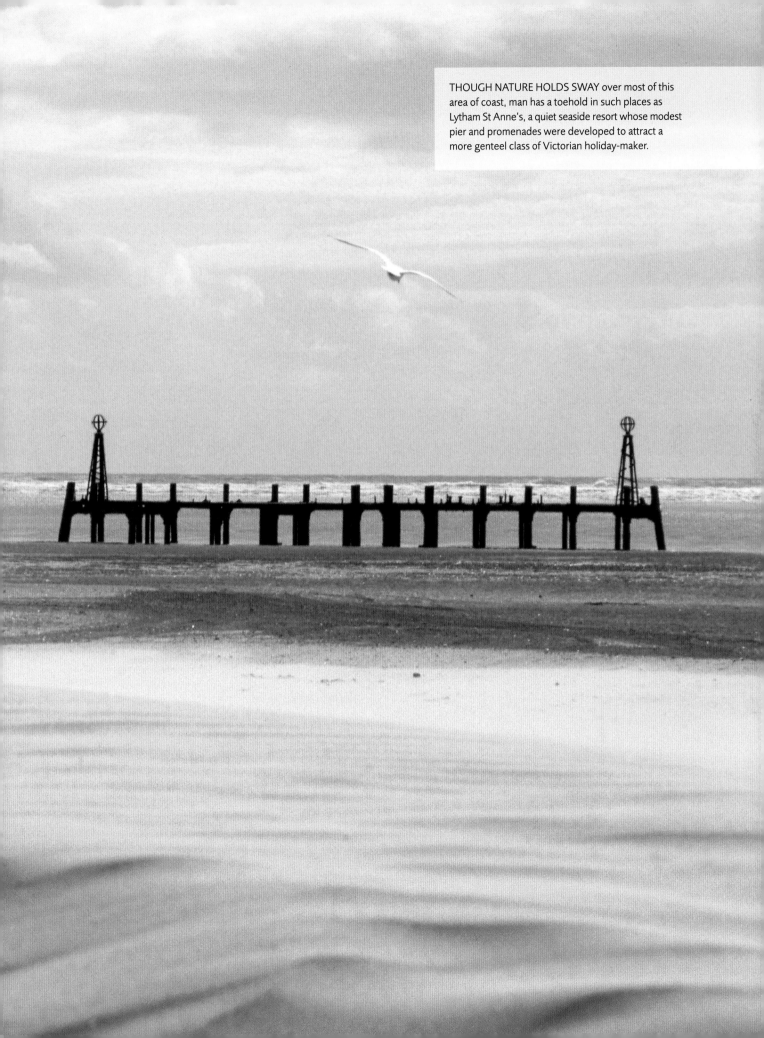

THOUGH NATURE HOLDS SWAY over most of this area of coast, man has a toehold in such places as Lytham St Anne's, a quiet seaside resort whose modest pier and promenades were developed to attract a more genteel class of Victorian holiday-maker.

The Fylde's blunt-nosed peninsula, between the Ribble and Lune estuaries, was a waste of marsh and scrub until it was drained for agriculture in the eighteenth century. Two neighbouring villages lay on the southern edge of the Fylde – Lytham, which grew prosperous when the local landowning Clifton family built docks there in the 1840s, and the fishing hamlet of St Anne's, alongside Lytham. St Anne's received its boost in the 1890s, when the Cliftons developed it to amalgamate with Lytham as a genteel resort for holiday-makers who wished to avoid the bouncy brashness of Blackpool, just to the north. Blackpool had grown out of nothing – first as a spa, then as Britain's premier seaside resort for northern working-class families after the railway arrived here in 1846.

To the north of Blackpool lies Fleetwood, a small village that landowner Peter Hesketh-Fleetwood decided to transform into a seaside resort around the time Blackpool got its railway. But it was the docks, built in the mid-nineteenth century, that turned out to be the gold mine at Fleetwood – passengers and goods set out from here by steamer to the Isle of Man, Scotland, Ireland and dozens of English ports, and fish caught by Fleetwood boats were sent all over the country by railway.

Blackpool has been through its commercial ups and downs as tastes in holidaymaking have changed over the past half-century. Blackpool Tower and the three piers – Victorian icons all – have their devoted admirers, but it's the Pleasure Beach funfair,

DEEP-SEA TRAWLERS still work out of the Fylde port of Fleetwood, though the fishing business of the town is only a shadow of how it was in the great nineteenth-century years, when a fisherman could walk from one side of the dock to the other across the decks of the close-packed boats.

SIGN, STANDARD AND SYMBOL of England's greatest
seaside resort, the Blackpool Tower stands 518 feet tall.
It boasts its own circus with acrobats and clowns, a
ballroom floor of 30,000 blocks of wood, an aquarium
featuring 57 species of fish, a giant playground – and,
of course, the Mighty Wurlitzer organ.

with its complex of scream-inducing, cutting-
edge, white-knuckle rides, that really pulls the
crowds these days. As for Fleetwood, a late
twentieth-century decline in fishing stocks and
the application of European Union rules and
quotas has decimated the famous fishing fleet,
which used to battle the sea as far afield as
Iceland. Songs, stories and museum displays,
such as the 'heritage trawler' *Jacinta* in the Fish
Dock, keep alive memories of one of the very
toughest ways to earn a living. On a much
smaller scale, fishing activity goes on in the
estuaries from Ribble to Solway by traditional
methods – fishing for flounders (locally called
flukes), digging for cockles in the sands of
Morecambe Bay and spreading big 18-foot
haaf-nets across the tides of Solway, Lune or
Ribble in hopes of salmon.

Lancaster, far up the River Lune, became a
prosperous port in the late seventeenth century,
but the city couldn't combat the silting of the
river, which denied bigger ships access to its
quays. New facilities were built nearer the mouth
of the estuary, at Glasson Dock, which was
connected to the city by canal and then railway.
Glasson had shipyards, now silent, but the
docks still handle outgoing coal and incoming
agricultural materials; the little town, though,
has slipped into a gentle and sleepy retirement.

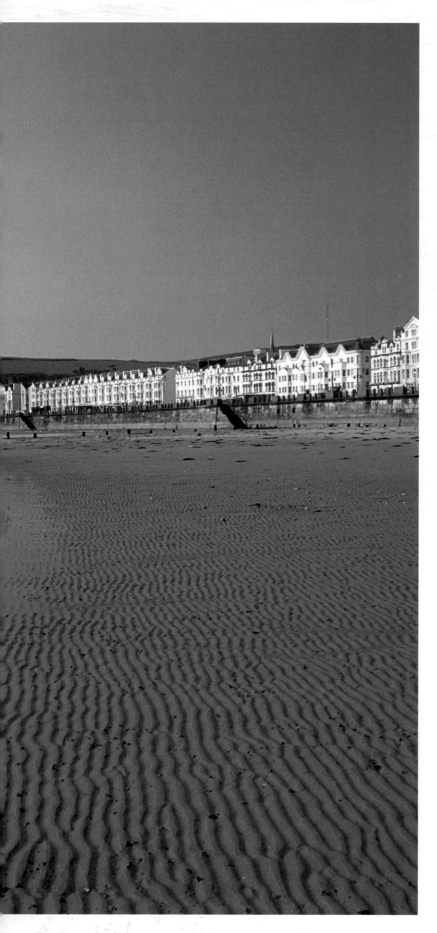

The Gulf Stream bathes the Isle of Man with warm waters that are rich in plankton and attract basking sharks, the second largest fish in the sea. Here, I had the great privilege of swimming with one – face to face.

MIRANDA KRESTOVNIKOFF, PRESENTER

By far the most atmospheric and poignant place on this coast of silted rivers and vast marshes and mud flats is Sunderland, a hamlet in a wonderfully lonely position at Sunderland Point, the tip of the peninsula that forms the northern flank of the Lune estuary. Cut off at each high tide, the few sandstone houses of Sunderland stand alongside warehouses on docksides built at the turn of the eighteenth century, when Lancaster was set to be a boom town. It's rumoured that this was where the very first bales of raw cotton from the New World were landed in 1701, a million pounds' weight of cotton that lay neglected on Sunderland's quay for a whole year because no one knew what the strange stuff was or what to do with it. Across the headland from Sunderland, against a stone wall in the corner of a green field, lies Sambo's grave, marked with an inscription. One of many black servant/slaves brought to Britain from the Caribbean, Sambo landed at Sunderland in 1736 and died shortly afterwards – probably from pneumonia, although locals said the cause was a broken heart.

RIBBED SANDS lead the eye along the front at Douglas, capital town of the Isle of Man and its biggest seaside resort. Long ranks of Victorian 'wedding-cake' hotels are separated from the sea by a fine promenade that runs the length of the beachfront.

Northwards along the coast is Heysham, ferryport for the Isle of Man. The island, about 60 miles out in the Irish Sea, is a land apart, ruled by its own parliament of Tynwald and with its own distinctive (though seldom practised) language. Man is famous for its strict anti-yobbery laws and for its annual TT motorbike races round the narrow mountain roads. It is also a wonderful place for walkers. The island is 33 miles long and 13 miles broad and the 25-mile Millennium Way threads the hilly backbone of the island, with many footpaths dipping into the flowery valleys running down to the sea.

If you want sand, Morecambe Bay has got it – 117 square miles of the stuff at low tide, when the sea retreats more than 10 miles from the land. Millions of waders, ducks and geese overwinter here. Pragmatists say the locally famed phenomenon of the 'singing sands' is merely the whistling of the wind over the ribs of cockle shells in their vast beds, exposed by the falling tide, but romantics will surely hear the songs of mermaids or maybe of the mysterious shifting sands themselves, carried in the sea breeze.

THIRTY YEARS AGO, Whitehaven was one of the most run-down towns in Britain, but massive investment in tourist-friendly projects has seen the town put on a handsome new face of bold modern design to complement its restored Georgian architecture. It has also discovered a new role as a town of museums, yachting and leisure activities.

THE KING OF PIEL

Why not seek an audience with the King of Piel Island? You can walk over the sands to the tiny island at low tide from the south end of the Isle of Walney, beyond Barrow-in-Furness, or take a boat from Roa Island, south of Barrow. A long-standing tradition, the King of Piel is the honorary title given to the landlord of the Ship Inn on Piel – one of the strangest sites for a pub, and even stranger for a monarch.

Round the corner from Morecambe Bay and its neighbouring Duddon Estuary, the cliffs of the West Cumbrian coast begin a northward march towards the Scottish border. Out at the furthest point of their westerly bulge lies the Georgian planned town of Whitehaven. As at Lytham and Fleetwood, it was a local landowning family – the Lowthers – who developed Whitehaven in the seventeenth century from a fishing village into a successful port for exporting coal from the Lowther mines. Sugar, rum and tobacco came in from the colonies, and new port facilities were built in Georgian times to accommodate the new trade. Financial success saw handsome architecture spring up around the town, both public buildings and private houses. Coal export maintained prosperity throughout the Victorian era. However, a century later the mines were closed, the colonial trade was a memory, and Whitehaven became Cumbria's 'forgotten town', its fine Georgian buildings run down and semi-derelict. Then, in the latter decades of the twentieth century, British Nuclear Fuels at the nearby Sellafield reprocessing plant took over from the mines, harbour and chemical companies as the main employer. The organization pumped money into refurbishing the town. Now the restoration programme is on its way to completion, and Whitehaven has undergone a remarkable renaissance.

Fireworks and Devil's Porridge

SOLWAY FIRTH TO THE FIRTH OF CLYDE

Between the broad bosom of the Solway Firth and the wide channel of the Firth of Clyde lies a corner of Scotland that few non-Scots coming north of the border trouble themselves to explore. The main roads to Glasgow and Edinburgh are tempting highways; only those in the know bother to turn aside and make their way down to the sea margins of Dumfries, Galloway and Ayrshire. The rest of the world rushes on north, unaware that an astonishingly varied coast lies waiting to be discovered there.

From the gentle green fields and long marshes of the Solway to the mountains and cliffs of the Isle of Arran, this is a coast of explosions, of upheavals and convulsions, a coast of outbursts and outpourings – geological, spiritual, military, literary and social. We see at first hand the consequences of volcanic fireworks in the contorted rocks of Ailsa Craig and Arran, and real, man-made explosions have left their imprint on this remote coastal country in munitions factories and in dumped bombs and flares stranded by the tide on pristine beaches. The coming of Christianity was itself an explosive event, sparking a revolution in thought and behaviour as new understandings combusted in heathen heads. The Ayrshire coast is forever coloured by the reckless shade of national poet and local boy Robbie Burns, with his skyrocket of a personality, and the waters of the Clyde's estuary by the gusto and crash-bang-boom of holidaying Glaswegians intent on making the absolute most of every minute on the beaches and in the jam-packed boarding houses and bars of Rothesay, Millport and Ayr.

RISING OUT OF THE SEA MISTS off the Ayrshire coast, like the humped back of some fabulous monster of the deep, the lonely granite outpost of Ailsa Craig lures intrepid sea kayakers and sailing-boat skippers to explore its rubbly coves and strands.

Real explosions first – or rather the means of making them. North-west of Carlisle, the village of Gretna straddles the border between England and Scotland on the north bank of the Solway Firth, a lonely area of meadows, merses or marshes, and low-tide mud and sand flats. This was the place chosen during the First World War for the building of a munitions factory – not just any munitions factory, but the biggest in the world in its day.

The Moorside complex, centred around Gretna, measured 9 miles from end to end and 2 miles wide, a consequence of the necessity of isolating each building from the next in case of an explosion. Workers were shipped in from across the United Kingdom and the wider British Empire. At Moorside's height of operations in 1917, 30,000 employees were working there,

manufacturing cordite RDB, the explosive component in shells and bullets – 800 tons a week, more cordite than all of Britain's other munitions factories put together. In its heyday, the complex contained hundreds of factory buildings, 130 miles of railway track, many miles of roadway, and loading bays and sheds. Workers were housed in specially built accommodation at Gretna and nearby Eastriggs, with schools, hospitals, dance halls, bowling alleys and tennis courts all provided. The British writer Sir Arthur Conan Doyle (1859–1930) visited Moorside in his role of war correspondent and coined the splendid phrase 'devil's porridge' to describe the explosive mixture of guncotton and nitroglycerine, which women workers kneaded into a paste with their bare hands as part of the cordite-manufacturing process. These women were known as 'Moorside canaries' because of the yellow tinge

NOTHING could look more peaceful than the wide sands of Luce Bay in the evening at low tide – but these glorious beaches of south-west Galloway have occasionally received unwelcome intruders in the shape of unexploded wartime ordnance washed up from the offshore dumping ground of Beaufort Trench.

MORNING SUNLIGHT paints vivid colours on Little Ross Island in Kirkcudbright Bay. Artists love the clear light of the Dumfriesshire coast and their 'colony' in Kirkcudbright has flourished for the past 100 years or so.

imparted to their skin by the cordite. In St John's Episcopalian Church in Eastriggs, volunteers maintain a Devil's Porridge exhibition to commemorate this extraordinary period in the area's history. Most of the complex's buildings were flattened after the war, and of this mighty metropolis only a few shapes in the grass now remain.

What is hidden in these offshore waters can prove a pretty incendiary topic of conversation hereabouts. Over a million tons of unused ordnance, explosives and weaponry of all kinds were dumped after the Second World War in Beaufort Trench, a deep trench in the sea bed off the hammerhead peninsula called the Rhinns of Galloway, which marks the south-western tip of Scotland. Bombs and phosphorus flares are dredged up from time to time in the nets of trawlers, and some have made unwelcome appearances on beaches such as those in Luce Bay. Locals also have concerns about the MoD's testing range on the marshes at Dundrennan near Kirkcudbright, where shells tipped with

depleted uranium are fired through targets into the Solway Firth. It is a constant battle to maintain the clean seas and unpolluted beaches that are so much the natural order in this out-of-the-way part of the world.

To see the wonders of explosive geology you have to round the Mull of Galloway at the southerly tip of the Rhinns and make your way north along the coast to the seaside town of Girvan. Standing on the harbour and looking west, you marvel to see a great grey dome under a green top, 8 miles out from land – the ancient volcanic plug of Ailsa Craig, rising over 1100 feet out of the sea. At their tallest, the granite columns of its cliffs tower more than 600 feet. Approaching Ailsa Craig in a boat, you can make out the castle, the white-painted lighthouse and other scattered dwellings, which tell you of centuries of human occupation of the now-abandoned island – mostly lighthouse-keepers and quarrymen working the granite.

Devotees of the Scottish sport of curling (essentially bowls on ice) have known since the eighteenth century that Ailsa Craig's blue hone granite, with its dense texture and non-porous surface, is perfect for making the curling stones they slide so dextrously across the ice. There is no more blasting on the Craig – it is now an RSPB reserve, thanks to a seabird population that includes guillemots, kittiwakes, puffins and a huge colony of some 40,000 breeding pairs of gannets. But enough fallen rock litters the quarries to keep the curlers happy for another good few centuries.

'Scotland in miniature' is the tag carried by the Isle of Arran, which lies due north of Ailsa Craig. Here, within sight of the gentle Ayrshire coast, the northern half of Arran rears into the granite mountains of Goat Fell, Caisteal Abhail and Beinn Tarsuinn, remnants of volcanic explosions some 60 million years ago and each over 2700 feet high. Chalks and clays jostle with the granite in central Arran, and dark dolerite sills are sandwiched in red sandstone to form the ledges and giant steps of the island's southern section. Everything has been turned, twisted and tilted. It's a stunning prospect, a snapshot of subterranean violence caught and frozen.

A PRETTY SCENE, with the conical summit of Goat Fell mirrored in still waters on a calm day in the Isle of Arran; but the island's mountainous landscape was forged in the crucible of volcanic explosion and rivers of molten rock – a true land of fire and brimstone.

Explosive ideas are characteristic of this coast. At Whithorn, west of the Solway Firth, stand the ruins of a twelfth-century priory. In all probability it was built, following common custom, on a very early Christian site – in this case, over the foundations of a humble church constructed around the turn of the fifth century AD by St Ninian, the first missionary to bring the Christian message to Scotland. The saint's sacred bones would have been laid under the altar stone by his followers.

The same claim is staked by another site nearby, a ruined medieval chapel down on the Isle of Whithorn at the southernmost tip of the Machars Peninsula. This chapel was in fact probably built for the benefit of sea-borne pilgrims making landfall on their way to the priory and the shrine of St Ninian. Just

around the headland, pilgrim crosses have been incised over many centuries, deep in the walls and rocks of a cave where Ninian is thought to have fasted and prayed. Tales about the man have become hard to verify, but the power of the message he brought has ensured his name would never be forgotten in this place. Pilgrims in their thousands still come to Whithorn today to pray in Ninian's Cave and give thanks in the lonely chapel for the saint and his message.

Not that man's convoluted interpretations of Christian teaching have always produced sweetness and light in this area. North of the peninsula from Whithorn lies Wigtown, where a gravestone in an enclosure in the parish church cemetery is poignantly inscribed: 'Here lyes Margrat Lachlane who

THE BONES OF ST NINIAN, the first missionary to bring the Christian message to Scotland, probably lie buried in the ruins of the twelfth-century priory church at Whithorn – built to accommodate his shrine some eight centuries after the holy man's death.

TOP SPOTS ■ SOLWAY FIRTH TO THE FIRTH OF CLYDE
Caerlaverock p.215 - Carlisle p.214 - Culzean Castle p.215
Dumfries p.214 - Girvan p.214 - Great Cumbrae Island p.214

was by unjust law sentenced to die by Lago.' Margaret McLachlan, a woman in her sixties, and teenager Margaret Wilson, having been convicted of 'non-conformity, disorderly behaviour, and absenteeism from church', were tied to stakes in Wigtown Bay on a May morning in 1685 on the orders of Sir Robert Grierson of Lag – 'Cruel Lag', Steward of Kirkcudbright, who was charged with the suppression of all Covenanters in the district. The Covenanters, the religious sect to which the two women belonged, were subject to savage persecution because they refused to acknowledge the king or the bishops he appointed as having authority over their Presbyterian church. Margaret Wilson's stake was nearer the shore, to give her a chance to repent when she saw the older woman drowning before her in the incoming tide. But the teenager refused, even though a dragoon held her head up out of the water until the last possible moment. A 'martyr's stake' monument on the marshes marks the spot where they died.

A POETIC LIGHT gleams in the eyes of the 'heav'n-taught ploughman', Robert Burns, in this typically idealized portrait of a man who loved laughter, pretty girls and a decent measure of wickedness. Scotland's national poet, he was born in Alloway, Ayrshire; his birthplace has become a museum.

A moment of explosive passion left a shadow on Baldoon Castle, a moody ruin just outside Wigtown. It provided a brilliant ghost story, on which Sir Walter Scott based *The Bride of Lammermoor*. Local tales say that the spirit of young Janet Dalrymple walks Baldoon by night each 12 September, the anniversary of her death in 1669. Poor Janet died insane shortly after being discovered lying drenched in blood beside her wounded bridegroom, David Dunbar, in their bedchamber on her wedding night. As happened to so many gently born girls in those days, she had been forced to marry the rich young Dunbar against her will. Did she

try to murder Dunbar – or was it Lord Rutherford, her impoverished but dashing true love, who hid himself in the chamber and escaped after stabbing his rival...?

The favourite and most famous native son of Ayrshire, Robert Burns (1759–96), was nothing if not volcanic in character and in self-expression. The wild young ploughman poet from Alloway lived fast, loved heedlessly, drank recklessly and died young. But he worked hard on his verses: tender love poems; stirring nationalistic songs such as 'Scots wha hae wi Wallace bled'; blasts of social polemic, for example 'A Man's a Man for a' That'; comic ballads in the

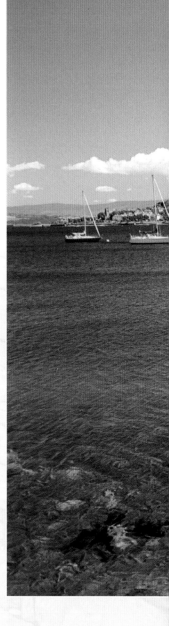

'DOON TH' WATTER': Rothesay on the Isle of Bute was one of the holiday resorts within easy reach of Glasgow that played host to the mass migration of Glaswegians during Glasgow Fair, a two-week vacation when the city's workers downed tools and went looking for a lively good time.

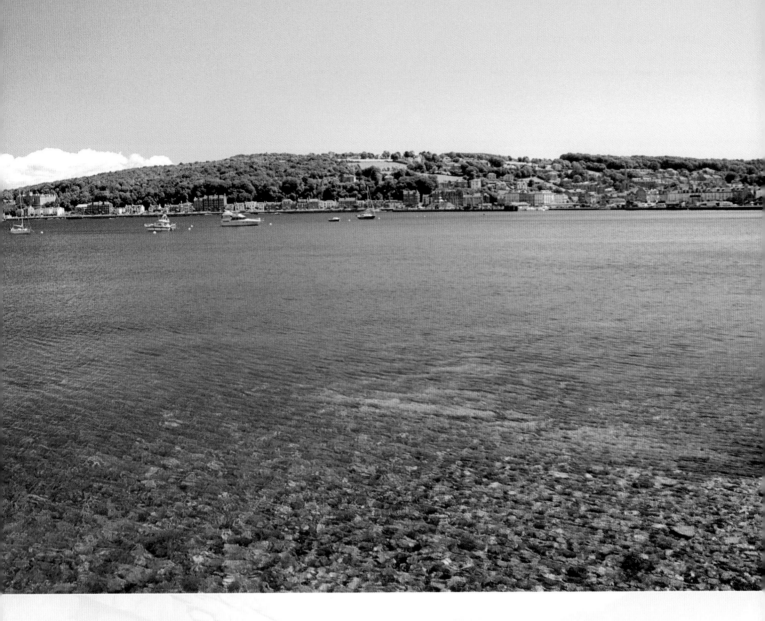

vein of 'Tam o'Shanter'; and witty, caustic
jibes at the great, the good and the stuffy.

As we near the Firth of Clyde, a last
explosive blast belongs to the 'mad-for-it'
Glaswegians of yesteryear, who boarded the
Clyde paddle-steamers each July and went
'doon th' watter' *en masse* to the coastal
resorts for a proper blow-out on the annual
holiday fortnight of Glasgow Fair:

A sail doon th' watter it is the whole go,
To Millport, to Rothesay and Greenock also;
Garelochead, Dumbarton and also to Ayr,
They will jaunt with their sweethearts
* on Glasgow Fair.*

While filming, I fantasized about
being cast away on Ailsa Craig. The
mainland was just a pencil line on the
horizon, butterflies tumbled and
the sun blazed on a cobalt sea.
I'm told that it's not the same in winter!

NICHOLAS CRANE, PRESENTER

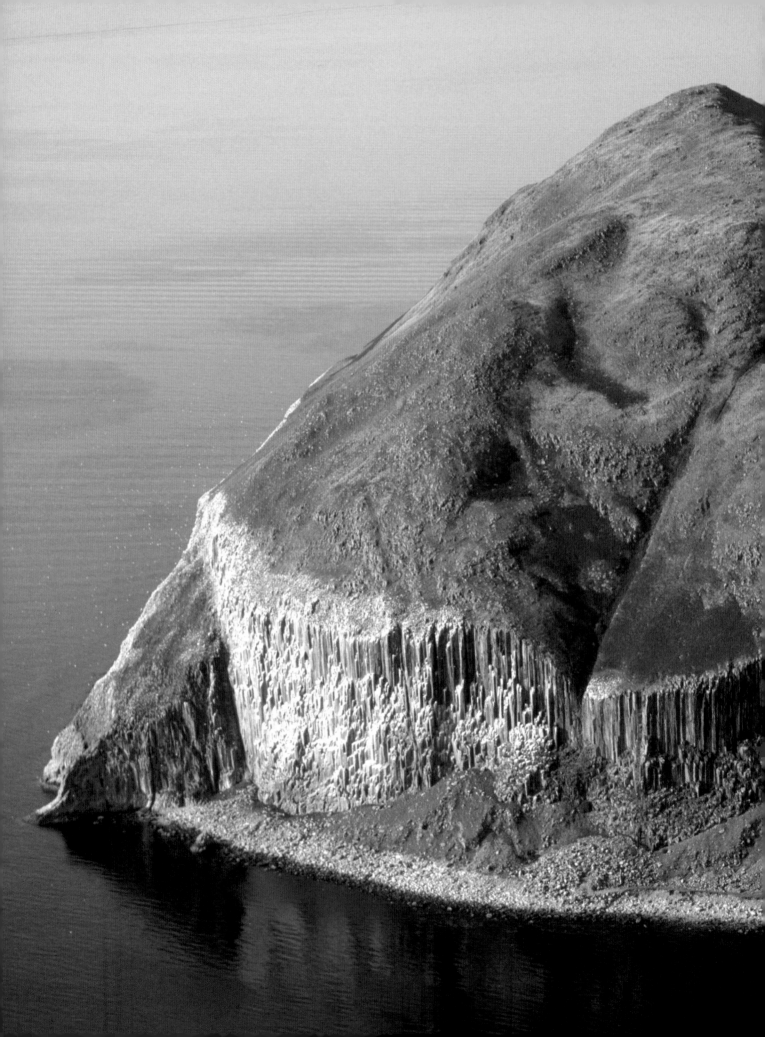

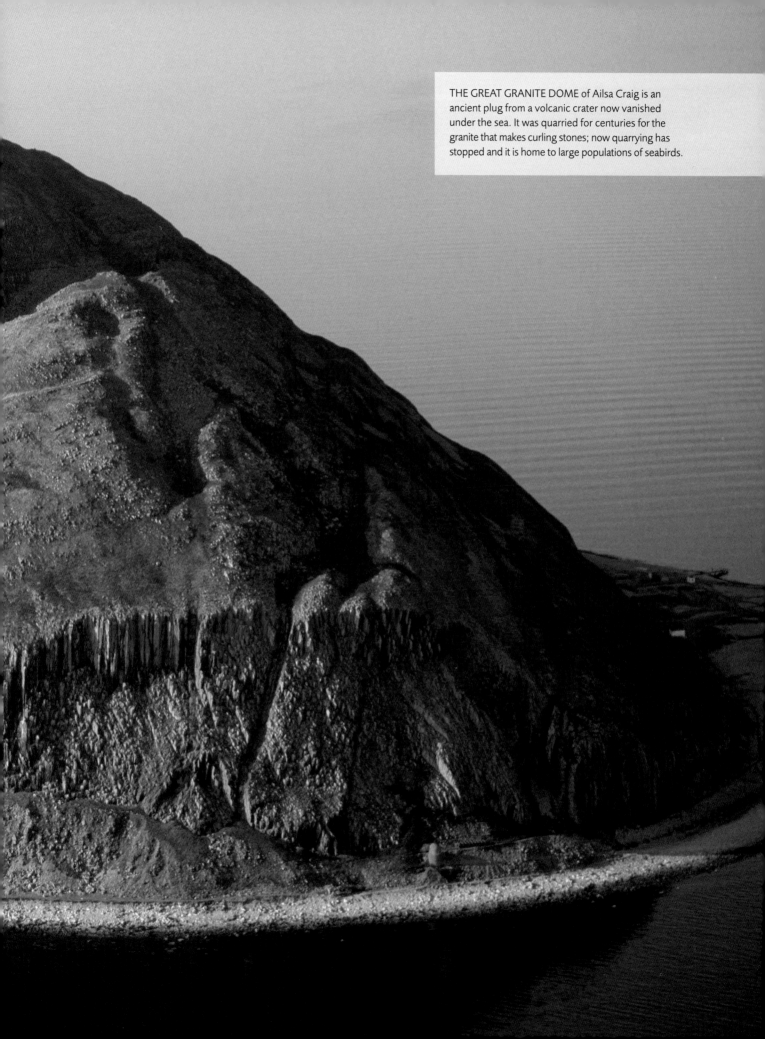

THE GREAT GRANITE DOME of Ailsa Craig is an ancient plug from a volcanic crater now vanished under the sea. It was quarried for centuries for the granite that makes curling stones; now quarrying has stopped and it is home to large populations of seabirds.

The Granite Archipelago

THE OUTER HEBRIDES

The Outer Hebrides, also known as the Western Isles, lie 50 miles west of the Scottish mainland, like a shield curved protectively against the force of the Atlantic. From high in the air, or on a map, the island chain resembles a dinosaur, a great fish lizard curled north-eastwards and stripped to a skeleton. From the spear-blade-shaped skull that is the Isle of Lewis, the long archipelago trails away for 130 miles through Harris, North Uist, Benbecula, South Uist, Eriskay, Barra and a whole scatter of smaller islands – the vertebrae of a disarticulated but still-coherent spine. Geologically, they conform closely; almost all the islands are composed of Lewisian gneiss, the oldest rock in Europe – an ancient granite, first formed from molten magma some 3300 million years ago.

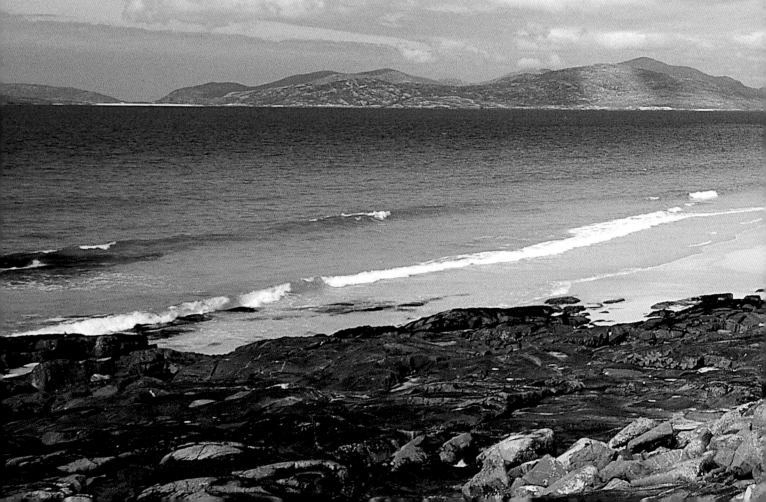

Gneiss forms a harsh, unfruitful landscape of poor acid soil, many small lakes (lochans) and lumpy hills of exposed rock breaking through a thin skin of heather and peat. Add to this unforgiving geology the stiff winds and frequent gales of the open Atlantic, dangerous natural harbours, constant drifts of salt spray and isolation from the amenities and comforts taken for granted on the mainland, and you can appreciate how hard it has always been to maintain a basic farming and fishing existence out on the westernmost fringe of Britain. Things may have eased since the introduction of air services, modern plumbing, electricity, good schooling, medical facilities and of course the on-line communications revolution – the islands and their people have been heavily subsidized by grants, loans and favourable terms, and recently they have also enjoyed a measure of self-government through Comhairle nan Eilean (the Council of the Islands) and the Co-Chomunn (island co-operatives). But make no mistake: an islander's day-to-day life is still tough, though perhaps more psychologically than physically these days.

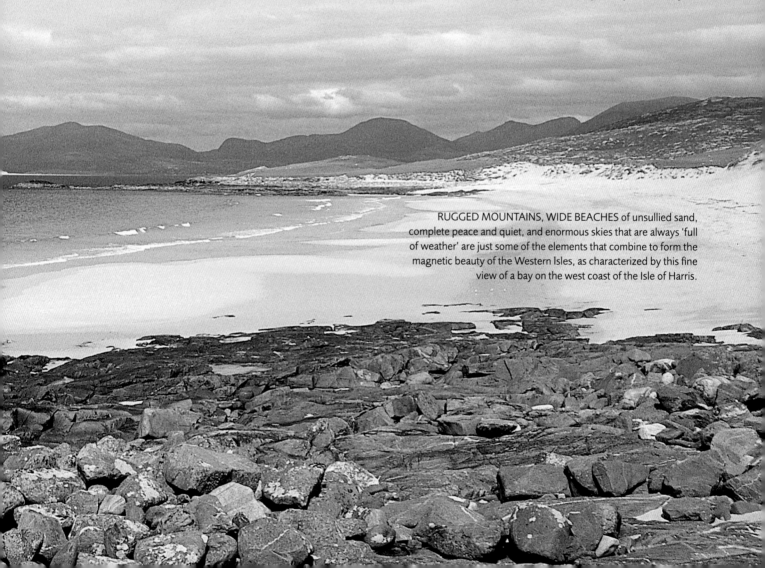

RUGGED MOUNTAINS, WIDE BEACHES of unsullied sand, complete peace and quiet, and enormous skies that are always 'full of weather' are just some of the elements that combine to form the magnetic beauty of the Western Isles, as characterized by this fine view of a bay on the west coast of the Isle of Harris.

Callanish is over 5000 years old. The stones were here before anything or anyone we've ever heard of – 3000 years before the birth of Christ and before the great pyramids of Egypt. Callanish has always been here.

NEIL OLIVER, SERIES PRESENTER

The total population of the Western Isles is 26,000 or thereabouts, and 13 of the islands are inhabited. The communities are close-knit – each island forms a self-contained unit in its own right, and also belongs to the broader community of the archipelago as a whole. Although the islanders have their differences – for example, the Catholic inhabitants of Barra, at the southern end of the chain, do not necessarily see eye-to-eye with the Free Presbyterians of Lewis in the north – they have historically enjoyed an enormous amount in common in terms of their geographical and economic situation, as well as shared history and language. Almost all native-born islanders with more than three generations in the Hebridean genetic bank have a background heritage of crofting, fishing and kelp-gathering, and a shared history of tenancy under an all-powerful laird, as well as of cultural isolation hand in hand with communal ways of working and interacting.

This situation is now changing, slowly but surely. More incomers are settling in the islands. They value the easy-paced, hospitable way of life, the clean air and water, the lack of crime, the empty beaches and the peace and quiet. Inevitably, their arrival on the scene has led to a hike in house and land prices, and to a cultural shift that has impacted heavily on the native islanders. Some newcomers, tuned in to these nuances of their presence, take the time and trouble to integrate themselves in a sensitive way, learning Gaelic, attending church, and shouldering their share of community duties; others go blundering in with both feet foremost. But

STANDING TOGETHER like a convocation of grave and silent elders, the tall granite monoliths that make up the Callanish Stone Circle on the west coast of the Isle of Lewis hold a power and mystery that bridges the five millennia since they were first set up.

however carefully and humbly they tread, these 'white settlers', or 'blow-ins' (as they are styled by native islanders), cannot help but act as agents of change. This is not always for the worse – often they push for the introduction of amenities such as a better plane service or improvements to shops or schools, and it can seem as though their forceful southern demands are attended to with a promptness and energy which somehow were never quite manifest when it was Hebridean voices doing the asking. Incomers can also bring a blast of fresh organizational or entrepreneurial skills to local councils and community groups and the management of small businesses. Some have taken on responsibility for aspects of traditional island life, too – visiting old and lonely people, arranging ceilidhs, and propping up church attendance – alongside the islanders themselves. Such new blood, if carefully and sensitively integrated, can be a blessing rather than a curse to the islands.

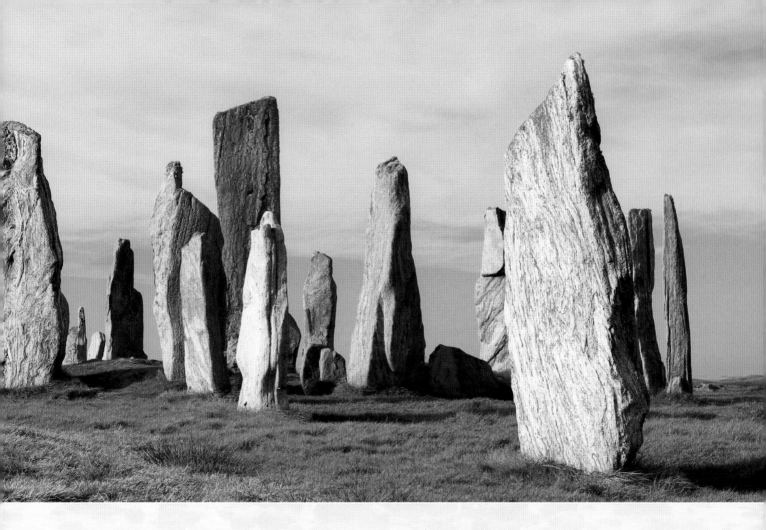

Emigration still saps the Western Isles, with bright and ambitious youngsters leaving – as they have been doing over the past few centuries – to enjoy the bright lights, higher education and better job prospects of the mainland. Strict religious observance is on the wane; and so, regrettably, is the Gaelic language, of which the Western Isles have always been a stronghold. Just over 60 per cent of all islanders are now Gaelic-speakers, a drop of 10 per cent since the 1991 census. Perspectives are inexorably broadening. Far greater numbers have television and take foreign holidays. That greatest of all horizon-expanders, the Internet, has become well entrenched since the turn of the twenty-first century – and in January 2006, a £5 million scheme was announced to bring Broadband to the islands. Another bold new initiative has been the completion of a chain of causeways and bridges between the main islands, something that should help to hold back the scourge of population decline.

Neither Broadband nor television, ceilidhs nor community meetings raise the faintest of echoes in the little clachans or villages by the white sand beaches of Sandray, Pabbay, Mingulay and Berneray. These lonely islands south of Barra, spaced out at the southerly end of the Outer Hebridean chain, were long ago emptied of their inhabitants, either through emigration or clearance by the landowners. Colonel Gordon of Cluny may not have been the worst, but he is certainly the most notorious for his mid-nineteenth-century attempt to clear the islands from Barra to South Uist and sell them to the British government for use as a penal colony. The twentieth century brought better times for Barra, after the 45th chief of Clan MacNeil, American architect Robert Lister, bought Kisimul Castle in its fairytale island location in the bay of Castlebay, along with 12,000 acres of his ancestral island. His son Ian, 46th Chief, completed the restoration of the castle, and in 2000 leased it to Historic Scotland for the fittingly characterful annual rent of £1 and a bottle of whisky.

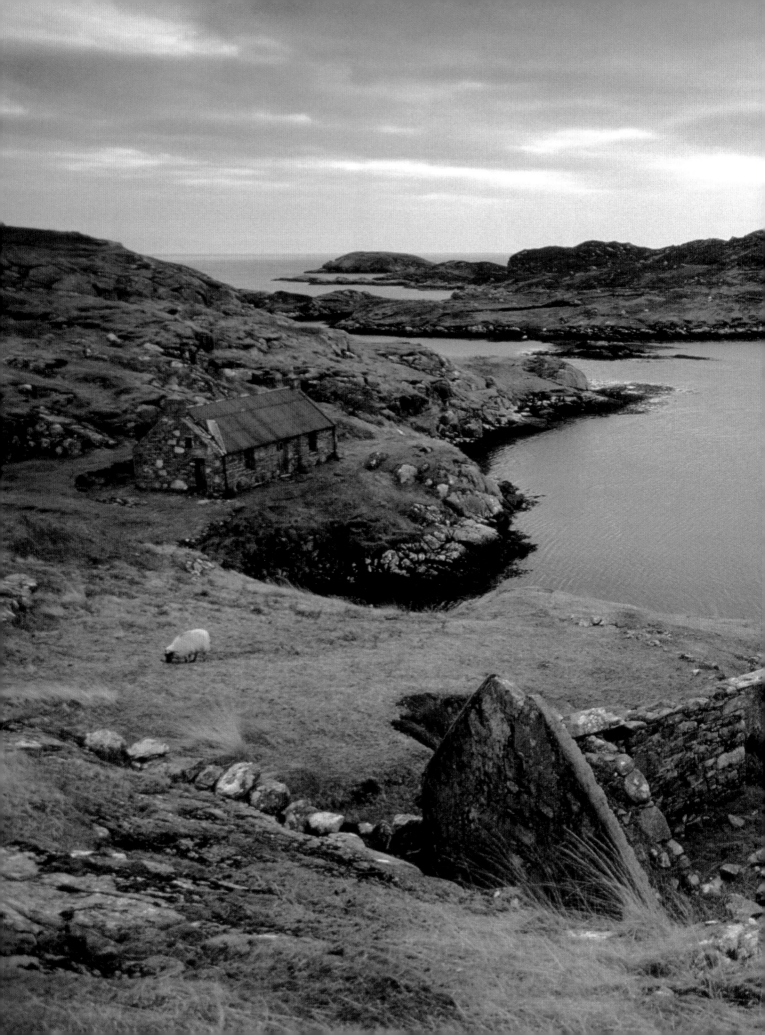

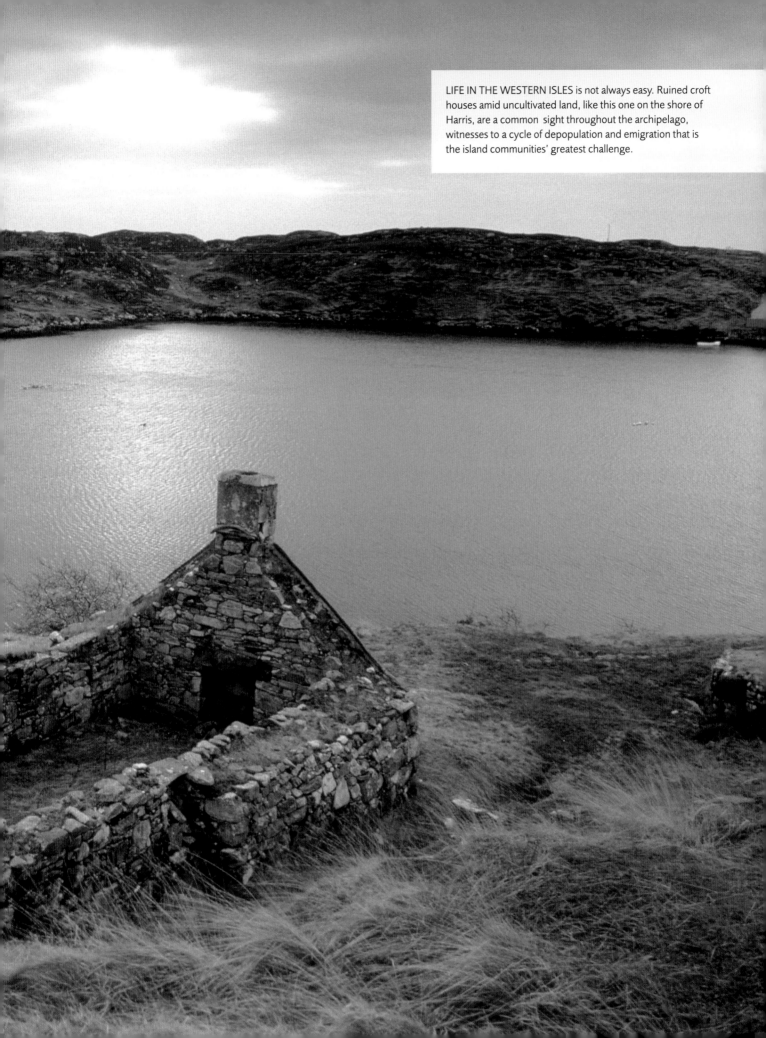

LIFE IN THE WESTERN ISLES is not always easy. Ruined croft houses amid uncultivated land, like this one on the shore of Harris, are a common sight throughout the archipelago, witnesses to a cycle of depopulation and emigration that is the island communities' greatest challenge.

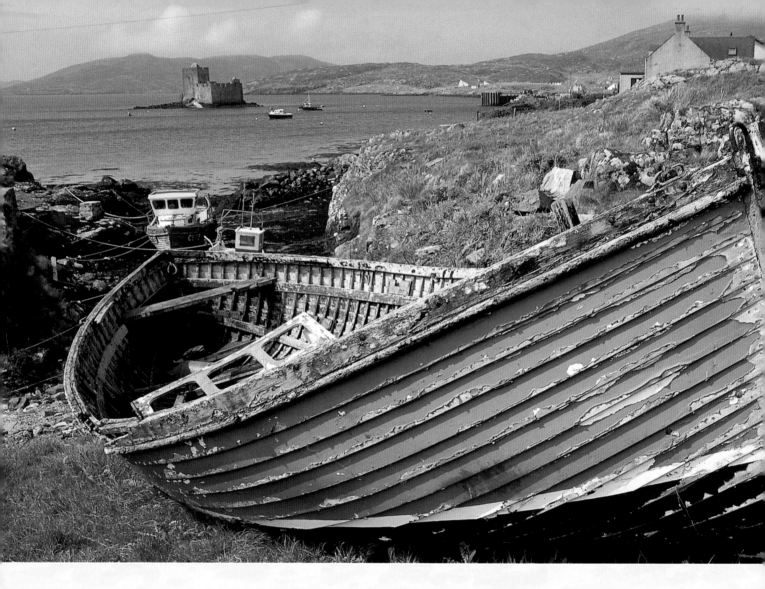

In 2003, the clan chief made arrangements for the whole of Barra to be placed in the ownership of the islanders themselves. So it looks as if Barra, with its population of 1078 (most Gaelic-speaking and many devoutly Catholic), seems set to continue faring well, provided that the islanders and their political representatives can persuade Loganair to maintain the island's perma-threatened air service from Glasgow. The difficulties are genuine enough. Not the least of them is the nature of the landing strip – when arriving in Barra, the antiquated Twin Otter planes put down not on a tarmac or grass airstrip, but directly on the firm sands of Traigh Mhór, the 'Great Strand'. To rush along the white shell-sand beach, spray flying up from the wheels, hoping not to hit a sleepy seal, is the greatest thrill of flying in the Western Isles.

Celebrated writer Sir Compton Mackenzie built a house on Barra in 1935, and here he wrote the evergreen romp *Whisky Galore*. Mackenzie embroidered the true tale of the 1941 wreck of the freighter SS *Politician* on the neighbouring island of Eriskay, with a cargo of 250,000 bottles of prime Scotch whisky, untaxed and on their way to America to be exchanged for war materials. All sorts of skulduggery and tomfoolery ensued during the 'salvage' of the cargo by the islanders, the year-long ceilidh which followed, and the game of hide-and-seek that developed as the excise men tried to catch the liberators of the whisky red-handed with their booty. However, it wasn't all about the whisky; the freighter had also been carrying an estimated £1 million sterling or more in Jamaican banknotes –

KISIMUL CASTLE, seat of Clan MacNeil in the Isle of Barra for some 600 years, stands sentinel on its rock in Castlebay, surrounded by the low, granite-scabbed hills that form the spine of this harshly beautiful island.

some say as a contingency fund to bankroll the Royal Family in temporary exile if the Germans had occupied Britain. Many of these, too, were 'rescued', though the islanders found them harder to dispose of than the whisky.

North of Eriskay are the twin islands of South and North Uist, with the flat, waterlogged pancake of Benbecula lying like a stepping stone between them. The topography of both Uists sweeps up majestically, like a breaking wave, from flattish western shores to mountainous east coasts. These western beaches are magnificent, especially on the elongated South Uist, where wonderful white sands and swards of machair run the entire 20-mile length of the island. Machair is breathtaking – a thick, grassy lawn built up on lime-rich

shell sand that nourishes a spectacular flora of orchids, bird's-foot trefoil, scabious and blue vetches. North Uist's traditionally managed hay meadows shelter a small but growing population of the very rare and elusive corncrake, whose Linnaean name of *Crex crex* neatly voices its grating call. Piggy-in-the-middle Benbecula is quite unlike its neighbours – a tissue of peat and water, its thousand lochans wink like saucy eyes as you fly over them on a sunny day.

In spite of each boasting the prefix 'Isle of...', Harris and Lewis – the most northerly of the Western Isles – are not two separate geographical entities. They are in fact part of the same land mass, joined by a range of fine upstanding mountains that swell to the north before tumbling down to an immense plateau of peat and lochans stretching

LEAVING TYRE TRACKS THAT WILL BE erased by the next incoming tide, one of Loganair's Twin Otter planes takes off from the white shell-sand beach of Traigh Mhór, the 'Great Strand' – otherwise known as Barra Airport. Flights go to and from Glasgow and are a lifeline for the residents of Barra.

30 miles to the Butt of Lewis. Lord Leverhulme of Sunlight Soap fame and fortune bought most of Harris and Lewis after the First World War, intending to provide work and a decent living for the islanders. Whaling stations, kelp factories, roads, fishing fleets to supply his UK-wide chain of Macfisheries fish shops – Leverhulme tried everything to get the economy of Harris and Lewis permanently on its feet. But the harshness of the island conditions, the roughness of the seas and weather, and the intransigence of a hard core of islanders defeated him.

Harris is much loved by visitors for its jumbled upthrust of naked gneiss mountains, which give it the flavour of very wild country. Tiny roads snake for miles before expiring at some lonely croft or forgotten fishing pier. A handful of Harris islanders still make the dye for Harris tweed in the traditional way, by collecting wild plants, lichens, ore-stained soils, seaweeds and barks, and pounding or treading them in a tub. Lewis, by contrast, is the biggest, bleakest and toughest of all the Western Isles, a place that seems impossible to coerce into prosperity. The Free Presbyterian Church is still very influential here, so much so that Sunday transport links with the mainland were bitterly opposed by upholders of the island's traditions for years, and commenced only in 2006. A giant wind farm is planned for the northern bog lands – 190 turbines or

more, each over 450 feet tall, plus attendant roads, pylons and cables, generating 702 megawatts – enough to serve almost half a million homes. Maybe that will bring prosperity to the region, or perhaps the speculators will strike oil off the north-west coast during the current explorations and a Shetland-style boom time will ensue.

Far out to the west, beyond the Western Isles, lie two islands of magic and mystery. The tragic tale of St Kilda, an archipelago of four islands and some stacks that lies 50 miles west of North Uist, is well known – the island at the end of the world, craggy and steep beyond belief,

THE BALRANALD RESERVE in western North Uist boasts great swathes of machair – the lime-rich, shell-sand sward, so characteristic of the Western Isles, that underlies colourful carpets of clovers, vetches, orchids and numerous other flower species.

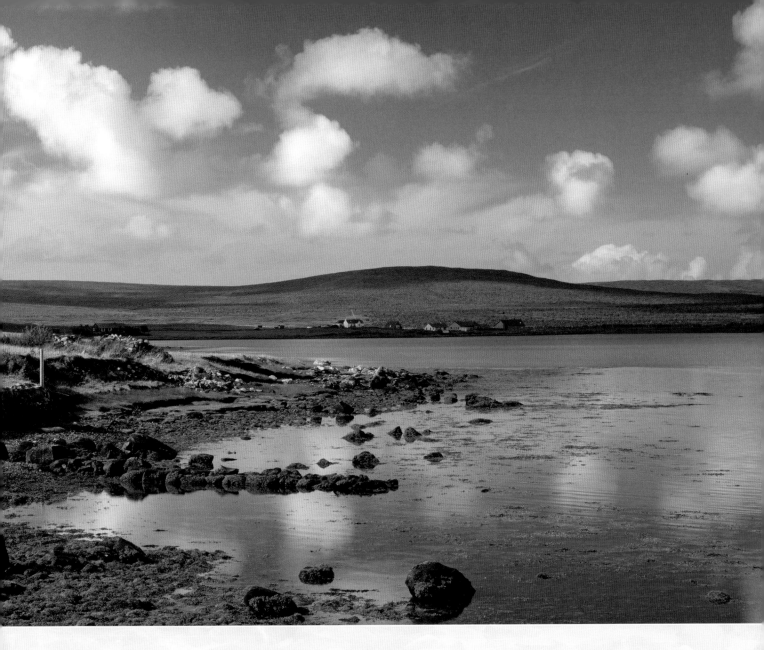

ROMANTIC DREAM?
Some incomers base their move to Outer Hebridean islands such as North Uist on fantasies of living the easy life in a pretty thatched cottage away from other people. In fact, to cope with the isolation, lack of amenities and fierce winters, both natives and 'blow-ins' have to be hard-working, self-reliant and community-minded.

whose hardy native islanders used to climb their perilous cliffs to catch gannets, fulmars and puffins for food. They hung on in their Atlantic outpost until they were forced to evacuate to the mainland when the subsidy for their post office and resident nurse were withdrawn in 1930. Today, the empty island, rearing dramatically from the sea, supports half a million breeding seabirds, including 60,000 pairs of gannets – the largest gannetry in the world.

More mysterious is the story of the gull-haunted Flannan Isle, a lonely hump of grassy rock that rises out of the sea some 15 miles west of the Isle of Lewis, with only

seabirds for residents. This was the scene of a famous and still-unsolved mystery. What could have happened to Thomas Marshall, James Ducat and Donald MacArthur on 15 December 1900? These three fit and able lighthouse-keepers, sole inhabitants of the tiny island, simply disappeared, leaving their lunch half-eaten on the table. The best guess is that they were swept away by a sudden, tsunami-like swell that overwhelmed Flannan Isle. No one knows – and the steep green island in the restless Atlantic tells no tales.

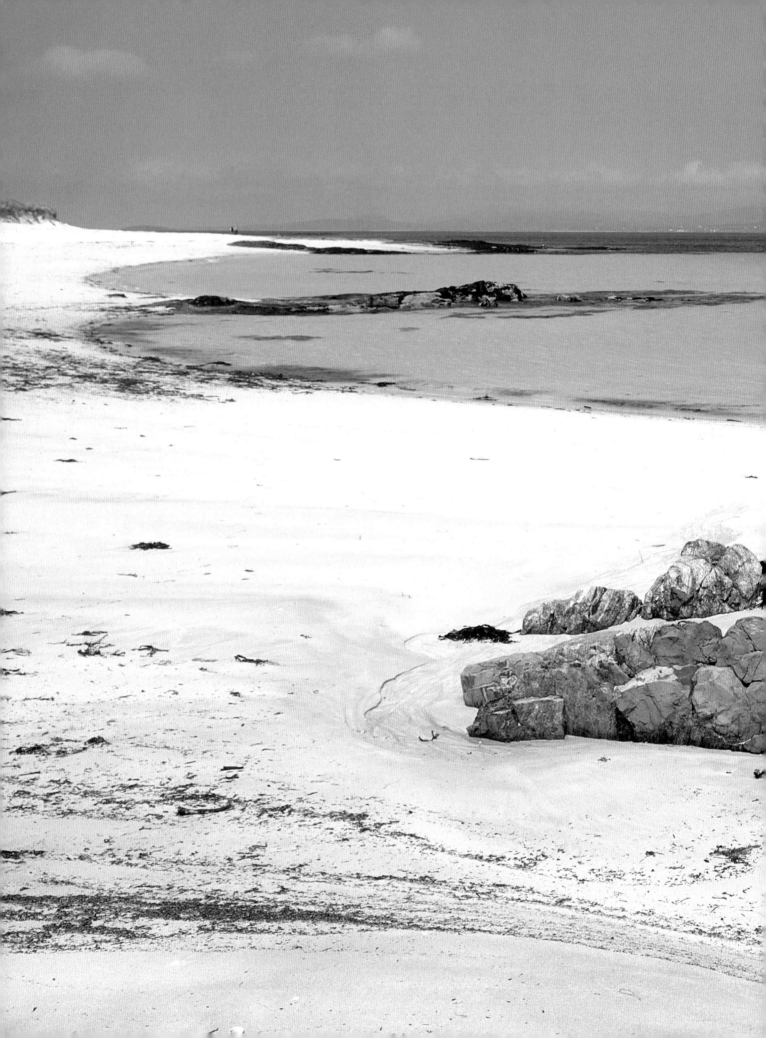

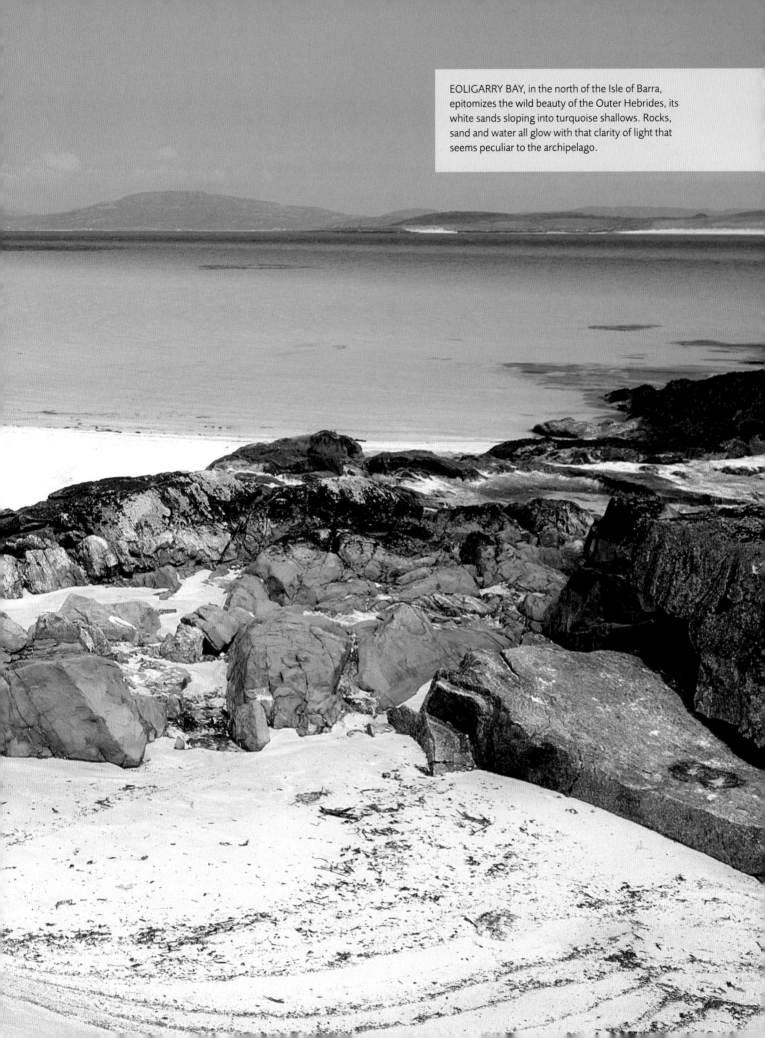

EOLIGARRY BAY, in the north of the Isle of Barra, epitomizes the wild beauty of the Outer Hebrides, its white sands sloping into turquoise shallows. Rocks, sand and water all glow with that clarity of light that seems peculiar to the archipelago.

Wild Isles of the Far North

ORKNEY AND SHETLAND

Orkney and Shetland share a strong Norse heritage. In Lerwick, Shetland's capital town, you are as close to Bergen in Norway – 200 miles away – as you are to Aberdeen. The Northern Isles did not even become Scottish territory until the fifteenth century and, technically, they are still on loan from the Scandinavian monarchy (see box, page 138). They offer the best sea-watching and birdwatching in Britain, an astonishing beauty that gets starker the further north you go, and a compelling fondness for welcoming strangers and for unbridled nights of wild music and dancing. Orcadians and Shetlanders know how to soften the harshness of life up here in the wind-whipped seas off the north-east corner of Britain. Although Orkney and Shetland are neighbouring archipelagos, they are far from identical. The differences between their traditions and music, their landscape and their wildlife, are part of their charm.

IF YOU ARE a particularly intrepid type with a steely head for heights and no qualms about being attacked by aggressively territorial seabirds, the ascent of the 450-foot Old Man of Hoy, King of the Orkney sea stacks, is one of the greatest challenges in the rock-climbing world.

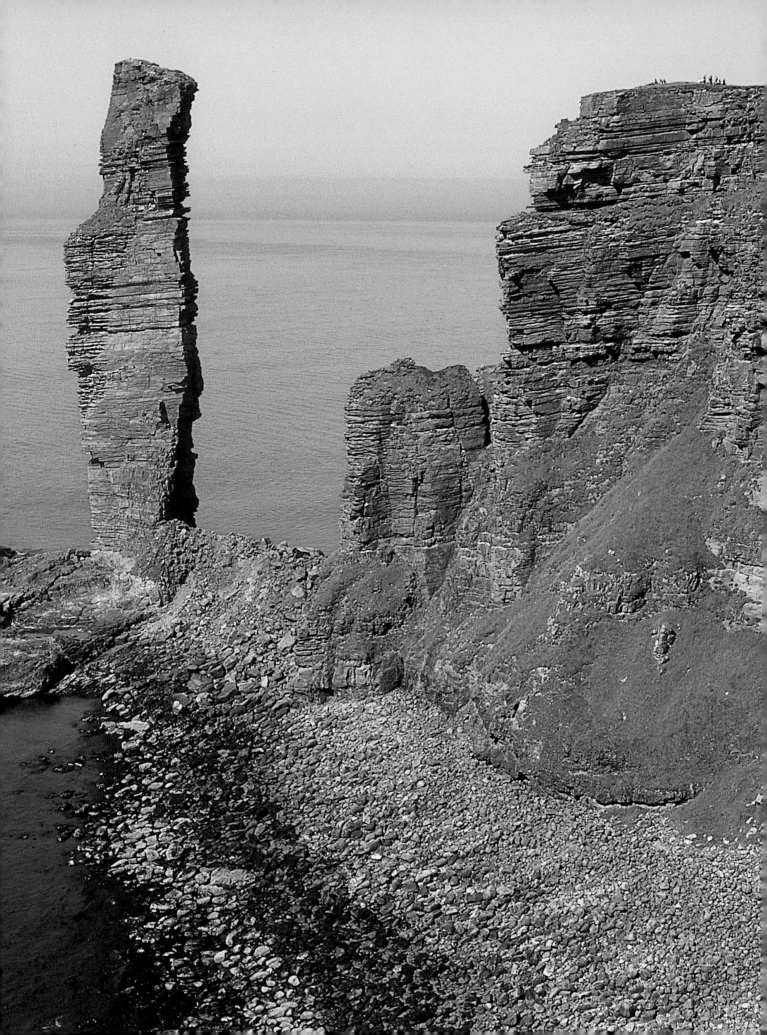

The islands were devastated by a series of giant waves some 7500 years ago, after a vast section of the continental shelf broke off under the ocean near the Norwegian coast. But even without the propulsive thrust of a giant submarine landslide, waves and wind bite harder here than anywhere else in Britain. It is no coincidence that the strongest gust of wind ever recorded in the UK – 177 miles per hour before the equipment blew to pieces – was in Shetland's Isle of Unst at Saxa Vord, the most northerly point of the British Isles. Shipwrecks are legion. The captain of the oil tanker *Braer*, which sank in Quendale Bay on 5 January 1993, spilling 84,700 tonnes of oil around Shetland's shores, reported, 'There were green seas on the main deck every ten seconds or so,' a phrase that evokes the full fury of the weather. And it is not just seafarers who have to bend to the will of the elements: farmers battling salt spray and seed-scattering winds, householders watching their slates go skimming, drivers on cliff-edge roads in sideways sleet and gales must learn to be self-reliant, hardy and full of 'bouncebackability' – characteristics embedded in the people of these wild island coasts.

The 70-odd islands of Orkney – 17 of which are inhabited – are greenly fertile and founded on warm sandstone. Prehistoric Orcadians found this bedrock easy to cut and shape, and gave the islands an unrivalled collection of Stone and Bronze Age monuments. Standing stones, stone circles and huddled villages of primitive houses lie scattered across the archipelago. Experts come from all over the world to immerse themselves in this pool of archaeological riches.

Orcadians, like their Shetland cousins, were always sea wanderers, of sheer necessity. They earned a reputation as men you could rely on, but wouldn't want to mess with. In the eighteenth century, the hugely influential Hudson's Bay Company – controller of the fur trade throughout British North America – picked Orcadians almost exclusively to man its stores and settlements in Canada. The Company's opinion was that they were cheaper than the English and less fond of the bottle than the Irish. Orcadians went whaling, too, as did Shetlanders who joined ships on their way up to the hunting grounds of the Davis Straits and Greenland. Those who returned to the Northern Isles had survived and learned from extraordinary experiences in outlandish places. They were kin in spirit, and in some cases in blood, to the tough Norwegians of the Second World War who operated the 'Shetland Bus', sailing in converted fishing boats from Scalloway across some of the roughest seas in the world to bring arms, equipment and trained radio operators to the Resistance in Occupied Norway.

SHATTERED on the rocks of Quendale Bay, where she was driven by storm waves in January 1993, the oil tanker *Braer* spews crude oil into Shetland waters.

FULMARS, kittiwakes, guillemots and gulls cut their eternal aerial circles around the jagged cliffs of Hermaness at the brow of the Isle of Unst, northernmost point of the Shetland archipelago and apex of the British Isles.

THE PROMONTORY of Hermaness is now a National Nature Reserve because of the hundreds of thousands of seabirds – such as the puffin or 'tammy norie' as Shetlanders call it – that congregate here to fish the inshore waters, nest on the cliffs and breed.

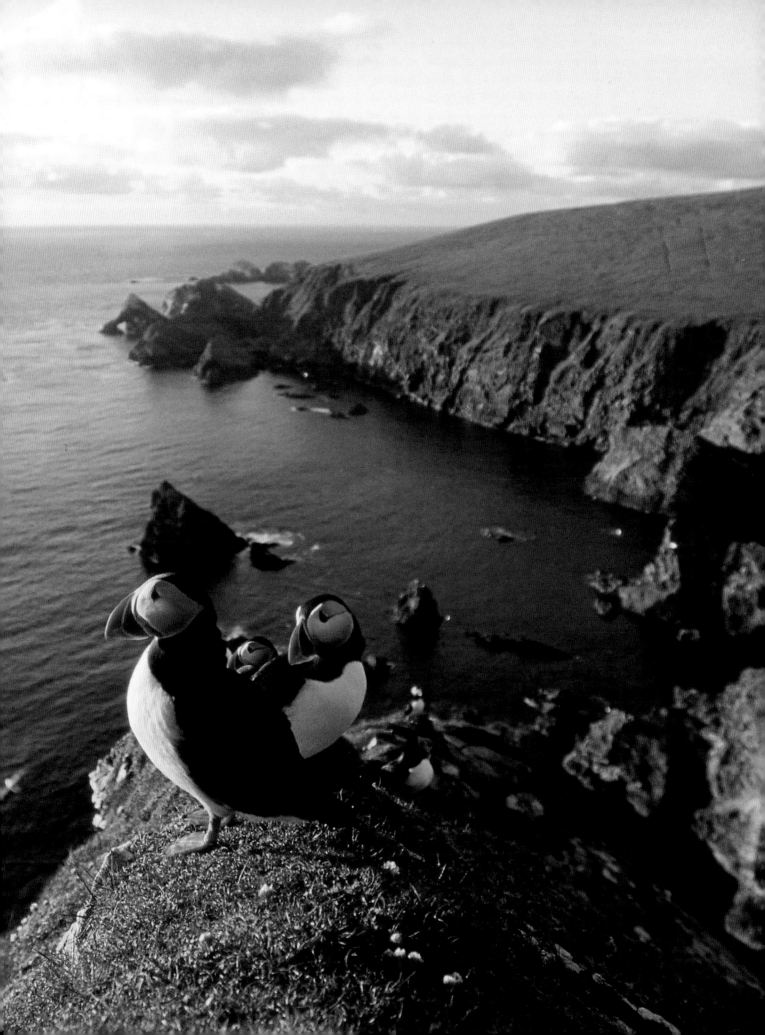

The Orkney Isles are centred around the biggest island, ragged with inlets and peninsulas, known logically enough as Mainland. In the very centre of the island rises the burial mound of Maes Howe, a solemn chamber of meticulously fitted stone slabs raised nearly 3000 years before the birth of Christ. The entrance aligns exactly with the position of the sun at winter solstice, as though to capture the dying source of light within the belly of the monument would fire the earth's long gestation into springtime revival. Entry into the heart of the tomb is by squirming along a narrow, waist-high stone passageway. Tolkien-like runes scratched in the walls by Viking marauders boast of how they robbed the tomb of its treasures. Crouching in the low light of a torch, a stranger feels to the full the crushing power and weight of cold piled stone.

It is a sensation one comes to recognize time and again in Orkney, delving into these 5000-year-old tombs that lie so silently in the fields and on the shores of the islands.

INSIDE THE 'SHIP OF DEATH': it is a special and rather eerie experience to walk the central passage of the great chambered tomb on the Orkney island of Rousay, peering into one after another of the compartments where Orcadians of the late Stone Age lodged their burials.

CUT FROM the thin-layered Orkney sandstone and shaped into upstanding blades some 4500 years ago, the stones of the Ring of Brodgar form a mighty circle in a beautiful moorland setting on Mainland Island.

A ferry-ride away, on the island of Rousay, the stone cylinder of an old broch or defensive stronghold stands next to the 'Ship of Death', a mighty chambered tomb 100 feet long, where human remains were discovered lying in 24 neat compartments, back to back. Broch and tomb make a memorable ensemble, starkly outlined on the rocky shore. Out on the west coast of Mainland Island lies the excavated Bronze Age Settlement at Skara Brae. Walking the dunes in which the houses are buried, you can picture the narrowness and intimacy of life in these cramped stone apartments before sandstorms wiped them out some 4000 years ago. And then there were those who laboured to shape huge blades of sandstone and position them in the great stone circles of Stenness and the Ring of Brodgar, near the mound of Maes Howe, around 4500 years ago.

In contrast to Orkney's gentle green pastorality, much of Shetland is a wind-scoured landscape of heathery peat moor – sombre, brown and endlessly rolling to cliffs and rocky shores. This outflung archipelago, the northernmost land in Britain, stretches 70 miles from the toe to the tip of its main islands – Mainland, Yell and Unst. The North Sea and the Atlantic have bitten so deeply into the islands from the east and west that nowhere is more than 3 miles from the sea.

Conversation comes as naturally as breathing in the Shetlands, where the weather, harsh

conditions and isolation give everyone common ground. The more senior the company, the more likelihood that you'll hear 'Shetlandic' spoken – that mixture of Norse, Gaelic and home-grown dialect that calls a gate a 'grind', a little shed a 'peerie böd', a thorough spring-clean a 'voar redd-up', and a good-going fiddle tune a 'clinkin spring'.

In Lerwick, the little stone-built capital of Shetland, players of all ages, stages and temperaments are plunged together into almighty sessions of music in the Da Noost pub or the upstairs bar of The Lounge. Shetland has a wonderfully rich tradition of home-grown music, passed on from generation to generation. This is the place to come if you love whirling reels and bitter-sweet slow airs played on the fiddle, Shetland's national instrument, which drives music in these parts. Shetland reels and airs get deep into your DNA after a time in the islands, and it is just as good – often better – to hear them in someone's back kitchen as in a public bar or on the stage of a community hall. Yet the distinction between bar and back kitchen can get blurred. The Lounge band might consist of, say, a 17-year-old girl playing blindingly effective fiddle, a septuagenarian retired school-teacher in baggy flannels pounding the pub piano, and a motley crew of banjo-pluckers and accordion-squeezers. You might even muster up the courage to join in and help raise the roof.

TOP SPOTS ■ ORKNEY AND SHETLAND
Fair Isle p.220 · Hermaness Nature Reserve p.220
Isle of Fetlar p.220 · Isle of Foula p.220 · Isle of Sanday p.220

SCOTLAND OR SCANDINAVIA?

Most people think that the Northern Isles belong to Scotland, but in point of fact they don't. The isles were Scandinavian sovereign territory when, in 1468, a marriage was contracted between Margaret, daughter of King Christian I of Norway and Denmark, and the Scottish King James III. Christian was too poor to raise more than 2000 florins of the agreed marriage dowry of 60,000 florins, so he pledged his estates in Orkney and Shetland to the Scottish crown in lieu of the remaining 58,000 florins. The theory was that Norway should retain sovereignty and take back control of the islands once the money had been paid. In fact, the pledge never was redeemed, and the Scottish crown ruled the Northern Isles from then on. For the next 300 years, Denmark made periodic attempts to regain the islands, but to no avail.

Shetlanders are Norsemen rather than Scots – and anyone who doubts it should be in Lerwick on the last Tuesday in January, when the Shetlanders throw themselves neck, crop and gizzard into the wild celebration of Up Helly Aa. This is Shetland's defiant shout in the face of winter, a day and night of insanity, during which bearded Vikings cry misrule through the streets, flaring torches send a full-size longship to a flaming Valhalla by night, and the dancing and drinking would wear out an army of trolls.

Shetland has some ancient monuments to rival Orkney's best, notably the stunning

Jarlshof site near Sumburgh airport, with its jam-packed archaeological layer-cake of Bronze Age hovels, round wheelhouses of the Iron Age, Norse longhouses, and later farm buildings and big manor houses. But if you are intent on tasting wild, wind-scoured scenery, on seeing enough seals and seabirds to last you until you can venture this near the Arctic Circle again, then you must forge north up the island chain to Unst, the most northerly of all Britain's isles. The road heading north through Unst winds through settlements with uncompromisingly Norse names – Uyeasound, Baltasound and Haroldswick. From Haroldswick, the road continues for another 3 miles to reach the point beyond Stackhoull where you leave the

LERWICK, capital of the Shetland archipelago, is a town as much Scandinavian as Scottish in atmosphere. This Norse character comes bubbling up during the midwinter festival of Up Helly Aa, when a specially built longship is torched by night, accompanied by wild singing.

car. From here, you walk the last couple of miles over the back of Hermaness Nature Reserve to stand on the outermost brow of Britain. Here, multitudes of seagulls, kittiwakes, razorbills, fulmars and great skuas send their unbelievable din rocketing around the cliffs. Out in the sea, a row of canted rock stacks lies stained by storm-driven waves: Vesta Skerry, Rumblings, Tipta Skerry, Muckle Flugga, with its dramatically perched lighthouse, and finally little round Out Stack, the northerly full stop that closes off Britain. Gales here, blasting straight down from the Arctic, are cold and fierce enough to wither even a Viking. It's a kind of wind-blown northern heaven, with half a million raucous seabirds for company and a stupendous view that opens northwards over an indigo sea.

The Orkneys and Shetlands have layers of history preserved in their island landscape, with archaeological sites in virtually every field. Neolithic villages and tombs such as Skara Brae and Maes Howe or Viking settlements like Jarlshof must surely rank as some of Europe's finest ancient monuments.

MARK HORTON, PRESENTER

MUCKLE FLUGGA LIGHTHOUSE perches at the summit of its naked rock stack, one of a chain of wave-beaten islets off the outer tip of the Shetland island of Unst that closes the northernmost point of Britain like a row of full stops out in the sea.

Lifeline to the Capital

THE FIRTH OF FORTH

Three giant cats' cradles of steel stand in line, high over a calm sea inlet
at night. The red glare of a locomotive's firebox and the yellow squares
of the lamplit carriage windows are reflected among the arches and girders.
A plume of smoke snakes away into the cobalt sky. The ultimate symbol
of railway romance – a night journey towards unknown land and a new
dawn – is caught to perfection in a poster designed by Henry George
Gawthorn in 1928 for the London & North-Eastern Railway. The wide
tideway is the Firth of Forth, just upstream of Scotland's capital city of
Edinburgh, and the great spidery span that marches so majestically across
it is Britain's most famous railway landmark, the Forth Railway Bridge.

It is a curious icon, this behemoth of a bridge. By the time it was opened in the spring of 1890 it had consumed 54,000 tons of steel, six and a half million rivets and the lives of 63 men, and it cost the equivalent of £250 million in today's money to build. It is the ultimate emblem of Victorian hard-headedness, ruthlessness and practicality. Yet it symbolizes airy ideals as well – dreams of open space and freedom, leaving the humdrum world behind, hurdling obstacles and striking out for something new and wonderful. It is a highway from the known to the unknown, from the world of commerce and common-sense to the world of the free spirit. In this its graceful, soaring form represents the seaward journey of the estuary in whose bedrock it stands so firmly rooted.

MAKING CONNECTIONS: the Forth Railway Bridge (foreground) with its huge dinosaur-like cantilevers, slender yet immensely strong, was one of the wonders of the age when it was opened on 4 March 1890 by the future King Edward VII. Over 70 years later, on 4 September 1964, Edward's great-granddaughter Queen Elizabeth II opened the Forth Road Bridge just upriver.

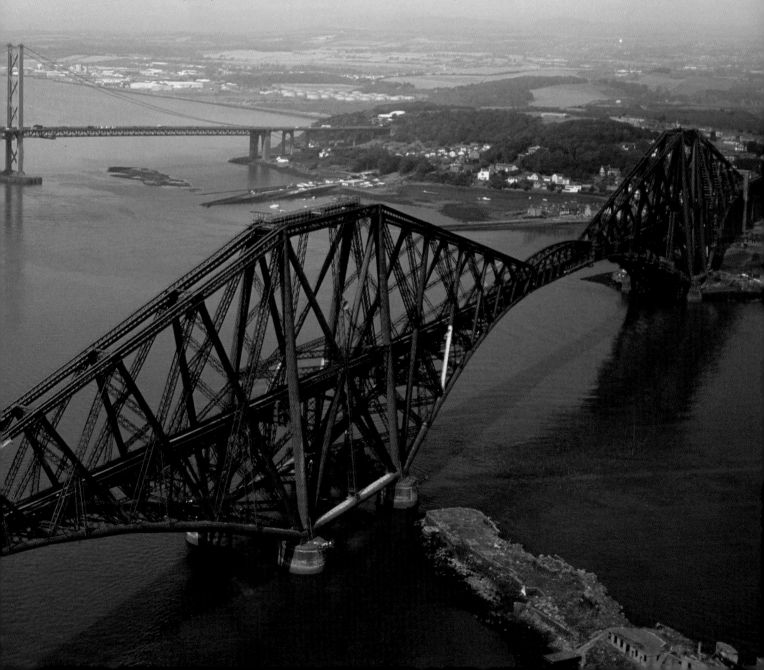

A FORMIDABLE stronghold built in the 1440s to command the south bank of the Firth of Forth downriver of Bo'ness, the castle of Blackness suffered many a battering. Prisoners incarcerated in Blackness down the centuries have included political detainees, Napoleonic prisoners-of-war and Covenanters (see pages 114 and 215).

The shores of the Firth of Forth extend far west of the Forth Railway Bridge. The estuary reaches nearly 15 miles inland from the bridge as a ragged sea loch more than 2 miles wide, until it finally narrows towards the mouth of the River Forth at Kincardine Bridge. It is here, where the Kingdom of Fife melds into Clackmannanshire and West Lothian meets Falkirk, that the journey begins – in estuarine mud and slag-heap muck, in coal, iron, lead, salt, oil and gas. Seaside and scenery be damned. If it had not been for the armaments and heavy machines produced at the Carron Ironworks by the River Carron, the salt that was dredged from pans in Torry Bay, and the coal hewn from seams under the firth at Longannet, Edinburgh and its port of Leith 20 miles downriver would never have enjoyed the prosperity they did in Georgian and Victorian times. The same goes today for the Grangemouth petrochemical plant, at the inmost point of the estuary, which processes 200,000 barrels of North Sea crude oil a day and fills the night sky with a giant's geometry backlit by the flares of hell. As for the

dockyard at Rosyth, almost under the Forth Bridge, it mended and refitted the ships of the Royal Navy throughout the major international conflicts of the twentieth century – the conventional warships that fought the two world wars against Germany and her allies, and the nuclear submarines used in the Cold War against Russia and the Iron Curtain satellite countries.

Not that the whole firth west of the bridge is one long succession of industrial plants. There's a triste charm to exploring such faded ports as Charlestown and Limekilns, with their capacious harbour basins and numerous piers that hint at former prosperity from the export of coal and lime. Ranks of lime-burning kilns, now cold and clean, confirm their decline into picturesque retirement. But you can also seek out fine houses and lowering old castles, tumbledown or in good fettle, among woods and lonely marshes – ruined Orchardhead, which looks across the mud flats to the pipes and flares of Grangemouth; the grim fifteenth-century fortress of Blackness Castle on its promontory; Dunimarle Castle, where Macduff's wife and children were murdered on the orders of Macbeth; the Baroque symmetry of the Hope family's vast eighteenth-century pile, Hopetoun House.

The span of the Forth Railway Bridge, at 8296 feet, is closely shadowed by another just alongside – the slightly shorter and infinitely plainer-looking Forth Road Bridge, opened in 1964. As soon as you pass east of these two crossings, the estuary widens, from just over a mile at the bridges to 5 miles at Edinburgh's port of Leith. Then there is a sudden and dramatic tripling in breadth, with the far shore shrinking to a skyline smudge; Lower Largo, on the northern or Fife shore of the firth, is the best part of 20 miles from Musselburgh near Edinburgh. Finally, a brief narrowing of the estuary heralds the open sea, some 50 miles east of Kincardine Bridge.

Edinburgh would always have suffered economically from its situation inland of the sea, had not the port of Leith been so conveniently on its doorstep. Leith has always been Edinburgh's lifeline, and the city

DWARFED BY THE GIANT Forth Railway Bridge, a 'Clyde Puffer' steam ferry waits at South Queensferry while passengers embark for the short but sometimes sickening crossing of the Firth of Forth. When the private car came on the scene in the early twentieth century, the puffers began carrying motor vehicles across the estuary, a service that saw them become busier than ever. It was the opening of the Forth Road Bridge in 1964 that finally put paid to the much-loved ferries.

FANCY A NICE sea trout caught just here? A fishing boat idles on a calm day in the upper Firth of Forth, opposite the 'giant's geometry' of Grangemouth oil refineries and chemical plants with their smoking and steaming chimneys, vents and flares.

has prospered by the connection. Goods, people, news and ideas have all moved in and out of the capital through its firth-side gateway for centuries. Some fine merchants' houses and a huge area of docks remain in Leith from the maritime heyday of the port.

Leith was a separate burgh until it was merged with the capital in 1920, in a move opposed by most of Leith's inhabitants. During the latter half of the twentieth century, Leith slid into a decline, gaining the ominous reputation for violence and crime so graphically detailed by Irving Welsh in his gritty novel *Trainspotting*. But a bold and hugely expensive drive to regenerate the waterfront has paid off handsomely. By the turn of the millennium, Leith was the trendiest part of town, the place above all others for young, upwardly mobile people to live, work and have a good time. Begbie and Sick Boy from *Trainspotting* wouldn't know where to put themselves in this resurgent Leith of the twenty-first century.

With the port of Leith on the south side of the estuary, the naval dockyard of Rosyth on the north, the vital transport link of the Forth Railway Bridge right in the

middle and the oil refineries of Grangemouth just upriver, the Firth of Forth was a prime target when it came to air and sea attack during the twentieth-century's two world wars. For this reason, full use was made of the estuary's cluster of tiny, rocky islands, right in the path of any aircraft, warship or submarine bold enough to navigate itself up the firth. Inchgarvie lies at the very foot of the central cantilever of the Forth Railway Bridge, Inchcolm and Inchmickery a few miles downriver, and the slightly larger Inchkeith in the middle of the fairway 12 miles east of the bridge. These scraps of rock – known locally as the Four Inches – were heavily fortified in wartime with gun, searchlight and communications emplacements as well as listening posts and garrison quarters, in some cases utilizing ancient fortifications from the battles of long ago.

After the war, no one came out to clear the military detritus away. The Four Inches remain much as they were in 1945, overburdened with concrete slabs and squares. Some see them as uglified monuments to war. Yet today they are the most peaceful places in the Firth of Forth. You can buzz out from Leith Docks in one of

PEACEFUL SPOT: the low sun at dusk lays a track of gold across the ripples in Largo Bay, a sheltered scoop located in the north bank of the Firth of Forth, at a point downriver of Edinburgh where the sea-going estuary is some 20 miles wide.

Seafari Adventure's inflatables, or join a more stately cruise aboard the *Maid of Forth* from South Queensferry, and have only seabirds and thick-necked seals for company.

Inchgarvie, beneath the bridge, has been a prison and a quarantine station in its time. These days herring gull chicks in fluffy grey overcoats shuffle furtively through the grasses, while their parents scream and yowl at the neighbouring fulmars. On

Inchmickery, the vegetation is deliberately kept short for the benefit of the island's breeding pairs of sandwich terns and the very rare roseate terns. On the rocks of nearby Oxcars lighthouse, where a pioneering hydrophone station was set up in 1915 to listen for submarines, common seals haul out. The more isolated Inchkeith was used as a quarantine station for Edinburgh's medieval plague victims; it also saw service as a fort (Mary Queen of Scots came out to inspect it in 1564), a gaol, a POW camp during the Napoleonic wars, and an animal sanctuary in the 1980s. Nowadays, the ledges of the mile-long island are nesting sites for guillemots and razorbills, while puffins stand like portly house-husbands at the doors of their burrows among white drifts of sea campion.

I've always been mesmerized by the enormous scale and engineering elegance of the Forth bridges, each a tribute to their own age. They're the beautiful bond between one of the UK's most spectacular cities, Edinburgh, and our greatest mountain wilderness.

NICHOLAS CRANE, PRESENTER

Inchcolm is the odd man out, for here it is not wartime ruins that dominate the slim-waisted island, but the great bulk of Inchcolm Abbey. The church was founded on the island in 1123, on the orders of King Alexander I of Scotland (1107–24), as a thanksgiving for deliverance from danger – he had been caught in a vicious storm out on the Firth of Forth, and had been obliged to shelter on Inchcolm for three days with the resident hermit. This is one of Scotland's most striking monastic buildings, the church complete with vaulted side buildings and a tower from which there is a really fine view across the gull-haunted island. Inchcolm has been a holy site for many centuries. The invading Vikings, recognizing this sacred quality, paid good gold for the privilege of having their dead buried here, after being defeated by Macbeth and his fellow warrior

ISLAND IN DISGUISE

Inchmickery island, in the Firth of Forth, looks exactly like a battleship moored in the river, its observation towers and blockhouses resembling a warship's upper works, superstructure and gun turrets. These were added during the Second World War as a deliberate act of deception to scare off aeroplanes or any would-be attacker looking through a submarine periscope.

Banquo at the Battle of Kinghorn, as the Earl of Ross recounts in Act I, Scene II of Shakespeare's *Macbeth*:

Sweno, the Norways' king, craves composition;
Nor would we deign him burial of his men
Till he disbursed, at Saint Colme's-inch,
Ten thousand dollars to our general use.

The south coast of the Firth of Forth curves round east of Musselburgh in a great knobbed nose of land that balances a scatter of islets at its tip – Eyebroughy, Fidra, Lamb and Craigleith, seabird sanctuaries all. By far the most striking, though, is the vast blunt volcanic plug known as the Bass Rock, seen from far off as a crinkled dome rising from the sea, whitened with the guano and the feathered bodies of its 80,000 resident gannets. No other single rock in the world plays host to such a colony. To land from a North Berwick boat and climb the zigzag path to a perch among the packed ranks of gannets is an extraordinary experience – the stink, the noise and the sheer proximity of so many of the blue-eyed, dagger-beaked birds are overwhelming.

THE ISLE OF MAY, out in the mouth of the Firth of Forth, is not an easy place to land because of the heavy North Sea swell. Summer visitors lucky enough to scramble ashore, however, are sure to be transfixed by the sight of the island's puffins – up to 150,000 strong.

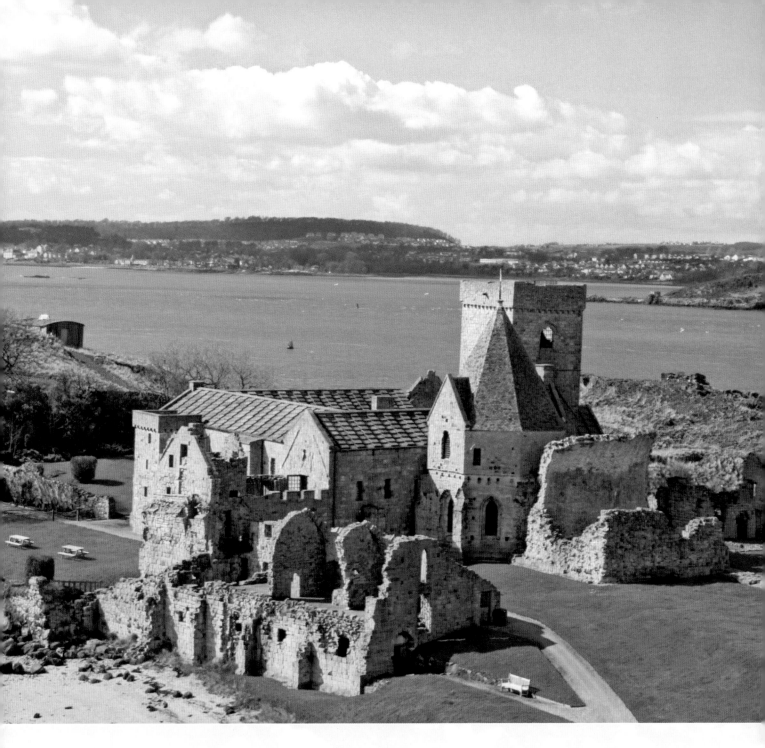

'MAY THIS HOUSE stand until an ant has drunk up the flowing sea and a tortoise has circumambulated the entire world' – the inscription over the doorway of the twelfth-century Inchcolm Abbey in the Firth of Forth.

Perhaps the Bass Rock's only rival for sheer sensation is the Isle of May, which lies in the open mouth of the Firth of Forth some 15 miles from the northern shore. St Adrian was martyred here by the Danes in May AD 875, and since then the island has seen saints, smugglers, farmers and pirates come and go. Today, it is a National Nature Reserve, thanks in part to its wonderful bird life. The one-mile-long island holds almost 150,000 breeding puffins in summer, a mind-boggling number. Wandering the cliff-tops through clumps of sea pinks, where puffins line every rock, ledge and tuffet of grass, listening to the calls of kittiwakes volleying in the caves and crevices of the May, savouring the sun, rain and salty wind of the Firth of Forth, you might believe you'd died and gone to heaven.

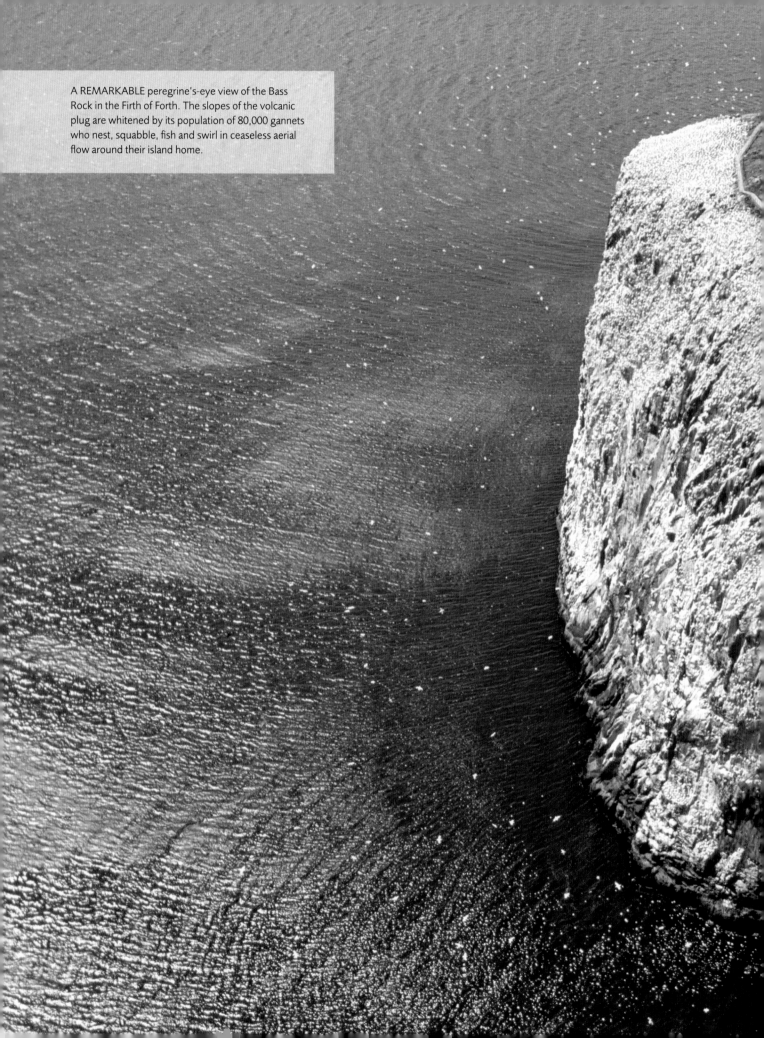

A REMARKABLE peregrine's-eye view of the Bass Rock in the Firth of Forth. The slopes of the volcanic plug are whitened by its population of 80,000 gannets who nest, squabble, fish and swirl in ceaseless aerial flow around their island home.

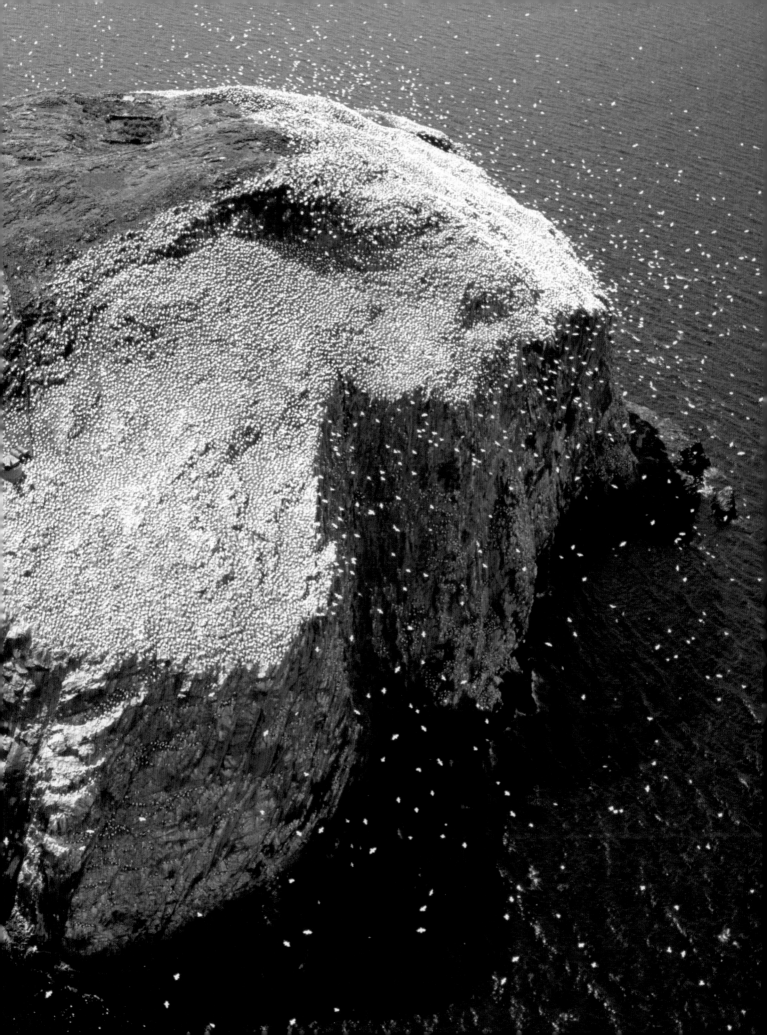

Land of Preachers and Pitmen

THE TYNE TO THE HUMBER

When 'Praying Johnny' Oxtoby came to Filey in 1823, the spiritual health of the little fishing town on the Yorkshire coast was in a very bad way. The fishermen were notorious for being a bunch of hard-swearing, hard-drinking ruffians, the women for their slatternly demeanour and lewd talk. Itinerant preachers had found the town far too hard a nut to crack. The rude folk of Filey would abuse them, pelt them with mud, stones and dried skate, and chase them out of town. But Praying Johnny, by all accounts a nondescript man with no great gifts of intelligence or eloquence, had

a faith strong enough to move mountains. When he began to preach, some of Filey's sinners wept. Others shook like jellies, or fell to their knees and prayed for mercy. 'In answer to the earnest breathings of his soul,' recorded Praying Johnny's fellow-preacher Mr Bottomley, 'a whole assembly has been moved as the trees are moved when shaken with a strong wind. A mighty shaking has been felt, and a great noise heard, amongst the dry bones. The breath of Jehovah has been felt, numbers among the slain have been quickened, and a great army has been raised up.'

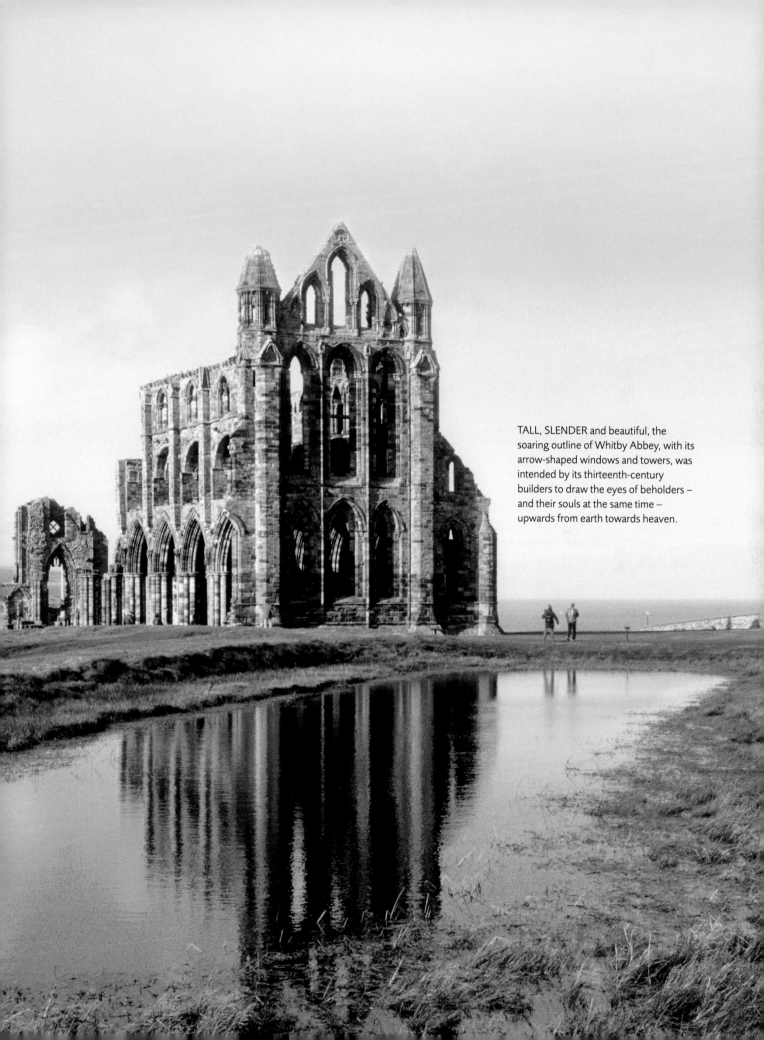

TALL, SLENDER and beautiful, the soaring outline of Whitby Abbey, with its arrow-shaped windows and towers, was intended by its thirteenth-century builders to draw the eyes of beholders – and their souls at the same time – upwards from earth towards heaven.

Men of the stamp of Praying Johnny Oxtoby have been active up and down the coast of north-east England since the first stirrings of Christianity at the onset of the Dark Ages, around 1500 years ago. Some, like Oxtoby, are all but forgotten. Others gained reputations that have reached the world at large. Most had to tackle rough work on a tough coast, a place of practical-minded realists engaged in the no-nonsense occupations of mining, seafaring, fighting in wars, fishing and farming. One, however, spent almost his whole life in the comparative ease and tranquillity of a monastery at Jarrow on the River Tyne, dealing with the world only as it came to him on the tip of his inky quill.

The Venerable Bede (AD 673–735) represents the reverse side of the coin from Praying Johnny – a Dark Ages monk who

comes across, in his own writings and in contemporary accounts of him, as a remarkably sensitive, broad-minded and gentle man as well as an exceptionally learned scholar. God never called Bede to stride into the shady side of town with sleeves rolled up, or force the drunkards and cursers to feel the breath of Jehovah. Instead, Bede stayed home and let his quill do the talking. He wrote a number of hymns and treatises on Gregorian chant, as well as a life of St Cuthbert in prose and in verse, commentaries on the Scriptures, religious contemplations and a history of the world from Creation up to his own time. His most lasting work, and his masterpiece, was his *Ecclesiastical History of the English People*, on which the church still bases its knowledge of the very early Christian church in these islands. Bede was scrupulous in acknowledging his sources of information – something authors throughout history have not always been careful to do. Quite simply, everyone who knew him seems to have admired him.

WATER BUBBLES and cascades down a natural staircase of magnesian limestone in Castle Eden Dene, one of the thickly wooded denes or steep coastal valleys of County Durham's Heritage Coast.

TOP SPOTS ■ THE TYNE TO THE HUMBER
Bede's World p.226 - Filey Methodist Church p.226 - Hull p.226 - Humber Bridge p.226 - National Glass Museum p.226

Anyone coming up with the title 'Durham Heritage Coast' 20 years ago would have been laughed out of court. Few outsiders were aware that the 'county of coal mines' even possessed a coast. A century of activity by half a dozen collieries along the dozen miles of cliffs, and the primitive sanitation of their associated villages, had thoroughly fouled the beaches and inshore sea with colliery sludge and waste, small coal and human excrement. Now the coal mines have all closed, the sea has been allowed to do its cleansing work unfettered, and local ex-miners and others have carried out a quite remarkable job of restoration. The pit sites have been cleared and landscaped, and decades of fly-tipped rubbish have vanished. The sea is steadily ridding the beaches of their carapace of minestone – the local name for colliery waste. A new shore and cliff-top footpath runs the length of the coast, dipping in and out of lovely steep, wooded valleys (denes) – such as the nature reserves of Castle Eden Dene and Hawthorn Dene – striking features of the magnesian limestone cliffs.

There are few reminders of the vigorous, dirty and dangerous colliery work that sustained the communities hereabouts. At Easington Colliery, a pit cage has been erected on the grassy hillock that was once the mine head. Up in the village's cemetery is a tall relief carving of a pitman with helmet lamp and hand lantern, a memorial to the 81 miners and two rescuers who died underground in the region's worst accident on 29 May 1951, after firedamp or methane gas exploded and sent a fireball shooting through the colliery workings. The gas was touched off when fine powder dust of iron pyrites caught fire while being pounded by the blunt picks of a coal-cutting machine. All the men were buried together in a communal grave. An avenue of 83 trees leads to a Garden of Remembrance, beautifully kept and often frequented by people who come to remember and pray for the men who died.

The spiritual wellbeing of Swedish seafarers is provided for at the Scandinavian Church and Swedish Seamen's Mission in Middlesbrough. This northern part of the coastline, however, is above all an area of heavy industry, and it doesn't come heavier in today's north-east than around the giant chemical plants, flaring oil refineries and fuming steelworks of Billingham and Middlesbrough, where the River Tees slides to the North Sea through sand and mud banks. Fantastically

LIKE A SKELETON 'push-me-pull-you' braced on four stout legs, Middlesbrough's great Transporter Bridge – built in 1911, the largest transporter bridge in the world – is a familiar landmark as it stands silhouetted against the Cleveland sky.

complicated shapes of pipework, lit like starships, grope at the clouds. The great Transporter Bridge bestrides the Tees like a colossus. Chemicals smear the evening sky over the western hills with famously dramatic sunsets. Since one man's Hades of a view is another's fascinating array of shape and colours, some photographers, painters and idle gazers can't get enough of these skylines. Meanwhile the seals, ringed plovers and sandwich terns, seemingly indifferent to all this industrial drama, continue to frequent the muddy shores and marshes of the Teesmouth National Nature Reserve.

Over the county border roll the magnificent cliffs of Cleveland and North Yorkshire, a kaleidoscopic jumble of mineral colours and geological sandwich fillings, of rocks bent as no rocks should be, and countless millions of hard little casts of leaves, flowers, shells, bones, teeth, scales and the prints of claws. Naming these 35 miles of

cliffs and beaches the 'Dinosaur Coast' was a master-stroke for the tourist industry, but it doesn't tell a scintilla of the story. Here are 300 million years of history, all laid out as if in a scale model: the rise and fall of land and sea, one above the other in successive aeons – the crimson and orange of sandstone, the grey and black of mud and clay, and the cream and green of limestone; through it all is a fossil record of life developing, from primitive plants and shellfish to sea monsters that Jules Verne never dreamed of – and back again to shells and plants once more.

Today, it is hard to imagine the furore that Charles Darwin provoked with the publication in 1859 of his treatise *On the Origin of Species by Means of Natural Selection, or the Preservation of Favoured Races in the Struggle for Life*. Geologists had been studying and thinking about fossils scientifically for well over half a

century by then. It was pretty clear that dinosaur remains were not those of mythical giants or creatures drowned in Noah's Flood, nor had they been placed in the rock layers by God to puzzle humans. But the notion that such creatures might have mutated into others in a chain that led directly to the human race was too much for many devout Christians to swallow, and remained so for many years after the *Origin of Species* made its appearance.

Filey marks the point where the tall ramparts of the Dinosaur Coast give way to the low, wave-eroded clay cliffs of Holderness, East Yorkshire's gently rolling coast that runs in a straight 40-mile line south to the Humber Estuary. Out in the flatlands north of the Humber stand the 'King and Queen of Holderness', officially known as St Augustine's Church at Hedon and St Patrick's Church at Patrington. They stand majestic and aloof, separated by 10 miles of low-lying farmland, with no comparable building anywhere nearby to challenge their joint rule. St Augustine's – dubbed the 'King' – was founded around AD 1190 and took more than 200 years to complete, with its massive tower, great interior arches and

THE CLIFFS of the North Yorkshire coast around Cowbar and Staithes are heavily stratified, very unstable and subject to sudden falls of rock, sending boulders, clay and stones, along with fossils, thundering down on to the shore.

FOUNDED AROUND AD 1190 at Hedon, on the north bank of the River Humber, St Augustine's Church raises 16 tall crocketed pinnacles from the parapet of a 128-foot central tower. Masculine in its four-square solidity, the church is known as the 'King of Holderness'.

EVERY KING needs a queen, and the consort of St Augustine's at Hedon (above) is St Patrick's Church at nearby Patrington. The slender 189-foot spire – a masterpiece of grace and beauty – has earned the church the title of 'Queen of Holderness'.

There's still jet to be found around Whitby. The jet hunters leave their marks on the surrounding cliffs – small holes burrowed into the stone. Jet is the fossilized remains of ancient driftwood – harder than coal but just as black.

ALICE ROBERTS, PRESENTER

TOP SPOTS ■ THE TYNE TO THE HUMBER
Newcastle p.226 - Old St Stephen's Church p.226
Robin Hood's Bay p.226 - Scarborough p.226

superb dog-tooth carving. By contrast, St Patrick's – the 'Queen' of Holderness – was built to a master plan in the first few decades of the fourteenth century, with a great cloud-piercing 189-foot spire. Inside St Patrick's is a cool stone forest of pillars, arches and rib vaulting. The capitals of the pillars are carved with superb naturalistic foliage. The eye travels up beyond these into the shadowy upper regions of the church, where lumpy carved faces of monks, laymen and beasts make humorous blobs among the arches. The reign of the King and Queen of Holderness was founded on wealth generated by the export of cloth and wool from the prosperous ports of Hedon and Patrington on the Humber Estuary. Now, after centuries of silting and land reclamation, the twin

monarchs stand several miles inland, ruling an arable realm where scarcely a sheep is seen.

'Praying Johnny' Oxtoby, Primitive Methodist, scourge and saver of the wicked folk of Filey in the 1820s, died a couple of years before freedom was finally granted to the slaves of the British Empire in 1834. But he was surely a brother-in-Christ and an equal in moral courage to Hull-born William Wilberforce (1759–1833), MP for his native city and lodestar of the campaign to extinguish slavery over the best part of half a century. Oxtoby's forerunner in Methodism, John Wesley, was a tremendous supporter of the East Yorkshire MP. It was to Wilberforce that Wesley sent the last letter he ever

and his supporters another 25 years to secure the emancipation of existing slaves with the Abolition of Slavery Bill. The news that it would be passed came to Wilberforce just two days before he died on 29 July 1833.

The handsome red-brick house where William Wilberforce was born still stands on Hull's High Street. Nowadays, it houses a museum dedicated to the story of slavery, past and present, and to the memory of yet another man of the north-east coast who was driven by God and a restless conscience to put himself and his life on the line for his fellow men.

YORKSHIRE BORN AND BRED, Frank Meadow Sutcliffe (1853–1941) was a pioneer photographer who won lasting local fame for his studies of the fishing communities of the North Yorkshire coast, in particular of Whitby, where he made this fine and saucy study of two young girls enjoying the seaside *c*.1880.

THE HUNGRY North Sea has eaten huge chunks of the crumbly cliffs around Robin Hood's Bay; it has taken much of the shoreside medieval settlement, too, and would have had the rest but for the strongly built sea walls of the village.

wrote, encouraging him: 'Unless God has raised you up for this very thing, you will be worn out by the opposition of men and devils. But if God be for you, who can be against you? Are all of them together stronger than God? O be not weary of well doing! Go on, in the name of God and in the power of his might...'

Britain and her colonies earned tens of millions of pounds annually from the slave trade, and Wilberforce was reviled, cursed, attacked and threatened with death. Slaving as a trade in British countries was actually abolished in 1807, but it took Wilberforce

TOP SPOTS ■ THE TYNE TO THE HUMBER
St Patrick's Church p.226 - Sunderland p.226 - Whitby p.226
Wilberforce House Museum p.227 - Withernsea p.226

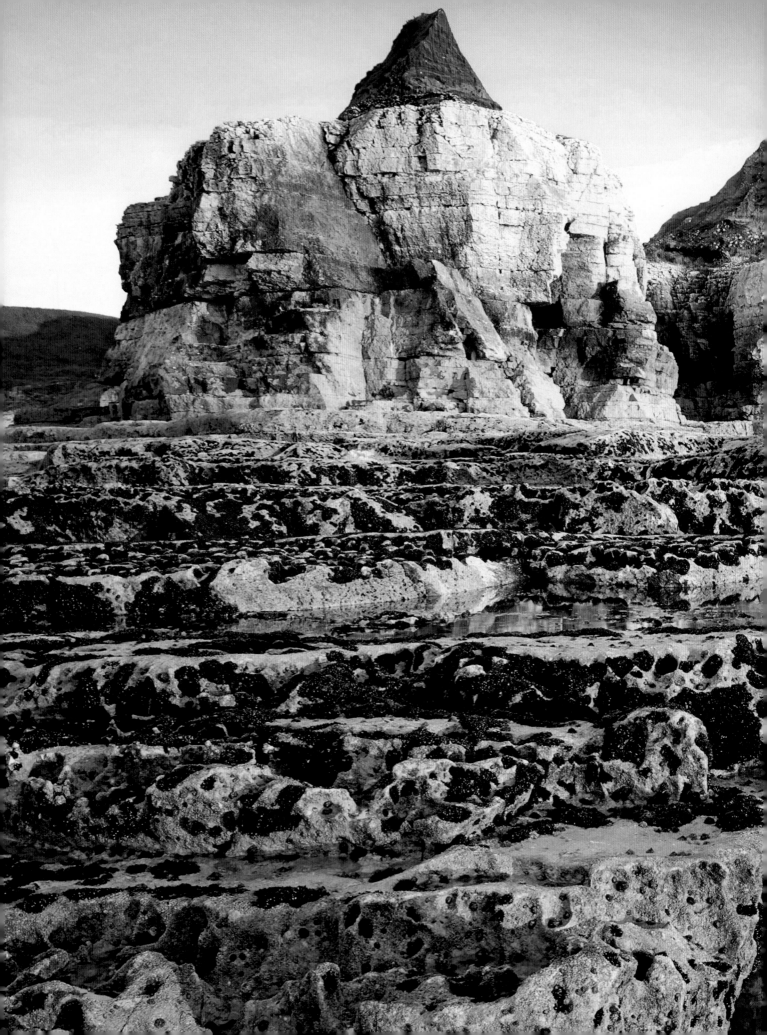

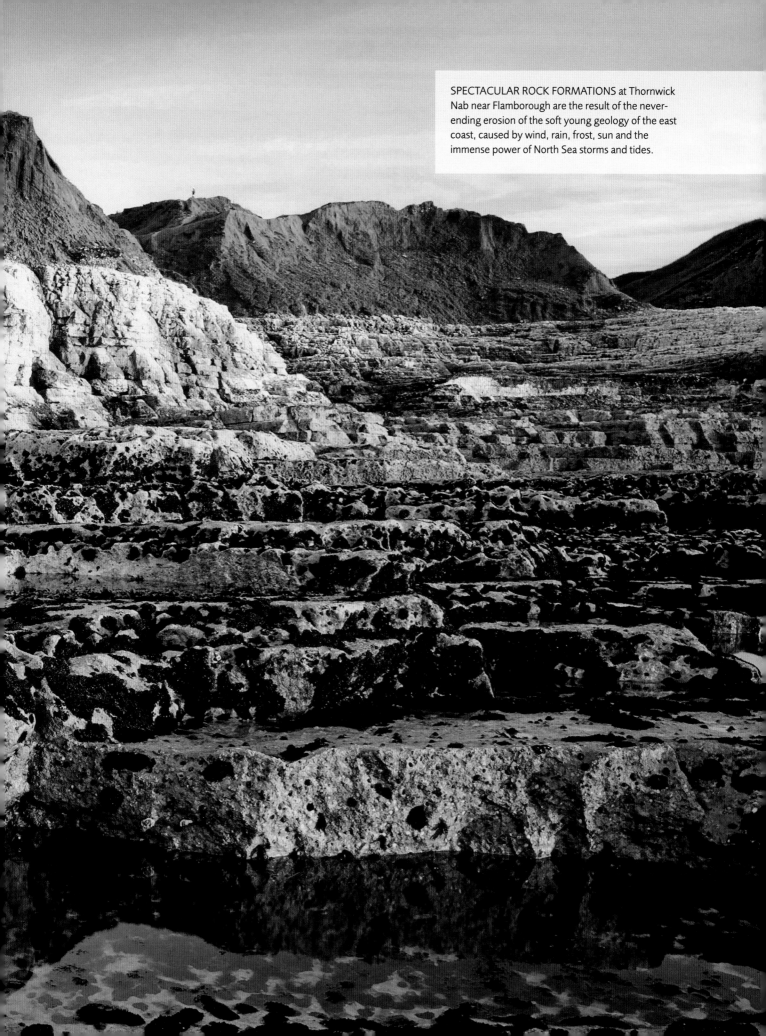

SPECTACULAR ROCK FORMATIONS at Thornwick Nab near Flamborough are the result of the never-ending erosion of the soft young geology of the east coast, caused by wind, rain, frost, sun and the immense power of North Sea storms and tides.

Coast on the Move

THE HUMBER ESTUARY TO GREAT YARMOUTH

A shifting coastline of mud, sand and salt marsh runs south from the Humber Estuary and then east, tracing the sea margins of Lincolnshire and Norfolk for 170 miles. It is characterized by its two big bulges, which represent the bellying coastlines of the twin counties, and two deep indentations, formed by the great estuaries of the Humber and the Wash. Here, in spite of centuries of man's activities – seaside recreation, fishing and fowling, practising warfare and reclaiming land from the sea for agriculture and then defending it against the tides – it is nature that wields the big stick of influence. Of all the coasts in Britain, this is the lowest-lying, with land and sea mingling on a level plane. It is especially vulnerable to the rising sea levels that are beginning to threaten many parts of our shores. On the plus side, it is one of the richest areas for wildfowl, countless invertebrates, and silence and solitude.

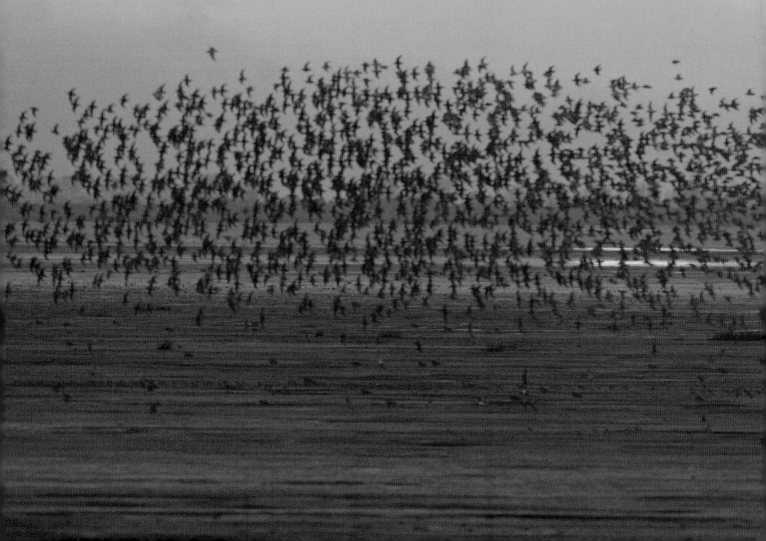

The estuary of the River Humber cuts inland between East Yorkshire and Lincolnshire. The Humber itself is only 40 miles long, but it is a mighty river. Together with its tributaries it drains some 10,000 square miles of country, about one-fifth of England's total land area. It empties more water than any other river into the North Sea, and its tidal range of over 20 feet is second only to that of the River Severn in the United Kingdom. The Humber countryside is flat – more than 300,000 people in this region live below sea level, protected from the tides by man-made barriers.

SILHOUETTED AGAINST the dramatic backdrop of a November sky at sunset, a vast congregation of knots twists and turns before settling itself to roost at the RSPB's Snettisham reserve on the Norfolk shore of the Wash.

There is a sombre beauty to the smooth backs of the sand and mud flats of the Humber Estuary, the ochre and purple of hummocks like whales rolling clear of the tide. It's not for nothing that most of these flats are designated Sites of Special Scientific Interest, or that the estuary as a whole enjoys Special Protection status and is a Ramsar Convention wetland of international importance. The Humber is one of the most important estuaries in Europe for wintering birds, particularly waders. These enormous mud and sand flats in and around the tidal river nurture up to a million organisms per cubic yard of mud. In a typical winter, they feed and protect 150,000 birds, such as knots, golden plovers and pink-footed geese, as well as a thriving colony of nearly a thousand Atlantic grey seals down at Donna Nook, on the southern border of the estuary.

There are also about 5000 acres of salt marsh here – winding creeks, brackish pools and tough, salt-resistant plants – where birds breed and hide, and seldom-seen insects and invertebrates flourish.

Sea levels are rising, and at the same time the east coast of Britain is sinking – only by a few tenths of an inch each year, but those tiny measurements soon accumulate into inches and then into feet. Estimates vary, but the average level of the sea could increase by up to 3 feet during the twenty-first century, if the most dramatic current predictions about global warming and melting glaciers prove accurate. The accepted relation between sea-level rise and shore retreat is 4 inches of retreat per $\frac{1}{2}$ inch of rise. That could mean the sea moving 300 feet inland in places.

BIG SHORE, big sky: the sense of spaciousness so characteristic of the North Norfolk coast is well illustrated in this scene on the beach at Holme-next-the-Sea, on the margins of the North Sea.

more tightly between man's flood defences and the advancing sea. This 'coastal squeeze' diminishes bird, plant and insect life as nature's barriers melt away, and the ecology of the region becomes impoverished.

Current thinking is moving away from maintaining rigid traditional defences everywhere and at all costs. Finance alone would prohibit the maintenance of hard sea defences all along the tidal Humber. Today, strategy is leaning towards 'managed realignment'. The line will be held rigorously around Hull, Grimsby and Immingham docks, but more flexibly elsewhere. At Paull Holme Sands, near Thorngumbald, a few miles seaward of Hull, the defences have been moved well inland of the current shoreline – up to 1500 feet in places – as an experiment in 'setback'. The sea has begun to reclaim the abandoned farmland and create mud banks, the foundation for new salt marshes. The same kind of action is planned for 1100 acres of low-lying agricultural land at Alkborough Flats, far upriver of the Humber Bridge. If all goes well, and these carefully managed experimental areas develop a biodiversity as rich as the neighbouring 'natural' intertidal areas, it will mean that the future tide defences of the Humber basin can be planned with the estuary as a whole in mind – a piece of land could be yielded to the sea here, while hard defences are strengthened there, maintaining the balance of the estuary's ecosystem.

Nature provides low-lying coasts with efficient defences against the sea. Sand, shingle and mud break the force of the tide. The tightly tangled miniature forest of salt-marsh plants acts as a flexible but stout and complex obstacle. Left to its own devices, the sea would continue to rise, but its power to capture the land would be greatly dissipated by these natural impediments. Yet man's presence and his needs bring an opposing pressure to bear. Coastal towns and villages, docks and factories, farms and farmland – all need protection from flooding by the tides. Hard defences, such as walls of concrete, metal piling or barriers of stone, can keep the sea at bay, but only at the expense of the intertidal zone. Marshes, mud flats, shingle bars and sand banks become narrower and more easily eroded by strengthening tides as they get squeezed

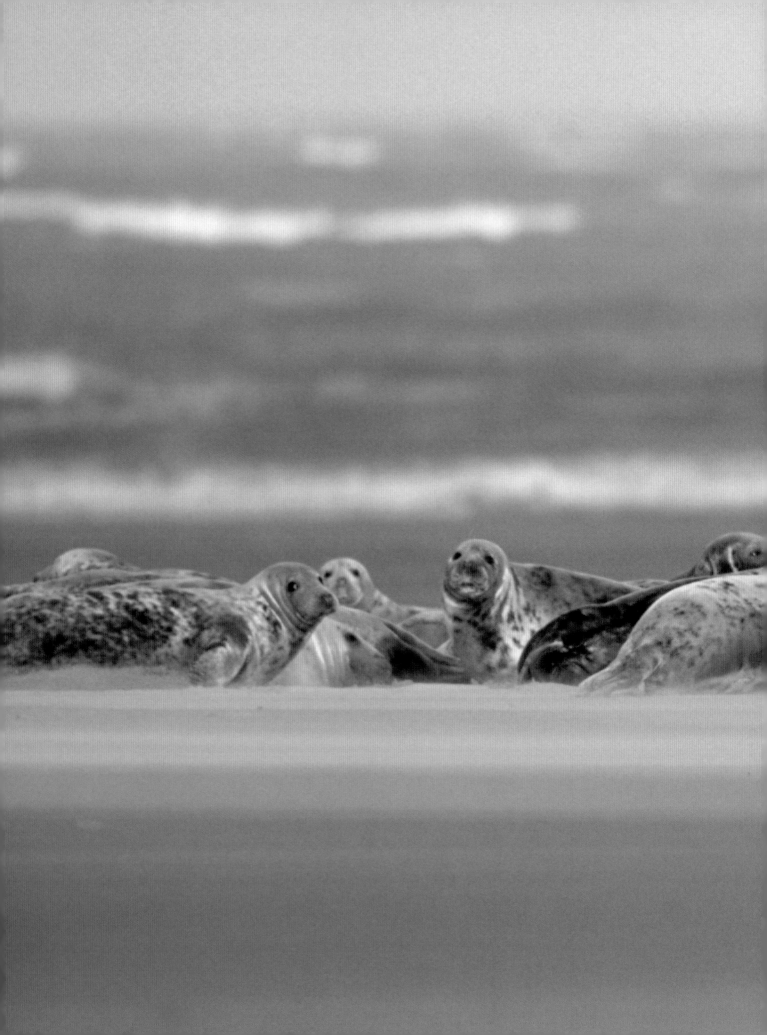

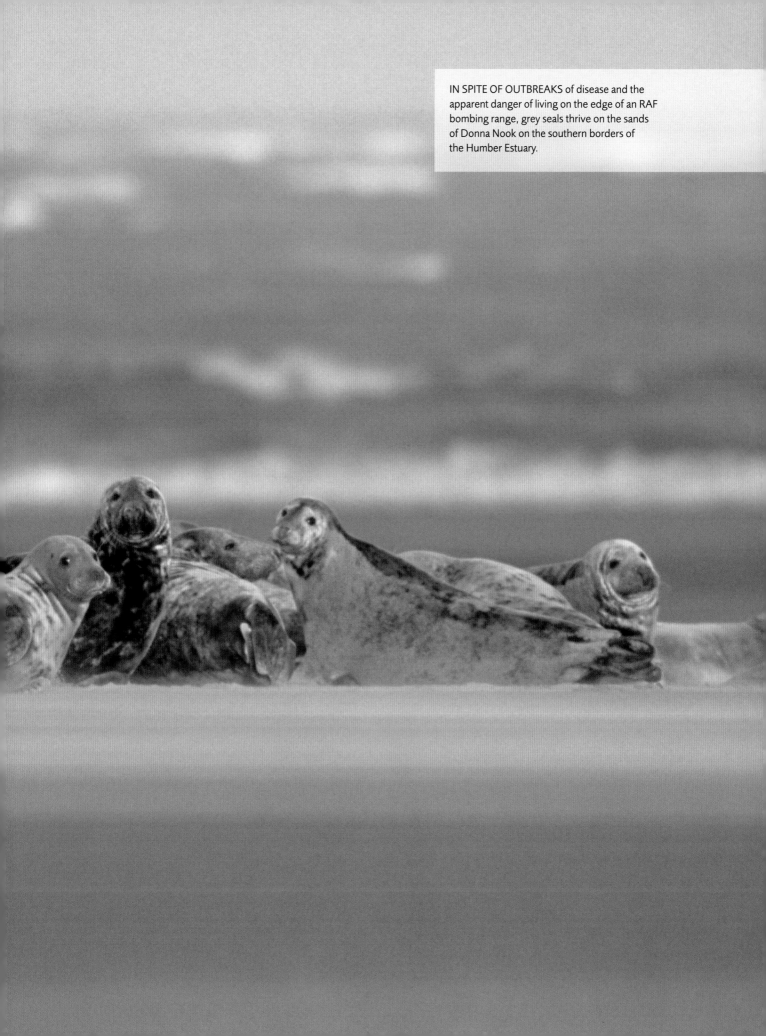

IN SPITE OF OUTBREAKS of disease and the apparent danger of living on the edge of an RAF bombing range, grey seals thrive on the sands of Donna Nook on the southern borders of the Humber Estuary.

Sand dunes are another form of effective natural barrier between land and sea. There are several notable ranges of dunes along this stretch of coastline, and Lincolnshire possesses two of the finest in Saltfleetby and Theddlethorpe Dunes, a National Nature Reserve at the southernmost edge of the Humber Estuary, and further south beyond Skegness at Gibraltar Point, also a nature reserve. Dunes are mobile structures, forever changing shape and stance in response to shifts in wind and tide. Once established in an area, they stay put – those at Gibraltar Point are up to 300 years old, while the dunes at Saltfleetby and Theddlethorpe date back to the thirteenth century. Like estuary muds and marshes, the dunes are rich in wildlife. Late spring here is wonderful for flowers, including early orchids, cowslips and the tiny white flowers of meadow saxifrage. For the rest of the year, there are huge numbers of birds to see.

When the topic is wildfowl in really serious numbers, though, the focus inevitably shifts south to the gigantic square-sided estuary of the Wash, which forms the boundary between Lincolnshire and Norfolk. This enormous basin, the largest estuarine system in Britain, is the wintering haven of over 300,000 birds, including dark-bellied brent geese, grey plovers, knots, turnstones, wigeons and pintails. In summer, the marshes and muds ring with the haunting, piping cries of redshanks, curlews and oystercatchers. Spring sees the Wash play its part as a rest-and-refuel stop for millions of birds going north to their Arctic breeding grounds. Thousands of common seals live in the Wash, too, breeding in the summer months. Their numbers reached 7000 in the late 1980s, before a viral

SAND DUNES are becoming rarer around the coasts of Britain because of erosion by sea, human trampling and development; but those at the Saltfleetby and Theddlethorpe National Nature Reserve in Lincolnshire, which were created in the thirteenth century, are carefully managed and safeguarded.

epidemic killed more than half. Since then the seal population has been slowly recovering. All these temporary and permanent residents of the Wash are drawn here by the estuary's 65,000 acres of intertidal sand and mud flats, and also by its 10,000 acres of salt marsh, about 10 per cent of the UK's total. As for what lies beneath the surface at high tide – the intertidal flats represent less than half of all the mud and sand banks present in the Wash. The rest are subtidal and remain permanently under water, providing superb feeding and breeding grounds for mussels, cockles and shrimps, and for flatfish such as sole and plaice.

All this is to say nothing of the stark and lonely power of the Wash, the magical beauty of cold winter dawns under an apple-green sky rippled by lines of pink-footed geese, the sensation of stepping out across the marshes and knowing that no other human being is drawing breath for miles around. There have been many mad plans down the centuries for this 'useless waste', ranging from speedway tracks to a brand new town of 750,000 people, complete with airport. Somehow the great tidal basin, with its moody shapes and colours and its unceasing yet infinitely subtle shifts and changes, has remained remote and inviolate, a land apart under its vast skies.

A MUDDY CREEK snakes its way towards the sea through the vast flat mudscape – seemingly barren, but teeming with unseen life – of the salt marshes at Terrington Marsh on the southern shores of the Wash, where Lincolnshire meets Norfolk.

In the Wash, everything seems to be on an enormous scale: huge skies, mile after mile of shoreline enclosing the vast mud flats that teem with invertebrates – essential food for the massive flocks of birds that live, breed and stop here to refuel. It is a dynamic place of remote beauty.

MIRANDA KRESTOVNIKOFF, PRESENTER

'OH YES HE IS!' – waiting for 'Professor' Frank Welsh to make with the gloves in his Sensational Punch & Judy Show, one of the perennial attractions of the beach in summer at Norfolk's biggest seaside resort, Great Yarmouth.

BLAKENEY, on the North Norfolk coast, looks like a seaside village, but its connection to the open sea is now reduced to a winding channel 4 miles long through the muds and marshes that have grown to the landward side of the shingle spit of Blakeney Point.

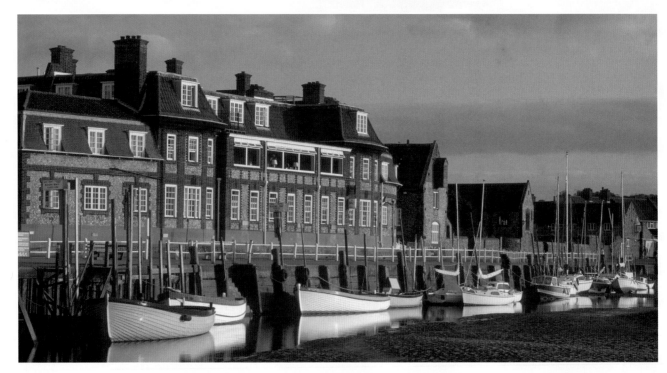

KING'S LYNN on the Norfolk shore of the Wash became one of the most prosperous of the East Coast ports from medieval times onwards, thanks to its connections with the Hanseatic League trading confederation – a prosperity mirrored in the handsome architecture of the seventeenth-century Customs House on Purfleet Quay.

The great convex bulge of the Norfolk coast begins at the characterful old port town of King's Lynn, tucked into the lowest corner of the Wash, and runs from there in a 75-mile semi-circle of almost geometrical perfection to the ancient fishing town-turned-resort of Great Yarmouth. This is a coast of three distinct segments – salt marsh along the north coast, cliffs from Sheringham to Happisburgh and dune-backed beaches from there on south. The salt marshes of the north-west continue to grow as rivers spread fertile silt along the coast, so that villages such as Brancaster, Blakeney and Cley-next-the-Sea, all pretty flint-and-brick places that once saw coastal shipping tie up at their wharves, now lie in retirement behind immense barriers of marsh stretching north to a seashore a mile or more away. By contrast, the yellow-and-red clay cliffs of the north-east Norfolk coast are tottering and tumbling into the sea at an ever-increasing rate as winter storms bite into them. In this part of the country you will find 'realignment' in action – not at the instigation of local authorities or the Environment Agency, but through the blind, inexorable processes of nature herself.

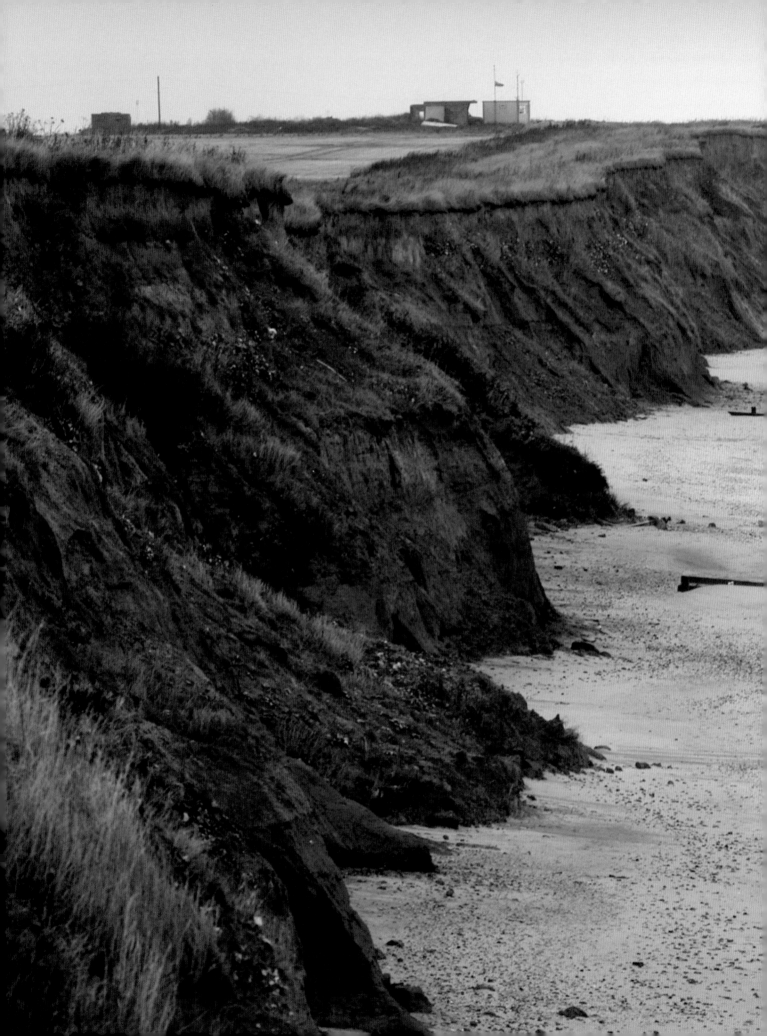

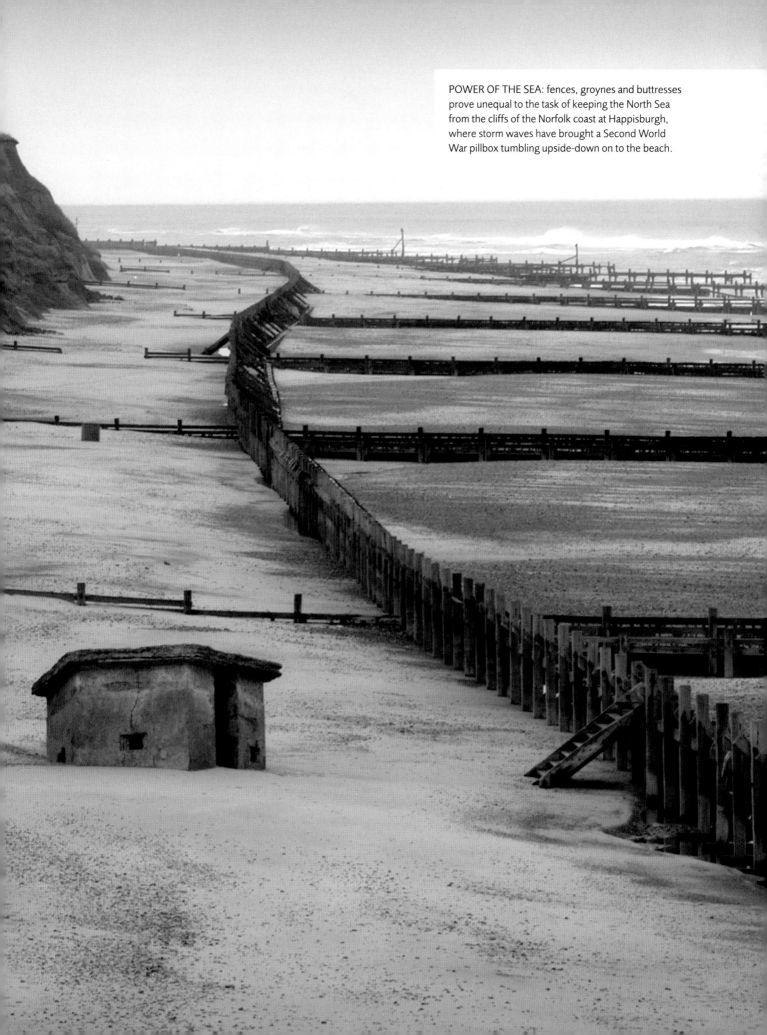

POWER OF THE SEA: fences, groynes and buttresses prove unequal to the task of keeping the North Sea from the cliffs of the Norfolk coast at Happisburgh, where storm waves have brought a Second World War pillbox tumbling upside-down on to the beach.

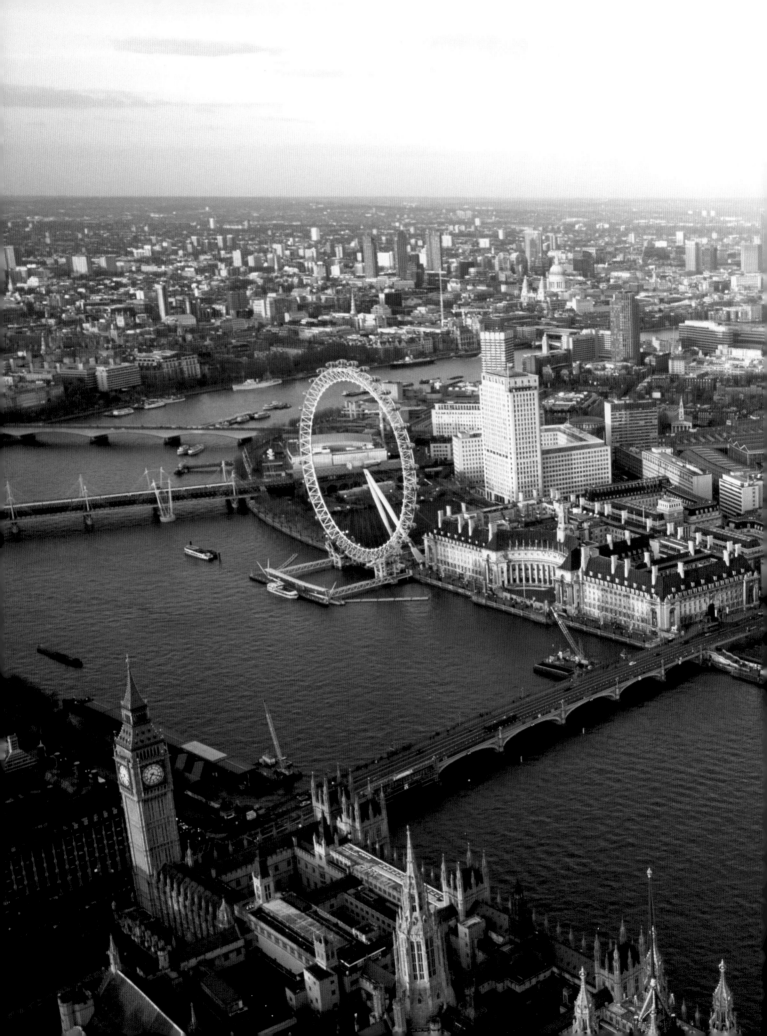

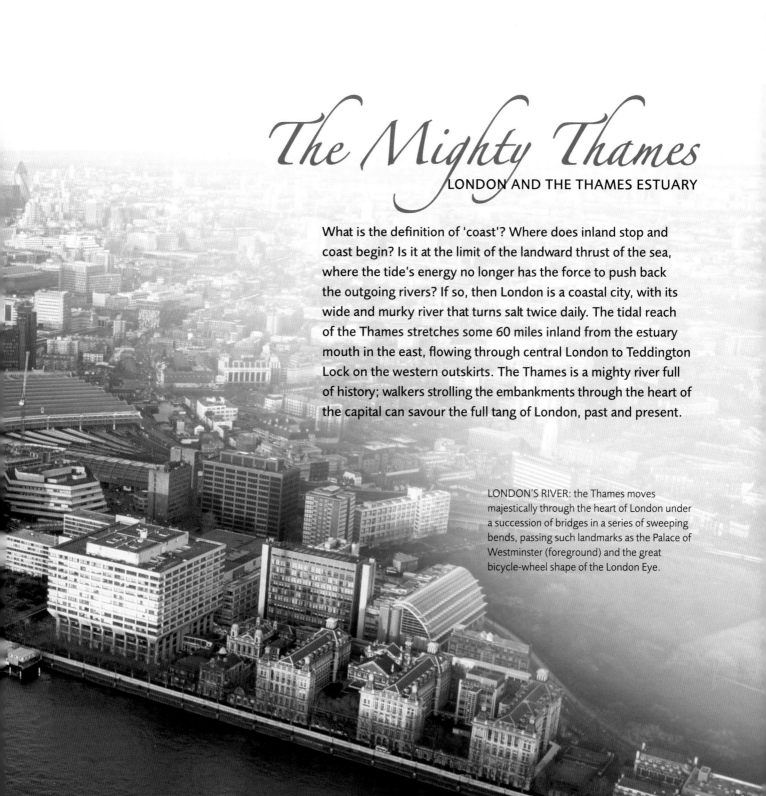

The Mighty Thames

LONDON AND THE THAMES ESTUARY

What is the definition of 'coast'? Where does inland stop and coast begin? Is it at the limit of the landward thrust of the sea, where the tide's energy no longer has the force to push back the outgoing rivers? If so, then London is a coastal city, with its wide and murky river that turns salt twice daily. The tidal reach of the Thames stretches some 60 miles inland from the estuary mouth in the east, flowing through central London to Teddington Lock on the western outskirts. The Thames is a mighty river full of history; walkers strolling the embankments through the heart of the capital can savour the full tang of London, past and present.

LONDON'S RIVER: the Thames moves majestically through the heart of London under a succession of bridges in a series of sweeping bends, passing such landmarks as the Palace of Westminster (foreground) and the great bicycle-wheel shape of the London Eye.

The energetic and practical Romans discovered that timing was everything when navigating the Thames upstream. If they came in from the North Sea on a good rising tide, they could stow the sails and oars away and have themselves swept 40 miles inland. At the point where the width of the river diminished to about 870 feet, it was narrow enough to bridge and to establish a settlement on both banks – the city of Londinium. Dark Ages Danes and seventeenth-century Dutchmen, coming upriver to raid the capital, likewise utilized the free energy source of the flowing tide. So did merchant ships in times of peace and prosperity, carrying uncountable wealth from colonies across the world and a steady influx of foreigners to enrich the city's bloodlines and thicken the cultural stew.

LIKE A ROW OF CRUSADER HEADS in mailed cowls, the hoods of the Thames Flood Barrier guard the river in Woolwich Reach, a symbol of London's vulnerability to high tides and rising sea levels.

Tide works both ways, of course. Downriver from the capital went the produce of the Industrial Revolution's 'Workshop of the World', carried seaward on the ebb together with a human spate of Empire administrators, Arctic explorers, railway builders and Christian missionaries. Also sailing away went uncounted thousands of hungry, disillusioned men and women who had found nothing for them in the city whose streets they had thought were paved with gold.

Until the Victorians cleaned it up, the Thames was London's stinking open sewer. All that was unwanted in the teeming city was committed to the river – butchers' offal, excrement, street sweepings, ashpit cleanings, factory chemicals, dead dogs – to be borne round the bends and away beyond smelling distance, out of sight and out of mind. Much of this noxious material never reached the sea, but beached itself on the mud of Wapping Flats, Barking Reach or Erith Rands.

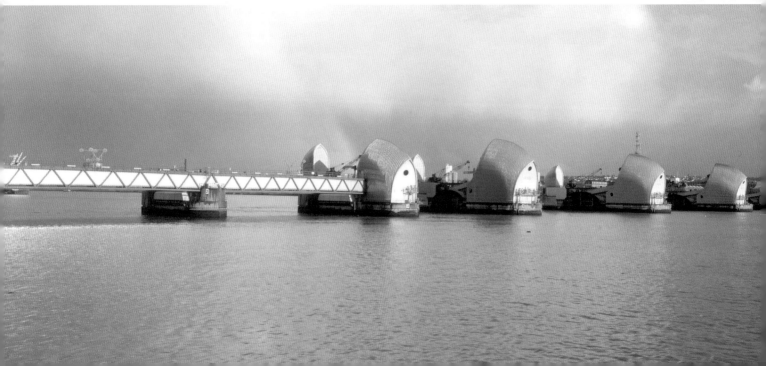

TOWERS OF BABYLON: in smoked glass, concrete and marble, the towers of Canary Wharf rise from the heart of London's Docklands and look across Blackwall Reach to the Millennium Dome on the far bank of the Thames.

Human jetsam became stuck downriver, too – convicts crammed into decommissioned ships of war, known as prison hulks, that were moored off the marshes of Beckton, the Isle of Dogs, Woolwich and Deptford. The inmates of the rotting hulks were ill-treated and fettered night and day. They stank so vilely that on hot days the entire river region became intolerable to local inhabitants, most of whom were living in conditions that were not much better than those in the hulks. The squalor and the underclass atmosphere of the downstream districts, and the desolation of their uninhabited marshes, seem to have bred an ongoing unease in Londoners about these alien flatlands on their eastern borders. It's an attitude that one can trace today in their disregard for the downriver county of Essex, a reluctance to explore east for fear of what they might find along those outlandish shores.

For so many years Londoners turned their back on the Thames, but now they are beginning to rediscover their river – warehouses are being converted into flats and boats carry commuters to work.

MARK HORTON, PRESENTER

TOP SPOTS ■ LONDON AND THE THAMES ESTUARY

Convicts and hulks, marshes and the tidal Thames – unlikely inspiration, one might think, for one of the greatest novels of English literature. But Charles Dickens had intimate knowledge of the smells and sounds of the river in its course through London, having spent three miserable years as a young boy wrapping up bottles of boot-black in Warren's Blacking Factory at Hungerford Stairs after his father was imprisoned for debt. He had seen the sinister, stinking prison hulks moored along the Thames. And he knew the wide marshes of the Hundred of Hoo, which look across the Thames from the Kentish shore of the river beyond Chatham, the town where he grew up. This is where open countryside and a sense of the sea begin, now as then. Dickens put it all into his marshland masterpiece of 1860–1, *Great Expectations*. Young Pip, the central character, moves through scenes easily distinguishable today – the weatherboarded building in Chalk village, which was the forge and home of the good-natured blacksmith Joe Gargery and his vinegary wife; the marshland graveyards of St James's Church, Cooling, and St Mary's, Lower Higham, which Dickens amalgamated for the terrifying opening scene when Pip meets the runaway convict Magwitch; and the lonely gun battery on the Thames shore, where his young hero runs with a file and some stolen 'wittles' for the convict on a foggy Christmas morning.

THE LONELY Kentish marshland churchyard at St Mary's, Lower Higham, was the setting for the opening chapter of *Great Expectations*, where Charles Dickens has the runaway convict Magwitch terrifying young Pip by turning him upside down among the gravestones.

MEAN, DARK AND MOODY, the mud flats of the River Medway's estuary have been a repository through many centuries for abandoned items, from superannuated boats to plague corpses and the unwanted persons of felons, madmen and prisoners-of-war.

Beyond the Hundred of Hoo, the Kent coast takes a sharp inland kink to encompass the muddy shores of the River Medway's estuary. The Medway is moody at this point, its broad tideway plugged with hundreds of tiny islets of salt marsh and mud. When Isambard Kingdom Brunel's giant steamship *Great Eastern* ended her service after laying the first transatlantic telegraph cable in 1866, she spent years anchored forlornly in Saltpan Reach before being broken up. During the Napoleonic Wars, the Medway was filled with derelict hulks holding French prisoners-of-war in miserable conditions. Hundreds died of smallpox and cholera, and their bodies were dug into the mud of Deadman's Island and Prisoners' Bank, whose soil still lies blackened by bonemeal nutrients.

East of here the coast is shadowed by the Isle of Sheppey, a large island separated from the mainland by the narrow channel called the Swale, whose mud flats ring with seabird piping all year round. Sheppey's ground rises northwards from sea-level marshes by the Swale to cliffs that fall 160 feet into the estuary. Hereabouts, the Thames broadens to a stretch of water some 5 miles wide. At Shoebury Ness, on the opposite shore, the Essex coast turns to the north-east and dwindles away to a vanishing point on the horizon. The southern coast, meanwhile, runs on past the oyster beds of Whitstable and the elegant promenades of Herne Bay, to rise at last into the great chalk nose of North Foreland, at the outermost tip of Kent.

HERNE BAY, a traditional-style seaside resort on the North Kent coast at a point where the Thames Estuary has become the open sea, is proud of its beautiful Blue Flag beaches of clean sand.

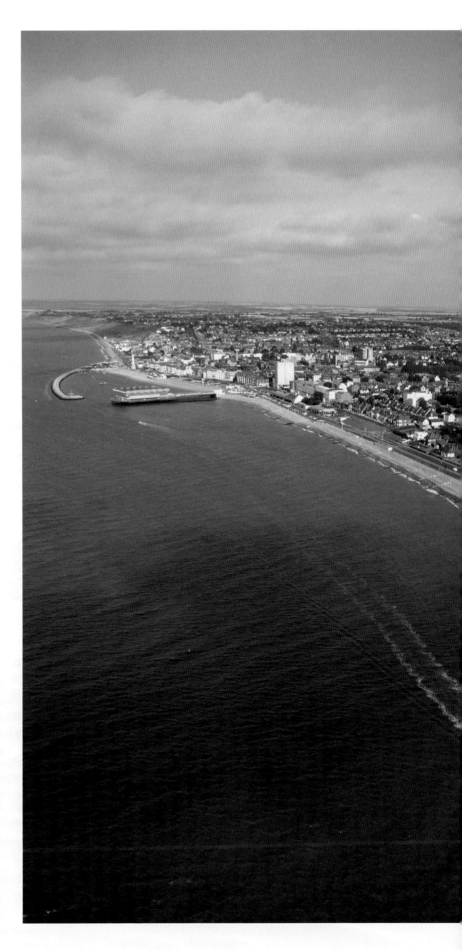

The journey of the Thames's north or Essex coast, running from the heart of London to the outer sea, parallels that of the Kentish shore for much of the way. Here are the same low-lying marshes, the same commuter towns and off-kilter waterside pubs and cottages. But Essex's shore is far more built-up. There are huge docks and a big power station at Tilbury, vast landfill sites on the marshes at Mucking and Pitsea. Thurrock has landfill, too, and the supersize Lakeside shopping mall. Coryton dominates all with the sky-stabbing chimneys, pipes and flares of its oil refinery.

Yet anyone wandering here without their prejudice-spectacles on will find all manner of fascinations in among the blockbusting industrial megaliths. Rainham, Aveley and Wennington Marshes, for example, 2 miles upriver of the Dartford Crossing, where a medieval landscape of marshes and silt lagoons – the largest piece of wetland along these upper reaches of the Thames Estuary – has been miraculously preserved, to the benefit of such wading birds as lapwings, ringed plovers and blue-legged avocets. A little further downriver at Tilbury, squeezed between the docks and the power station, lies a seventeenth-century fort so improbable in its setting that one can only marvel how its double moats and sharply pointed pentagonal walls have escaped demolition through all these years. Tilbury is redolent of this island's extraordinary story. Here in 1588 Queen Elizabeth I, rallying the crowds who had gathered to defend London against the Spanish Armada, made her famous declaration: 'I know I have the body of a weak, feeble woman; but I have the heart and stomach of a king.' It was at Tilbury, too, that the passenger liner SS *Empire Windrush* docked in 1948 with the first Caribbean immigrants to come to Britain.

Pausing a while here and picturing the marshy shores that flank the Thames to the north and south, it is hard indeed to credit the extraordinary 'Thames Gateway' plans now taking shape for the coast downriver of London. In low-lying country that is especially vulnerable to flooding, in an era of dramatically rising sea levels, in the most drought-

ITS VERY EXISTENCE unsuspected by most passers-by, the distinctive star shape of the seventeenth-century Tilbury Fort lies between industrial sites on the Essex bank of the Thames, immediately downriver of Tilbury Docks.

EUREKA!

In Roman times, Cassius Petrox, Commander of the Roman legion at Maldon, Essex, had picked up a nasty marsh ague that caused his joints to ache. His servants knew that after a hard day's route march he liked to bathe in salt water, drawn from the Blackwater Estuary and warmed to just the right temperature to ease his pains. One day, Cassius arrived home late, looking forward to his soothing soak, to find that the fire had been kept roaring under the bath all day and the water was far too hot. The soldier was furious – until he noticed a layer of pure white crystals at the bottom of the tub. Quite by chance, they had discovered the secret of making salt from seawater.

Once his brother officers had sampled this new salt, word got around and demand soared. The lucky Commander resigned his commission and waxed prosperous as the first salt-maker in Maldon, discovering that gold was even more efficacious than warm salt water in helping him forget his aches and pains.

SEAGULLS, swans and wading birds find rich pickings along the mud banks exposed on the ebb tide in the River Blackwater, just below the old Essex salt-making port of Maldon.

prone region of Britain, upwards of 200,000 houses and their infrastructure are to be built across an area 40 miles long and 20 miles wide, stretching from the centre of London out to Southend-on-Sea in Essex and beyond Faversham in Kent. The imagination can only boggle.

Up, up and away from all that, up through the salt marsh, creeks and mud flats of the dour and beautiful north Thames coast – up past Foulness and Dengie, curlew-haunted Mersea Island and the crumbling cliffs of the Naze – to land in the salty old port of Harwich on its spit of land at the outer limits of Essex. Here, in a Trinity House yard on Harwich Harbour lie the bulbous, sea-stained shapes of buoys, rusted and salt-streaked from long sea duty, each waiting its turn for a fresh coat of paint in pink, green or red. Soon they will be winched into a boat and taken out to be attached again to their anchoring chains on lonely sandbanks and reefs, to spin and creak mournfully through storms and shine, guarding seafarers from the hazards of our island coast that stand lettered so evocatively along their hollowly booming sides, a poetry that moves you from the safety of the land out into the wilderness of the sea: Old Harwich, Orford Haven, Solent Bank, Royal Sovereign, Oaze Bank, Hook Spit, Rough Tower, Stone Banks, South West Goodwin, Spit Buoy, Shivering Sands, Black Deep…

22 JUNE 1948 – a day with momentous significance for our present multicultural society in Britain, when a group of young Jamaicans disembarked from SS *Empire Windrush* at Tilbury Docks in Essex. They were the pioneers of post-war Caribbean immigration to Britain.

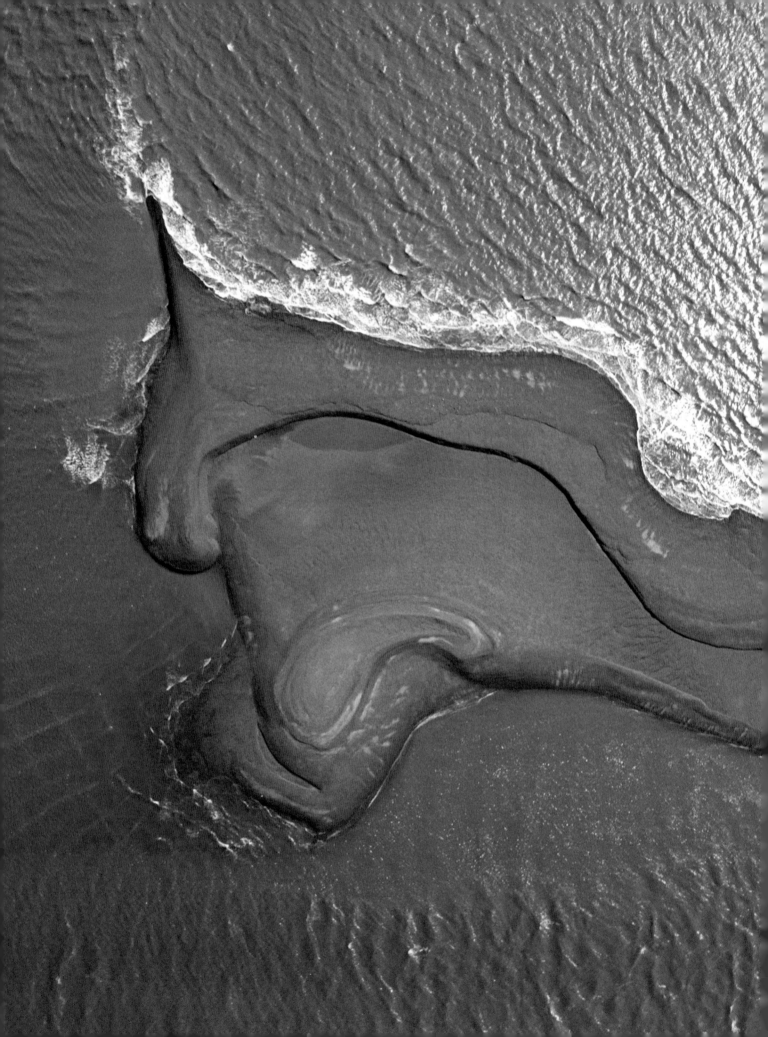

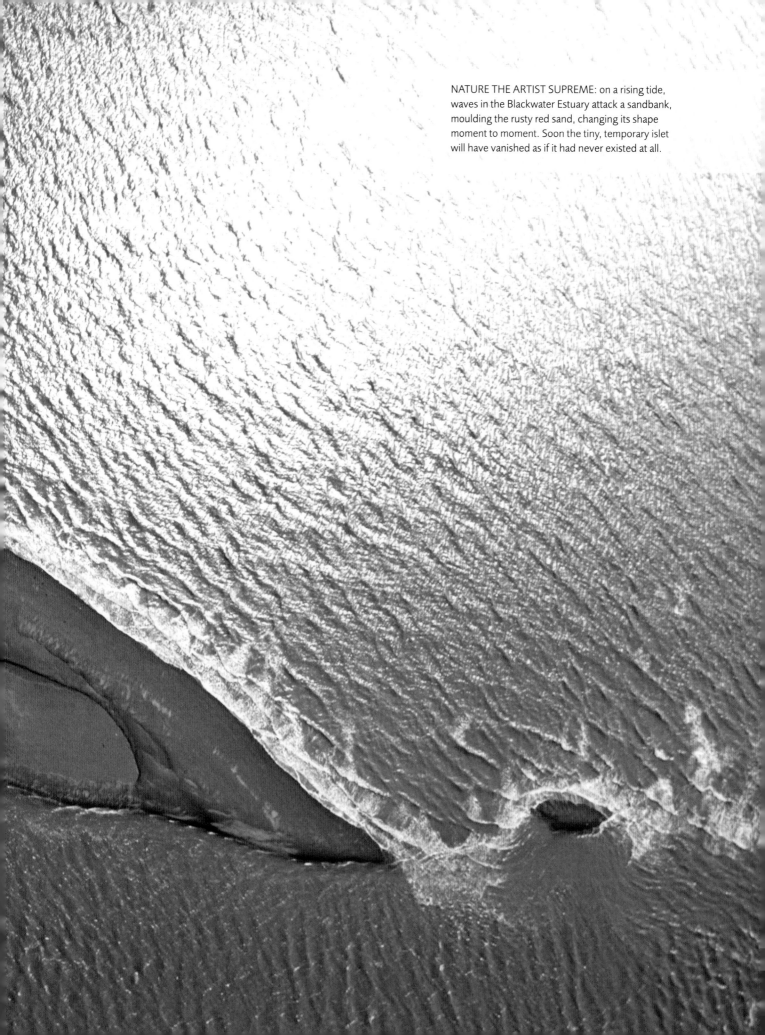

NATURE THE ARTIST SUPREME: on a rising tide, waves in the Blackwater Estuary attack a sandbank, moulding the rusty red sand, changing its shape moment to moment. Soon the tiny, temporary islet will have vanished as if it had never existed at all.

Gazetteer

How do you set about exploring for yourself these magical, seductive 10,000 miles of coast – the most varied and most inspiring coastline on earth? Where will you find the inspiring places that so enticed you when viewing the BBC2 series *Coast* or when reading the first part of this book? Where exactly is that romantic castle in the Northumbrian surf? What's the best way to reach those remote Hebridean islands where the camera showed you wild flowers growing thickly round the beautiful white beaches? When is the right time to visit the wild geese you marvelled at on their marshy East Anglian wintering grounds?

These and a thousand other practical questions are answered in this Gazetteer section, which is organized by region. The Gazetteer aims to be a very practical tool, helping you to plan journey after journey of discovery in search of the wonders of our uniquely fascinating coastline.

SYMBOLS

✆ Contact telephone number (in 'Places to Visit' this is usually the Tourist Information Centre, unless otherwise stated)

🚢 Ferry/boat trip/cruise information

✈ Air travel information

🚁 Helicopter travel information

USEFUL WEBSITES

Below is a selection of useful websites for organizations that are responsible for looking after the coast including its wildlife, natural environment, buildings and historic sites.

UNITED KINGDOM (GENERAL)
www.bbc.co.uk/coast
www.blueflag.org
www.countryside.gov.uk
www.goodbeachguide.co.uk
www.nationaltrust.org.uk
www.rspb.org.uk
www.wildlifetrusts.org
www.wwt.org.uk

ENGLAND
www.english-heritage.org.uk
www.english-nature.org.uk
www.rspb.org.uk/england/index.asp

NORTHERN IRELAND
www.ehsni.gov.uk
www.ntni.org.uk
www.rspb.org.uk/nireland/index.asp
www.ulsterwildlifetrust.org

SOUTHERN IRELAND
www.iwt.ie
www.birdwatchireland.ie
www.antaisce.org

SCOTLAND
www.escapetotheedge.co.uk
www.historic-scotland.gov.uk
www.nnr-scotland.org.uk
www.nts.org.uk
www.rspb.org.uk/scotland
www.snh.org.uk
www.undiscoveredscotland.co.uk
www.visithighlands.com
www.visitscotland.com

WALES
www.cadw.wales.gov.uk
www.castleuk.net/castle_lists_wales
www.castlexplorer.co.uk/list-wales.php
www.ccw.gov.uk
www.pembrokeshirecoast.org.uk
www.rspb.org.uk/wales

DUNLUCE CASTLE, COUNTY ANTRIM, NORTHERN IRELAND

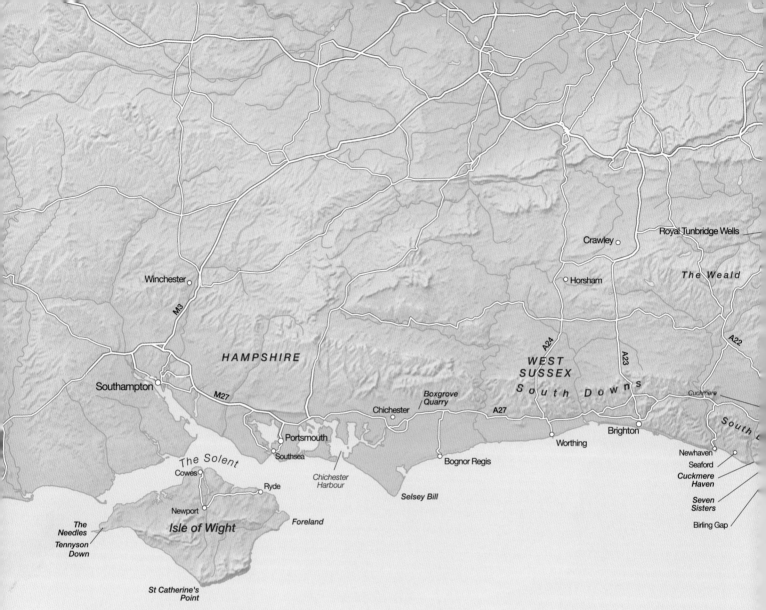

Dover to the Isle of Wight

THE CHALK COAST

PLACES TO VISIT

■ Brighton, West Sussex

'Old Ocean's Bauble, glitt'ring Brighton' is the south coast's definitive good-time, razzmatazz resort. Today it's arty youngsters, rollerbladers, festival-goers and spenders of the pink pound, rather than families on traditional seaside holidays, who stroll pier and promenades all year round – a new, funky and edgy flavour to the town that's seen among the refurbished arcades along the seafront with their second-hand bookshops, cafés, craft workshops and other chic emporia.

▶ ☎ 0906 711 2255 **www.visitbrighton.com**

■ Eastbourne, East Sussex

Eastbourne preserves the tranquillity – and gentility – that Brighton lacks. It boasts all the trimmings of a seaside resort, however, including a clutch of splendiferous Victorian hotels of which the Grand (built in 1875) is a classic of 'white wedding cake' architecture. The seafront has several promenades at different levels. It features a fine 1930s Art Deco bandstand, the Carpet Gardens with more than 65,000 plants producing two different displays each year and a Victorian pier complete with theatre, camera obscura, pavilions and steamer jetties, wind shelters adorned with dolphins and a whole mass of spires and gazebos – all held up on a cat's-cradle of spindly cast-iron legs and cross-bracing.

▶ ☎ 0906 711 2212 or 01323 415450
www.visiteastbourne.com

■ Hastings, East Sussex

This is a fascinating place, with its castle and atmospheric Old Town and its East Hill and

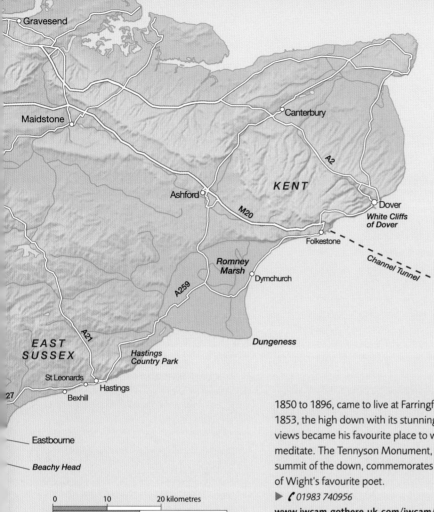

woodland and provided with water features.

▶ **http://matt.pope.users.btopenworld.com/boxgrove/boxhome.htm**

■ Dover Castle, Kent

One of the great castles of Britain, Dover Castle, on its commanding cliff-top, was first built in 1198 and has been added to ever since – notably underground, where a maze of tunnels dug by Napoleonic prisoners-of-war was used in the Second World War as a command post during the Battle of Dunkirk. Also from Napoleonic times is the extraordinary Grand Shaft, a triple spiral staircase 140 feet deep.

▶ ✆ *01304 211067 or 01304 201066*

■ Needles Old Battery, West Highdown, Isle of Wight

You approach from Tennyson Down (see left), walking westward along the Isle of Wight coast path, to reach this curious and historic place out on the western tip of the island. The nineteenth-century Needles Battery was positioned here to defend the English Channel from much-feared French invasions that never materialized, and it was in laboratories adjacent to the battery site that British scientists tried to propel the UK into the Space Race with the Black Arrow and Black Knight rocket experiments of the 1950s–60s (see **Find Out More**, page 188).

▶ **www.nationaltrust.org.uk**

■ Portsmouth Historic Dockyard

2005 saw the 200th anniversary of the death of England's greatest naval hero, Admiral Horatio Lord Nelson, at the Battle of Trafalgar. Portsmouth Historic Dockyard has developed a superb new Trafalgar Experience permanent exhibition alongside its perennial crowd-pleasers, the figureheads, the Nelson memorabilia and the three great ships – the Victorian ironclad battleship *Warrior*, the skeletal frame of King Henry VIII's flagship *Mary Rose*, which was salvaged from Portsmouth Harbour, and Admiral Nelson's flagship in which he gained the epic victory at Trafalgar, HMS *Victory*.

▶ ✆ *023 9286 1533* **www.flagship.org.uk**

■ Royal Pavilion, Brighton

George, Prince Regent of England, was a very naughty boy indeed before he became King George IV in 1820, and the roisterous atmosphere of early nineteenth-century

1850 to 1896, came to live at Farringford in 1853, the high down with its stunning sea views became his favourite place to walk and meditate. The Tennyson Monument, at the summit of the down, commemorates the Isle of Wight's favourite poet.

▶ ✆ *01983 740956*

www.iwcam.gothere.uk.com/iwcam/HTML-JavaFiles/2001/010525java.htm

ISLANDS

■ Isle of Wight

A compact lozenge of an island some 23 miles broad and 13 miles from north to south, the Isle of Wight lies separated from the Hampshire coast by the strongly tidal waterway of the Solent. Queen Victoria's favourite south coast holiday spot (she and Prince Albert adored their great house of Osborne on the island), the Isle of Wight is famous for sailing – especially the 'Yachtsman's Ascot' of Cowes Week – and for its network of walking routes, a remarkable 500 miles of footpaths that lead through woods, ravines, villages and wonderful coastal scenery.

▶ ✆ *01983 813818* **www.isleofwight.com**

▶ 🚢 *from Southampton or Lymington*

SITES OF INTEREST

■ Boxgrove Quarry, West Sussex

Boxgrove Quarry in West Sussex, the place where 'Boxgrove Man' was discovered in 1994 (see box, page 13) has been bought for the nation by English Heritage. Much of the site has been planted for pasture and

West Hill Lifts or funicular railways. The Stade, a great pebble beach backed by restored seventeenth-century fishermen's huts, is home to the largest beach-based fishing fleet in Europe. The East Hill Lift rises to Hastings Country Park, a beautiful 660-acre cliff-top mosaic of heathland, grassland and woods, criss-crossed by footpaths. Of the grandiose functionalist architecture commissioned in the 1930s by the 'Concrete King' of Hastings, Sydney Little (see page 16), the double-decker seafront car park and 'Bottle Alley' promenade still remain.

▶ ✆ *01424 781111* **www.visithastings.com**

▶ *Hastings Country Park* **www.wildhastings.org.uk/reserves/hcp.aspx**

■ Tennyson Down, Isle of Wight

Situated at the western tip of the Isle of Wight, Tennyson Down is one of the most spectacular pieces of chalk downland in Britain, forming a beautiful curve of turf that covers a cliff almost 500 feet high. When Alfred Lord Tennyson, Poet Laureate from

Scale: 0 – 10 – 20 kilometres / 0 – 10 – 20 miles

Brighton suited him to a T. Here he planned and built the ultimate fantasy palace, the Royal Pavilion – a preposterously grandiose confection crowned with minarets and onion domes and filled with draperies, damask, dragons and other decadent delights.

▶ ℓ *01273 290900* **www.royalpavilion.org.uk**

■ Spinaker Tower, Portsmouth

A stunning piece of modern architecture, the bone-white Spinaker Tower rises 558 feet into the air from the Portsmouth waterfront near the Historic Dockyard, its slender needle shape lent grace by a bellying 'sail'. The three viewing platforms are over 300 feet above ground level and provide a breath taking panorama over Portsmouth, the Solent, Southampton and the Isle of Wight.

▶ ℓ *023 9285 7520* **www.spinakertower.co.uk**

NATURAL WORLD

■ Chalk cliffs

Tiny shell-backed creatures lived and died in the Great Chalk Sea that covered most of Europe some 60–80 million years ago. Their remains formed massive deposits on the sea floor. Compressed into a band approximately 1700 feet thick, this layer of chalk is exposed along the coasts of Kent, East Sussex and the Isle of Wight. Fine examples include the White Cliffs of Dover (up to 350 feet), Beachy Head (530 feet), the Seven Sisters, Tennyson Down and Highdown. The National Trust's Neptune Walks (see National Trust website) follow much of this coastline.

▶ *Beachy Head* **www.eastbourne.org**
▶ *Seven Sisters* **www.sevensisters.org.uk**
▶ *White Cliffs of Dover* **www.whitecliffscountry.org.uk**

■ Flint

Layers of flint are seen as dark lines running horizontally along the faces of the chalk cliffs.Flint was formed some 60 million to 100 million years ago, when the skeletons of ancient sponges and other marine inhabitants of the Great Chalk Sea died and dissolved. These produced crystals of silica, which then coalesced to form layers of flint (See **Find Out More**, right).

■ The Needles

The Needles consists of three slim blades of chalk rising from the sea at the sharp western tip of the Isle of Wight. A famous landmark, they are especially striking when they shimmer white in the sun, or when winter storms send waves bursting over them.

▶ *The Needles Park (tourist attraction)*
ℓ *0870 458 0022*

■ Rock pools

At Holywell (the westernmost end of Eastbourne's seafront) low tide exposes a big shelf of rock that contains some of the best rock pools on the chalk coast.

▶ **www.glaucus.org.uk/aquariol.htm**

■ Shingle

Europe's largest vegetated shingle spit, Dungeness is a weird and a wonderful place – a vast prairie of pebbles that blooms with rare plants, a dry wasteland thronged with birds where the RSPB maintains a reserve, a place of extreme loneliness where fishermen congregate and an elemental desert over-shadowed by a nuclear power station. Film-maker, painter and iconoclast Derek Jarman (1942–94), suffering from AIDS towards the end of his life, settled between Lydd-on-Sea and Denge Beach at Dungeness, and created a wonderful shingle garden with flotsam, jetsam and hardy beach plants around his wooden shack, Prospect Cottage. The cottage and garden are privately owned.

▶ **www.english-nature.org.uk/ livingwiththesea/project_details/good_ practice_guide/habitatcrr/enrestore/ champs/dungeness-pettlevels/dungeness/ summary.htm**

ACTIVITIES

■ Flint-knapping

Flint-knapping is the art of making tools from flint. The following organizations run flint-knapping courses:

▶ *Kent Archaeological Field School of Faversham*
ℓ *01795 532548* **www.kafs.co.uk**
▶ *Natural Pathways of Littlehall Pinetum, Canterbury* **www.natural-pathways.co.uk/ flint-knapping.htm**

■ Fossil-hunting

The cliffs of Hastings Country Park between Covehurst Wood and Lee Ness Ledge are especially good for plant fossils. Birling Gap, and the cliffs towards Beachy Head from Holywell at the west end of Eastbourne seafront, are good for ammonites.

▶ **www.visithastings.com/attractions/hcp_ fossils.asp**

■ Walking

The Saxon Shore Way long-distance footpath skirts the entire Kentish coast from Gravesend to Hastings. The South Downs Way National Trail follows the cliffs from Eastbourne to Winchester via Cuckmere Haven. The Vanguard Way goes from Croydon to Newhaven, via Cuckmere Haven. The undercliff shore walk stretches from Newhaven to Brighton. The Isle of Wight Coastal Path and Tennyson Trail both follow the same route, from Freshwater Bay to Tennyson Down and The Needles.

▶ **www.ramblers.org.uk/info/regional/ southernengland**

FIND OUT MORE

Isle of Wight and the Space Race

The Isle of Wight witnessed Britain's attempts to compete in the international Space Race with a ballistic nuclear missile, a satellite and its launcher.

Black Knight rocket **www.spaceuk.org/bk/ bk.htm**
Black Arrow satellite launcher **www.spaceuk.org/ ba/blackarrow.htm**
Prospero satellite **http://news.bbc.co.uk/2/hi/ uk_news/magazine/3388535.stm**

Channel Tunnel/Eurotunnel

Information about this wonderful triumph of modern engineering.
www.theotherside.co.uk/tm-heritage/ background/tunnel.htm
www.lcrhq.co.uk
www.eurotunnel.com

Flint and its formation

Flint can be seen along the chalk cliffs of this coastline. Below are some websites that explain its formation and uses.
www.chalk.discoveringfossils.co.uk/ Chalk%20Group.htm
www.england-in-particular.info/buildings/ b-flint.html
http://museums.ncl.ac.uk/flint/menu.html
http://members.aye.net/~bspen/fire.html

Global warming and chalk

Erosion of the chalk cliffs by rising and intensifying waves, and the destruction of marine shells by carbon dioxide.
www.eastbourne.org/tourism/beachyhead/ geology.php
www.resurgence.org/resurgence/issues/ harding204.htm
www.timesonline.co.uk/article/0,,2089-2058687,00.html

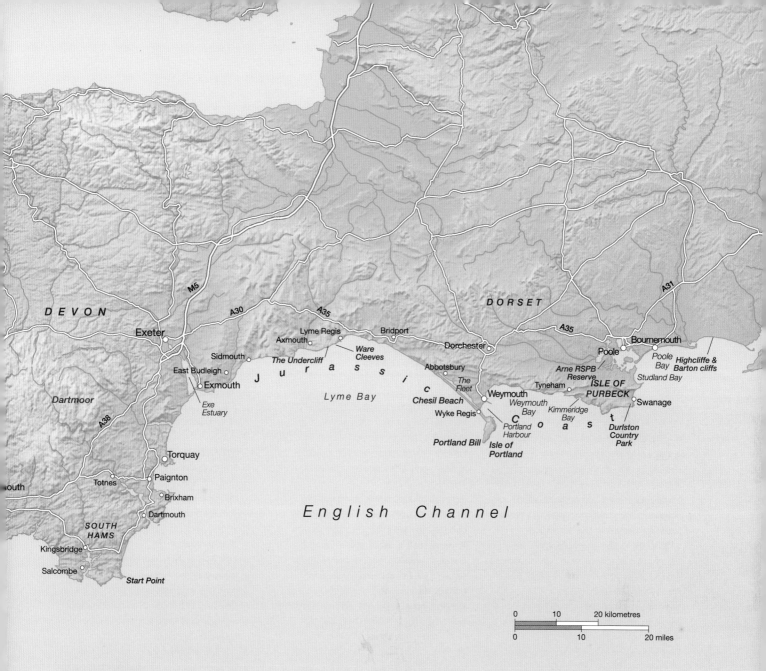

DEVON

Exeter

M5

A30

A35

DORSET

A35

A31

Lyme Regis
Axmouth

The Undercliff

Ware
Cleeves

Bridport

Dorchester

Bournemouth

Poole

Poole
Bay

Highcliffe &
Barton cliffs

Sidmouth

East Budleigh

Exmouth

Dartmoor

A38

Exe
Estuary

J u r a s s i c

Lyme Bay

Abbotsbury

The
Fleet

Chesil Beach

Wyke Regis

Weymouth

Weymouth
Bay

Arne RSPB
Reserve

Tyneham

ISLE OF
PURBECK

Kimmeridge
Bay

Studland Bay

Swanage

C o a s t

Durlston
Country
Park

Torquay

Paignton

Totnes

Brixham

Dartmouth

SOUTH
HAMS

Kingsbridge

Salcombe

Start Point

Portland
Harbour

Portland Bill

Isle of
Portland

English Channel

0 10 20 kilometres

0 10 20 miles

Bournemouth to Plymouth

THE ENGLISH RIVIERA

PLACES TO VISIT

■ Bournemouth, Dorset

Bournemouth is an elegant resort that has reinvented itself as a well-appointed conference venue. There are miles of attractive public gardens, filled with flowers and trees, and well-kept promenades. The town also has a fabulous sandy beach.

▶ ☎ 01202 451700 **www.bournemouth.co.uk**

■ Brixham, Devon

Lovely villas peep out of the woods around Brixham, but the smallest of Torbay's three neighbouring resorts is still the most focused on the ancient industry of fishing. Alongside the recently developed marina and the harbour with its fish quay (fresh fish on **sale** here) is the working port from which the fleet goes out. There are pebbly beaches and many fish restaurants.

▶ ☎ 01803 852861 **www.brixham.uk.com**

■ Dartmouth, Devon

The English Riviera's most beautiful and characterful resort town, tucked away up the estuary of the River Dart and connected by ferry with Kingswear opposite. Cobbled laneways, narrow streets, bookshops, restaurants, ancient pubs and a historic waterfront, where the Pilgrim Fathers stopped in 1620 *en route* to Plymouth, before their Big Sail to the New World.

▶ ☎ 01803 834224
www.discoverdartmouth.com

■ Lyme Regis, Dorset

This small resort on the Dorset–Devon border is located along the famous Jurassic Coast (see **Natural World**, opposite). If you are unlucky enough not to have found a fossil on the beach, you can buy one as a souvenir at the Lyme Regis Fossil Shop. Lyme Regis also has distinguished literary connections (see **Cobb breakwater**, right).

▶ ☎ 01297 442138
www.lymeregistourism.co.uk

■ Plymouth, Devon

A great historic seaport on the Devon–Cornwall border. The attractions of Plymouth are all along its waterfront: Plymouth Hoe with its Francis Drake statue, the seventeenth-century Royal Citadel that guards the harbour, Mayflower Stone and Mayflower Steps on Sutton Harbour, and the nineteenth-century Royal William Victualling Yard, which is being transformed into a residential and leisure development. Boat

trips from Sutton Pool show you all this from the water.

▶ ☎ 01752 306330/306331
www.visitplymouth.co.uk

■ Sidmouth, Devon

A pearl of a Regency resort, with white terraces set in a cleft between red sandstone cliffs, parks, old-fashioned shops and beaches, with rock pools and plenty of red sand exposed at low tide. Sidmouth Folk Week in high summer is an internationally renowned festival of traditional music, song and dance.

▶ ☎ 01395 516441 **www.visitsidmouth.co.uk**

■ Swanage, Dorset

Swanage is a little resort town with an interesting architectural history. George Burt, a local stonemason, was involved in the rebuilding of Victorian London, and incorporated many wonderful pieces of 'Old London' in the streets and buildings of his home town – including his own residence of Purbeck House, on the High Street (see **Sites of Interest**, opposite).

▶ ☎ 01929 422885 **www.swanage.gov.uk**

■ Torquay and Paignton, Devon

Together with its sister resort of Paignton, Torquay's elegant Victorian 'wedding-cake' architecture draws as many foreign as domestic visitors. The main attraction is the cliff setting among lush woods and gardens, with a wonderful traditional seafront promenade; there's also Babbacombe Miniature Village, an 'indoor beach' with wave-machine pool, and a cliff railway. Paignton has a zoo, a water park and good sandy beaches.

▶ ☎ 0870 7070 010
**www.theenglishriviera.co.uk/torquay/
torquay.asp**

■ Weymouth, Dorset

A long-established West Country favourite, with plenty of fine Regency and Victorian architecture, thanks to its profitable connection with King George III, commemorated by a fine statue of him on the town's seafront. It was through the Dorset port of Melcombe Regis (nowadays part of Weymouth) that the devastating scourge of the Black Death plague entered Britain in 1348 and killed roughly half the population of the country within a year.

▶ ☎ 01305 785747
www.weymouth-dorset.co.uk

ISLANDS/PENINSULAS

■ Isle of Portland, Dorset

The Isle of Portland, the 'Gibraltar of Wessex', is connected to the southern end of Weymouth by a slender peninsula; but Portland might as well be an island, because it's definitely a place apart, with its grimly forbidding prison and borstal, giant harbour guarded by breakwaters, gaunt quarries that have been worked for stone for 600 years, and its southerly point of Portland Bill.

▶ ☎ 01305 785747
**www.resort-guide.co.uk/pagedest.
php3?destcode=115**

SITES OF INTEREST

■ Abandoned village of Tyneham, Isle of Purbeck, Dorset

Tyneham is a ghost village on the east Dorset cliffs, between Worbarrow Bay and Kimmeridge Bay. The Army requisitioned buildings and land in 1943, the inhabitants moved out, and no one has ever moved back again. A permanent exhibition in Tyneham's church (open on Ministry of Defence open days) tells its story.

▶ ☎ 01929 404819
www.isleofpurbeck.com/tyneham.html

■ Abbotsbury Swannery, Dorset

Several hundred swans enjoy protection at Abbotsbury Swannery, between Weymouth and Bridport, as they have since medieval times (when they were destined for the Abbot's table). From June onwards, you can walk to their nesting site and watch the young cygnets and parents together.

▶ ☎ 01305 871858
www.abbotsbury-tourism.co.uk/swannery.html

■ All Saints Church, Wyke Regis, Dorset

This church overlooks the eastern end of Chesil Beach. In an unmarked grave in the churchyard lies William Wordsworth's seafaring brother John, who drowned along with 300 passengers when the East Indiaman *Earl of Abergavenny* – of which he was captain – was wrecked off Portland on 5 February 1805. Many other shipwreck victims also lie buried here.

■ Cobb breakwater, Lyme Regis, Dorset

The Cobb, Lyme Regis's ancient breakwater, has curved from the beach out to sea like a petrified snake for the past 700 years. It has

been battered and breached by storms and rebuilt many times. Two famous literary scenes have been set there – Jane Austen gave Louisa Musgrove a near-fatal fall from the tiny steep steps called 'Granny's Teeth' in *Persuasion*, and John Fowles allowed us a first glimpse of his heroine Sarah Woodruff, the 'Scarlet Woman of Lyme', at the end of the Cobb in his classic novel *The French Lieutenant's Woman*.

■ Durlston Country Park, Swanage, Dorset

High on the cliff of Durlston Point, to the south of Swanage, one of Britain's first country parks was established in the 1880s. It is laid out in what was the estate of George Burt, the well-to-do Swanage stonemason who wanted his fellow townspeople to enjoy his land and educate themselves at the same time. Words of wisdom are etched on stone plaques beside the paths leading to the Great Globe, which is made of 40 tons of Portland stone. Today, there is a visitor centre, shop and the Lookout Café in the annexe to the nineteenth-century Durlston Castle.

▶ ☎ 01929 424443 www.durlston.co.uk

■ Philpot Museum, Lyme Regis, Dorset

The late John Fowles, novelist and resident of Lyme Regis, was one of the distinguished curators of the Philpot Museum. The museum offers an excellent run-through of the history of the town and is also home to one of the world's great fossil collections.

▶ ☎ 01297 443370
www.lymeregismuseum.co.uk

■ Purbeck House, Swanage, Dorset

Turreted, gabled and be-chimneyed, Purbeck House lords it over Swanage High Street. A great granite residence built in 1875 by George Burt (see **Durlston Country Park**, above) in lavish 'Scottish Baronial' style, Purbeck House incorporates many pieces salvaged from Burt's rebuilding of old London – parts of Billingsgate Fishmarket (columns and balustrades), the Albert Memorial (walls), Hyde Park Corner (archway), Westminster Hall (gargoyle), the medieval Houses of Parliament (carving), Waterloo Bridge (columns) and the Royal Exchange (statues). After years of use as a convent, the building is now a hotel.

▶ ☎ 01929 422872
www.purbeckhousehotel.co.uk

NATURAL WORLD

■ Cliffs

The yellow Barton and Highcliffe cliffs near Bournemouth are of clay and sand, the much-quarried white cliffs of Purbeck and Portland are of a hard limestone known as freestone (excellent for building) and the black striated cliffs at Kimmeridge are of shale. Around Lyme Regis, the unstable blue-grey cliffs topped with yellow and white are of blue lias clay under chalk and greensand, while those towards the Exe Estuary are of rich red sandstone.

▶ www.soton.ac.uk/~imw/barton.htm
▶ www.soton.ac.uk/~imw/lyme.htm

■ Jurassic Coast

The 95-mile stretch of coast between Studland Bay in East Dorset and Exmouth in East Devon has been designated a UNESCO World Heritage Site because of its extraordinary geology, which runs from the hard pale limestone of the east to the warm red sandstone of the west, with every kind of formation, bend, twist and zigzag in between.

▶ www.jurassiccoast.com

■ Lagoons

The great shingle bank of Chesil Beach in Dorset shelters the shallow, brackish waters of the Fleet, a lagoon that is warmer in summer and colder in winter than the surrounding area. Its semi-salty water supports large varieties of seaweeds, and enough kinds of molluscs and aquatic plants to feed a large number of bird species.

▶ www.soton.ac.uk/~imw/Fleet-Lagoon.htm

■ Woodland

A single narrow footpath runs through the Undercliff for 5 miles along the edge of the cliffs between Lyme Regis and Axmouth. Unstable geology has caused huge landslips, and for 150 years no one has lived in the Undercliff, hence its status as a beautiful piece of woodland full of wild flowers.

▶ www.woodland-trust.org.uk

ACTIVITIES

■ Birdwatching

You'll find excellent birdwatching on Arne RSPB Reserve on Poole Harbour (nightjars, Dartford warblers) and Chesil Beach, including the Fleet (wading birds, swans, terns, ringed plovers and skylarks – NB restrictions in breeding season, March–July).

▶ www.naturalist.co.uk/nothe/nothe1.htm

■ Fossil-hunting

Fossil-hunting is wonderful along the Jurassic Coast, especially at the foot of the cliffs around Lyme Regis and in the yellow cliffs near Bournemouth. Take sensible precautions: some of the ground is sinking, and a sudden cliff fall is always a possibility.

▶ www.jurassiccoast.com/index.jsp?articleid=26806

■ Sailing

There is sailing in Portland Harbour and on the Exe Estuary, but the main centre is around Salcombe and the Kingsbridge Estuary in the South Hams of Devon. Salcombe's ICC (Island Cruising Club) provides courses, instruction and boat hire.

▶ ☎ 01548 531176 www.icc-salcombe.co.uk

■ Walking

The South-West Coast Path National Trail runs the whole length of the English Riviera from Poole westward, and makes a truly memorable walk. It connects with several other long-distance paths, and there are many shorter walks too.

▶ ☎ 01305 871858 www.ramblers.org.uk/info/paths/southwestcoast.html

FIND OUT MORE

Plymouth breakwater

An extraordinary construction a mile long, nearly 50 feet wide and 80 feet tall, which has saved countless lives since it was built between 1812 and 1847, at a staggering cost of £1.5 million.
www.plymouthdata.info/Breakwater.htm

Shale oil well

Strange but true – a 'nodding donkey' oil well at Wytch Farm, on the black shale cliffs at Kimmeridge Bay in the Isle of Purbeck, is still harvesting shale oil from Middle Jurassic strata far below, as it has done for the past 40 years.
www.coastlink.org/kimmeridge/past.htm
www.soton.ac.uk/~imw/kim.htm

Sir Francis Drake

A very English hero, Plymouth's most prominent son, and a bit of a rapscallion into the bargain.
www.plymouthdata.info/PP-Drake.htm

Sir Walter Raleigh

Elizabethan courtier, explorer, writer and Devon man, born at Hayes Barton near East Budleigh.
www.btinternet.com/~richard.towers/jim/raleigh.html

The Channel Islands

GATEWAY TO THE CONTINENT

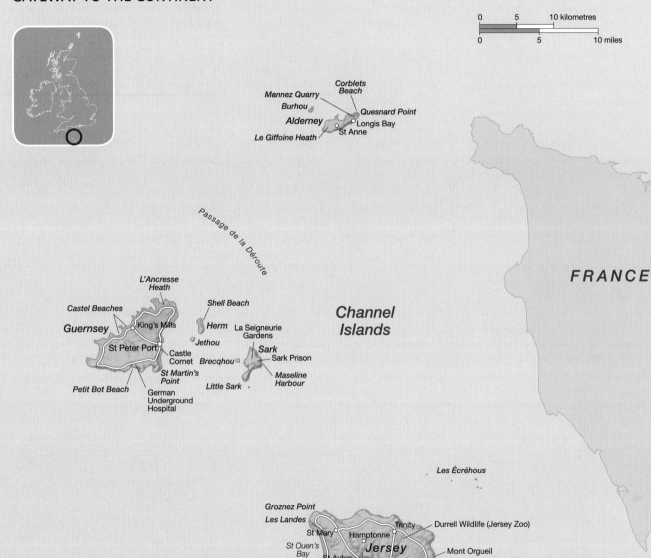

0 5 10 kilometres
0 5 10 miles

FRANCE

Corblets Beach

Mannez Quarry

Burhou

Alderney

Quesnard Point

Longis Bay

St Anne

Le Giffoine Heath

Passage de la Déroute

Channel Islands

L'Ancresse Heath

Castel Beaches

Shell Beach

Herm

La Seigneurie Gardens

Guernsey

King's Mills

Jethou

Sark

St Peter Port

Castle Cornet

Brecqhou

Sark Prison

St Martin's Point

Little Sark

Maseline Harbour

Petit Bot Beach

German Underground Hospital

Les Écréhous

Groznez Point

Les Landes

Trinity

Durrell Wildlife (Jersey Zoo)

St Mary

Hamptonne

St Ouen's Bay

Jersey

Mont Orgueil

St Aubin

St Helier

Corbière Point

Royal Bay of Grouville

Jersey War Tunnels

St Aubin's Bay

Les Minquiers

PLACES TO VISIT

■ Alderney

Out at the north-east edge of the archipelago, Alderney is only 9 miles from the tip of the Cotentin Peninsula, in France. Auregnais is the native language, but it has all but vanished. St Anne, snug in the centre of the island above the harbour on the north-west coast, is Alderney's only town, with plenty of amenities and a charming cobbled High Street. From here, roads radiate out through the gently rolling interior to the cliffs of the south and east coasts and the fine crescent-shaped beaches of the west. You can travel there by air or can take the ferry from Guernsey.

▶ ℓ *01481 822994* **www.alderney.net**
▶ ☙ ℓ *01481 701316*
www.manche-iles-express.com

■ Guernsey

Guernsey lies to the north-west of Jersey. St Peter Port, Guernsey's picturesque 'capital town', rises in terraces and cobbled laneways in the centre of the rugged east coast. The native language is Dgèrnésiais. The town is the focal point for Guernsey's many festivals, and it has a number of really good restaurants and pubs. Make for the west coast if you are looking for good beaches and for the eastern cliffs to spot seabirds and stroll flowery paths – these criss-cross the interior, too. You can get to Guernsey by air or by ferry.

▶ ℓ *01481 723552* **www.visitguernsey.com**
▶ ☙ *from Poole, Portsmouth, Weymouth*
ℓ *0870 243 5100* **www.condorferries.com**
▶ ☙ *from Southampton* ℓ *01481 251840*
www.shipandfly.com

■ Herm

The island of Herm lies 3 miles east of Guernsey, and is 1½ miles long and ½ mile wide. Herm is a car-free island, leased by the resident Heyworth family. It possesses Shell Beach – as its name suggests, a lovely beach of shell sand. The diminutive harbour has a few shops and a couple of pubs. Hotels, self-catering accommodation and camping are all available to the visitor. This is a real away-from-it-all place, full of wild flowers and subtropical plants. You can get to Herm by ferry from Guernsey.

▶ ℓ *01481 722377* **www.herm-island.com**
▶ ☙ ℓ *01481 721379* **www.herm-island. com/gettinghere/herm_ferry/default.aspx**

■ Jersey

As the biggest, most southerly and most populous of the Channel Islands (with nearly 90,000 inhabitants), Jersey boasts the largest town, St Helier, occupying one side of St Aubin's Bay on the south coast. What St Helier lacks in chocolate-box charm, it makes up for in facilities and nightlife. The island has a wonderful sandy beach in St Ouen's Bay in the west and the Royal Bay of Grouville to the east, while the cliff-bound north coast is rocky, and the interior is a green patchwork of woods and farmland. Jerriais, the native language, is occasionally spoken. You can get there by air or ferry from Poole, Portsmouth or Weymouth.

▶ ℓ *01534 500700* **www.jersey.com**
▶ ☙ ℓ *0870 243 5100* **www.condorferries.com**

■ Jethou

Jethou is now owned by the States of Guernsey. The island is not open to the public, but there are great views from the Herm ferry, while outfits such as Island Ventures (ℓ *01227 793501* **www.islandventures.co.uk**) offer wildlife cruises around Jethou to see puffins and other seabirds.

▶ **www.faed.net/cfaed/jethou/jethou.htm**

■ Sark

A diminutive, ragged-edged island, Sark is some 3 miles long and half as broad. It lies 6 miles east of Guernsey's south-eastern headland. The native language of Sercquiais is still spoken by some of the 600 inhabitants. Sark village lies above Maseline Harbour, and from here untarmacked, car-free roads lead south to fine beaches, sheltered by headlands around the isthmus leading to Little Sark. Steep paths take you down to the beaches, and the headlands and roadsides are full of wild flowers. You can get around Sark on foot, by bicycle or horse-drawn carriage, and can reach it by ferry from Guernsey.

▶ ℓ *01481 832345* **www.sark-tourism.com**
▶ ☙ ℓ *01481 724059*
www.sarkshipping.guernsey.net

SITES OF INTEREST

■ Alderney Society Museum

Located at St Anne, this gives an excellent overview of the island, from early history through quarrying, the German Occupation, wildlife and the story of the Alderney cow.

▶ ℓ *01482 823222*
www.alderneysociety.org/museum.html

■ Castle Cornet, Guernsey

Castle Cornet is a stern stronghold overlooking Guernsey's harbour; it contains four museums, including an enjoyable Maritime Museum.

▶ ℓ *01481 721657*
www.museum.guernsey.net/castle.htm

■ Gardens of La Seigneurie, Sark

The gorgeous gardens of La Seigneurie (home of the Seigneur, Sark's 'feudal ruler' since the sixteenth century) are a great attraction on this island.

▶ ℓ *01481 832345* **www.sark-tourism.com**

■ German Military Underground Hospital, Guernsey

The German Military Underground Hospital at La Vassalerie, St Andrews, Guernsey, is a vast and eerie complex of tunnels excavated by slave labourers from 1940 to 1944.

▶ ℓ *01481 239100* **www.bbc.co.uk/guernsey**

■ Guernsey Tapestry, St Peter Port, Guernsey

The Guernsey Tapestry at the Dorey Centre, St Peter Port, gives a fascinating account of the island's history.

▶ ℓ *01481 727106*
www.guernseytapestry.org.gg

■ Jersey museums

Good museums in St Helier include the comprehensive **Jersey Museum** (ℓ *01534 633300*) and the hands-on, child-friendly **Maritime Museum** (ℓ *01534 811043*) with its special gallery containing Jersey's remarkable Occupation Tapestry. Outside the town, **Hamptonne Country Life Museum** in St Lawrence (ℓ *01534 863955*) is a through-the-centuries look at farming that has plenty for all ages. **Jersey War Tunnels** is an Occupation museum, well displayed in a wartime hospital/bunker complex (ℓ *01534 860808* **www.jerseywartunnels.com**).

▶ **www.islandlife.org/forts_jsy.htm**

■ Jersey Zoo

In the centre of the island is Jersey Zoo, now renamed Durrell Wildlife, a sanctuary dedicated to the preservation of threatened species from extinction.

▶ ℓ *01534 860000* **www.durrellwildlife.org**

■ Mont Orgueil Castle, Jersey

This castle at Gorey is a fabulous, lowering beast of a fortress, built in the thirteenth century as defence against the French.

▶ ℓ *01534 853292*
www.islandlife.org/forts_jsy.htm

■ Sark Prison
A popular attraction on Sark is the tiny two-cell prison located in the Junior School yard. It was last used in 1999 to sober up some over-refreshed visitors.
▶ ℓ 01481 832345 **www.sark-tourism.com**

■ Second World War fortifications, Alderney
Alderney is littered with Second World War fortifications, such as the Bauhaus-style fire-control tower at Mannez Quarry. Until recently, these were uncared-for and open to intrepid explorers. Today, the island's tourist authority is beginning to promote and explain the watchtowers and bunkers to interested visitors.
▶ ℓ 01481 822811 **www.subbrit.org.uk/sb-sites/sites/a/alderney/index.shtml**

NATURAL WORLD
■ Beaches
Each island possesses wonderful beaches for sandcastling, rockpooling and sunbathing. Don't miss St Ouen's Bay in Jersey, Petit Bot and Castel in Guernsey, and Corblets and Longis Bay in Alderney.
▶ *Alderney* **www.alderney.gov.gg/index.php/pid/79**
▶ *Guernsey* **www.islandlife.org/beaches_gsy.htm**
▶ *Jersey* **www.aboutjersey.net/see/beaches.html**
▶ *Sark* **www.islandlife.org/beaches_sark.htm**

■ Cliffs
Jersey's north coast, threaded by a scenic footpath, skirts handsome cliffs, as does Guernsey's east coast. Alderney's cliffs are home to the extremely rare spotted rockrose, while Sark's are seamed with precipitous footpaths leading down to the island's beautiful bays.
▶ *Guernsey* **www.gov.gg/ccm/environment/coastal-management/coastal-management/cliff-paths**
▶ *Jersey* **www.islandlife.org/walking_jsy.htm**

■ Heaths
Les Landes, at the north-western tip of Jersey, is a fine stretch of coastal heath, valued for its bird and plant life, as are L'Ancresse on the north coast of Guernsey, and Le Giffoine in west Alderney, where the threatened Dartford warbler thrives.
▶ **www.nationaltrustjersey.org.je/showcase/naturalheathlands.asp**

■ Reefs
Two Channel Island reefs are Les Écréhous, 6 miles north-east of Jersey, and Les Minquiers ('The Minkies'), 12 miles south of the island. Each possesses a handful of seldom-inhabited stone cottages, a lonely atmosphere and an other-worldly beauty.
▶ *Les Écréhous* **www.jcc.org.je/guide/Ecrehous.asp**
▶ *Les Minquiers* **www.jcc.org.je/guide/Jersey_Minquiers.asp** **www.seapaddler.co.uk/LesMinquiries.htm**

ACTIVITIES
■ Beach sports
Blokarting, sand-yachting, riding and kiteboarding are popular on many beaches, especially St Ouen's Bay in Jersey.

■ Birdwatching
The Channel Islands are well known as a touching point for birds of passage on autumn and spring migrations. Breeding birds of Alderney and its outpost islets include puffins, fulmars and 7000 pairs of gannets. Rare visitors have included black kites, golden orioles and fan-tailed warblers. Burhou Island, an offshore reserve, has accommodation and can be rented from August to February.
▶ **www.islandlife.org/birdwatching_ald.htm**
▶ *Burhou Island* **www.burhou.com**

■ Cycling
Cycling is a genuine pleasure in the Channel Islands. Jersey has its network of 'green roads', Guernsey and Alderney have their unfrequented by-lanes, and Sark is completely car-free.
▶ *Guernsey* **www.visitguernsey.com/gettingaround/results.aspx?typeid=3**
▶ *Jersey* **www.jersey.com/cycling**

■ Festivals
A selection from the dozens of annual Channel Islands festivals:
Alderney Wildlife Festival Week (May–June); Alderney Week and Wildlife Festival Weekend (August); Angling Festival (October).
Guernsey 'La Fete d'la Mair' seafood and maritime festival (June–July); Anglo-Normandy Music Festival (August); Victor Hugo International Music Festival and Guernsey Folk Festival (September); International Dance/Sport Festival (November).
Jersey Spring Flower Show (April); Liberation Day (9 May); Polish Summer Festival (June); Out Of the Blue Maritime Festival (July); Battle of Flowers (August); Jersey Regatta (September).
Sark Seafood Festival (June).

■ Walking
Guided walks are laid on in several of the islands, for example Andrew Syvret's 'moon walks' (ℓ 01534 485201) and Mike Stentiford's north-coast rambles (ℓ 01534 861114) in Jersey and Gill Girard's guided walks around Guernsey (**www.gillgirardtourguide.com**). Jersey and Guernsey both possess networks of footpaths and hold walking festivals.

■ Watersports
Angling, surfing, windsurfing, sailing, water-skiing, snorkelling and scuba diving are all present and correct in these clear, unpolluted waters and fine wave-prone bays. There are also boat trips around the islands.
▶ *around Alderney* **www.alderney.gov.gg/index.php/pid/36**
▶ *around Jersey* **www.jersey.com/active/content_page.asp?id=1355"**

FIND OUT MORE
Brecqhou
Tiny Brecqhou, a strictly private islet just west of Sark, is the site of an extravagant castle built at an estimated cost of nearly £100 million by property and newspaper squillionaires David and Frederick Barclay after they bought the island in 1993.
http://en.wikipedia.org/wiki/Brecqhou

Channel Islands Government
The exact legal and political status of the self-governing Channel Islands has always been a source of fascination to the visitor.
http://en.wikipedia.org/wiki/Channel_Islands

Guernsey knitwear
Genuine oiled-wool garments finished by hand in Guernsey homes.
www.guernseyknitwear.co.uk

Ormers
The beautiful (and delicious) ormer is right at the limit of its northern range here, surviving thanks to the warm waters. You may find one of these large, nacreous shellfish with the distinctive row of holes at low tide or may be lucky enough to find ormer stew on a Jersey fish restaurant menu.
www.glaucus.org.uk/ormer.htm

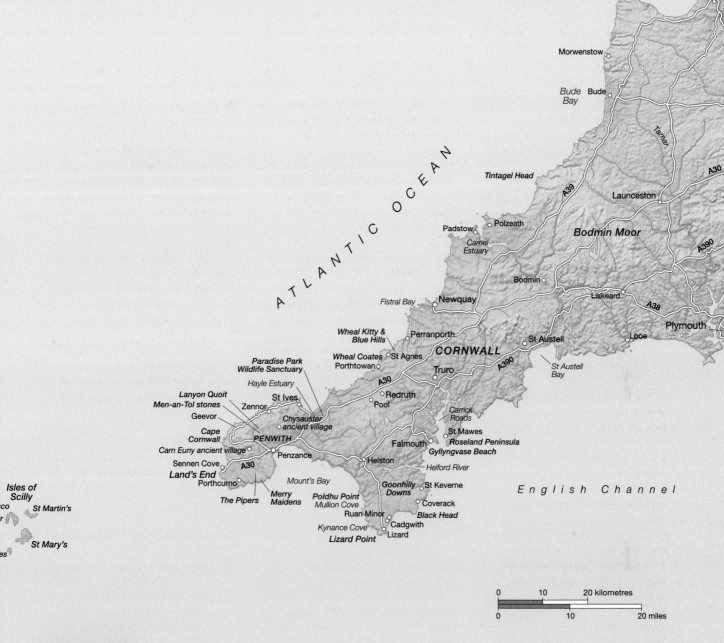

MORWENSTOW

Bude
Bay | Bude

Tintagel Head

Launceston

Bodmin Moor

Padstow | Polzeath

Camel
Estuary

Bodmin

ATLANTIC OCEAN

Fistral Bay | Newquay

Liskeard

Plymouth

Looe

Wheal Kitty &
Blue Hills | Perranporth

St Austell

CORNWALL

Wheal Coates | St Agnes

Porthtowan

St Austell
Bay

Paradise Park
Wildlife Sanctuary

Truro

Hayle Estuary

Redruth

Lanyon Quoit
Men-an-Tol stones | St Ives | Pool

Carrick
Roads

Zennor

Geevor

Chysauster
ancient village | St Mawes

Cape
Cornwall | PENWITH | Roseland Peninsula

Falmouth | Gyllyngvase Beach

Carn Euny ancient village

Penzance

Sennen Cove | Helston

Helford River

Land's End

Porthcurno

Goonhilly
Downs | St Keverne

The Pipers | Merry
Maidens | Mount's Bay

Poldhu Point
Mullion Cove

Coverack

Isles of
Scilly | Ruan Minor | Black Head

resco

St Martin's

Kynance Cove | Cadgwith

her

Lizard

gnes | St Mary's | Lizard Point

English Channel

0 10 20 kilometres

0 10 20 miles

Cornwall and the Scilly Isles

A LAND APART

<div style="float:left">**Cornwall and the Scilly Isles**
A LAND APART</div>

PLACES TO VISIT

■ Falmouth
The grey stone houses among flower gardens tightly hug the west side of the entrance to the mighty waterway of Carrick Roads, with the smooth or choppy sea always adding drama to the view. Pendennis Castle on the Point looks across the water to St Mawes and the green Roseland Peninsula.
▶ ☎ 01326 312300 www.go-cornwall.com

■ Looe
Looe lies on the south coast in east Cornwall. This is a fishing town of two halves: the more bustling East Looe contains the main shops and the busy fishing harbour, while across the bridge the settlement of West Looe is a lovely, quiet spot with a couple of nice restaurants. Sea angling trips are one of the town's great attractions.
▶ ☎ 01503 262072 www.looe.org

■ Padstow
A very characterful small town in a sheltered spot on the north Cornish coast, tucked round the corner of the Camel Estuary. Rick Stein has his highly acclaimed fish restaurant here. The best time to be in Padstow is on May Evening at midnight for the wild ceremony of night singing, a preliminary to the pagan ceremony of the two 'Obby Osses', which prance through the streets the next morning to celebrate May Day.
▶ ☎ 01841 533449 www.padstowlive.co.uk

■ Porthcurno
Porthcurno Cove was where the great telegraph cables that first linked Britain with India came ashore in 1870. Above in the village is the Porthcurno Telegraph Museum (See **Sites of Interest**, right).
▶ www.cornwall-online.co.uk/westcornwall

■ St Agnes
The former tin-mining village of St Agnes, on the north coast between Redruth and Perranporth, lies at the centre of a great concentration of nineteenth-century tin-mining relics and remains. These range from the ruin of Wheal Coates pumping-engine house, dramatically sited above the sea, to the still-operating Blue Hills tin-streaming works, where you can see the process at work and buy tin products.
▶ ☎ 01872 554150 www.perraninfo.co.uk

■ St Ives
There has been a thriving artists' colony at St Ives for nearly 100 years, and no wonder.

The clear north light, the charms of the grey-roofed fishing town and the beautiful surroundings of sand, sea and rock have attracted painters, sculptors and potters to west Cornwall. There are several galleries, including the Barbara Hepworth Museum and Sculpture Garden and Tate St Ives (see **Sites of Interest**, right and opposite).
▶ ☎ 01736 796297 www.go-cornwall.com

ISLANDS AND PENINSULAS
■ Isles of Scilly
The Scilly archipelago, 28 miles west of Land's End, consists of five inhabited islands. St Mary's is the 'capital island', with its flower fields and 5 miles of road; Tresco is famed for its subtropical gardens; and St Martin's, St Agnes and Bryher are all rugged and traffic-free. Warm seas, an early spring and mild winters make the Scillies an island paradise. You can fly to the Scillies from Southampton, Bristol, Exeter, Newquay or Land's End, or get the ferry or helicopter from Penzance.
▶ ☎ 01720 422536 www.simplyscilly.co.uk
▶ ☎ 0845 710 5555 www.ios-travel.co.uk
▶ ✈ ☎ 01736 363871
www.islesofscillyhelicopter.com

■ Lizard Peninsula
Lizard Point, at the southward tip of the Lizard Peninsula, is Britain's most southerly point, and many people drive the 10-mile road from Helston purely to stand there. This peninsula is bounded by wonderful coastal scenery – Black Head, Lizard Point, Kynance Cove, Mullion Cove – and seeded with characterful out-of-the-way villages such as St Keverne, Coverack, Cadgwith and Ruan Minor. In Lizard Town you can buy polished serpentine artefacts and the best pasties in the world at the Lizard Pasty Shop.
▶ ☎ 01326 565431 www.go-cornwall.com
▶ www.cornwalltouristboard.co.uk/aToZ.lizard

SITES OF INTEREST
■ Ancient sites
The moors of Penwith, in westernmost Cornwall, are rich in standing stones (Men-an-Tol near Gurnard's Head, the Merry Maidens and the Pipers near St Buryan), tombs (Lanyon Quoit near Madron) and ancient settlements (Chysauster near Nancledra, Carn Euny near Sancreed).
▶ www.shimbo.co.uk/history/historic.htm

■ Barbara Hepworth Museum and Sculpture Garden, St Ives
The house, grounds, studio and gardens in St Ives where Dame Barbara Hepworth lived and worked from 1949 until her death in 1975 are now an outstanding museum and gallery celebrating her life and inspiration.
▶ ☎ 01736 796226
www.tate.org.uk/stives/hepworth

■ Beam engines, Pool
At Pool, near Redruth, the National Trust maintains two enormous old beam engines of the type which, driven by steam, used to pump the water from the ever-flooding Cornish mines.

■ Isles of Scilly Museum, St Mary's
A notable small museum featuring displays on archaeology from the Bronze Age, the huge number of shipwrecks around the islands and the unique Scilly wildlife.
▶ ☎ 01720 422337 www.iosmuseum.org

■ Marconi monument, Poldhu Point
At Poldhu Point, just north of Mullion Cove, stands a monument commemorating the use of the site by Guglielmo Marconi for some of his early radio broadcast experiments, including the first transatlantic radio message on 12 December 1901. Some of the foundations of his original Poldhu Wireless Station (1900–33) can still be seen here.

■ Morwenstow Church and Vicarage
The church where Parson Hawker preached (see page 53) lies sheltered by trees next to the Vicarage he built (now a B&B); you can see the tall chimneys of the house, which Hawker had built in the shape of church towers. A signed path along the cliffs leads to the little hut where he wrote poems, smoked opium and meditated.
▶ www.atlantic-highway.co.uk/Villages/Morwenstow/Default.asp

■ Old Guildhall Museum, Looe
A fascinating trot through the varied and rambunctious history of East and West Looe, featuring a motley collection of seafarers, fishermen, smugglers, excisemen, preachers, tinners, lifeboatmen and artists – all housed in the fine old Tudor Guildhall.
▶ ☎ 01503 263709 www.cornucopia.org.uk/html/search/verb/ListIdentifiers/set/location/1789

■ Porthcurno Telegraph Museum
Housed in converted wartime bunkers, this museum tells the fascinating story of how a

tiny seaside community became the largest cable station in the world.

▶ ☎ *01736 810966* **www.porthcurno.org.uk**

■ **Tate St Ives**

St Ives has enjoyed an extraordinarily rich artistic heritage for the past century, with artists as eminent as sculptor Dame Barbara Hepworth, ceramicist Bernard Leach and painter Ben Nicholson. The Tate Gallery's outstation in St Ives does full justice to these and many more, while mounting a wide range of exhibitions.

▶ ☎ *01736 796226* **www.tate.org.uk/stives**

■ **Tin Mine, Geevor**

Geevor was a working tin mine until 1990; now it offers Cornwall's most comprehensive tin-mining experience, with underground tours, the Mill processing plant, the miners' changing rooms and showers, a wide range of original machinery and a museum.

▶ ☎ *01736 788662* **www.geevor.com**

■ **Tresco Gardens, Scilly Isles**

From the mid-nineteenth century, Augustus Smith, autocratic owner and ruler of the Scilly Isles, established these remarkable subtropical gardens on the island of Tresco, importing exotic plants from the four corners of the earth – a wonderful burst of lush growth in a windy, harsh environment.

▶ ☎ *01720 424108*
www.tresco.co.uk/the_abbey_garden

NATURAL WORLD

■ **Beaches**

Cornwall has so many wonderful beaches, and you will discover your favourite for yourself. Several hold the coveted Blue Flag award for European beaches. In 2005 these were Gyllyngvase (near Falmouth), Sennen Cove (near Land's End), Porthmeor and Porthminster (both at St Ives), Porthtowan (near St Agnes) and Polzeath.

▶ **www.cornishlight.co.uk/beach.htm**

■ **Cliffs**

The magnificent cliffs of Penwith in westernmost Cornwall, of characteristic dark granite, are symbolic of the defiance, harshness and sombre beauty of the county. At Kynance Cove on the Lizard Peninsula, this darkness is relieved by the soft, colourful hues of serpentine – a rock that shimmers in iridescent blues, greens and pinks. Kynance is one of the most striking and unusual bays in Cornwall. For much of eastern Cornwall,

old red sandstone and blue-grey slate form the cliffs.

▶ **www.countryside.gov.uk/LAR/Landscape/ DL/heritage_coasts/Cornwallhc.asp**

■ **Estuaries**

Several fine estuaries split the Cornish coast – notably the vast natural harbour of Carrick Roads at Falmouth, the Helford River in the eastern flank of the Lizard Peninsula (setting of Daphne du Maurier's romance *Frenchman's Creek*), the broad, muddy Hayle south-east of St Ives, and the winding Camel from Padstow inland to Wadebridge.

▶ **www.cornwall.gov.uk/index. cfm?articleid=4386**

■ **Heaths and moors**

The interior of Penwith has plenty of moorland studded with granite tors (outcrops), which stand out like castles or towers against the sky. The Lizard Peninsula has fine patches of heath, especially around Goonhilly Downs, where you'll find Cornish heath (*Erica vagans*) – a bushy shrub with delicate, pinky white, bell-shaped flowers; it is very rare in most of Britain but much in evidence here.

▶ *Heaths* **www.cornwall.gov.uk/index. cfm?articleid=4637**
▶ *Moors* **www.cornwall.gov.uk/index. cfm?articleid=4642**

ACTIVITIES

■ **Birdwatching**

Seabird-watching is wonderful in this area, as you would expect. One special conservation triumph has been Operation Chough, a project to entice back the red-legged and scarlet-billed Cornish chough to its native county, which it abandoned in 1952. In 2002, the first young choughs for 50 years hatched in west Cornwall. Today, efforts centred on Paradise Park wildlife sanctuary, near Hayle, should see more choughs in the wild.

▶ *Paradise Park* ☎ *01756 751020 or 753365*
www.paradisepark.org.uk/choughs/index.htm

■ **Diving**

Looe is a well-known centre for diving on wrecks (including a Second World War USAF B17 bomber) and other locations.

▶ **www.looedivers.com/divesites_detail.htm**

■ **Surfing**

Atlantic rollers hit the coast of North Cornwall and funnel into narrow bays, producing the sort of high, reliable waves

that surfers love. There are tremendous surfing beaches at Newquay and Fistral, and at Polzeath a little further up the north coast.

▶ **www.bbc.co.uk/cornwall/surfing/ surfinguide**

■ **Walking**

The South-West Coast Path National Trail runs for 630 miles right round the rim of the south-west peninsula, from Poole Harbour in Dorset through South Devon, Cornwall and North Devon to Minehead in Somerset. About 300 miles of this is in Cornwall, an unforgettable path along the cliffs and sands.

▶ **www.swcp.org.uk**

FIND OUT MORE

Alfred Wallis, St Ives painter
A St Ives fisherman (1855–1942) and pioneer of the 'naif' style, who began to paint when he was 70 years old.
www.nmm.ac.uk/mag/pages/mnuInDepth/ Biography.cfm?biog=67

Dr Crippen and Marconi
Dr Crippen, wife-murderer, was caught with the help of one of the radio transmitters first tried out by Guglielmo Marconi at Poldhu Point.
www.titanic-whitestarships.com/The%20Dr.%20 Crippen%20Story.htm

Falmouth Packet story
The express maritime communications and delivery service that lasted around 200 years and made Falmouth's fame and fortune.
www.falmouth.packet.archives.dial.pipex.com

Padstow May Day
The official day of madness in the Cornish seaside town, when the Blue and Red Ribbon 'Obby Osses' come out to play.
May Day song in full: http://home.freeuk.net/ bribbonobbyoss/maysong.html

Tin mining
Cornwall's financial, industrial and social mainstay for thousands of years until twentieth-century economic realities killed off the industry.
www.users.bigpond.com/nqsearch/minehist/ mining.html

Cornish shipwrecks
Vicious reefs, rocks, and tides, treacherous fogs, storms and promontories have seen thousands of ships wrecked around the Cornish coast.
www.divernet.com/wrecks/lizwrek2.htm
www.aqua-photography.com

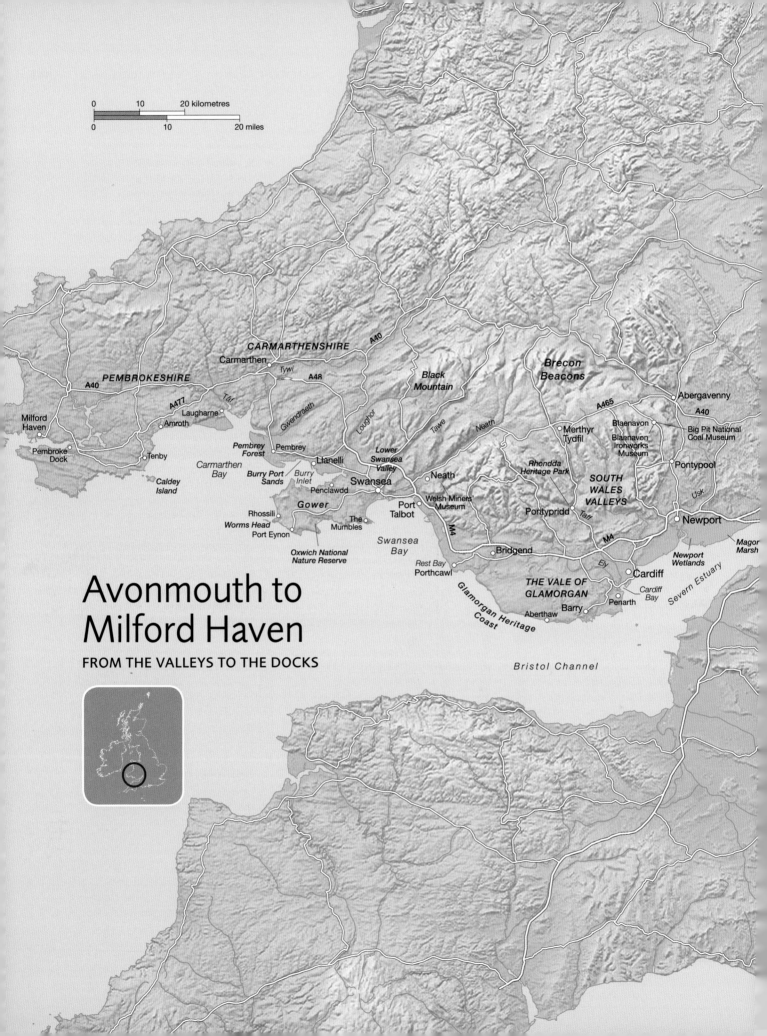

Avonmouth to Milford Haven

FROM THE VALLEYS TO THE DOCKS

0 10 20 kilometres
0 10 20 miles

PEMBROKESHIRE

CARMARTHENSHIRE

Brecon Beacons

Carmarthen

Milford Haven

Pembroke Dock

A40

A477

Laugharne
Amroth

Tenby

Caldey Island

Tâf

Tywi

A48

Gwendraeth

Pembrey Forest

Carmarthen Bay

Pembrey

Burry Port Sands

Burry Inlet

Penclawdd

Llanelli

Loughor

Lower Swansea Valley

Swansea

Gower

Rhossili
Worms Head
Port Eynon

The Mumbles

Oxwich National Nature Reserve

Swansea Bay

Port Talbot

Black Mountain

Tawe

Neath

Neath

Welsh Miners' Museum

Rest Bay
Porthcawl

M4

Bridgend

Glamorgan Heritage Coast

THE VALE OF GLAMORGAN

Aberthaw

A465

Merthyr Tydfil

Blaenavon

Blaenavon Ironworks Museum

Abergavenny

A40

Big Pit National Coal Museum

Pontypool

Rhondda Heritage Park

SOUTH WALES VALLEYS

Pontypridd

Taff

Usk

M4

Ely

Newport

Newport Wetlands

Magor Marsh

Cardiff

Cardiff Bay

Penarth

Barry

Severn Estuary

Bristol Channel

PLACES TO VISIT

■ Barry, South Glamorgan
With its funfairs, pleasure park, arcades, scenic railway and a good sandy beach, Barry Island is a lively, old-style resort serving Cardiff and the South Wales Valleys. Barry Docks are still working, though diminished from their coal heyday. Now part of the docks is being refurbished as 'The Waterfront', a complex of housing, shops, businesses, sports facilities and restaurants.
▶ ☎ *01446 747171*
www.barrywales.co.uk/theisland

■ Cardiff Bay
Cardiff's dockland, so active in the great days of coal export, became run-down and semi-derelict in the late twentieth century. Now the area is being revitalized with new housing, museums, shops, restaurants and nightspots. The barrage that closed off the bay from the sea has turned a previously estuarine area of mud flats into a freshwater environment, some of which is being managed for wildlife.
▶ ☎ *029 2046 3833* **www.cardiffbay.co.uk**

■ Milford Haven, Pembrokeshire
Milford Haven is a huge natural harbour, with some of its inner shoreline developed as a complex of oil refineries, storage and onward transmission facilities.
▶ ☎ *01646 690866* **www.pembrokeshire-wales.info/milfordhaven**

■ Porthcawl, Mid Glamorgan
This is a former coal port that reinvented itself in the twentieth century as a seaside resort. It has fine sands, the Porthcawl Royal Golf Course attracts golfers from far and wide, and Rest Bay has become a great surfing centre.
▶ ☎ *01656 786639*
www.welcometoporthcawl.co.uk

■ Swansea
Wales's second city has revamped its atmospheric South Dock area, site of the excellent National Waterfront Museum, the Dylan Thomas Centre and the Swansea Museum (see **Sites of Interest**, right) as well as a marina. The Lower Swansea Valley – once a post-industrial wasteland – now contains Swansea Enterprise Park, with its light, clean industries centred round a green park with a lake and footpaths.
▶ ☎ *01792 468321* **www.visitswanseabay.com**
▶ **www.swanseaheritage.net/themes/industry/swanval.asp**

PENINSULAS

■ Gower Peninsula, West Glamorgan
A strange and lovely land apart, with great natural beauty in the form of heaths, splendid beaches, woods, cliffs, rock pools, caves and promontories, as well as pretty villages, country lanes, castles, ancient Bronze Age cairns and Iron Age hillforts.
▶ **www.explore-gower.co.uk**

SITES OF INTEREST

■ Big Pit: National Coal Museum, Pwll Mawr, Blaenavon
Former miners show you around 300 feet underground, a memorable trip through the old workings. Above ground, there are shops, former stables, engines, pithead gear, a gallery and various exhibitions.
▶ ☎ *01495 790311*
www.museumwales.ac.uk/en/bigpit

■ Blaenavon Ironworks Museum, Torfaen
Fifteen miles north of Newport lies western Europe's finest preserved eighteenth-century ironworks – a UNESCO World Heritage Site, a stunning spectacle. It is now a museum, where you can see furnaces, cast houses, ironworkers' cottages and a huge water balance tower.
▶ ☎ *01495 792615* **www.blaenavontic.com**

■ Burry Port, Carmarthenshire
Fine sands to the west of Llanelli, where Amelia Earhart, the first woman to fly the Atlantic, landed on 18 June 1928.
▶ **www.sandspeedwales.co.uk/4604.html?*session*id*key*=*session*id*val***

■ Dylan Thomas Centre, Swansea
Sited in the newly refurbished dock area of Swansea, the Dylan Thomas Centre offers an overview of the life, work, reputation and wild times of Wales's romantic, headstrong and melancholy national poet.
▶ ☎ *01792 463980* **www.dylanthomas.org**

■ National Museum, Cardiff
Cardiff's grand National Museum, in the handsome Cathays area of the city, contains an overview exhibition of the development of Cardiff's docks and industries.
▶ ☎ *029 2039 7951*
www.museumwales.ac.uk/en/cardiff

■ National Waterfront Museum, Swansea
A modern and excellent replacement for Swansea's old Maritime Museum.
▶ ☎ *01792 638950*
www.waterfrontmuseum.co.uk

■ Newport Medieval Ship, Newport, Gwent
Saved from destruction just in time, the Tudor ship found at Newport (see page 57) is being preserved and will be on public display.
▶ **www.abc.se/~pa/publ/sos_newp.htm**
▶ **www.thenewportship.com**

■ Norwegian Church, Cardiff
Striking weatherboarded church on Cardiff Bay, built for the city's many visiting Scandinavian seamen in 1868. It now houses a coffee shop and art gallery, and stages concerts and other arts events.
▶ **www.wcities.com/en/record/,5069/7/record.html**

■ Port Talbot, Neath
A most impressive structure, best seen from the M4 motorway around Junctions 40 and 41 – Port Talbot's giant steaming Margam Steelworks is one of very few still operating in this part of the world.
▶ **www.bbc.co.uk/wales/southwest/sites/porttalbot**

■ Porthcawl Lifeboat Station, Bridgend
One of three lifeboat stations that serve the coast of South Wales. The Porthcawl lifeboat is helmed by Aileen Jones (see **Find Out More**, page 200). You can look at the lifeboat and the stirring collection of rescue photographs. Profits go to the RNLI.
▶ ☎ *01656 783299 or 782672* **www.rnli.org.uk/rnli_near_you/west/stations/porthcawl**
▶ **http://porthcawllifeboat.co.uk**

■ Rhondda Heritage Park, Lewis Merthyr Colliery, Trehafod, Rhondda
Part of the Rhondda Heritage Trail, where you can visit over 20 sites of historical importance relating to the nineteenth-century coal-mining industry. There are underground tours, a reconstructed village street, exhibits and a cafeteria.
▶ ☎ *01443 682036*
www.rhonddaheritagepark.com

■ Swansea Museum
The oldest museum in Wales is housed in a wonderful porticoed building in the Maritime Quarter of Swansea. Its collections range from historic vessels moored in the docks to artworks, curiosities and artefacts reflecting Swansea life since prehistoric times.

Avonmouth to Milford Haven
FROM THE VALLEYS TO THE DOCKS

▶ ✆ *01792 653763* **www.swansea.gov.uk/ index.cfm?articleid=1076**

■ Welsh Miners' Museum, Cymmer, West Glamorgan

Fascinating museum in Afan Argoed Country Park, telling the story of the hard everyday life of a coal miner in South Wales.

▶ ✆ *01639 850564*
www.southwalesminersmuseum.com

NATURAL WORLD

■ Estuaries

The Severn Estuary (known as the Bristol Channel in its lower and wider reaches) is the most dynamic tidal waterway in Britain, with a tidal range of over 40 feet and an intertidal zone with vast sand and mud flats. Several smaller estuaries debouch into the Severn Estuary/Bristol Channel along the South Wales coast, among them the Usk below Newport; the Taff and Ely, now tamed by the Cardiff Bay barrage; the Neath and Tawe, between Port Talbot and Swansea; the Loughor, on the north coast of the Gower Peninsula (known as Burry Inlet); and the great tripartite confluence of Tywi, Tâf and Gwendraeth, flowing into Carmarthen Bay near Dylan Thomas's house at Laugharne.

▶ **www.jncc.gov.uk/ProtectedSites/ SACselection/sac.asp?EUCode=UK0020020**

■ Sand dunes

Beyond Burry Port, west of Llanelli, lie the 2500 acres of Pembrey Forest, a rare sand-dune forest with lovely Blue Flag beaches. Riding and nature trails, orienteering, cycling and walking are all first class. Butterflies (35 species), birds and plants all thrive here.

▶ **www.forestry.gov.uk/website/recreation. nsf/LUWebDocsByKey/WalesCarmarthenshire PembreyForest**

■ Wetlands

The Burry Inlet on the north side of the Gower Peninsula has special status as a wetland of international importance. Learn all about it in the National Wetlands Centre, opposite Llanelli.

▶ **www.wwt.org.uk/visit/llanelli**

ACTIVITIES

■ Birdwatching

There are several first-class birdwatching sites. Two notable ones side by side are up along the Severn Estuary. Magor Marsh is known for breeding snipe, reed buntings,

kingfishers and marsh warblers. At the neighbouring Newport Wetlands you may find bitterns, short-eared owls, hen harriers and dozens of duck species in winter. The tip of Worms Head on the Gower Peninsula is excellent for puffins, guillemots, shearwaters and other seabirds. Bitterns have been heard and seen among the reeds of the Oxwich National Nature Reserve's pools.

▶ **www.rspb.org.uk/wales/reserves**

■ Boat trips

There are some excellent boat trips along this stretch of coast, where you can enjoy the beautiful scenery of this area.

▶ *Gower* **www.swansea.gov.uk/index. cfm?articleid=881**
▶ *Pembrokeshire* **www.pembrokeshire-online.co.uk/things_to_do.htm**
▶ *South Glamorgan*
www.waverleyexcursions.co.uk

■ Eating local food

Penclawdd cockles and laverbread – a little slice of heaven. The cockles are picked from their beds under the sands of Burry Inlet, the laverbread (not bread at all, but the edible seaweed *Porphyra dioica* and *P. purpurea*) from the rocks – though nowadays most laverbread, while processed in Wales, is imported from Scotland and further afield. The laverbread is cooked into a stew; you can eat it on baker's bread or with bacon for breakfast. Cooked cockles can be eaten from the shell with a squeeze of lemon, but they are best in a cockle chowder.

▶ **www.penclawddshellfish.co.uk/cockles. html**

■ Rockpooling

The Gower Peninsula in particular has wonderful rockpooling, with the wide acres of the Worms Head causeway near Rhossili a special favourite.

▶ **www.glaucus.org.uk/gower1.htm**

■ Walking

The Glamorgan Heritage Coast, just west of Cardiff, between Aberthaw and Porthcawl, has few roads and no unsightly development, and there's an 18-mile walking trail between to show you the best of it. The beautiful Gower Peninsula is encircled by a footpath, and further west the tremendous 186-mile Pembrokeshire Coast Path National Trail begins at Amroth near Tenby.

▶ *Glamorgan Heritage Coast*
www.valeofglamorgan.gov.uk/Leisure

▶ *Gower* **www.glamorganwalks.com/gower_ coast.htm**
▶ *Pembrokeshire* **www.pembrokeshirecoast. org.uk**

■ Watersports

There are various excellent watersports centres in the area, where you can do canoeing, sailing, kayaking, powerboating and windsurfing.

▶ *Cardiff and South Glamorgan*
www.touristnetuk.com/Wa/cardiff/ activities/watersports/index.asp
▶ *Gower* **www.gogwa.com**
▶ *Pembrokeshire* **www.pembrokeshire-watersports.com**

FIND OUT MORE

■ Coal mining

The history of coal mining in Rhondda and coal shipping from Cardiff and Barry.
www.therhondda.co.uk/facts/markets.html

■ Copper industry

The history of the copper industry in the lower Swansea Valley.
www.page-net.com/swansea.localhistory/ llansamlet/pages/swanseavalley.htm

■ Energy sources

Milford Haven is a vital centre for energy supplies, including liquefied natural gas (LNG) and the Wave Dragon, which harnesses the energy of the Severn Estuary tides to provide power.
http://en.wikipedia.org/wiki/LNG
www.wavedragon.co.uk/why-wave-energy-.html

■ Individual achievements

Aileen Jones, helmsman of Porthcawl lifeboat, and the brave rescue that gained her the RNLI's bronze medal.
www.rnli.org.uk/what_we_do/rnli_gallantry/ stories_of_courage/story_5
Amelia Earhart, the first woman to fly the Atlantic, who landed on Burry Port sands in 1928.
www.sandspeedwales.co.uk/4604.html?*session *id*key*=*session*id*val'
Swansea Jack, the Labrador who saved 27 lives.
www.explore-gower.co.uk/swansea/ swanseajack.html

■ Severn Estuary tsunami

The story of the devastating 1607 tsunami, in which 2000 or more people were drowned.
http://en.wikipedia.org/wiki/Bristol_Channel_ floods%2C_1607

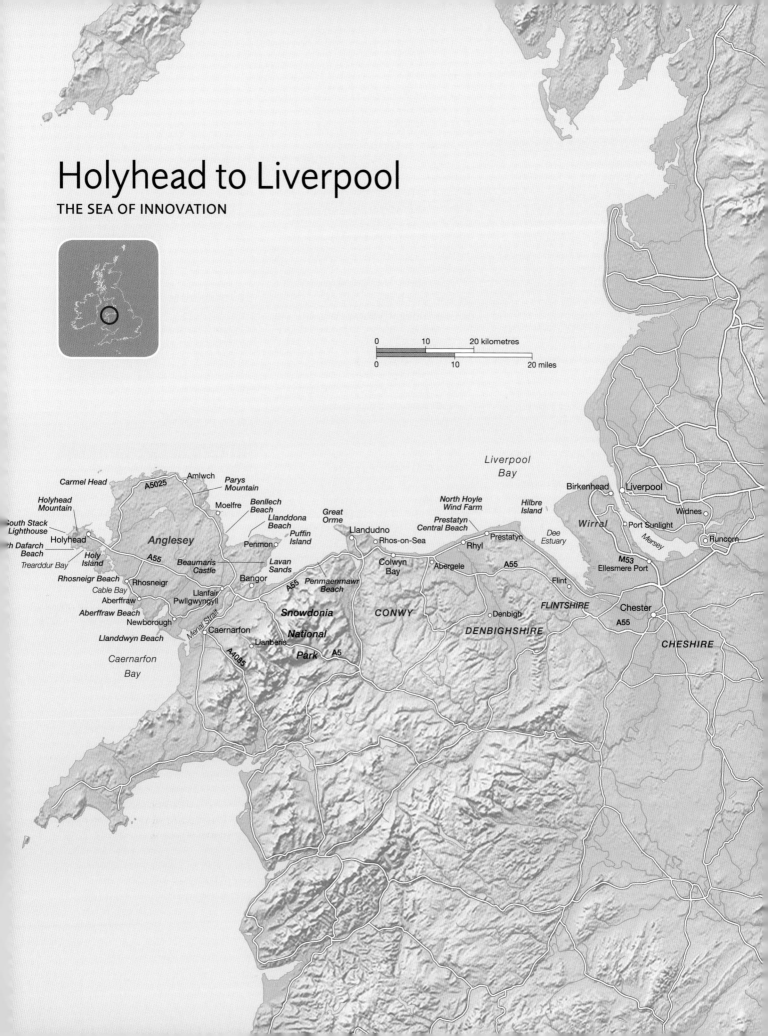

Holyhead to Liverpool

THE SEA OF INNOVATION

0 10 20 kilometres
0 10 20 miles

Carmel Head

Amlwch

Parys Mountain

A5025

Holyhead Mountain

Moelfre

Benllech Beach

Llanddona Beach

South Stack Lighthouse

Great Orme

Liverpool Bay

North Hoyle Wind Farm

Birkenhead

Liverpool

Penmon

Puffin Island

Llandudno

Prestatyn Central Beach

Hilbre Island

Widnes

h Dafarch Beach

Holyhead

Anglesey

Rhos-on-Sea

Wirral

Port Sunlight

Trearddur Bay

Holy Island

A55

Beaumaris Castle

Lavan Sands

Colwyn Bay

Rhyl

Prestatyn

Dee Estuary

Mersey

Runcorn

Rhosneigr Beach

Rhosneigr

Bangor

Penmaenmawr Beach

Abergele

A55

M53

Ellesmere Port

Cable Bay

Llanfair Pwllgwyngyll

A55

Flint

Aberffraw

CONWY

FLINTSHIRE

Aberffraw Beach

Newborough

Menai Strait

Snowdonia

Denbigh

Chester

Llanddwyn Beach

Caernarfon

Llanberis

National

DENBIGHSHIRE

A55

Caernarfon Bay

A4085

Park

A5

CHESHIRE

PLACES TO VISIT

Birkenhead, Wirral
The Mersey Railway, one of the world's pioneering underwater railways, was built here in 1886. Birkenhead Park was the UK's first publicly funded park, designed in 1843 by Joseph Paxton of Crystal Palace fame.
▶ *Mersey Railway* **www.urbanrail.net/eu/liv/liverpool_merseyrail.html**
▶ *Birkenhead Park* **www.wirral.gov.uk/er/birkenheadpark_history.htm**.

Great Orme, Conwy
The round-nosed promontory of the Great Orme sticks out from the North Wales coast at Llandudno. There are ancient copper mines to visit and great seabird-watching. One of the 11 stations of the Liverpool–Holyhead optical telegraph was established here.
▶ **www.llandudno.com/orme**

Holyhead, Holy Island
Situated on Holy Island at the outer edge of the Isle of Anglesey, Holyhead was put on the map when the Chester and Holyhead Railway opened in 1848, bringing the Irish Mail and thousands of passengers to the Irish ferries. Nowadays, Holyhead is the chief UK ferry port for Dublin and Dun Laoghaire.
▶ ✆ *01407 762622* **www.holyhead.org**

Liverpool, Merseyside
This port on the River Mersey was a point of embarkation for millions of nineteenth-century emigrants. The dock area of the city has undergone a transformation since the run-down days of the 1970s. Today the grand buildings of the Pier Head have a worthy neighbour in the revitalized Albert Dock area, with its bars, restaurants, shops, tour boats and clutch of first-class museums (see **Sites of Interest**, right and opposite).
▶ ✆ *0151 237 3925* **www.visitliverpool.com**
▶ **www.albertdock.com**

Llandudno, Conwy
An old Victorian resort in a fabulous position under the headland of the Great Orme, Llandudno has vast stretches of sand and a pier nearly ½ mile long. The promenade has great views from its crescent sweep along the front – views that may soon feature the 200-odd turbines of Gwynt-y-Môr offshore wind farm (see **Find Out More**, opposite).
▶ ✆ *01492 876413*
www.llandudno-tourism.co.uk

Penmon, Anglesey
Penmon lies at the eastern tip of Anglesey.

This is a wonderful place, not only for everyone who loves beautiful rural and coastal scenery, but also for anybody with a feel for ancient monuments. Here you'll find a covered well-house containing St Seiriol's Well, the extraordinarily complete twelfth-century buildings of Penmon monastery, and two carved High Crosses that might be more than 1000 years old.
▶ **www.anglesey-history.co.uk/places/penmon/index.html**

Port Sunlight Village, Wirral
Victorian soap mogul William Lever built this model settlement on the Mersey shore of the Wirral Peninsula for the workers at his Sunlight soap factory. 'Old English', classical, Gothic, Baroque and Arts & Crafts styles were all employed, and the inhabitants enjoyed light, air and space hitherto unknown to the nineteenth-century urban working class.
▶ **www.portsunlight.org.uk**

ISLANDS
Anglesey
Until the arrival of the Romans, the island of Anglesey was a centre of the Druidic religion, and there are many ancient sites scattered over the island's rolling landscape. Surfers enjoy the bays of the south-west coast, while lovers of places with long names head for Llanfairpwllgwyngyllgogerychwyrndrobwllllantysiliogogogoch, 'the church of St Mary in the hollow of the white hazel near a fierce whirlpool and St Tysilio near the red cave'. You can drive or take the train on to Anglesey via the road and railway bridges that span the Menai Strait.
▶ *Holyhead* ✆ *01407 762622*
www.holyhead.org
▶ *Llanfairpwllgwyngyll* ✆ *01248 713177*
llanfairpwll@nwtic.com

Hilbre Islands
The three Hilbre Islands lie in the Dee Estuary, off West Kirby on the Wirral Peninsula. You can walk out at low tide to the little sandstone ledges, following a set course through the treacherous sands, to visit the bird observatory on Hilbre, the biggest of the three. Here you'll find relics of the Liverpool to Holyhead optical telegraph. The telegraph station building and the telegraph keeper's house, both built in 1841, are still in good shape.

▶ **www.ecosert.org.uk/leaflets/Hilbre.pdf**
▶ **www.deeestuary.co.uk/hilbre**

Puffin Island
Just off the easternmost tip of Anglesey, this is a small island with a long ecclesiastical history. St Seiriol of nearby Penmon set up a monastery here in the sixth century, and you can still see the church tower and other buildings of the early medieval monastery that superseded the saint's original foundation. Rats that came ashore after a shipwreck threatened the rich birdlife, but they have since been eradicated. There are boat trips around the island but landing is not allowed without special permission.
▶ **http://en.wikipedia.org/wiki/Puffin_Island,_Anglesey**
▶ 🚢 **www.starida.co.uk** *or* **www.beaumaris.org.uk/cerismar.html**

SITES OF INTEREST

Beaumaris Castle, Anglesey
The last of King Edward I's 'Iron Ring' of fortresses to subdue the rebellious Welsh, Beaumaris was begun on the Menai Strait in 1295. With 4 miles of defences and 16 bastions, the castle was at the cutting edge of military design. Today, it seems the most romantic of places.
▶ ✆ *01248 810361*

Beatles Story, Liverpool
The Beatles are undoubtedly the most famous foursome ever to come out of Liverpool, and the Beatles Story tells the extraordinary tale of the Fab Four's rise to glory, from the early days through to their break-up in 1970. There's also a vast array of Beatles merchandise available.
▶ ✆ *0151 709 1963* **www.beatlesstory.com**

Conwy Castle, Conwy
Another of Edward I's 'Iron Ring', Conwy Castle was begun in 1283, the same year as Caernarfon. The castle is irregularly shaped to take account of the underlying rock, but it gives the impression of symmetry with its tall drum towers. Conwy town walls, dating from the same era, are a mile in length and offer a memorable stroll with wonderful views.
▶ ✆ *01492 592358* **www.conwy.com**

Great Orme Mines, Llandudno
Bronze Age miners dug for copper in a labyrinth of galleries, which you can visit.
▶ ✆ *01492 870447*
www.greatorme.freeserve.co.uk

■ Merseyside Maritime Museum, Liverpool
This fascinating museum tells the story of one of Britain's greatest ports, including Liverpool's relationship with the sea (from transatlantic liners to ferries across the Mersey), the wartime bombing and tales of emigration and the slave trade.
▶ ☎ 0151 478 4499
www.liverpoolmuseums.org.uk/maritime

■ Museum of Liverpool Life, Liverpool
The very popular Museum of Liverpool Life, an intimate telling of the city's story, closed early in 2006 for a major overhaul. It will re-open in 2010 as the Museum of Liverpool, in a fine new building at the Pier Head. To keep up with developments, visit the website.
▶ www.liverpoolmuseums.org.uk/about/capitalprojects/museumofliverpool.asp

■ Tate Liverpool
Tate Liverpool is the largest modern art gallery outside London, featuring important sculptures, paintings, installations and other kinds of work from all over the world. It has an impressive permanent collection and also holds temporary exhibitions.
▶ ☎ 0151 702 7400
www.tate.org.uk/liverpool

■ Wind farms
The shallow water and windy expanses off the North Wales coast are ideal for building offshore wind farms. Already up and running is North Hoyle; waiting to be built are Rhyl Flats and Burbo Bank. The giant Gwynt-y-Môr, 'The Wind from the Sea', is planned (see **Find Out More**, right).

NATURAL WORLD
■ Beaches
This stretch of coast possesses eight Blue Flag beaches: Benllech, Llanddona, Llanddwyn, Trearddur Bay and Porth Dafarch (all in Anglesey); Rhos-on-Sea and Penmaenmawr (near Conwy); and Prestatyn Central (in Denbighshire).
▶ www.bbc.co.uk/wales/northeast/sites/beaches

■ Holyhead Mountain Heritage Coast, Holy Island, Anglesey
Beautiful coastline that stretches for 8 miles on the western side of Holyhead Mountain, on Holy Island just west of Holyhead. Seabirds on the cliffs include puffins,

guillemots and razorbills, scarlet-beaked choughs and the deadly little peregrines, which can strike down other birds at speeds approaching 125 miles per hour. You can climb down to South Stack lighthouse, or walk up to the top of Holyhead Mountain, which offers spectacular views.
▶ www.britainexpress.com/countryside/coast/holyhead.htm

■ Sea straits
Sand and mud flats flank the narrow Menai Strait, between mainland Wales and the Isle of Anglesey. Shellfish thrive here, benefiting from the nutrients stirred up by the tides, and there are multitudes of wading birds.
▶ www.bbc.co.uk/wales/northwest/outdoors/placestogo/reserves/menai.shtml

ACTIVITIES
■ Birdwatching
Puffin Island is good for seabirds such as common and black guillemots, razorbills, kittiwakes and common eiders. There's a huge population of cormorants and a colony of shags. As for the puffins – since the eradication of the island's brown rats in 1998, numbers are slowly recovering. Anglesey in general is fruitful birdwatching territory, especially the cliffs of Holy Island, while lovers of estuarine birds are rewarded at Lavan Sands on the Menai Strait with sightings of divers and ducks, including red-breasted mergansers and great crested grebes. The Dee Estuary is thronged with waders in their millions, and birds of prey such as hen harriers, peregrines and merlins.
▶ www.anglesey.gov.uk/english/tourism/bird.htm
▶ www.deeestuary.co.uk/neshore

■ Diving
There are several wrecks to dive on, including *Royal Charter* (see right).
▶ www.divernet.com/wrecks
▶ http://mysite.wanadoo-members.co.uk/angleseywreckdiving

■ Surfing
Anglesey Island has many good surfing beaches on its south-west coast, for example Aberffraw, Rhosneigr and Cable Bay.
▶ www.bbc.co.uk/wales/northwest/sites/surfing

■ Walking
Anglesey's new coast path is a beauty; there are 125 miles all around the island

(guidebook *The Isle of Anglesey Coastal Path* by Carl Rogers, £9.99, Mara Books). There's also a series of circular walks on the island, named after Welsh saints, from 2 to 14 miles in length. The North Wales Path runs for 60 miles from Bangor to Prestatyn, either along the coast or on the mountain slopes behind, giving stunning coastal views.
▶ ☎ 01248 752450
▶ www.walking.visitwales.com

FIND OUT MORE

Shipwrecks
Resurgam was Britain's first full-sized steam-powered submarine, designed by Manchester curate George Garrett. It sank off Rhyl in 1880 and was rediscovered in 1995.
www.threeh.demon.co.uk/SitesResurgam2.htm
www.divernet.com/wrecks/resur496.htm
Rothsay Castle was a pleasure steamer that was wrecked on Dutchman's Bank off Anglesey in 1831; 150 drowned.
http://hometown.aol.co.uk/honomeround/normanton.html
Royal Charter was an Australian clipper wrecked off Moelfre Bay in a hurricane in 1859, with the loss of over 450 lives. As a result of this wreck, Robert FitzRoy introduced modern weather forecasting.
http://en.wikipedia.org/wiki/Royal_Charter_(ship)
http://en.wikipedia.org/wiki/Robert_FitzRoy
Thetis was a T-class submarine lost on diving trials in Liverpool Bay in 1939; 99 men died and just four escaped.
www.angelfire.com/co3/submarinethetis/thetis.htm

Welsh settlers in Patagonia
A group of 153 Welsh emigrants left Liverpool on 28 May 1865 to found a Welsh-speaking, Welsh-culture colony in Patagonia, 7000 miles away. Their descendants still live there today.
www.bbc.co.uk/wales/history/sites/cag/pages/cag-patagonia.shtml
http://myweb.tiscali.co.uk/casamirror/mimosa1.htm

Wind farms
A map is available of NPower's wind farms, operational, agreed and proposed (as of spring 2006) along the North Wales/Merseyside coast.
www.npower-renewables.com/gwyntymor/location.asp

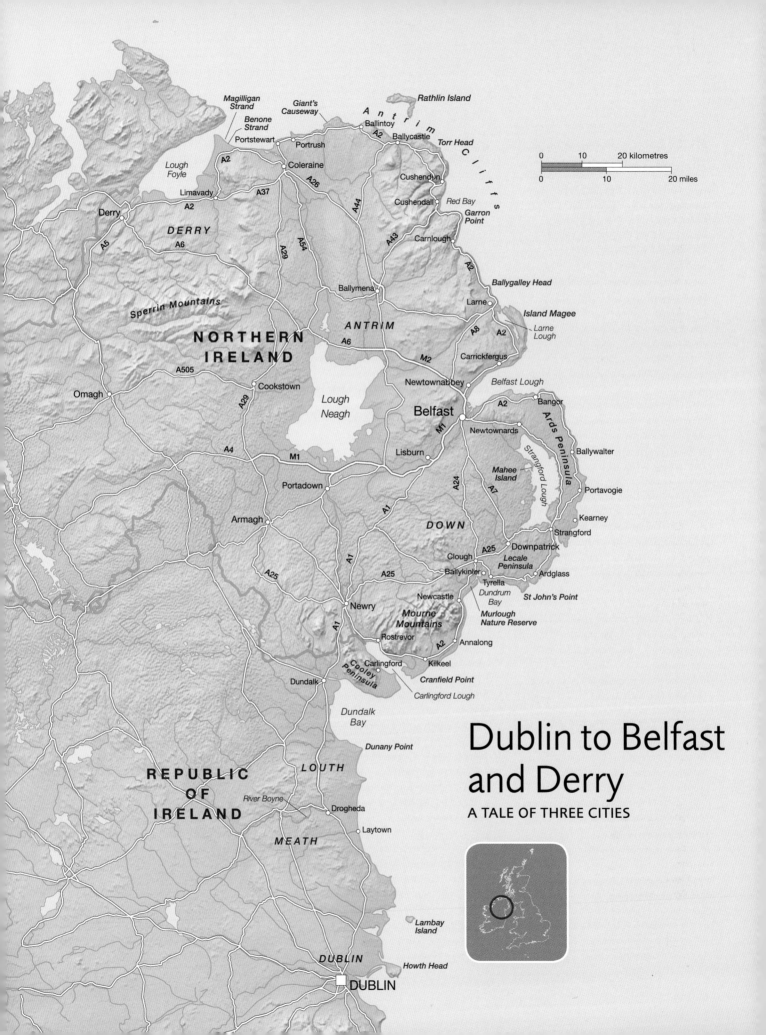

Magilligan
Strand
Benone
Strand
Portstewart
Giant's
Causeway
Ballintoy
A2
Ballycastle
Rathlin Island
Torr Head
Portrush
Lough
Foyle
A2
Coleraine
Cushendun
A26
Limavady
A37
Cushendall
Red Bay
Garron
Point
Derry
A2
A6
A54
A29
A44
A43
Carnlough
A5
DERRY
A2
Ballygalley Head
Sperrin Mountains
Ballymena
Larne
A2
NORTHERN
IRELAND
ANTRIM
A6
A8
Island Magee
Larne
Lough
A505
Cookstown
M2
Carrickfergus
Omagh
A29
Lough
Neagh
Newtownabbey
Belfast Lough
A2
Bangor
Belfast
M1
A4
M1
Newtownards
Ards Peninsula
Ballywalter
Lisburn
Strangford Lough
Portadown
Mahee
Island
Portavogie
Armagh
A24
A7
Kearney
Strangford
DOWN
A25
Downpatrick
A1
Clough
Lecale
Peninsula
Ardglass
A25
Ballykinler
St John's Point
Newry
A25
Tyrella
Dundrum
Bay
Newcastle
Murlough
Nature Reserve
A1
Mourne
Mountains
A2
Annalong
Rostrevor
Carlingford
Kilkeel
Cooley
Peninsula
Cranfield Point
Dundalk
Carlingford Lough

Dundalk
Bay

REPUBLIC
OF
IRELAND
LOUTH
Dunany Point

River Boyne
MEATH
Drogheda
Laytown

Dublin to Belfast and Derry
A TALE OF THREE CITIES

Lambay
Island

DUBLIN
DUBLIN
Howth Head

0 10 20 kilometres
0 10 20 miles

PLACES TO VISIT

■ Belfast

At the inner end of lovely Belfast Lough and backed by mountains, Belfast doesn't look like a city to be frightened of – and it isn't. Belfast folk are dryly humorous and extremely keen to share with you all the good things about their home town, from regulation tourist attractions (see **Sites of Interest**, right and page 206) to modern delights such as the cleaned-up waterfront along the River Lagan, with its fishing, cycling, footpaths and river trips; Black Taxi tours to the 'Troubles hotspots'; and celebrated sectarian murals. Belfast has great nightlife, too, and lots of characterful old pubs such as the Kitchen Bar, Bittles and the Crown Liquor saloon, which is so ornate it's cared for by the National Trust.

▶ ℭ *028 9024 6609* **www.gotobelfast.com**

■ Carlingford, Co. Louth

Carlingford is an attractive fishing village with a very strong border atmosphere, partly owing to the presence of its two gaunt castle ruins (Taafe's Castle, in the village, and King John's Castle, overlooking Carlingford Lough) and partly to its situation, looking over to Northern Ireland across the broad waters of the lough, with the tall humps of the Mourne Mountains prominent on the coast of County Down.

▶ ℭ *042 937 3033*

■ Carrickfergus, Co. Antrim

The coastal town of Carrickfergus is best known for its giant stronghold of a Norman castle that frowns out over the entrance to Belfast Lough. But there is more to the town than meets the eye. Unknown and unseen by visitors, vast caverns created by mining for rock salt extend some 8 miles out under the waters of the lough. Half a million tons of rock salt for de-icing is transported each year to customers by ship from a deep-water port on the north shore of the lough.

▶ ℭ *028 9335 8049* **www.carrickfergus.org**

■ Derry/Londonderry

Derry had more than its share of the Troubles, but that's all in the past for this city of energetic and optimistic people. You'll find a neat little Georgian and Victorian centre enclosed in a magnificent run of seventeenth-century city walls – the circular walk around their parapets is a must. The city's colourful and riotous (literally) history is depicted all about you, in the stained glass windows of the Guildhall, the proudly exhibited mementoes of the Great Siege of 1688–9 in St Columb's Cathedral and the Tower Museum's display of the story of Derry (see **Sites of Interest**, page 206).

▶ ℭ *028 7126 7284* **www.derryvisitor.com**

■ Dublin

Dublin is one of the most famous and best-loved of European cities. Its wealth is literary, architectural, theatrical, conversational, musical and artistic – very fine qualities of a capital city that still retains its heart and soul. It is small enough to stroll across, relaxed enough for conversation with total strangers, and funky enough for great pubbing and clubbing. Dublin has some wonderful museums (see **Sites of Interest**, page 206) and great cultural treasures, such as the Book of Kells, which is permanently on display in the library of Trinity College Dublin.

▶ ℭ *01 605 7700* **www.visitdublin.com**

ISLANDS

■ Rathlin Island, Co. Antrim

The L-shaped Rathlin Island lies 5 miles off Ballycastle, on the far side of a vigorous tide race. Among the 70 people who live here is a handful of children, enough to keep open the tiny primary school. Farming methods are traditional, maintaining a varied wildlife that includes hares, carpets of orchids and a rich bird population.

▶ *Kebble Cliffs birdwatching viewpoint (RSPB)*
ℭ *028 2076 3948*

▶ 🚢 ℭ *08705 650000*
www.calmac.co.uk/timetables.html

SITES OF INTEREST

■ Bendhu House, Ballintoy, Co. Antrim

A pretty fishing harbour in the Antrim cliffs, Ballintoy contains one or two striking houses, none more so than the privately owned Bendhu House, started in 1936 by Cornish art teacher and visionary Newton Penprase, and finished some six decades later. Its spiky outline, all turrets, angles, curves and squares, the unrestrained sculptures that adorn it, and its general atmosphere of a necromancer's secret castle, make it the most remarkable domestic building of this coast.

▶ **http://freespace.virgin.net/mp.hearth/ AntrimCo.html**

■ Botanic Gardens, Belfast

A quiet green oasis in the city, with strolling paths shaded by hundreds of tree species. There are two giant iron-and-glass Victorian conservatories, one of which is a splendid palm house, full of tropical vegetation. Nearby is a 30-foot-deep 'tropical ravine', housed inside a glass-roofed building of the 1880s – a pioneering reconstruction of an ecosystem where fish and terrapins swim beneath cinnamon trees, loquats and banana.

▶ ℭ *028 9032 4902*
http://en.wikipedia.org/wiki/Belfast_ Botanic_Gardens

■ Carrickfergus Castle, Co. Antrim

Norman lord John de Courcy built Carrickfergus Castle towards the end of the twelfth century, shortly after the Normans had invaded Ireland, to deter any would-be intruder from venturing up Belfast Lough.

▶ ℭ *028 9335 1273*
www.ehsni.gov.uk/places/monuments/ carrick.shtml

■ Dunluce Castle, Co. Antrim

Dunluce Castle's superb jumble of broken walls, turrets and windows perch on a promontory of dark-coloured basalt at the very edge of the cliffs between Bushmills and Portrush. It was the scene of a great triumph in 1584, when Sorley Boy Macdonnell recaptured it from the English by having his fighting men hauled up the cliffs in baskets; it was also the setting for a terrible disaster in 1639, when many were killed as the kitchens collapsed in a storm and toppled into the sea.

▶ ℭ *028 2073 1938* **www.northantrim.com/ dunlucecastle.htm**

■ Murlough Nature Reserve, Dundrum Bay, Co. Down

The mud and sand flats of Dundrum Bay are wonderful for wintering birds – notably grebes, greenshank and light-bellied brent geese – and for common seals. The National Nature Reserve at Murlough on the bay, a Special Area of Conservation, boasts the best dune heaths in Northern Ireland, and one of the most diverse and rich dune systems, wonderful for flowers and butterflies.

▶ ℭ *028 437 5146* **www.english-nature.org. uk/thh/default.asp?S|00060001**

▶ **www.jncc.gov.uk/ProtectedSites/ SACselection/sac.asp?EUCode=UK0016612**

■ National Museum, Dublin

Dublin's National Museum is crammed with beautiful artefacts from a pre-Norman Golden Age of Celtic art, ranging from silver-gilt chalices to gold-encrusted and jewelled rings, reliquaries and brooches.

▶ (01 677 7444 www.museum.ie

■ Tower Museum, Derry

Constructed within the city walls in the shape of a Celtic tower, Derry's Tower Museum was built during the dark days of the Troubles by a local man, Paddy O'Doherty, to point the way to a brighter future for the city. Opened in 1992, it offers a fascinating stroll through the history of Derry, up to and including the Troubles themselves.

▶ (028 7137 2411
www.discovernorthernireland.com/product.aspx?ProductID=2910

■ Ulster Museum, Belfast

The Ulster Museum is one of the best museums in Ireland, with a solid but fascinating core collection and an imaginative range of temporary exhibitions. Highlights include the wide-reaching modern art collection, some splendid old textile and heavy engineering machines, a fine display of ancient treasures and the gold, silver and personal belongings salvaged from the Spanish Armada warship *Girona*, wrecked near the Giant's Causeway in 1588.

▶ (028 9038 3000 www.ulstermuseum.org.uk

■ Writers' Museum, Dublin

Oscar Wilde, Jonathan Swift, James Joyce, Samuel Beckett, George Bernard Shaw, W. B. Yeats, Mary Lavin, Patrick Kavanagh, Brendan Behan, John Millington Synge, Lady Gregory, Frank O'Connor – can you imagine a more literary island than Ireland? They are all celebrated here, with displays that range from manuscripts and first editions to letters and personal belongings.

▶ (01 872 2077 www.writersmuseum.com

NATURAL WORLD

■ Beaches

During the 30 years of the Troubles, between 1970 and 2000, the beaches of Northern Ireland were very little visited. The presence of the army base at Ballykinler, behind Tyrella beach near Newcastle in County Down, ensured public exclusion from the area and a safe haven for seals. Ballykinler has grown to be an important breeding ground, where seals give birth and a large colony hauls out. Many of Northern Ireland's beaches are superb and have been awarded the Blue Flag.

▶ www.discovernorthernireland.com/beaches.aspx

■ Cliffs

The great cliffs of the Antrim coast are famous for their impressive height – up to 800 feet in places – and for the variety of colour imparted by their succession of rock types. The best way to see them is via the A2 Coast Road and its Torr Head scenic route.

▶ www.ehsni.gov.uk/natural/coast/habitats.shtml#Rocky_cliff

■ Giant's Causeway, Co. Antrim

Cold-blooded geologists would have you think that the 37,000 hexagonal basalt stumps jutting into the sea to form the grand promontory of the Giant's Causeway are the product of the meeting of molten lava and cold sea water some 65 million years ago. But doesn't the world know that the Irish giant, Fionn MacCumhaill, laid it down as a challenge to the uppity Scottish giant Benandonner, or maybe as a walkway for Fionn's girlfriend from the Hebridean island of Staffa? Whichever version you believe, the fact is that the basalt Causeway is the number one attraction of the Antrim coast.

▶ (028 2073 1855
www.giantscausewaycentre.com

■ Loughs

Carlingford Lough is a most beautiful sea inlet flanked by the hills of the Cooley Peninsula and the Mourne Mountains. Strangford Lough is the pride of County Down, a haven for wildfowl in winter. Belfast Lough cuts deeply into the flanks of the coast between County Down and County Antrim, while to the north Larne Lough all but makes an island of the peninsula called Island Magee. On the doorstep of Derry City, the angular Lough Foyle is the springtime birthplace of most of Northern Ireland's harbour porpoises.

▶ www.ehsni.gov.uk/natural/coast/marinehabitats.shtml

ACTIVITIES

■ Birdwatching

Birdwatching is sensational here, from casual sightings of peregrines and fulmars along the cliffs of counties Dublin, Meath and Louth to the huge convocations of geese and waders overwintering in the loughs of Northern Ireland and the skylarks that haunt the sand dunes at Dundrum, County Down, and Magilligan Strand on Lough Foyle.

▶ (028 9049 1547
www.geographia.com/northern-ireland/ukibrd01.htm

■ Fishing

Sea fishing is excellent, because the hot spots have not been overexploited, and there are dozens of beaches and promontories for shore anglers. Boat enthusiasts should try Carlingford Lough for tope, Ardglass in County Down for mackerel, codling, gurnard and whiting, or Portrush in County Antrim for ray and turbot. Wreck-fishing offers hopes of wrasse, dogfish and big conger.

▶ (028 9024 6609
www.discovernorthernireland.com/angling.aspx

■ Racing

Enthusiasts for horse racing flock to the strand at Laytown, County Meath, for a unique experience – a racing day held on a beach. Spectators cheer from the grandstand field on the low cliffs as the horses compete on a course of flat, firm sand.

▶ www.hri.ie/racing_info/racecourses.asp?CourseID=14

FIND OUT MORE

Brunel and Dundrum Bay
It was in Dundrum Bay that the celebrated engineer Isambard Kingdom Brunel spent an anxious year in 1846-7, trying to refloat his pioneering steamship SS *Great Britain* after she ran aground in the bay.
www.scienceandsociety.co.uk/results.asp?image=10437986

Formation of the Giant's Causeway
How the Causeway was formed, who discovered it and how.
www.northantrim.com/Causewayguide.htm

Lambay Island's worst shipwreck
The emigrant ship *Tayleur* struck rocks off Lambay in January 1854, with the loss of 380 lives.
www.malahideheritage.com/Lambay%20Island.htm

Operation Deadlight Expedition
Operation Deadlight is the first attempt to examine the wrecks of Second World War German U-boats off the Northern Ireland coast.
www.operationdeadlight.co.uk

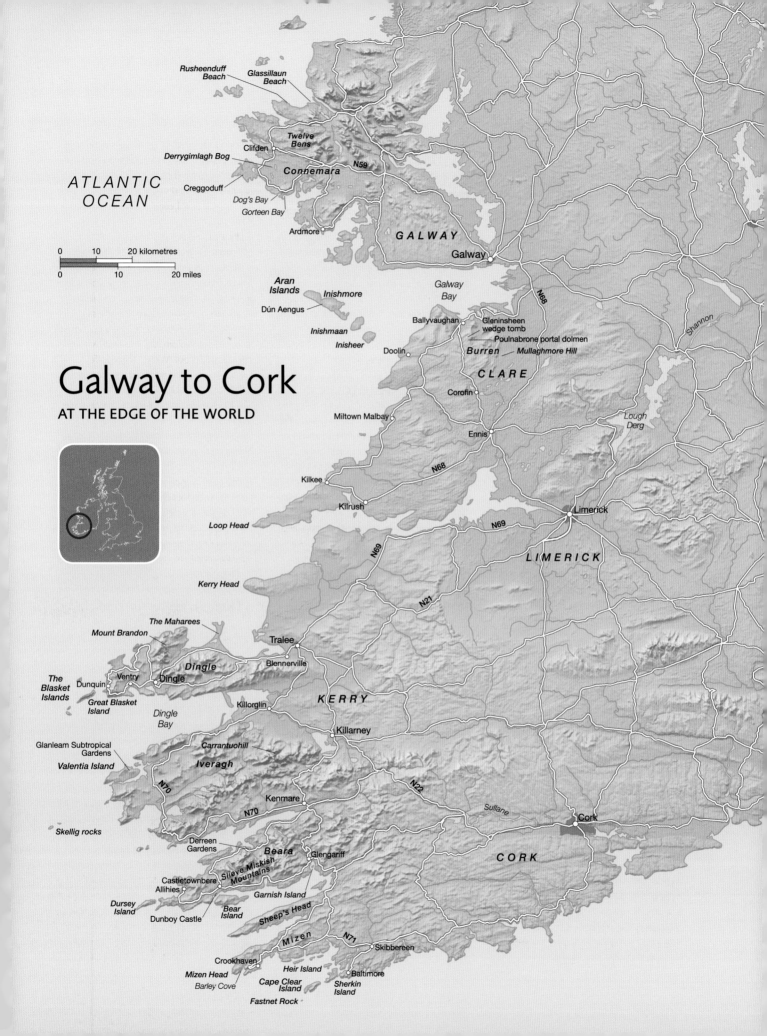

ATLANTIC
OCEAN

Galway to Cork
AT THE EDGE OF THE WORLD

Connemara

Rusheenduff
Beach
Glassillaun
Beach
Twelve
Bens
Clifden
Derrygimlagh Bog
Creggoduff
Dog's Bay
Gorteen Bay
Ardmore

GALWAY
Galway
N59

Galway
Bay
N68

Aran
Islands
Inishmore
Dún Aengus
Inishmaan
Inisheer

Ballyvaughan
Gleninsheen
wedge tomb
Poulnabrone portal dolmen
Burren
Mullaghmore Hill
Doolin
CLARE
Corofin

Miltown Malbay
Ennis

Shannon

Lough
Derg

N68

Kilkee
N69

Kilrush
Limerick
N69
Loop Head
N69
N69

LIMERICK

Kerry Head
N21

The Maharees
Mount Brandon
Tralee
Blennerville

Dingle
The
Blasket
Islands
Dunquin
Ventry
Dingle
Great Blasket
Island
Killorglin
Dingle
Bay

KERRY

Killarney

Glanleam Subtropical
Gardens
Valentia Island
Carrantuohill
Iveragh
N70
Kenmare
N70
N22

Sullane

Cork

Skellig rocks

Derreen
Gardens
Beara
Glengariff
Slieve Miskish
Mountains
Castletownbere
Allihies
Garnish Island
CORK
Dursey
Island
Dunboy Castle
Bear
Island
Sheep's Head
Mizen
N71
Crookhaven
Heir Island
Skibbereen
Mizen Head
Cape Clear
Island
Baltimore
Barley Cove
Sherkin
Island
Fastnet Rock

0 10 20 kilometres
0 10 20 miles

PLACES TO VISIT

■ Baltimore, Co. Cork
This is the ferryport for the Roaringwater Bay islands (see right). The Algiers Inn recalls the raid of 1631, when Barbary pirates took all the villagers off into slavery.
▶ www.baltimore-ireland.com

■ The Burren, Co. Clare
Naked limestone domes nurture the most profuse archaeological remains, most varied flora and best traditional music in Ireland. Ballyvaughan is a village on the north-facing coast of the Burren, an excellent centre for exploring the region. Try Monk's Bar on a Thursday for a great session of traditional music. Doolin is another small village famed as a Shangri-la for Irish traditional music, based around three pubs – O'Connor's, McGann's and McDermott's.
▶ www.ballyvaughanireland.com
▶ www.burrenpage.com
▶ www.doolin-tourism.com

■ Clifden, Co. Galway
The 'capital' of Connemara, a pleasant nineteenth-century town with all the amenities including the Connemara Walking Centre. Liveliest moment: the Connemara Pony Show (see **Activities**, opposite).
▶ ℭ 095 21163 www.clifdenchamber.com

■ Dingle, Co. Kerry
A delightful small town on a circular bay, famous for its resident dolphin named Fungi (see **Find Out More**, opposite). Great music at the Small Bridge pub; summer fun at the Dingle Show and Dingle Regatta in August.
▶ ℭ 066 915 1188
www.dingle-peninsula.ie/dingle/index.html

■ Galway, Co. Galway
The 'capital city' of the west, and a great place to spend a few days. Visit medieval Lynch's Castle and the town museum, stroll beside the River Corrib, buy a Claddagh Ring in the town that originated them, and enjoy Irish music in The Crane pub on Sea Road.
▶ ℭ 091 537700 www.irelandwest.ie

■ Kenmare, Co. Kerry
A friendly town in a beautiful position at the head of the Kenmare River's wide bay. Excellent base for the 'Ring of Kerry' and for sealwatching, sailing and other watersports.
▶ ℭ 064 41233 (seasonal) www.kenmare.com

■ Kilkee, Co. Clare
Traditional, relaxed seaside resort near the tip of the south-west Clare Peninsula, with a

splendid bathing beach with vigorous Atlantic waves, yet sheltered by a reef.
▶ ℭ 065 905 6112 www.kilkee.ie

■ Skibbereen, Co. Cork
Old-style country town with a lived-in feel, friendly locals and plenty of music – especially around Skibbereen's Welcome Home Festival (see **Activities**, opposite).
▶ ℭ 028 21766 www.skibbereen.ie

■ Tralee, Co. Kerry
Another 'real town' that hasn't given itself over body and soul to tourism – nonetheless, the annual Rose of Tralee International Festival (see **Activities**, opposite) is a hoot.
▶ ℭ 066 712 1288 www.tralee.ie

ISLANDS AND PENINSULAS

■ Aran Islands, Co. Galway
This group of three islands out in Galway Bay is the nearest you'll come to 'traditional Ireland', especially if you visit out of the tourist season and explore on foot or bicycle. Dún Aengus, a 2000-year-old stone fort on the main island of Inishmore, is breathtaking. You can take the ferry from Galway, Rossaveal or Doolin, or fly from Galway.
▶ www.visitaranislands.com
▶ ⛴ to Inishmore ℭ 091 568903
▶ ⛴ to Inishmaan and Inisheer ℭ 065 707 4189

■ Beara Peninsula, Co. Kerry/Cork
The 'middle one' of the Five Peninsulas, Beara is shared between Kerry and Cork. It is ruggedly beautiful – 30 miles long with wonderful views. Highlights include Allihies village, under the Slieve Miskish mountains, the evocative ruins of the huge Dunboy Castle, and Garnish Island, with its lovely gardens. Tranquil yet rugged Dursey Island sits off the end of the Beara Peninsula and is reached by a most exciting, swinging and swaying cable car ride from Ballaghboy. Bere Island lies off Castletownbere. There is fine hill walking along a 13-mile stretch of the Beara Way.
▶ www.bearainfo.com
▶ www.bearawebdesign.com/tooltips/pages/dursey.html
▶ ⛴ to Bere Island ℭ 027 75009 or 027 75014
www.bereisland.net

■ Dingle Peninsula, Co. Kerry
This is a lovely hill-backed peninsula, with great sandspits on both north and south and the lively town of Dingle. Ventry's magnificent curved strand and Mount

Brandon, all joined by the Dingle Way long-distance path. The Blasket Islands lie off the tip of the Dingle Peninsula. Great Blasket Island is the largest of the archipelago. It was the scene of a brief and extraordinary literary flowering; its population of 120 produced three great authors in Tomas O'Crohan (*The Islandman*, 1929), Maurice O'Sullivan (*Twenty Years A-Growing*, 1933) and Peig Sayers (*Peig*, 1936).
▶ www.dinglepeninsula.net
▶ ⛴ to Blasket Island ℭ 066 915 6422
www.blasketisland.com

■ Iveragh Peninsula ('Ring of Kerry'), Co. Kerry
This is the best known of the Five Peninsulas because of the famous 'Ring of Kerry' drive that loops round the peninsula. This offers stunning views of the coast, neighbouring Dingle and Beara peninsulas, and the rocky Skelligs out at sea. Valentia Island lies off the coast, with high cliffs on the west and north and tiny fields. A 2500-mile transatlantic telegraph cable was laid between the island and Newfoundland in 1866 (see **Find Out More**, opposite). There is a car and passenger ferry to the island and a bridge.
▶ www.ringofkerrytourism.com
▶ ⛴ to Valentia Island ℭ 066 947 6141
http://indigo.ie/~cguiney/valentia.html

■ Mizen Peninsula, Co. Cork
The Mizen Peninsula trends south-west through rocky country to reach Mizen Head, mainland Ireland's most southerly point.
▶ www.mizenhead.net

■ Roaringwater Bay islands, Co. Cork
East of the Mizen Peninsula, Roaringwater Bay opens out, dotted with islands including three you can visit by ferry – Cape Clear, tiny Heir Island and Sherkin. Cape Clear Island is a beautiful, Irish-speaking and exceptionally friendly place, with one of Ireland's best bird observatories. There are also great views of the Fastnet Rock.
▶ *Cape Clear Island* www.oilean-chleire.ie/english/index.htm ⛴ ℭ 086 346 5110
▶ *Heir Island* www.heirisland.com
⛴ ℭ 086 888 7799
▶ *Sherkin Island* www.sherkinisland.ie
⛴ ℭ 028 20125

■ Sheep's Head Peninsula, Co. Cork
Poking out between the Beara and Mizen peninsulas, Sheep's Head is the narrowest, quietest, least frequented and most peaceful

of the Five Peninsulas. Enjoy it on foot along the Sheep's Head Waymarked Way.
▶ **www.ahakista.com/Sheeps_Head/ sheeps_head.html**

SITES OF INTEREST

■ Blasket Centre, Dunquin, Co. Kerry
The modern and innovative Blasket Centre celebrates the character and spirit of the tiny community that lived on the Blasket Islands until 1953, and explores the lives and work of its three great writers, Tomas O'Crohan, Maurice O'Sullivan and Peig Sayers.
▶ ☎ *066 915 6444* **www.dingle-peninsula.ie/ attractions.html**

■ Blennerville windmill, Co. Kerry
The great white windmill at Blennerville, near Tralee, is the tallest windmill in Ireland, at 66 feet high. Housing a fascinating exhibition, it has been immaculately restored and its sails whirl round once more.
▶ ☎ *066 712 1064*
www.travelireland.org/kerry/visitor_ attractions/blennerville-windmill.html

■ Derreen Gardens, Co. Kerry
Woodland garden planted on Beara Peninsula in 1870s by the 5th Marquess of Lansdowne. There are tree ferns, huge rhododendrons, azaleas and camellias, and splendid sea and mountain views.
▶ ☎ *064 83588* **www.gardensireland.com/ derreen-garden.html**

■ Glanleam Subtropical Gardens, Valentia Island, Co. Kerry
These are Victorian gardens of subtropical plants from South America, the Antipodes and the Far East, growing in lush profusion and seen from a network of paths.
▶ ☎ *066 947 6176*
http://en.wikipedia.org/wiki/Valentia_Island

■ Maritime Museum, Mizen Peninsula, Co. Cork
Housed in a former signal station, the Mizen Head Visitor Centre and Maritime Museum is reached by a steep flight of steps and a vertiginous bridge. Once there, you can enjoy displays about the lighthouse-keepers and the wildlife of the rugged peninsula.
▶ ☎ *028 35115* **www.mizenhead.net**

■ Poulnabrone dolmen, the Burren, Co. Clare
The splendid Poulnabrone portal dolmen stands by the R480 road from Ballyvaughan

to Corofin. This 4500-year-old Stone Age tomb, like a square stone house topped by a huge yet slender capstone, is one of the Burren region's many remarkable prehistoric monuments; another, nearby, is Gleninsheen wedge tomb, of similar date.
▶ **www.stonepages.com/ireland/ poulnabrone.html**

■ Skellig Experience Centre, Co. Kerry
Models, tableaux and displays explore the life of the monks living on the Skellig rocks and the birds and flowers that still inhabit the rugged islets.
▶ ☎ *066 947 6306* **www.skelligexperience.com**

NATURAL WORLD

■ Beaches
Lovely white sand beaches on Connemara's southern coastline include Ardmore, Gorteen Bay, Dog's Bay and Creggoduff; and on the north at Rusheenduff and Glassillaun. The Maharees is a 5-mile scimitar-shaped sandspit with superb beaches on the north shore of the Dingle Peninsula. Kilkee, in County Clare, and the magnificent Barleycove, near Crookhaven in County Cork, are among several Blue Flag beaches.
▶ **www.antaisce.org/images/BlueFlagMap.pdf**

■ Bog land
Don't hurry past the great expanses of bogland you'll find in Connemara and other parts of the west. Apart from their sombre beauty, these vast tracts of heather and turf teem with insects, birds and plant life.
▶ **www.allaboutirish.com/library/places/ bogs.shtm**

■ Limestone hills
The limestone hills of the Burren, naked and barren as they seem, are a treasure-house of plants. They exude a quiet magic of their own, too, particularly the twisted and swirling shape of Mullaghmore, north of Corofin.
▶ **www.clarelibrary.ie/eolas/coclare/places/ the_burren/burren_karst.htm**

■ Mountains
Carrantuohill, on the Iveragh Peninsula, is Ireland's highest mountain, at 3414 feet; Mount Brandon, on the Dingle Peninsula, is another magnificent peak, at 3127 feet. The Twelve Bens of Connemara are lower, but just as impressive as a tight group.
▶ **www.wesleyjohnston.com/users/ireland/ geography/physical_landscape.html**

ACTIVITIES

■ Archaeology
The Burren contains a wonderful array of ancient stone tombs, carved crosses, ring forts, churches, castles and standing stones.
▶ **http://mockingbird.creighton.edu/ english/micsun/IrishResources/archaeol.htm**

■ Botany
County Clare's Burren region draws botanists for the thrill of finding plants from entirely different habitats all thriving side by side.
▶ **www.askaboutireland.ie/show_narrative_ page.do?page_id=303**

■ Festivals
Co. Clare – Willie Clancy Week of Traditional Music, Miltown Malbay (early July); Micho Russell Festival Weekend of Music, Doolin (late February).
Co. Cork – Welcome Home Festival, Skibbereen (end July/beginning August).
Co. Galway – Connemara Pony Show, Clifden (3rd Thursday in August); Galway Arts Festival and Galway Races (July/August).
Co. Kerry – Dingle Regatta (August); Puck Fair, Killorglin – crowning a goat and other revels (August); Rose of Tralee International Festival (August).

■ Walking
Beara Way, Burren Way, Western Way (through Connemara), Dingle Way, Kerry Way (Iveragh Peninsula) and Sheep's Head Way are waymarked national trails.
▶ ☎ *095 21492* **www.walkingireland.com**

FIND OUT MORE

Celebrity dolphin
A profile of Fungi, the bottlenose dolphin of Dingle Bay, and where you can find him.
www.net-rainbow.com/fungi.html

Transatlantic flight
Details of Alcock and Brown's first non-stop transatlantic flight, with all its hitches.
www.aviation-history.com/airmen/alcock.htm

Transatlantic sea voyages
The transatlantic currach voyages of St Brendan (c. AD 550) and Tim Severin (1976–7).
www.ics.villanova.edu/in_saint_brendan.htm

Transatlantic telegraph cable
The epic saga of the transatlantic telegraph cable, finally laid in 1866.
http://en.wikipedia.org/wiki/Transatlantic_ telegraph_cable

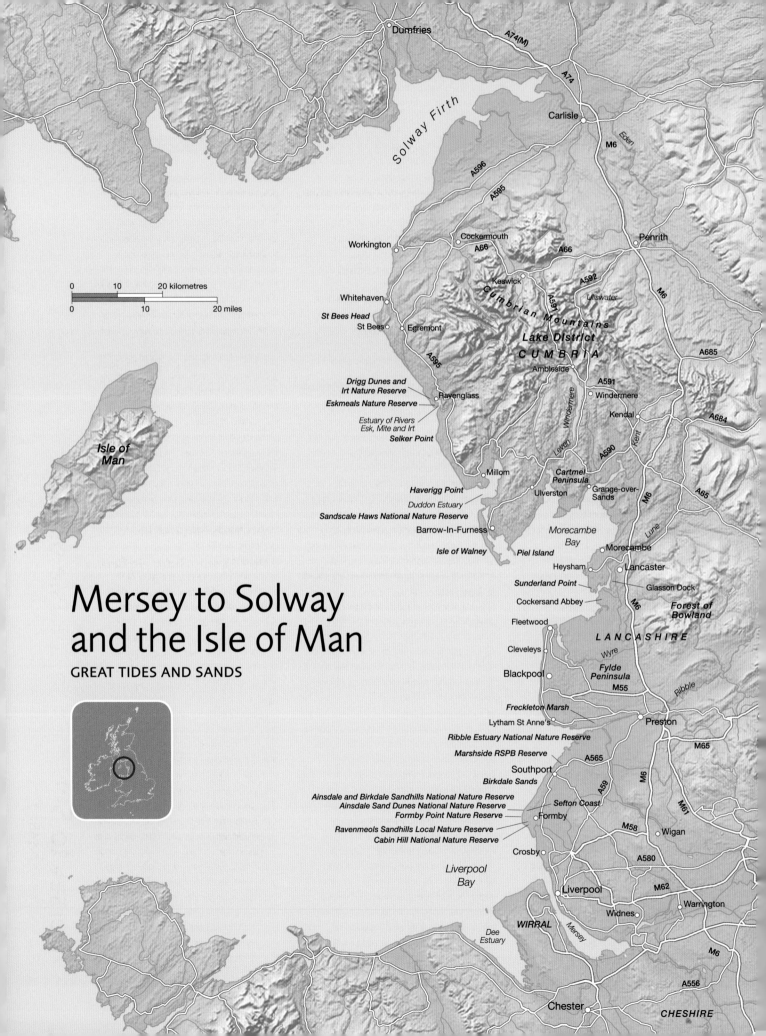

Mersey to Solway and the Isle of Man

GREAT TIDES AND SANDS

Dumfries

A74(M)

Solway Firth

Carlisle

A74

A596

Eden

M6

A595

Workington

Cockermouth

Penrith

A66

A66

Keswick

A592

Ullswater

Whitehaven

Cumbrian Mountains

A591

St Bees Head

St Bees

Egremont

Lake District

CUMBRIA

A685

Ambleside

A591

A595

Windermere

Windermere

Drigg Dunes and
Irt Nature Reserve

Ravenglass

Kendal

A684

Eskmeals Nature Reserve

Leven

Estuary of Rivers
Esk, Mite and Irt

Windermere

Kent

A590

Selker Point

A65

Millom

Cartmel
Peninsula

Grange-over-
Sands

M6

A65

Haverigg Point

Ulverston

Duddon Estuary

Sandscale Haws National Nature Reserve

Lune

Barrow-In-Furness

Morecambe
Bay

Isle of Walney

Piel Island

Morecambe

Heysham

Lancaster

Sunderland Point

Glasson Dock

Forest of
Bowland

Cockersand Abbey

M6

Fleetwood

LANCASHIRE

Cleveleys

Wyre

Fylde
Peninsula

Blackpool

Ribble

M55

Freckleton Marsh

Lytham St Anne's

Preston

Ribble Estuary National Nature Reserve

M65

Marshside RSPB Reserve

A565

Southport

A59

M6

Birkdale Sands

Ainsdale and Birkdale Sandhills National Nature Reserve

Sefton Coast

Ainsdale Sand Dunes National Nature Reserve

Formby Point Nature Reserve

Formby

M58

Ravenmeols Sandhills Local Nature Reserve

Wigan

Cabin Hill National Nature Reserve

Crosby

A580

M61

Liverpool
Bay

Liverpool

M62

Widnes

Warrington

WIRRAL

Mersey

M6

Dee
Estuary

Chester

A556

CHESHIRE

Isle of
Man

0 10 20 kilometres

0 10 20 miles

PLACES TO VISIT

■ Barrow-in-Furness, Cumbria
Barrow lies out on a limb at the southern tip of the Furness Peninsula. The wide streets and handsome architecture show its origin as a Victorian planned town, built on the back of prosperity from Barrow's great iron and steel works. Today, Barrow houses Britain's most important shipyard, building nuclear submarines for the Royal Navy.
▶ ℓ 01229 894784　www.barrowtourism.co.uk

■ Blackpool, Lancashire
The premier resort of this coast offers the white-knuckle rides of the Pleasure Beach, the perennial September–November attraction of the Blackpool Illuminations, the trams, the Golden Mile, the three piers and Blackpool Tower.
▶ ℓ 01253 478222　www.blackpooltourism.com

■ Fleetwood, Lancashire
The trawler fleet is diminished since the old days, but this is still a great place to come for the smack of the sea. Visit Fleetwood's 'heritage trawler' *Jacinta* in the Fish Dock, and also Fleetwood Museum to learn the story of the trawlermen and the unbelievable hardships they underwent – and still undergo – in the course of their work.
▶ www.fleetwood-trawlers.connectfree.co.uk/jacinta.html

■ Glasson Dock, Lancashire
The port for the city of Lancaster, Glasson Dock was developed near the mouth of the River Lune from the 1750s onwards, as the river silted up and choked off Lancaster itself. These days it is a quiet, atmospheric little place, with great walks along the old Glasson–Lancaster canal and a fine blues, folk and traditional music festival in summer.
▶ www.glassonfestival.org.uk

■ Grange-over-Sands, Cumbria
Genteel, delightful Victorian resort on the Cartmel Peninsula, looking out over Morecambe Bay's vast acres of marsh and sand.
▶ ℓ 01539 534026　www.lakelandgateway.info

■ Lancaster, Lancashire
Lancaster's late seventeenth- to eighteenth-century heyday as a port is long gone, but this is a fine city with an exciting history. The medieval Lancaster Castle and the Maritime Museum are well worth visiting (see **Sites of Interest**, right and page 212).
▶ ℓ 01524 32878　www.visitlancaster.co.uk

■ Millom, Cumbria
Cumbria's 'forgotten town', this former iron-working settlement stands on an isolating loop of road at the end of a peninsula on the west shore of the Duddon Estuary. Norman Nicholson (1914–87), Cumbria's greatest twentieth-century poet, was a native of Millom; there is a blue plaque on his birthplace, the house where he lived all his life – 14 St George's Terrace.
▶ www.visitcumbria.com/wc/millom.htm
▶ *Norman Nicholson* http://rylibweb.man.ac.uk/data2/archives/ncnlist.txt

■ Morecambe, Lancashire
Morecambe has plenty of bold seaside architecture – notably the fabulous Art Deco Midland Hotel and the pretty Winter Gardens theatre, not to mention its prancing statue of comedian and local boy Eric Morecambe (1926–84) – to tell you of its past glories as a large, popular seaside resort. Things have been faded and shabby for some time. But now, with enterprises such as the Tern Project (see **Find Out More**, page 212), Morecambe intends to reposition itself as a centre for ecologically aware holiday-makers keen on birdwatching and exploring the sands of Morecambe Bay.
▶ ℓ 01524 582808　www.visitmorecambe.co.uk

■ Sunderland Point, Lancashire
This is a tiny community, cut off twice a day by high tide and isolated at the end of a road on the north bank of the River Lune below Lancaster. The first bale of cotton from the New World, harbinger of the Industrial Revolution, is said to have been landed here at the turn of the eighteenth century; warehouses and quays can still be seen. Across the headland lies the grave of Sambo, a servant/slave brought to Sunderland from the Caribbean (see page 106).
▶ www.timetravel-britain.com/05/July/sunderland.shtml

■ Whitehaven, Cumbria
Whitehaven has had a remarkable turn-round in its fortunes (see page 107). Today you can wander and admire well-restored Georgian architecture, a lively marina and harbourside café scene, and arts and crafts outlets including the well-known Whitehaven Pottery Shop. There are also some good museums (See **Sites of Interest**, page 212).
▶ ℓ 01946 852939　www.whitehaven.talktalk.net

ISLANDS
■ Isle of Man
The self-governing Isle of Man lies in the Irish Sea, some 60 miles from its mainland ferry ports of Liverpool and Heysham, a green mountain-backed island measuring 33 miles by 13 miles. Douglas is a lively resort, and there are plenty of pretty villages tucked away. Wooded glens lead to the sea, and there's beautiful walking along the Millennium Way footpath (see **Activities**, page 212).
▶ ℓ 01624 686766　www.isle-of-man.com
▶ ⛴ ℓ 01624 661661　www.steam-packet.com

SITES OF INTEREST

■ Cockersand Abbey, Lancashire
Of the Premonstratensian Abbey of St Mary's-in-the-Marsh, founded in 1192 by Hugh Garth (known as 'Hugh the Hermit') in the lonely marshland at the mouth of the River Lune, all that remains is the Chapter House, built in about 1230. Stones from the monastery can be spotted locally in the sea wall below the ruin and in local houses, farm buildings and field walls.
▶ www.british-history.ac.uk/report.asp?compid=38355

■ Dock Museum, Barrow-in-Furness
The Dock Museum tells the story of the development of Barrow into a classic Georgian planned town, of the area's iron and steelworking industries, and of shipbuilding and the story of the Vickers Shipyard through historic photographs.
▶ ℓ 01229 894444　www.dockmuseum.org.uk

■ Formby Point Nature Reserve, Lancashire
This beautiful nature reserve consists of grazing fields, dunes, beaches and old pine groves, which shelter one of England's largest populations of native red squirrels.
▶ ℓ 01704 878591　www.nationaltrust.org.uk

■ Lancaster Castle
This Castle forms an impressive ensemble with its Norman keep and various medieval towers and other structures. The castle is still used as a court and a prison, which gives an added *frisson* to a tour of the place – this includes ancient halls, the splendid Judges' Lodgings, grim old cells and the Drop Room, or hanging room, where felons met their execution. Today, the castle is the setting for opera performances, plays and concerts.
▶ ℓ 01524 64998　www.lancastercastle.com

Mersey to Solway and the Isle of Man

GREAT TIDES AND SANDS

■ Lifeboat Museum, Lytham St Anne's

There's an excellent Lifeboat Museum in the old lifeboat station at Lytham St Anne's, and a permanent exhibition in the old windmill that is situated alongside.

▶ www.btinternet.com/~m.fish/museum1.htm

■ Maritime Museum, Lancaster

The Maritime Museum, in the beautiful Georgian Customs House on St George's Quay, offers a fascinating overview of Lancaster's rise to become a great trading port, then the decline of the quays as the River Lune silted up.

▶ ☎ 01524 64637
www.lancashire.gov.uk/education/museums/lancaster/maritime.asp

■ Whitehaven museums, Cumbria

Three treats are the Beacon Visitor Centre and Museum, Haig Pit Mining Museum, and a museum dedicated to rum – The Rum Story.

▶ www.visitcumbria.com/museum.htm

NATURAL WORLD

■ Cliffs

The rugged red sandstone cliffs around St Bees in West Cumbria are the only ones on this coast.

▶ www.whitehaven.ukfossils.co.uk
▶ www.stbees.org.uk/tours/vt_Fleswick.htm

■ Estuaries

There are several notable estuaries here. Ribble reaches the sea among wide flats of mud and sand on the southern side of the Fylde Peninsula, Wyre on the north, and Lune below Lancaster. Leven, Leer and Kent flow through the great sands of Morecambe Bay and its dividing peninsulas, Duddon further west. Esk, Mite and Irt join to wind through the sandbanks at Ravenglass, while the vast flats of the Solway Firth separate England and Scotland.

▶ www.duddon-estuary.org.uk
▶ www.morecambebay.com
▶ www.ribble-estuary.co.uk

■ Sand dunes

There are some splendid dune systems along the Sefton Coast, supporting natterjack toads, great crested newts and many rare dune plants. Among the best nature reserves are Ainsdale Sand Dunes, Cabin Hill, Ainsdale and Birkdale Sandhills and Ravenmeols Sandhills (all in Merseyside). There are also good ones at Lytham St Anne's, Sandscale Haws (at the southern mouth of the Duddon Estuary), the Eskmeals and Drigg dunes and the Irt Estuary (all at Ravenglass).

▶ www.lbap.org.uk/bap/habitat/sand.htm

ACTIVITIES

■ Birdwatching

This coast comes into its own in winter. Marshside Reserve, saltwater and freshwater marshes and lakes just north of Southport, is excellent for ducks, geese and waders. Ribble Estuary National Nature Reserve is good for waders such as oystercatchers, grey plovers, black-tailed godwits, knots, dunlins and sanderlings, and Freckleton Marsh on the Ribble for lapwings and golden plovers. On the Lune Estuary you can find mute swans, pinkfoot geese, curlews, shelducks and redshanks. Morecambe Bay is of international importance for birds over-wintering and on migration passage, including large numbers of ringed plovers, sanderlings, turnstones, knots and golden plovers; also lapwings, pinkfoot geese and shelducks.

▶ www.sefton.gov.uk/page&3964
▶ www.rspb.org.uk/reserves/guide/m/morecambebay/index.asp

■ Cycling

A free bicycle-loan scheme operates along the Sefton Coast.

▶ ☎ 0845 140 0845
www.seftoncoast.org.uk/visit_cycling.html

■ Fishing

Traditional ways of fishing, such as whammelling, cockling and haaf-netting, are still active in some parts, notably the Lune Estuary, Morecambe Bay and the Solway Firth (see **Find Out More**, right).

▶ www.nettingthebay.org.uk/explore/coastal/haafnetting.htm

■ Walking

One of the great attractions of the area is a walk with the Sands Guide, Cedric Robinson. This is a strenuous and exciting trek of several hours across the sands, muds and rivers of Morecambe Bay – a place it's deadly dangerous to visit without a guide. Contact Cedric via Morecambe Tourist Information Centre (☎ 01524 582808) or Grange Tourist Information Centre (☎ 01539 534026).

The 45-mile Cumbria Coastal Way runs around the outer edges of the Cartmel and Ulverston peninsulas; the 137-mile Lancashire Coastal Way links Merseyside and Cumbria. The Isle of Man is threaded by the 25-mile Millennium Way.

▶ *Cumbria Coastal Way* www.ramblers.org.uk/INFO/paths/cumbriacoastal.html
▶ *Lancashire Coastal Way* www.lancashire.gov.uk/environment/countryside/walking/wcoastal.asp
▶ *Isle of Man Millennium Way* www.iomguide.com/millenniumwaytrail.php

FIND OUT MORE

Birkdale Sands, Lancashire

This is the somewhat unlikely cradle of commercial aviation in Britain. Britain's first regularly scheduled passenger service began here in 1919, on a sand airstrip.

www.seftoncoast.org.uk/articles/01winter_aviation.html

Blackpool Pleasure Beach

A historical timeline showing the development of this highly popular resort town.

www.coastergrotto.com/reviews/features/bpb-timeline.jsp

Fishing

Excellent account of the Fleetwood trawlermen's life and hardships.

www.fleetwood-trawlers.connectfree.co.uk/industry.html

Haaf netting in the bays and estuaries of the Irish Sea coastline.

www.nettingthebay.org.uk/explore/coastal/haafnetting.htm

Internment camps

First and Second World War internment camps on the Isle of Man.

http://timewitnesses.org/english/IsleOfMan.html

www.isle-of-man.com/manxnotebook/famhist/genealgy/intern.htm

www.iomguide.com/internment-camps/knockaloe.php

Tern Project, Morecambe

The Tern Project has spiced up a general revamping of Morecambe's storm-battered and semi-derelict 5-mile seawall promenade with sculptures, installations and other artworks.

www.tern.org.uk

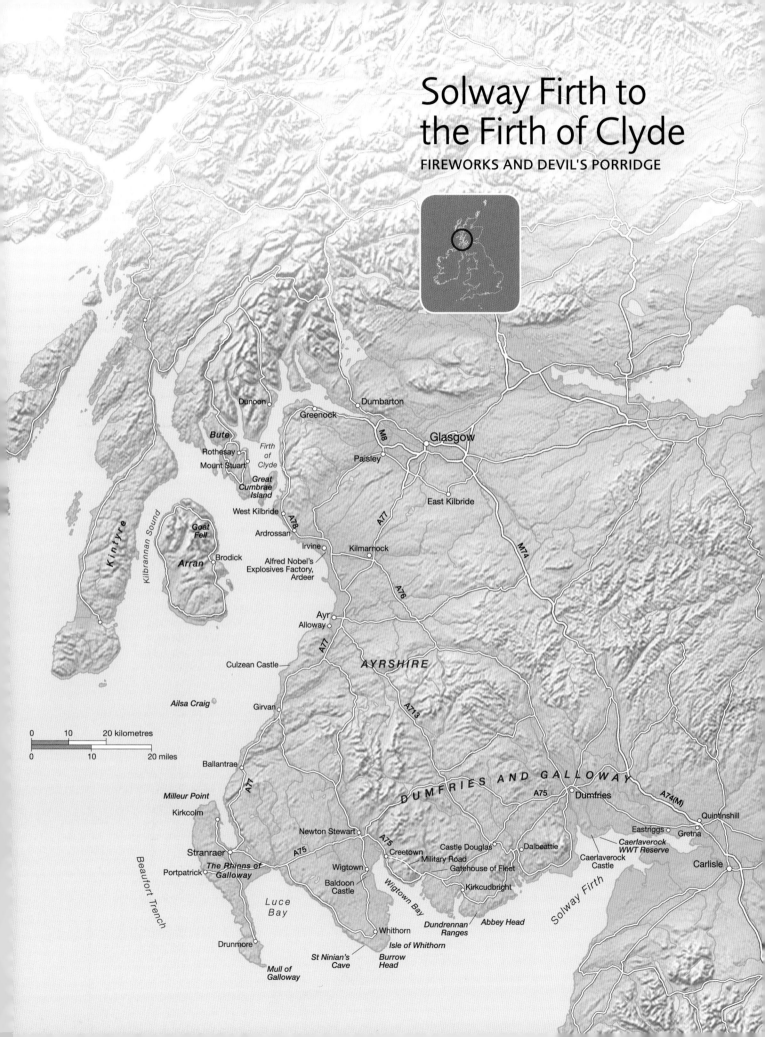

Solway Firth to the Firth of Clyde

FIREWORKS AND DEVIL'S PORRIDGE

Dunoon

Dumbarton

Greenock

Bute

M8

Glasgow

Rothesay

Paisley

Mount Stuart

Firth of Clyde

Great Cumbrae Island

East Kilbride

West Kilbride

A78

Goat Fell

Ardrossan

A77

Kintyre

Kilbrannan Sound

Arran

Brodick

Irvine

Kilmarnock

Alfred Nobel's Explosives Factory, Ardeer

A76

M74

Ayr

Alloway

Ailsa Craig

A77

Culzean Castle

AYRSHIRE

Girvan

A713

0 10 20 kilometres

0 10 20 miles

Ballantrae

A77

DUMFRIES AND GALLOWAY

A75

Dumfries

A74(M)

Milleur Point

Quintinshill

Kirkcolm

Eastriggs

Gretna

Newton Stewart

Caerlaverock WWT Reserve

Stranraer

A75

Creetown

Castle Douglas

Dalbeattie

Caerlaverock Castle

Carlisle

The Rhinns of Galloway

Portpatrick

Wigtown

Military Road

Gatehouse of Fleet

Beaufort Trench

Baldoon Castle

Wigtown Bay

Kirkcudbright

Solway Firth

Luce Bay

Drunmore

Whithorn

Dundrennan Ranges

Abbey Head

St Ninian's Cave

Isle of Whithorn

Burrow Head

Mull of Galloway

PLACES TO VISIT

Alloway, Ayrshire
This is the birthplace of the 'heav'n-taught ploughman', Robert Burns. The clay cottage where Scotland's national poet was born is now the Burns Cottage and Museum (📞 01292 443700). Other Burns locations in Alloway are the Burns Monument, the roofless shell of Alloway Old Kirk (where Burns's father is buried) and the early medieval Brig o'Doon – kirk and bridge both featuring in Burns's comic masterpiece *Tam O'Shanter*.
▶ **www.burnsheritagepark.com/attraction. php?id=1; www.robertburns.org**

Ardrossan, Ayrshire
Ardrossan is an old-fashioned resort with good sandy beaches (and a hilarious 'Not The Tourist Board' website: **www.geocities. com/lordeglinton**). An excellent on-line trail shows you around the handsome sandstone buildings of the town.
▶ **www.ardrossan.org**

Ayr, Ayrshire
Ayr is a solid, attractive old town. Among its best features are the Baronial/Italianate architecture of the Wallace Tower, the Town Hall with its great spire, the round arches of the fifteenth-century Auld Brig and the flatter ones of the handsome nineteenth-century New Bridge crossing the River Ayr, the walls of Oliver Cromwell's oppressive citadel – all these and a fine beach too.
▶ 📞 *01292 288688* **www.visitscotland.com**

Carlisle, Cumbria
Carlisle lies on the River Eden, at the head of the Solway Firth, just south of the Scottish border. This ancient, historic city has a massive Norman castle of sandstone, a Tudor citadel with great drum towers and a Norman cathedral, whose fourteenth-century stained glass is one of the treasures of this coast.
▶ 📞 *01228 625600* **www.historic-carlisle.org**

Dumfries, Dumfries & Galloway
This county town in south-west Scotland, built of warm red sandstone, is best known as the place where Robert Burns spent his last few years. A Robert Burns Trail leads you around the Burns sites – Burns House, where he died (📞 *01387 255297*); the Burns statue, by Greyfriars Church; the Burns Mausoleum, where he lies in St Michael's churchyard; and the Robert Burns Centre (📞 *01387 264808*),

which offers a comprehensive run-through of his life and work.
▶ 📞 *01387 253862*
www.visitdumfriesandgalloway.co.uk

Girvan, Ayrshire
Red sandstone town with a bustling, active harbour that's a pleasure to idle around, and spectacular views west to Ailsa Craig and north to the beautiful skyline mountains of the Isle of Arran.
▶ 📞 *01465 715500*
www.undiscoveredscotland.co.uk/girvan/ girvan/index.html

Gretna Green, Dumfries & Galloway
The village of Gretna Green is well known for just one reason: it was the first place over the Scottish border where runaway couples from England could marry under the age of 21 – an illegal proceeding south of the border for many years. Often it was one of the village blacksmiths who performed the ceremony. You can still get married at the Mill Forge today.
▶ **www.gretnamarriages.co.uk**

Kirkcudbright, Dumfries & Galloway
This is a pretty little town at the head of a bay on the Solway Firth. The beauties of the harbour and the nearby hill and coastal views made it very much a favourite hang-out for artists from the early twentieth century onwards; as a result, there is a scattering of galleries to enjoy.
▶ 📞 *01557 330494* **www.kirkcudbright.co.uk**

Whithorn, Dumfries & Galloway
In the gently sloping main street an archway leads to an excellent visitor centre and museum, and beyond them the nave and crypt of Whithorn's twelfth-century priory cathedral. Alongside lie the foundations of what may have been the 'Candida Casa' or White Church, St Ninian's original fifth-century building.
▶ **www.undiscoveredscotland.co.uk/ whithorn/whithorn/index.html**
▶ *Whithorn Trust Museum and Excavation* 📞 *01988 500508* **www.whithorn.com**

Wigtown, Dumfries & Galloway
'Scotland's Hay-on-Wye', Wigtown bulges with bookshops. In a railed-off enclosure in the graveyard of the parish church you'll find the gravestones of executed Covenanters, including Margaret McLachlan and Margaret

Wilson (see **Find Out More**, opposite). The Martyrs' Memorial to the two women lies beyond at the edge of the marsh.
▶ 📞 *01671 402431*
http://homepages.rootsweb.com/~dfsgal/ Wigtown/mrtyrs-01.htm

ISLANDS AND PENINSULAS
For details of ferries to all islands listed below: 📞 *08705 650000* **www.calmac.co.uk/ islands.html**

Great Cumbrae Island, Ayrshire
Another of Glasgow's traditional resorts, Great Cumbrae Island is home to Scotland's National Watersports Centre (📞 *01475 530757*), which is excellent for scuba, sea kayaking, sailing, windsurfing and many other sports.
▶ **www.millport.org**

Isle of Arran, Ayrshire
Arran has fine hill-walking, golf courses galore, the low-key seaside resort of Brodick with its sixteenth-century castle, and the 2868-foot mini-mountain of Goat Fell to climb for stunning views over the Firth of Clyde.
▶ 📞 *01770 302140/302401*
www.ayrshire-arran.com

Isle of Bute, Argyllshire
Glasgow's 'home island', Bute lies in the mouth of the Firth of Clyde, conveniently close to the capital. Though paddle-steamers no longer take Glaswegians 'doon the watter' in vast numbers, Bute's Victorian resort of Rothesay still does good holiday business. Mount Stuart, south of Rothesay, is a wonderful Gothic extravaganza of a house, built by Cardiff coal mogul the 3rd Marquess of Bute in the 1870s.
▶ 📞 *08707 200 619* **www.isle-of-bute.com**

Isle of Whithorn, Dumfries & Galloway
The Isle of Whithorn is no longer an island, being joined to the mainland by a slim isthmus. Here you'll find St Ninian's Chapel, a medieval church that marked the start of the pilgrimage route to St Ninian's church in Whithorn, 4 miles away (see left). Along the coast is St Ninian's Cave with its ancient incised crosses.
▶ **www.isleofwhithorn.com**

Rhinns of Galloway, Dumfries & Galloway
The hammerhead peninsula that forms the south-western tip of Scotland. A beautiful, other-worldly place, especially out at the two

ends – Milleur Point on the north, Mull of Galloway to the south.

▶ http://en.wikipedia.org/wiki/Rhinns_of_Galloway

SITES OF INTEREST

■ Ailsa Craig

A big volcanic plug 1100 feet high, standing out of the sea 8 miles off Girvan, this island is well known for the use of its granite in making curling stones. Nowadays an RSPB reserve, it is a haven for large seabird colonies (see **Activities**, right).

▶ www.ailsacraigonline.com; www.maybole.org/photogallery/ailsacraig/ailsacraig.htm

▶ ⚓ www.ailsacraig.org.uk

■ Baldoon Castle, Dumfries & Galloway

This is a ruined castle just outside Wigtown, with a brilliant seventeenth-century ghost story on which Sir Walter Scott based *The Bride Of Lammermoor* (see page 114).

▶ http://en.wikipedia.org/wiki/Wigtown#Places_of_interest

■ Caerlaverock Castle, Dumfries & Galloway

Built in the late thirteenth century by the locally powerful Maxwell family, Caerlaverock Castle is designed on a triangular plan unique in Scotland, and is surrounded by a double moat. Captured by Edward I in 1300, it saw three turbulent centuries before the arrival of quieter time along the border was signalled by the building of a fine gentleman's residence inside the castle courtyard.

▶ ☎ 01387 770244

www.phouka.com/travel/castles/caerlaverock/caerlaverock4.html

■ Caerlaverock Reserve, Dumfries & Galloway

The Wildfowl and Wetlands Trust's Reserve, on the marshes at Caerlaverock, south of Dumfries, is a haven for many kinds of wading birds and wildfowl – in particular the barnacle geese that throng there each winter from Norway.

▶ ☎ 01387 770200

www.wwt.org.uk/visit/caerlaverock

■ Culzean Castle, Ayrshire

Perched in a striking position on the edge of the Ayrshire cliffs, the medieval castle of Culzean (pronounced 'C'lane') was redesigned by Robert Adam in the late eighteenth century as a romantic mansion.

The interior has been furnished in superb Georgian style; its centrepiece is Adam's grand and graceful oval staircase.

▶ ☎ 01655 884455 or 0870 118 1945

www.culzeanexperience.org

■ Devil's Porridge exhibition, Eastriggs, Dumfries & Galloway

Housed in St John's Episcopalian Church, this exhibition tells the story of the Moorside munitions factory, the largest in the world. Other topics covered include two desperate First World War episodes from 1915 – the Gallipoli expedition, and the worst disaster in British railway history, the troop train crash at Quintinshill near Gretna that cost 227 lives.

▶ ☎ 01461 700021

www.devilsporridge.co.uk

NATURAL WORLD

■ Cliffs

Fine sandstone cliffs rise around the Rhinns of Galloway and along the coast of north-west Galloway and south Ayrshire. Ailsa Craig's basalt columns are spectacular seen from a boat (see **Sites of Interest**, left), while Arran's cliffs offer a splendid mishmash of vulcanized geology.

▶ www.ukbap.org.uk/lbap.aspx?id=368

■ Mountains

Arran's mountains are the cream of the crop along this coast – peaked granite rising over 2700 feet in the north of the island, and descending as a series of ledges or steps in the south.

▶ www.needlesports.com/galloway/gallowayindex.htm

■ Marshes

The marshes, known locally as merses, of the Solway Firth are rich in birds, especially overwintering geese and other wildlife, and flushed with colourful summer plants such as delicate pink sea milkwort, sea spurrey and pale purple sea aster.

▶ www.jncc.gov.uk/default.aspx?page=1980

▶ www.solwaycoastaonb.org.uk/marsh.php

ACTIVITIES

■ Birdwatching

Barnacle geese wintering on the Solway merses at Caerlaverock Wildfowl and Wetlands Trust's Reserve, puffins and razorbills on the cliffs of the Mull of Galloway, and the 40,000 breeding pairs

of gannets on Ailsa Craig are some of the birdwatching delights here.

▶ www.solwaycoastaonb.org.uk/marsh.php

■ Military history

There's a wealth of study for anyone interested in old military sites: remnants of the vast Moorside munitions factory at Gretna (see page 110); the MoD's Dundrennan ranges near Kirkcudbright (see **Find Out More**, below); the military road from Creetown to Gatehouse of Fleet, built 1763–4; Alfred Nobel's explosives factory in the dunes near Irvine; and local memories of the vast Second World War convoys that assembled in the Firth of Clyde.

▶ www.dalbeattie.com/scotland-creetown/history/index.html

■ Walking

There are few official rights of way, but you are welcome to walk virtually anywhere. Long-distance paths include the Isle of Arran Coastal Way (65 miles) and the 26-mile West Island Way through the Isle of Bute. The Walking Wild website has hundreds of walk routes and ideas throughout the area.

▶ www.walkingwild.com

▶ www.mountaineering-scotland.org.uk

FIND OUT MORE

Explosives in the sea

Explosives, dumped in the sea after the Second World War, still turn up around the Beaufort Trench. Today, shells are fired into the Solway Firth from an MoD testing site in Dundrennan.

www.marlab.ac.uk/Uploads/Documents/AE08Beauforts.FH10.pdf

http://news.bbc.co.uk/2/hi/science/nature/4032629.stm

www.west-dunbarton.gov.uk/bellsmyre/DisplayArticle.asp?ID=2382

The Covenanters

More about the Covenanters, the seventeenth-century religious group to which the Wigtown Martyrs belonged.

www.sorbie.net/covenanters.htm

The Wigtown Martyrs

The story of the brave women – Margaret McLachlan and Margaret Wilson – who became the Wigtown Martyrs in 1685.

http://homepages.rootsweb.com/~dfsgal/Wigtown/mrtyrs-01.htm

The Outer Hebrides

THE GRANITE ARCHIPELAGO

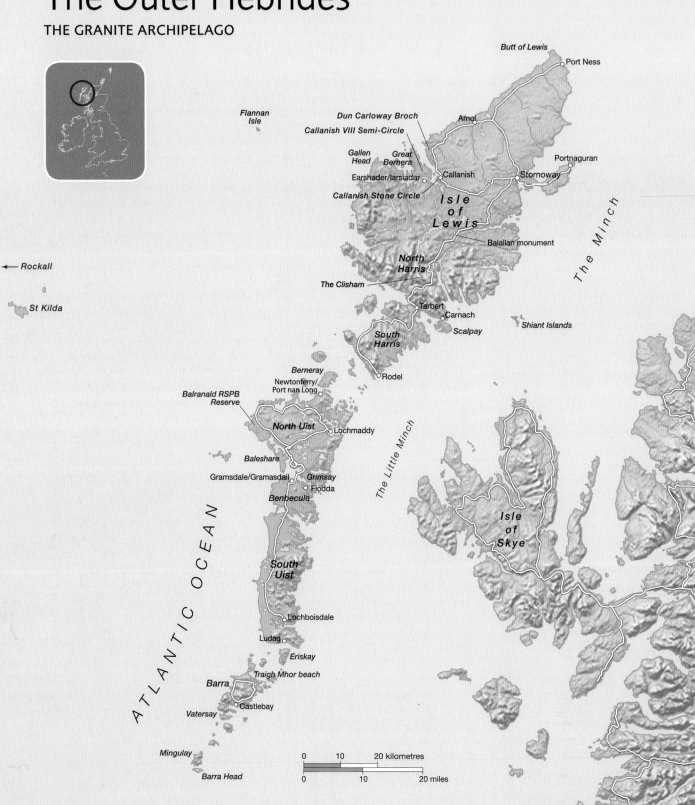

Butt of Lewis
Port Ness
Flannan Isle
Dun Carloway Broch
Callanish VIII Semi-Circle
Amol
Gallen Head
Great Bernera
Portnaguran
Earshader/Iarsiadar
Callanish
Stornoway
Callanish Stone Circle
Isle of Lewis
Balallan monument
North Harris
The Minch
The Clisham
Rockall
Tarbert
St Kilda
Carnach
Scalpay
Shiant Islands
South Harris
Rodel
Berneray
Newtonferry/Port nan Long
Balranald RSPB Reserve
North Uist
Lochmaddy
The Little Minch
Baleshare
Grimsay
Gramsdale/Gramasdail
Flodda
Benbecula
Isle of Skye
ATLANTIC OCEAN
South Uist
Lochboisdale
Ludag
Eriskay
Traigh Mhor beach
Barra
Castlebay
Vatersay
Mingulay
Barra Head

0 10 20 kilometres
0 10 20 miles

PLACES TO VISIT

All populations 2001 census

■ Baleshare
Pop. 49

Flat, sandy and magical, Baleshare would probably have been depopulated if its causeway had not been built in 1962. Head south to find white sandy beaches and dunes.

▶ **www.undiscoveredscotland.co.uk/ baleshare/baleshare**

▶ *Causeway from A865, North Uist*

■ Barra
Pop. 1078

Barra lays magic on you from the moment you arrive – either on a ferry as you pass Kisimul Castle, rising like a fairytale fortress on its rock in Castlebay harbour, or in an aeroplane, which touches down on the broad white cockle-shell sands of Traigh Mhór, the 'Great Strand'.

▶ ✆ *01871 810336* **www.isleofbarra.com**

▶ ✈ *from Glasgow* ⛴ *from Oban or Eriskay*

■ Benbecula
Pop. 1219

Get away on a bike or on foot to discover an island that's more water than land – moody, lonely and flat, apart from the 406-foot pimple of Rueval, a great lookout.

▶ **www.scotland-inverness.co.uk/ benbecula.htm**

▶ ✈ *from Glasgow; causeway from South and North Uist*

■ Berneray
Pop. 136

With its two hills and superb beaches, Berneray is scattered with ancient sites. There is also a monument at the birthplace of Angus MacAskill (1826–63), the 'Nova Scotia Giant', who was 7 feet 9 inches tall.

▶ **www.isleofberneray.com**

▶ *Causeway from just beyond B893 at Newtonferry (Port nan Long), North Uist*

■ Eriskay
Pop. 133

Eriskay is well known for its native breed of hardy little ponies. In addition, two great dates resonate in the island's history – 2 August 1745, when Bonnie Prince Charlie landed on Eriskay to start the second Jacobite rebellion, and 5 February 1941, when SS *Politician* ran aground here (see pages 124–5).

▶ **www.cne-siar.gov.uk/eriskay/eriskay.htm**

▶ ⛴ *from Barra; causeway from Ludag, South Uist*

■ Flodda
Pop. 11

A scrap of an island off the northern end of Benbecula, with a large seal colony to enjoy.

▶ *Causeway from A865 near Gramsdale (Gramasdail), Benbecula*

■ Great Bernera
Pop. 233

At Bostadh beach, in the north of Great Bernera, three late Iron Age Pictish houses of figure-of-eight shape, complete with lintels, peat floors and stone hearths, were uncovered by a storm in 1993. They have been reburied for preservation, but a replica house has been built nearby.

▶ **www.scotland-inverness.co.uk/bernera.htm**

▶ *Causeway from B8059 at Earshader (Iarsiadar), Lewis*

■ Grimsay
Pop. 201

Some 3 miles long, Grimsay sits at the eastern edge of the tidal sands that separate North Uist from Benbecula. The islanders fish for lobsters, scallops and flatfish from Kallin on the south-east side.

▶ **www.undiscoveredscotland.co.uk/ grimsay/grimsay**

▶ *A865 causeway*

■ Harris
Pop. 3601

Harris is not really an island in its own right, being connected by land to its northerly neighbour of Lewis. But it has an entirely different character, with harshly naked mountains of gneiss dominating the landscape. The island's famous tweed is still handwoven by the islanders, its credibility protected by the Harris Tweed Act of 1993 and by the Orb symbol of authenticity.

▶ ✆ *01859 502011*

www.scotland-inverness.co.uk/harris.htm

✈ *see Lewis (below)* ⛴ *from Isle of Skye or North Uist*

■ Lewis
Pop. 16,872

Lewis is the most northerly and by far the biggest island in the Outer Hebrides, a 40-mile stretch of peat bog and tiny lochs with its capital, Stornoway, the only town. Lewis is also the windiest place in the islands; hence the proposal for a huge wind farm, which would dominate the landscape (see **Find Out More**, page 218). You can see a museum and a working loom at the Black

House village of traditional houses near Arnol, on the west coast of Lewis.

▶ ✆ *01851 703088* **www.isle-of-lewis.com**

▶ ✈ *from Glasgow, Edinburgh or Inverness*

⛴ *from Ullapool*

■ North Uist
Pop. 1271

North Uist spreads into a heart-shaped mass of lochans and mountain peaks, one of the wildest of all Hebridean landscapes. Balranald RSPB Reserve in the north-west, full of flowery machair (see **Natural World**, page 218) and haymeadows, is a stronghold of the rare and endangered corncrake.

▶ ✆ *01876 500321*

www.undiscoveredscotland.co.uk/northuist/ northuist/index.html

⛴ *from Isle of Skye or Harris*

■ Scalpay
Pop. 322

Another wild and rugged island, lying just east of Harris in Tarbert Loch, with two lonely lighthouses on Eilean Glas – the newer red-and-white striped tower of 1824–6, with its stubby predecessor of 1789 (one of the oldest lighthouses in Scotland) at its feet.

▶ **www.scalpay.com**

▶ *Bridge from Carnach, east of Tarbert (Tairbeart), Harris*

■ South Uist
Pop. 1818

The Atlantic-facing west coast of South Uist, with its 20-mile run of white shell-sand beaches backed by flowery swards of machair, is the pride of the Western Isles. In the east, the land rises sharply to the twin peaks of Beinn Mhor (2033 feet) and Hecla (1988 feet).

▶ ✆ *01878 700286*

www.undiscoveredscotland.co.uk/southuist/ southuist/index.html

▶ ⛴ *from Oban and Barra; A865 from Benbecula*

■ Vatersay
Pop. 94

A fine online guide (see below) shows you many of the features of this H-shaped island, including a memorial to the wreck of the emigrant ship *Annie Jane*, with the loss of 350 lives on 28 September 1853. The population of Vatersay was handed a lifeline by the opening of the causeway in 1991.

▶ **www.isleofbarra.com/vatersay.htm**

▶ *Causeway just west of A888 at Castlebay (Bagh a Chaisteil), Barra*

The Outer Hebrides

THE GRANITE ARCHIPELAGO

UNINHABITED ISLANDS

■ Rockall

A bleak tooth of weather-beaten and wave-washed Atlantic Ocean rock some 300 miles from Britain at 57° 35' N, 13° 48' W, Rockall is nevertheless UK territory. Although its inhabitants are exclusively seabirds these days, it has its own online 'newspaper', the *Rockall Times*, which is required reading.

▶ www.therockalltimes.co.uk

■ Shiant Islands

Black basalt cliffs 500 feet high, green sward tops, hundreds of thousands of seabirds (including a quarter of a million puffins), relics of Dark Ages hermits and other hardy inhabitants – the three Shiant Islands, all of which are unoccupied and privately owned, lie 5 miles off south-east Lewis in a tiny, other-worldly archipelago.

▶ www.shiantisles.net

SITES OF INTEREST

■ Ancient sites, Lewis

There are numerous sites of great fascination on Lewis, such as Dun Carloway Broch and the Callanish Stone Circle on the west coast, the greatest ancient site in the Western Isles. It consists of a wonderful cross-shaped complex of stone circles and avenues and was erected around 3000 BC.

▶ www.undiscoveredscotland.co.uk/lewis/calanais

■ Callanish VIII megalithic stone semi-circle, Great Berneray

On the cliff overlooking the bridge from Lewis, four tall standing stones are grouped in a semi-circle – an unusual arrangement. Their bent grey shapes and swirling patterns of weathering give them the look of four old ladies cloaked against wild weather.

▶ www.megalithic.co.uk/article.php?sid=34

■ Monuments/memorials, Lewis

As well as ancient sites, Lewis also has more recent monuments, such as those at Bac and Balallan to the nineteenth-century 'land raiders', who trespassed on their landlords' property to draw attention to their need for land and the means of making a living. Another is the memorial just outside Stornoway to the *Iolaire* disaster in 1919, when 205 homecoming servicemen from Lewis lost their lives in a shipwreck at the entrance to Stornoway harbour.

NATURAL WORLD

■ Bog land and lochans

Any visitor to the Western Isles will see plenty of bog. Take a flower and bird book with you on your expeditions; these seemingly barren swathes are full of life and of sombre beauty. Lochans (small lakes) are everywhere – especially in Benbecula and North Uist, which seem more water than land.

▶ www.jncc.gov.uk/ProtectedSites/SACselection/sac.asp?EUCode=UK0019815

▶ www.cne-siar.gov.uk/factfile/environment/peatland.htm

■ Machair

Machair is green sward built up on top of lime-rich shell sand, packed with a fine flora, grazed and fertilized by extremely contented cows. South Uist has the best along its west coast– a lovely place for a picnic.

▶ www.jncc.gov.uk/protectedsites/SACselection/habitat.asp?FeatureIntCode=H21A0

■ Mountains

North Harris boasts the highest mountains in the Outer Hebrides – the Clisham (An Cliseam) is 2622 feet tall. There are other impressive mountains in South Uist (see **Places to Visit**, page 217).

▶ www.cne-siar.gov.uk/factfile/environment/upland.htm

ACTIVITIES

■ Birdwatching

Corncrakes are doing well in North Uist at Balranald RSPB reserve – a rare chance to hear and maybe see these secretive croakers.

▶ www.rspb.org.uk/reserves/guide/b/balranald/index.asp

■ Botany

The cultivated machair of South Uist is the best place to admire corn marigold, wild pansy, thyme, lady's bedstraw, vetches, scabious and a host of orchids.

▶ www.cne-siar.gov.uk/factfile/environment/flora.htm

■ Extreme sports

Hard men and women take on the fearsome 'Barra to the Butt' Hebridean Challenge in early July – rock climbing, swimming, kayaking, cycling and running from one end of the Hebrides to the other.

▶ www.hebrideanchallenge.com

Otter-watching

Sea otters are present all along the island chain, so keep your eyes peeled and your binoculars and camera at the ready if you hope to spot these shy creatures.

▶ www.wildlifehebrides.com/safari/other

Walking

The following websites are full of good ideas for walking in the Hebrides:

▶ www.mountaineering-scotland.org.uk

▶ www.walkingwild.com

▶ www.walkhebrides.com

Yacht-racing

The Uist-to-Barra Yacht Race that takes place in late June is a wild and enjoyable event surrounded by all sorts of merrymaking.

▶ www.visithebrides.com/events

FIND OUT MORE

Flannan Isle

Wilfrid Gibson's poem – a highly coloured telling of the story of the lighthouse-keepers who mysteriously disappeared from this remote island.

www.poetry-archive.com/g/flannan_isle.html

Jacobite Rebellion

In 1745, Bonnie Prince Charlie landed at Eriskay to start a rebellion against the British Crown.

www.undiscoveredscotland.co.uk/usbiography/charlesedwardstuart/index.html

Lewis archaeology

Up-to-date research on the remarkable archaeology of Lewis.

www.arcl.ed.ac.uk/arch/lewis/index.html

Lewis wind farm

A wind farm is planned for the northern moors which would see 190–230 turbines, each over 450 feet tall, installed.

www.lewiswind.com

Pictish houses

Pictish houses from Lewis's Iron Age civilization, some 2500 years ago, have been uncovered at the Callanish site in the west of the island and also on the off-island of Great Bernera.

www.arcl.ed.ac.uk/arch/cfa/tim

Sula Sgeir

A bleak rock some 40 miles north of the Butt of Lewis, the object of an expedition each August by the men of Ness in north Lewis, who come to harvest young gannets. The birds are sold or given away for eating – boiled, with potatoes.

http://en.wikipedia.org/wiki/Sula_Sgeir

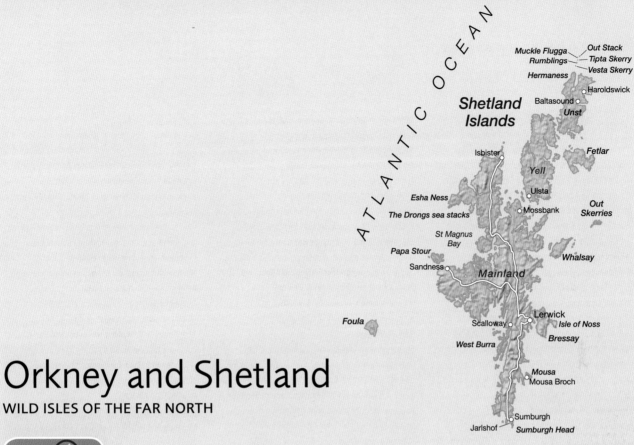

Orkney and Shetland

WILD ISLES OF THE FAR NORTH

ATLANTIC OCEAN

Shetland Islands

Muckle Flugga
Rumblings
Out Stack
Tipta Skerry
Vesta Skerry
Hermaness
Haroldswick
Baltasound
Unst

Isbister

Yell

Fetlar

Esha Ness
The Drongs sea stacks
Ulsta
Mossbank
Out Skerries

St Magnus Bay
Papa Stour
Sandness
Mainland
Whalsay

Foula
Lerwick
Scalloway
Isle of Noss
Bressay
West Burra
Mousa
Mousa Broch

Sumburgh
Jarlshof
Sumburgh Head

Fair Isle

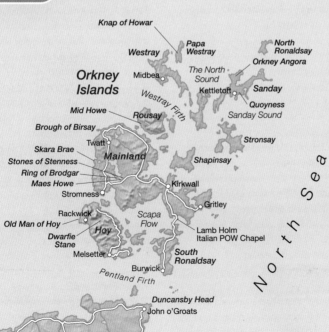

Knap of Howar
Papa Westray
North Ronaldsay
Westray
Orkney Angora
Midbea
The North Sound
Kettletoft
Sanday
Quoyness
Sanday Sound

Orkney Islands

Mid Howe
Rousay
Westray Firth
Stronsay
Brough of Birsay
Twatt
Shapinsay
Skara Brae
Mainland
Stones of Stenness
Ring of Brodgar
Maes Howe
Kirkwall
Stromness
Gritley
Rackwick
Scapa Flow
Old Man of Hoy
Hoy
Dwarfie Stane
Lamb Holm
Italian POW Chapel
Melsetter
South Ronaldsay
Burwick

Pentland Firth

Duncansby Head
John o'Groats

North Sea

0 10 20 kilometres
0 10 20 miles

PLACES TO VISIT

■ Kirkwall, Mainland, Orkney

Kirkwall is the 'capital' of the Orkney Isles, a handsome town dominated by the Cathedral of St Magnus (see **Sites of Interest**, right). The turreted bulk of the early seventeenth-century Earl's Palace ruins loom nearby.

▶ *(01856 872856* **www.visitorkney.com**

■ Lerwick, Mainland, Shetland

The 'capital' of Shetland is a lively and friendly place, with a maze of narrow, steep lanes winding down to a hardworking waterfront that's a pleasure to idle on. The Broch of Clickimin, a 2000-year-old defensive tower, lies in a loch just outside town. Lerwick's great winter festival is Up Helly Aa (see **Activities**, opposite).

▶ *(01595 693434* **www.visitshetland.com**

■ Scalloway, Mainland, Shetland

Shetland's former capital is dominated by Earl Patrick Stewart's castle, a lowering 400-year-old stronghold. The town museum has a good display on the 'Shetland Bus', a fleet of fishing boats that supplied the Norwegian Resistance during the Second World War.

▶ **www.undiscoveredscotland.co.uk/ shetland/scalloway/index.html**

■ Stromness, Mainland, Orkney

This characterful and historic seaport is threaded by a single twisting main street, the artery across which tumble steep, narrow lanes on their way to dozens of privately owned, stone-built wharves – the legacy of Stromness's heyday as an important port.

▶ **www.undiscoveredscotland.co.uk/ stromness/stromness/index.html**

OUTLYING ISLANDS

All populations 2001 census

■ Fair Isle, Shetland

Pop. 69

Fair Isle lies between Shetland Mainland and the Orkney archipelago, 25 miles from both. The 3-mile-long island is famous for the huge variety of birds that stop over on their migratory journeys. The well-known Fair Isle knitting is still produced on the island, and dances and celebrations are lively affairs.

▶ **www.fairisle.org.uk**

■ Isle of Fetlar, Shetland

Pop. 86

Fetlar lies just east of Yell. This rugged island is a birdwatchers' favourite for its red-throated divers, whimbrels, golden plovers,

black guillemots and almost all the UK population of red-necked phalarope – hence the presence of an RSPB reserve.

▶ *(01595 693434* **www.fetlar.com**

▶ *RSPB Reserve (01957 733246*

■ Isle of Foula, Shetland

Pop. 31

The tiny population on the remote, circular 'Island of Birds', 20 miles west of Shetland Mainland, keeps up Shetland traditions long gone elsewhere – for example, Christmas is celebrated on Old Yule, 6 January.

▶ **www.lonely-isles.com**

■ Isle of Sanday, Orkney

Pop. 478

Shaped like a downward-diving dolphin, Sanday with its fine beaches lies to the north-east of the Orkney archipelago. Kettletoft is a quiet harbour. At Orkney Angora in Breckan you can buy angora knitwear while the kids stroke the rabbits. The Quoyness Chambered Cairn (see **Sites of Interest**, opposite) is an archaeological gem.

▶ **www.sanday.co.uk**

■ Isle of Unst, Shetland

Pop. 720

The most northerly island in Britain, mineral-rich Unst has a rolling brown and green landscape, wonderful beaches and fearsome cliffs, culminating in Britain's Most Northerly Brewery and Post Office (in Baltasound and Haroldswick respectively), and finally Britain's Most Northerly Point, Hermaness (see **Sites of Interest**, right).

▶ **www.unst.org**

■ Isle of Yell, Shetland

Pop. 957

Sea otters, wild flowers, seabirds and beautiful deserted beaches are features of Yell – but to find them you have to leave the main road through the rectangular island of bleak peat moors that forms a stepping stone between Mainland and Unst.

▶ **www.visitshetland.com/area_guides/yell/ yell**

SITES OF INTEREST

■ Ancient sites, Mainland, Orkney

Dating from 2700 BC, Maes Howe is the finest chambered tomb in Europe, its central chamber aligned so that the last ray of the setting sun at the midwinter solstice shines into the heart of the mound. Skara Brae is a village buried in a sand dune some 4000

years ago. The houses have been perfectly preserved with their stone furniture. The Ring of Brodgar consists of 27 slim, tall and finely cut stones – about half of the original number – in a ring measuring 340 feet across, erected between 2500 and 2000 BC. Predating the Ring of Brodgar by up to 1000 years, the four mighty standing stones of Stenness are slim, towering and impressive.

▶ *Maes Howe (01856 761606*

www.maeshowe.co.uk/maeshowe/standing. html

▶ *Skara Brae/Ring of Brodgar (01856 841815*

■ Boat Haven, Isle of Unst, Shetland

The Unst Boat Haven, in Haroldswick, is a very enjoyable small collection of historic inshore and deep-sea boats, including the famous six-oared sixareens.

▶ *(01957 711528*

■ Cathedral of St Magnus, Kirkwall, Mainland, Orkney

The splendid red sandstone cathedral of St Magnus was founded in the twelfth century by Rognvald, Earl of Orkney, in memory of his murdered uncle, Magnus. The Romanesque arches are of red and yellow sandstone.

▶ **http://sites.scran.ac.uk/stmagnus/index. htm**

■ Dwarfie Stane, Isle of Hoy, Orkney

This is a strange creation, 5000 years old, which incorporates two cramped burial chambers cut into a huge block of sandstone.

▶ **http://easyweb.easynet.co.uk/ aburnham/scot/dwarf.htm**

■ Hermaness National Nature Reserve, Isle of Unst, Shetland

A fabulous bird reserve, the rounded brow and steep cliffs of Hermaness form the 'forehead of Britain'. From here, you look north over the sharp rock stacks of Vesta Skerry, Rumblings, Tipta Skerry and Muckle Flugga, and the rounded blob of Out Stack, towards the Arctic Circle.

▶ **www.undiscoveredscotland.co.uk/unst/ hermaness/index.html**

▶ *Scottish Natural Heritage (01595 693345*

■ Italian chapel, Lamb Holm, Orkney

A beautiful little chapel made out of two old Nissen huts, with furnishings of scrap tin and driftwood, stands on Lamb Holm. The chapel was constructed in 1943–5 by homesick Italian prisoners of war.

▶ **www.undiscoveredscotland.co.uk/ eastmainland/italianchapel**

■ **Jarlshof, Mainland, Shetland**

An extraordinary site at the southern tip of Mainland, where Bronze Age huts, Iron Age wheelhouses, Norse longhouses, medieval farms and lordly dwellings lie piled together in an exotic archaeological sandwich.

▶ ✆ 01950 460112

www.shetland-museum.org.uk

■ **Knap of Howar, Isle of Papa Westray, Orkney**

In a sand dune halfway down the west coast of tiny Papa Westray stand these twin houses, with internal walls and furniture all of stone. Dating back to 3700 BC, they are the oldest dwellings in northern Europe.

▶ **www.papawestray.co.uk**

■ **The Lounge, Lerwick, Shetland**

The musicians' favourite bar, on Mounthooly Street, where all comers from complete amateurs to the great names of music can sit down and play together.

▶ ✆ 01595 692231

■ **Mid Howe chambered tomb, Isle of Rousay, Orkney**

The Great Ship of Rousay, sometimes called the 'Ship of Death', is an enormous multiple tomb 100 feet long, built c.3500 BC, with 24 compartments ranged along it, in which excavators found the remains of 25 people buried in crouching positions.

▶ **www.garioch.demon.co.uk/orkney.htm**

■ **Mousa Broch, Isle of Mousa, Shetland**

The most complete example of an Iron Age 'broch', or defensive tower, this broch stands 40 feet tall, its hollow walls concealing flights of stairs up to the ramparts.

▶ ✆ 0131 668 8800

■ **Quoyness Chambered Cairn, Isle of Sanday, Orkney**

Quoyness Chambered Cairn lies at the tip of Els Ness Peninsula, a tall, six-celled stone chamber beautifully built and corbelled some 5000 years ago.

▶ **www.orkneyjar.com/history/tombs/ quoyness/index.html**

NATURAL WORLD

■ **Bog land**

More than one-quarter of Shetland's land surface is heather moorland underpinned by thick layers of peat. Stacks of drying peat cut for domestic fuel are still a feature of the landscape, as are the crenellated lines of old peat banks. Orkney has peat moors, too, hunted by merlins and hen harriers.

▶ **www.visitshetland.com/attractions_and_ activities/natural/flora/**

■ **Cliffs**

Shetland has some great cliffs, from the black volcanic ramparts of Eshaness to those at Hermaness (up to 500 feet), Noss on Bressay (600 feet), the western side of Fair Isle (650 feet) and The Kame on Foula (1220 feet).

▶ **www.snh.org.uk/publications/on-line/ geology/orkneyShetland/men.asp**

■ **Coastal flora**

Orkney's isles are very rich in maritime heath and the flowers that grow there – sea squill with blue flowers, sea thrift in pink carpets and orchids in the dunes.

▶ **www.orkneypics.com/webpage/page/ page036.html**

■ **Sea stacks**

The Old Man of Hoy, a tremendous sea stack of red sandstone rising from a granite base off the north-west corner of the Orkney island of Hoy, stands 450 feet tall. The Shetland coast has thousands of stacks – the tooth-like Drongs, off Ness of Hillswick in the north-west mainland, rise to 200 feet, while the north of Unst is rimmed with fine stacks.

▶ **www.ukclimbing.com/articles/pdf/ Orkney.pdf**

▶ **www.ukclimbing.com/articles/pdf/ Shetlands.pdf**

ACTIVITIES

■ **Archaeology**

Orkney and Shetland possess by far the greatest and most remarkable collection of archaeological sites in Britain – see **Sites of Interest**, opposite and left, for a sample.

▶ **www.orkneyjar.com/history/index.html**

▶ **www.visitshetland.com/attractions_and_ activities/historical/archaeology**

■ **Birdwatching**

Shetland and Orkney are both superb for seabirds. The RSPB manages three reserves in Shetland and 13 in Orkney, while Shetland has two bird-orientated national nature reserves at Hermaness, Unst (see **Sites of Interest**, opposite) and Noss (Bressay).

▶ **www.nnr-scotland.org.uk**

■ **Festivals**

The Folk Festivals of Shetland (early May) and Orkney (late May) are free-and-easy feasts of music. Up Helly Aa, on the last Tuesday of January, is the Shetlanders' great midwinter festival of flaring torches and a blazing longship amid much merriment.

▶ **www.orkneyfolkfestival.com**

▶ **www.shetlandfolkfestival.com**

▶ **www.up-helly-aa.org.uk**

■ **Island exploring**

Shetland's smaller isles include: Bressay (take the rubber-boat ride to view the huge seabird colony on 600-foot-high cliffs of the Isle of Noss); Out Skerries and Whalsay (friendly, isolated fishing communities); and Papa Stour (spectacular coast of sea-cut arches and rock stacks).

▶ *Bressay* **www.shetland-heritage.co.uk/ brochures/area_pages/bressay/bressay.htm**

▶ *Out Skerries* **www.shetland-heritage. co.uk/brochures/area_pages/out_skerries/ out_skerries/out_skerries.htm**

▶ *Papa Stour* **www.users.zetnet.co.uk/papa- stour**

▶ *Whalsay* **www.shetland-heritage.co.uk/ brochures/area_pages/whalsay/whalsay.htm**

■ **Music**

Just drop into The Lounge or Da Noost in Lerwick or any community hall to hear Shetland's famed fiddle music at its best.

FIND OUT MORE

Fiddle music

Shetland's 'national instrument' is the fiddle; the islands' tunes are highly addictive, thanks to their players' distinctive style.

www.scotlandsmusic.com/shetlandfiddlestyle.htm

Scapa Flow, Orkney

Orkney's great deepwater anchorage of Scapa Flow has been the scene of extraordinary events, including the scuttling of the captive German High Seas Fleet in 1919.

www.scapaflow.co.uk

Shetland Bus

During the Second World War, the Norwegian Resistance ran its famous 'Shetland Bus' (a fleet of fishing boats) from Scalloway.

www.shetland-heritage.co.uk/shetlandbus/ PAGES/the_crewmen.htm

Storegga Slide

About 7500 years ago a giant underwater landslip off the Norwegian coast sent a huge tsunami crashing into the coasts of Orkney and Shetland.

www.bbc.co.uk/dna/h2g2/A3022282

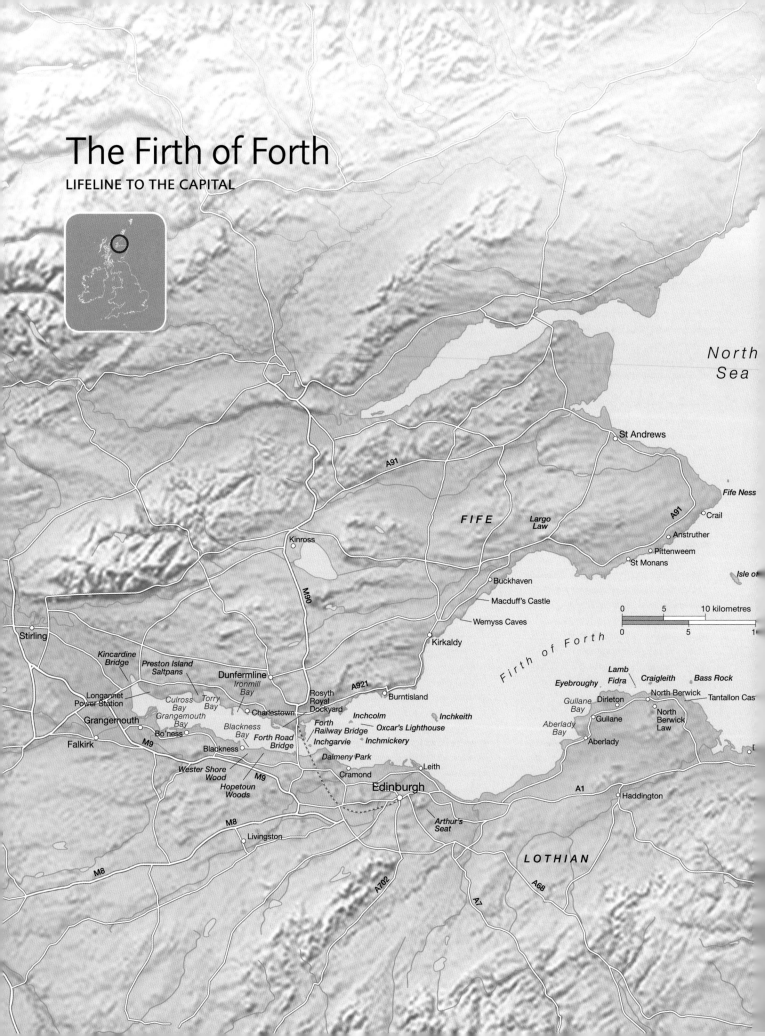

The Firth of Forth
LIFELINE TO THE CAPITAL

North Sea

St Andrews

Fife Ness

FIFE

A91

Crail

Largo Law

Anstruther

Kinross

Pittenweem

St Monans

Isle of

Buckhaven

Macduff's Castle

Wemyss Caves

Kirkaldy

Firth of Forth

Stirling

Kincardine Bridge

Preston Island Saltpans

Dunfermline

Ironmill Bay

Rosyth Royal Dockyard

A921

Burntisland

Lamb

Eyebroughy Fidra

Craigleith

Bass Rock

North Berwick

Tantallon Cas

Longannet Power Station

Culross Bay

Torry Bay

Charlestown

Inchcolm

Inchkeith

Gullane Bay

Dirleton

Grangemouth Bay

Forth Railway Bridge

Oxcar's Lighthouse

Gullane

North Berwick Law

Grangemouth

Bo'ness

Blackness Bay

Forth Road Bridge

Inchgarvie

Inchmickery

Aberlady Bay

Falkirk

M9

Blackness

Dalmeny Park

Aberlady

Wester Shore Wood

M9

Cramond

Leith

Hopetoun Woods

Edinburgh

A1

Haddington

M8

Livingston

Arthur's Seat

M8

LOTHIAN

A702

A68

A7

0 5 10 kilometres
0 5 1

PLACES TO VISIT

■ Anstruther, Fife
A neat harbour town in the East Neuk, whose waterfront boasts two treasures: the excellent Scottish Fisheries Museum and the fabulous Anstruther Fish Bar.
▶ *Scottish Fisheries Museum*
☎ *01333 310628* **www.scotfishmuseum.org**
▶ *Anstruther Fish Bar* ☎ *01333 310518*
www.insiteswd.co.uk/theanstruthefishbar

■ Crail, Fife
Crail's pretty little semi-circular tidal harbour with its fishing boats is a perennial favourite with painters.
▶ ☎ *01333 450869*
www.undiscoveredscotland.co.uk/crail/crail

■ Edinburgh
Scotland's capital city, with its cosmopolitan entertainments, solid business prosperity, vibrant Edinburgh Festival (and Fringe) and large student population, is one of Britain's liveliest and most attractive cities. It is also one of the most elegant in the country. The graceful Georgian architecture of the planned New Town is complemented by the crush of tall medieval houses and narrow wynds in the Old Town, stretching along the Royal Mile between the Castle and the Palace of Holyroodhouse. New architecture in the shape of the stunning Holyrood parliament building (architect Enric Miralles said he wanted to make it 'grow out of the land') has drawn gasps of horror and delight.
▶ ☎ *0845 22 55 121* **www.edinburgh.org**

■ Grangemouth, Falkirk
No tourist trap, Grangemouth refineries by night are a truly awe-inspiring spectacle, like a fleet of brightly lit spaceships setting the sky on fire.
▶ **www.inmagine.com/energy-production-photos/pixtal-pt133**

■ Leith, Edinburgh
Edinburgh's outlet to the sea, Leith brought prosperity to the Scottish capital, reflected in some fine merchants' houses. Today it plays a cornerstone role in the fortunes of the city, owing to the recent regeneration of its inner docks with new flats, bars and businesses.
▶ **www.visitleith.org**

■ North Berwick, East Lothian
North Berwick is an active little resort, a great golfing centre, home of the Scottish Seabird Centre, and the port of embarkation for boat trips to the Bass Rock, the Isle of May and the Firth of Forth islets of Craigleith, Lamb and Fidra. Boat trips to the islands are arranged through the Scottish Seabird Centre (see **Sites of Interest**, page 224).
▶ ☎ *01620 892197;*
www.undiscoveredscotland.co.uk/northberwick/northberwick/index.html

■ St Monans, Fife
Very attractive fishing village, typical of East Neuk architecture, with an ancient church on the beach and plenty of crowstepped gables, external staircases and whitewashed walls under red and grey roofs.
▶ **www.undiscoveredscotland.co.uk/stmonans/stmonans/index.html**

ISLANDS AND ISLETS

■ Cramond, Edinburgh
This is a causeway island just west of Leith (accessible two hours each side of low water), a peaceful green spot with many crumbling wartime buildings to explore.
▶ *Coastguard (for tide times)* ☎ *01333 450666*
▶ **http://en.wikipedia.org/wiki/Cramond_Island**

■ Fidra and neighbouring islets, East Lothian
Fidra, Lamb and Eyebroughy are RSPB reserves packed with seabirds; these and Craigleith are all featured on boat trips from the Scottish Seabird Centre (see **Sites of Interest**, page 224).
▶ **www.ourscotland.co.uk/forthislands.htm**
▶ **www.andrewsi.freeserve.co.uk/lothian-sites2.htm**

■ Inchcolm, Fife
This uninhabited island is dominated by Inchcolm Abbey with its vaulted monastic buildings and great church. There are stunning views from the roof of the church tower.
▶ *Heritage Scotland* ☎ *01383 823332*
▶ *from South Queensferry* ☎ *0131 331 4857*
www.maidoftheforth.co.uk

■ Inchgarvie, East Lothian
Lying in the fairway of the Forth, beneath the railway bridge, the little uninhabited island of Inchgarvie is in a superb position to defend the Forth Valley – hence its adornment with remnants of a fifteenth-century castle, seventeenth-century fortifications and twentieth-century wartime emplacements.
▶ **www.geo.ed.ac.uk/scotgaz/features/featurefirst1302.html**

▶ *Seafari Adventures* ☎ *0131 331 4857*
www.seafari.co.uk

■ Inchkeith, Fife
One mile long, Inchkeith lies opposite Leith, a good 3 miles from either shore of the Firth of Forth. The island was used in medieval times as a quarantine station, and then as a military base until the end of the Second World War. Today it is uninhabited.
▶ **www.geo.ed.ac.uk/scotgaz/features/featurefirst33.html**
▶ *See Inchgarvie, left*

■ Inchmickery, East Lothian
This tiny, boat-shaped island in the Firth of Forth was done up with concrete buildings during the Second World War to give it the silhouette of a battleship. It was one of the Forth islands used in the 1993 film of Iain Banks's thriller *Complicity*. Today it is an RSPB reserve with very rare breeding roseate terns and up to 600 pairs of sandwich terns.
▶ **http://en.wikipedia.org/wiki/Inchmickery**
▶ *See Inchgarvie, left*

■ Isle of May, Fife
A twitcher's paradise, populated by Arctic terns (spectacularly aggressive in the breeding season), razorbills, guillemots, black-backed gulls and kittiwakes, and up to 75,000 pairs of puffins. It is a National Nature Reserve run by Scottish National Heritage.
▶ *Scottish National Heritage* ☎ *01334 654038*
▶ *from Anstruther* ☎ *01333 310103*
www.isleofmayferry.com

SITES OF INTEREST

■ Bass Rock, East Lothian
Off North Berwick, the Bass Rock hosts more than 80,000 gannets. You can spy on their activities from the Scottish Seabird Centre in North Berwick (see **Sites of Interest**, page 224) with remote-controlled cameras, or run out to the Bass on a boat (trips organized through the Seabird Centre).
▶ **www.north-berwick.co.uk/bassRock.asp**

■ Blackness Castle, Falkirk
Grim and impressive medieval stronghold on the south bank of the Forth, strengthened in the sixteenth century. Wall-top walkway gives great views across the estuary.
▶ *Heritage Scotland* ☎ *01506 834807*
www.aboutbritain.com/BlacknessCastle.htm

■ Forth bridges
Two triumphs of engineering cross the Firth of Forth between South and North

Queensferry – the great 8296-foot railway bridge, opened in 1890, with its three vast double cantilevers; and the road bridge, opened in 1964, with a total length of 8259 feet and a mighty central span of 3300 feet.

▶ **www.forthbridges.org.uk**

■ **Macduff's Castle, Fife**

A sixteenth-century tower of pink sandstone built on the site of a former Macduff stronghold, now pitted into hollows by wind and weather and said to be haunted by a 'Grey Lady'.

▶ **www.rampantscotland.com/castles/ blcastles_macduff.htm**

■ **Oxcars lighthouse**

On the lighthouse rock near Inchmickery a pioneering hydrophone station was set up in 1915, a revolutionary experiment using an underwater microphone and ultrasonic waves to detect submarines.

▶ **www.lighthousedepot.com/database/ dataphotopage.cfm?value=3857**

■ **Preston Island Saltpans, Fife**

Remains of seventeenth- and eighteenth-century saltpans jut into the Forth near Longannet power station in a series of giant lagoons.

▶ **http://come.2dunfermline.co.uk/index.p hp?PageID=1&CATEGORY2=Preston+Island**

■ **Rosyth Royal Dockyard, Fife**

Just upriver of the Forth Railway Bridge, the Rosyth Royal Dockyard was established in 1909–16 and saw sterling service in both world wars. During the Cold War, Polaris submarines were refitted here.

▶ **www.geo.ed.ac.uk/scotgaz/towns/ townfirst52.html**

■ **Scottish Seabird Centre, North Berwick**

The Scottish Seabird Centre is one of the best visitor attractions of recent years to be opened in Scotland. Sited on the shore at North Berwick, with a wonderful view of the Bass Rock, it has superb displays on the varied seabird life of the coasts, a webcam revealing secrets of gannet life and various boat trips to the different bird-haunted rocks and islets in the Firth of Forth.

▶ ☎ *01620 890202* **www.seabird.org**

■ **Tantallon Castle, East Lothian**

The impressive remains of a fourteenth-century Douglas stronghold, half-destroyed by Cromwell's troops in 1651, overlook the Firth of Forth opposite the Bass Rock. Two towers and a Great Hall can still be seen.

▶ ☎ *01620 892727*

■ **Wemyss Caves, Fife**

A series of caves incised with ancient Neolithic, Pictish and Viking symbols.

▶ **www.thefifepost.com/wemysscaves.html**
▶ **www.wemysscaves.co.uk/gallery.php**

NATURAL WORLD

■ **Mud flats**

For mud flats upstream of the Forth bridges, and the wading birds that go with them, try Culross Bay, Torry Bay and Ironmill Bay on the north shore and Grangemouth Bay and Blackness Bay on the south.

▶ **www.falkirk.gov.uk/DevServices/ PlanEnv/ pdf/biopdf/mudflats_action_plan.pdf**

■ **Volcanic plugs**

Evidence of furious volcanic activity long ago stands tall in the shape of the Bass Rock (350 feet) in the mouth of the Firth, North Berwick Law (613 feet) just inland, Arthur's Seat in Edinburgh (822 feet) and Largo Law across the Forth (952 feet).

▶ **http://en.wikipedia.org/wiki/Volcanic_plug**

■ **Woods**

Good unspoiled sections of woodland on the south shore include Wester Shore Wood and Hopetoun Woods, Dalmeny Park just west of Cramond and the shore woods between Gullane and Dirleton.

▶ **www.eastlothian.gov.uk/documents/ contentmanage/ environmental%20trends%2 0final%20doc-1639.PDF**

ACTIVITIES

■ **Birdwatching**

There is fine birdwatching for seabird enthusiasts – in Aberlady Bay, which is excellent for geese in winter, and on the Isle of May (see **Places to Visit**, page 223), with its puffins, Arctic terns, razorbills and guillemots; also on the Bass Rock, where 80,000 gannets breed in summer (see **Sites of Interest**, page 223).

▶ **www.andrewsi.freeserve.co.uk/lothian-sites2.htm**

■ **Festivals**

Among the many lively festivals along the Firth of Forth are Leith Festival in early June, Pittenweem Arts Festival in early August, and on a more local level St Monans' Sea Queen Day in June and Burntisland Highland Games on the third Monday in July.

▶ *Pittenweem Arts Festival*
www.pittenweemartsfestival.co.uk
▶ *Leith Festival* **www.leithfestival.com,**

■ **Steam Railway**

The Bo'ness & Kinneil Steam Railway – one of the attractions of the area – runs along the south shore of the Firth of Forth, between Bo'ness and Birkhill, near Grangemouth.

▶ ☎ *01506 822298* **www.srps.org.uk/railway**

■ **Walking**

The Fife Coastal Path runs for 78 miles between the Forth and Tay bridges. The Water of Leith Walkway passes through Edinburgh on its 12-mile journey from Balerno to the sea at Leith.

▶ *Fife Coastal Path*
http://homepages.tesco.net/~fcp
▶ *Water of Leith Walkway*
www.wateroflleith.org.uk

FIND OUT MORE

Charlestown Harbour

Today this is a quiet village just upstream of the Forth bridges, but in the 1750s Charlestown and neighbouring Limekilns were bustling harbours exporting huge amounts of coal and lime.

www.undiscoveredscotland.co.uk/charlestown/ charlestown/index.html

Hopetoun House

This eighteenth-century house in West Lothian, seat of the Hope family since it was built, is an enormous and beautifully symmetrical pale stone pile, with curved colonnades that terminate in huge square pavilions.

www.hopetounhouse.com

Longannet Mine

Longannet coal mine near Kincardine Bridge was closed in 2002; but now there are plans to re-open the mine and use the coal seams in a far more environmentally friendly way.

http://news.bbc.co.uk/2/hi/uk_news/ scotland/689761.stm

http://living.scotsman.com/index. cfm?id=545382004

Scottish salt

Salt production was a very lucrative industry for coastal communities of the past, and the great saltpans at Preston Island in the upper Firth of Forth are still plain to be seen.

http://come.2dunfermline.co.uk/index.php?Pag eID=1&CATEGORY2=Preston+Island

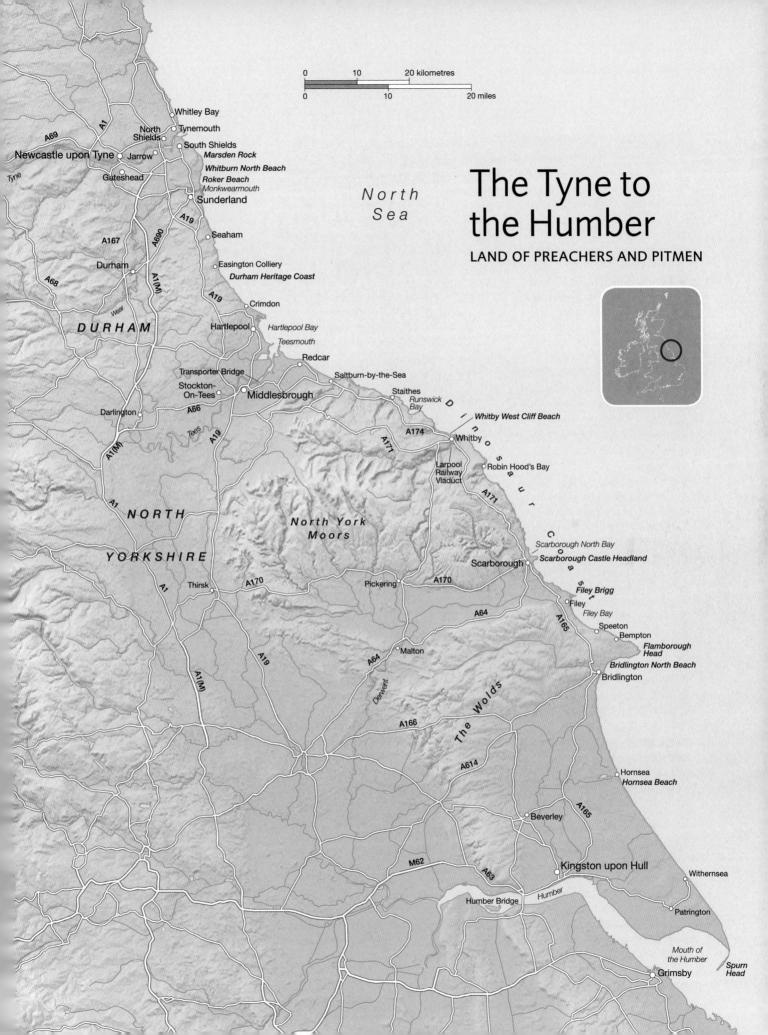

The Tyne to the Humber
LAND OF PREACHERS AND PITMEN

North Sea

Whitley Bay
Tynemouth
North Shields
South Shields
Marsden Rock
Newcastle upon Tyne
Jarrow
Gateshead
Whitburn North Beach
Roker Beach
Monkwearmouth
Sunderland
Tyne
A69
A1
A167
A690
A19
A68
Durham
A1(M)
Wear
DURHAM
Seaham
Easington Colliery
Durham Heritage Coast
A19
Crimdon
Hartlepool
Hartlepool Bay
Teesmouth
Redcar
Transporter Bridge
Saltburn-by-the-Sea
Stockton-On-Tees
Staithes
Runswick Bay
Middlesbrough
Darlington
A66
Tees
A19
A1(M)
A174
Whitby West Cliff Beach
A171
Whitby
Larpool Railway Viaduct
Robin Hood's Bay
A171
Dinosaur Coast
NORTH YORKSHIRE
North York Moors
A1
Scarborough North Bay
Scarborough Castle Headland
Scarborough
A170
Thirsk
A170
Pickering
A170
Filey Brigg
Filey
Filey Bay
A64
A165
Speeton
Bempton
A19
Malton
Flamborough Head
A64
Bridlington North Beach
Bridlington
A1(M)
Derwent
A166
The Wolds
A614
Hornsea
Hornsea Beach
Beverley
A165
M62
A63
Kingston upon Hull
Withernsea
Humber Bridge
Humber
Mouth of the Humber
Patrington
Spurn Head
Grimsby

0 10 20 kilometres
0 10 20 miles

PLACES TO VISIT

■ Kingston upon Hull, East Yorkshire

A fishing town full of character and charm, to be explored via Hull's City Trail or Seven Seas Fish Trail, or on a guided walk. Eight museums, including one in Wilberforce House dealing with Hull's involvement with the slave trade (see **Sites of Interest**, opposite) and The Deep, a fine aquarium.

▶ ☎ 01482 702118 or 01482 223559

www.hull.co.uk/visiting.aspx

■ Newcastle, Tyneside

Newcastle has seen a great revival in its fortunes since the collapse of the city's traditional heavy engineering and shipbuilding industries. Today the quaysides on both sides of the Tyne have sprouted attractions, including Newcastle's Baltic Centre for Contemporary Art, Gateshead's Sage Music Centre and a scattering of new public sculptures.

▶ Gateshead Quays ☎ 0191 477 5380
▶ Newcastle ☎ 0191 277 8000
▶ **www.visitnewcastlegateshead.com**

■ Robin Hood's Bay, North Yorkshire

Robin Hood's Bay Museum in Fisherhead and the exhibition in the Old Coastguard Centre give a good overview of the village's history of fishing, smuggling, farming and accommodating romantic visitors in love with charming, higgledy-piggledy 'Bay Town' and its precipitous tumble of red-roofed houses along steep, narrow lanes.

▶ ☎ 01723 383637

www.robin-hoods-bay.co.uk

■ Scarborough, North Yorkshire

North Yorkshire's best-known traditional resort, Scarborough is very much a family holiday place with its handsome Georgian and Victorian architecture, good clean beaches (North Bay is a Blue Flag beach), aquarium and water park with plenty of white-knuckle sliding.

▶ ☎ 01723 383636

www.discoveryorkshirecoast.com/ scarborough_welcome.asp

■ Sunderland, Wearside

Sunderland was very hard hit by the late twentieth-century collapse of its shipbuilding industry; but the town is now looking to a future as a tourist destination, with a special focus on the fine coast nearby (including lovely Blue Flag beaches at Roker and Seaburn). At the mouth of the River Wear lies Monkwearmouth, with its Saxon church of St Peter, on the site where the monastic scribe St Bede (AD 673–735) started his life as a monk before moving to Jarrow on the Tyne (see **Sites of Interest**, below).

▶ ☎ 0191 553 2000 **www.visitsunderland.com**

■ Whitby, North Yorkshire

Whitby is one of the most scenic and dramatic resorts in Britain, piled into a cleft in the North Yorkshire cliffs. Here, James Cook lived for nine years in Grape Lane, now the Captain Cook Memorial Museum, learning about boats and navigation. Up on the East Cliff stand the grand ruins of Whitby Abbey, scene of vampire activity in Bram Stoker's novel *Dracula*. Whitby jet is still made into jewellery in the town. West Cliff beach has Blue Flag status.

▶ ☎ 01723 383637 **www.whitbytourism.com**

■ Withernsea, East Yorkshire

A small, traditional resort a long way from anywhere with a good sandy beach and several mini-festivals in summer; for example, Withernsea Carnival in July, Summertime Special rock music festival and an Art and Book festival in August. The 127-foot-high lighthouse, now a museum, stands monumentally in the town.

▶ ☎ 01964 615683

www.council.withernsea.com

SITES OF INTEREST

■ Bede's World, Jarrow, Tyneside

The life of the Venerable Bede (AD 673–735) is celebrated at Bede's World, Jarrow, where he lived and worked. St Paul's Church, with its seventh-century chancel, stands near the 'Age of Bede' exhibition museum, a replica Dark Ages farm named Gwyre (Anglo-Saxon for 'Jarrow') and the foundations of the Anglo-Saxon monastery where Bede wrote hymns, religious contemplations, a life of St Cuthbert in prose and in verse, a history of the world, and his masterwork *Ecclesiastical History of the English People*.

▶ ☎ 0191 489 2106 **www.bedesworld.co.uk**

■ Easington Colliery mine disaster memorial, Co. Durham

On 29 May 1951, an explosion at Easington Colliery claimed the lives of 81 miners and two of the rescue team (see **Find Out More**, opposite). A Garden of Remembrance created at Easington Colliery Cemetery contains flowerbeds, benches and a fine relief sculpture. Leading to the Welfare Park is a memorial avenue of 83 trees, the first of which was planted by the colliery's youngest miner on 22 March 1952, and a large commemorative stone.

▶ **www.dmm-gallery.org.uk/ memorial/1951052900.htm**

■ Filey Methodist Church, Filey, North Yorkshire

This church is the home base of the Filey Fishermen's Choir; they also sing in many other churches all over the North of England (see website for forthcoming performances).

▶ **www.thefileyfishermenschoir.co.uk**

■ Humber Bridge, East Yorkshire/ Lincolnshire

Spanning the River Humber just west of Hull, the Humber Bridge was the longest single-span suspension bridge in the world (4626 feet) when it was opened in 1981. The two towers and roadway consumed 480,000 tonnes of concrete, and the bridge contains a mind-boggling 44,000 miles of wire.

▶ **www.humberbridge.co.uk**

■ National Glass Museum, Sunderland, Wearside

The innovative National Glass Centre on the south bank of the River Wear is both a museum to the craft practised for centuries in the town and also a functioning glassworks.

▶ ☎ 0191 515 5555

www.3k1.co.uk/ngc/general/indexglass.htm

■ Old St Stephen's Church, Robin Hood's Bay, North Yorkshire

A set of galleries overlooks ranks of fine box pews and one of those large three-decker pulpits that served to overawe as much as exhort nineteenth-century congregations. On the walls are restored examples of maidens' garlands, the wreaths that were traditionally carried in front of the coffin of a virgin at her funeral. All this is contained within a grim grey church like an industrial town chapel.

▶ **www.robin-hoods-bay.co.uk/html/ attractions/st_stephens.htm**

■ St Patrick's Church, Patrington, East Yorkshire

Considered by many to be the finest church in Yorkshire, the fourteenth-century 'Queen of Holderness', her pale stonework the basis for a beautiful slender spire, sails majestically over her subject village 10 miles inland of

Spurn Head. The beautifully lit interior is filled with carving – masterpieces of the stonemason's art. Take your binoculars!

▶ www.westair-reproductions.com/mappage/humbersi.htm

■ Transporter Bridge, Middlesbrough, Teesside

The world's largest transporter bridge, built in 1911 to connect Middlesbrough with the north bank of the River Tees, is 851 feet long and bestraddles the river some 177 feet above the water. It continues to transport up to nine vehicles and 200 people at a time.

▶ www.middlesbrough.gov.uk

■ Wilberforce House Museum, Kingston upon Hull, East Yorkshire

The birthplace of William Wilberforce (1759–1833), England's most effective campaigner for the abolition of slavery, is a museum dedicated to the history of slavery, Wilberforce's role in its elimination throughout the British Empire, and issues of slavery in the world today.

▶ ✆ 01482 613902
www.hullcc.gov.uk/museums

NATURAL WORLD

■ Beaches

There are Blue Flag beaches at Sandhaven near South Shields, Whitburn North at Seaburn near Sunderland, Whitby's West Cliff, Scarborough's North Bay, Bridlington North and Hornsea.

▶ www.seasideawards.org.uk/bf_list.asp

■ Cliffs

The beautiful run of magnesian limestone cliffs that stretches from Seaham in the north to Crimdon near Hartlepool is known as the Durham Heritage Coast. It supports such flowers as yellow rattle, eyebright, betony and many species of orchid. The sand, lime and mud rocks of the North Yorkshire cliffs are rich in minerals and fossils, and this area has been styled 'Dinosaur Coast', in recognition of the great range of fossil-bearing Jurassic (205–135 million years ago) and Cretaceous (130–65 million years ago) geology they expose. The Dinosaur Coast stretches 40 miles from Staithes south to Speeton. The mighty chalk cliffs around Bempton and Flamborough Head are the haunt of seabirds.

▶ www.durhamheritagecoast.org
▶ www.dinocoast.org.uk

■ Estuaries

The 5-mile-wide mouth of the River Humber marks the boundary between East Yorkshire and Lincolnshire, and is a wonderful place for anyone who enjoys watching seals, seabirds and wildfowl and appreciates the beauty of coastal marshes, mud flats and wide-open spaces under huge skies.

▶ www.cleethorpes-online.co.uk/humber.html

■ Promontories

On the North Yorkshire coast, Scarborough Castle Headland is of hard limestone, while Filey Brigg is a long headland of calcareous grits. Flamborough Head in East Yorkshire is of hard chalk, and Spurn on the Humber is a fast-eroding sandspit.

▶ Scarborough Castle Headland
www.bbc.co.uk/northyorkshire/iloveny/nature/walk_through_time/08.shtml
▶ Filey Brigg www.fileybrigg.com
▶ Flamborough Head
www.bbc.co.uk/england/sevenwonders/yorkshire/flamborough
▶ Spurn www.wilgilsland.co.uk/Spurnhead.htm; www.bbc.co.uk/england/sevenwonders/yorkshire/spurn

ACTIVITIES

■ Birdwatching

Seabird-watching is superb around Marsden Rock, Tyneside, and down at Bempton Cliffs and Flamborough Head in East Yorkshire. For waders, make for the sandbanks, muds and foreshores of the National Nature Reserves at Teesmouth and at Spurn on the Humber Estuary.

▶ Bempton Cliffs RSPB Nature Reserve
www.rspb.org.uk/england/north/school_visits/bemptoncliffs.asp
▶ Teesmouth www.stokeld.demon.co.uk/Wheretowatchbirds.html
▶ Spurn www.spurnpoint.com/bird_watching_at_spurn_point.htm

■ Industrial archaeology

For anyone interested in the area's industrial history it is well worth visiting the terraced mining villages on the Durham coast, the great timber wharves at Hartlepool, the 'giant's geometry' of Teesside's chemical plants, the numerous alum and jet mines in the cliffs of North Yorkshire, and the brick Larpool Viaduct on the Whitby–Scarborough railway path.

▶ Cleveland and Teesside www.ctlhs.org.uk
www.teesarchaeology.com/middlesbrough/index.html
▶ Durham coast http://durham.northumbrialearning.co.uk/?SHOP=NEW%20FL&DO=USERPAGE&PAGE=History#recent
www.dmm.org.uk/history/htdd03.htm

■ Walking

There is some great walking along this stretch of coast: the 11-mile cliff path through the restored landscape of the Durham coast, the 52-mile section of the Cleveland Way National Trail between Saltburn-by-the-Sea and Filey Brigg, and nearly 40 miles of beach walking between Bridlington and Spurn Head.

▶ Durham Coastal Trail ✆ 0191 586 4450 or 0191 384 3720 www.durham.gov.uk
▶ Cleveland Way www.clevelandway.gov.uk

FIND OUT MORE

Captain Cook's life and times

Whitby's best-known 'old boy' is Captain James Cook (1728–79) – explorer, navigator and adventurer supreme.

www.captaincooksociety.com

Dracula

The author Bram Stoker knew an atmospheric setting when he saw one: his classic 1897 vampire shocker Dracula was set in Whitby.

www.whitbydraculasociety.org

Easington Colliery disaster

On 29 May 1951, 81 miners and two rescuers died in Easington Colliery pit in the worst accident in the history of County Durham's coastal coalfield.

www.eastdurham.co.uk/easington1951/disaster.htm

Whaling

For the best part of a century, Whitby sent ships and men to the whaling in Arctic waters.

www.whitby-yorkshire.co.uk/whaling/whaling.htm

Whitby history

Whitby is more than a seaside resort amid wonderful coastal scenery; it is a town with a very long and colourful history. The gaunt twelfth-century abbey ruins on the cliff-top have been the symbol of Whitby for 900 years.

www.queensland.co.uk/hilda.html
www.english-heritage.org.uk/whitbyabbey

The Humber Estuary to Great Yarmouth

COAST ON THE MOVE

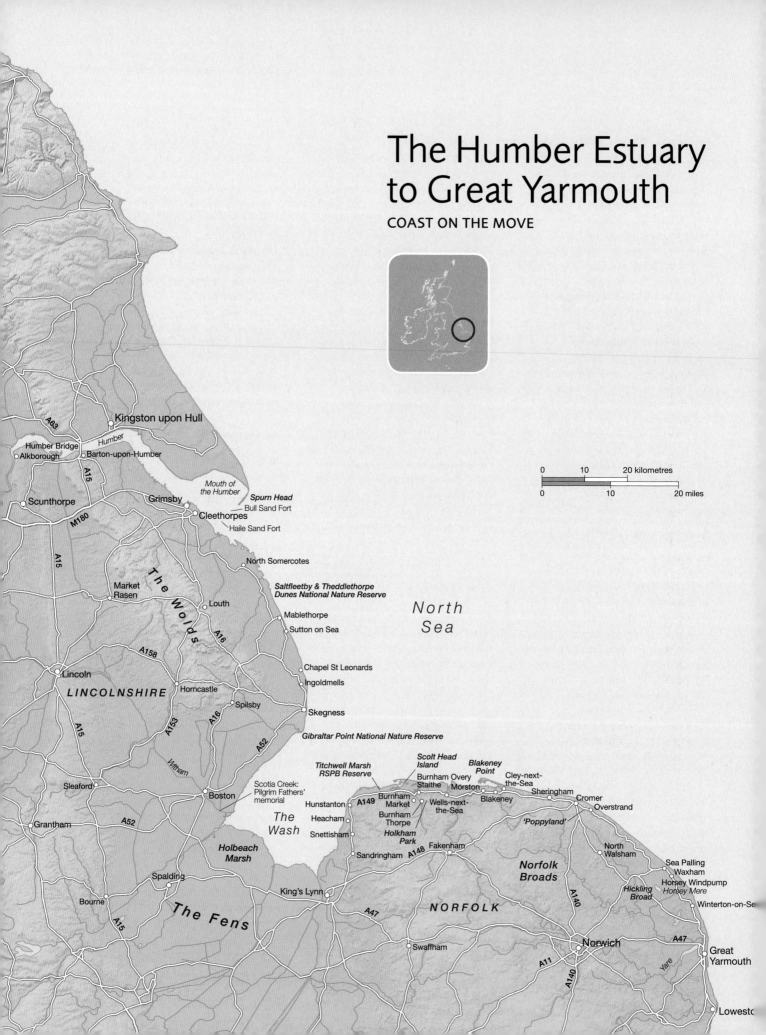

0 10 20 kilometres
0 10 20 miles

North Sea

Kingston upon Hull

Humber Bridge
Alkborough
Barton-upon-Humber

Humber

Scunthorpe

Grimsby
Mouth of the Humber
Cleethorpes
Spurn Head
Bull Sand Fort
Haile Sand Fort

North Somercotes

Saltfleetby & Theddlethorpe Dunes National Nature Reserve

Market Rasen

The Wolds

Louth

Mablethorpe
Sutton on Sea

Lincoln

Horncastle

Chapel St Leonards
Ingoldmells

LINCOLNSHIRE

Spilsby

Skegness

Witham

Gibraltar Point National Nature Reserve

Sleaford

Scotia Creek: Pilgrim Fathers' memorial

Titchwell Marsh RSPB Reserve

Scolt Head Island

Blakeney Point

Cley-next-the-Sea

Boston

Burnham Overy Staithe
Morston
Sheringham

Hunstanton
A149
Burnham Market
Wells-next-the-Sea
Blakeney
Cromer
Overstrand

Grantham

The Wash

Heacham
Burnham Thorpe

'Poppyland'

Snettisham
Holkham Park

North Walsham

Holbeach Marsh

Sandringham
A148
Fakenham

Norfolk Broads

Sea Palling
Waxham

Spalding

Hickling Broad

Horsey Windpump
Horsey Mere

Bourne

King's Lynn

The Fens

A47

NORFOLK

Winterton-on-Sea

Swaffham

Norwich

A47

Great Yarmouth

A11
A140

Yare

Lowesto

PLACES TO VISIT

■ Blakeney, Norfolk

Huge sands surround Blakeney, a characterful village now marooned more than a mile inland by the growth of North Norfolk's marshes. The Church of St Nicholas, patron saint of seafarers, has two towers – the more slender of the two was built at the north-east corner to hold a lantern to guide sailors and benighted travellers. Just east is Cley-next-the-Sea, with its superb tower mill. You can take a trip out to Blakeney Point, a slowly growing shingle spit that's now 3½ miles long. Here you can see common and grey seals, breeding terns and rare shingle plants. Access is by boat from Blakeney Quay or Morston Quay or on foot from Cley Beach.

▶ *☏ 01328 710885*
www.norfolkcoast.co.uk/location_norfolk/vp_blakeney.htm
▶ *Blakeney Point Nature Reserve ☏ 01263 740480 (April–Sept) or 740241 (October–March)*
⛴ www.norfolkbroads.com/leisure/norfolk/blakeney

■ Boston, Lincolnshire

Famous for its Boston Stump – the enormously high tower of St Botolph's Church that looms 272½ feet above this Fen town. There's the bustling atmosphere that an active port always lends. In fine, clear weather there is a breathtaking view from the upper storeys of the Stump, over the flat Fens as far as the towers of Lincoln Cathedral some 30 miles away.

▶ *☏ 01205 356656* www.bostonuk.com

■ Burnham Thorpe, Norfolk

This little village, 3 miles inland, plays a big part in our island's history; it was the birthplace of Britain's greatest naval hero, the victor of the Battle of Trafalgar – Admiral Horatio Lord Nelson (1758–1805). All Saints' Church contains a Nelson exhibition and many artefacts associated with the great man, while in the Lord Nelson pub across the road (Nelson's local) you can toast the Immortal Memory in a glass of spicy 'Nelson's Blood'.

▶ *Lord Nelson pub ☏ 01328 738241*
www.nelsonslocal.co.uk

■ Cromer, Norfolk

A first-class example of a British seaside resort: small, friendly, family-orientated, with a fine sandy beach and a celebrated lifeboat.

Cromer has one of the country's last surviving 'end-of-the-pier' shows.

▶ *☏ 01263 512497*
www.norfolkcoast.co.uk/location_norfolk/vp_cromer.htm

■ Great Yarmouth, Norfolk

The famous old fishing town, divided by the River Yare, has become East Anglia's meatiest, beatiest, biggest and bounciest seaside resort. The Pleasure Beach funfair is one of the main attractions. A spread of good museums includes the Norfolk Nelson Museum (See **Sites of Interest**, right) and Time and Tide, telling the town's story.

▶ *☏ 01493 846345*
www.great-yarmouth.co.uk

■ Grimsby, Lincolnshire

Today, Grimsby's famous trawler fleet is a shadow of its former self. But the town has played to its traditional strengths to boost its economy – it buys in fish and sells it through Grimsby fish market, and processes and fillets fish as it has always done.

▶ www.visitgrimsby.co.uk

■ King's Lynn, Norfolk

Situated on the east bank of the River Great Ouse, King's Lynn has a rich legacy of buildings from centuries of prosperity as a trade partner of the Hanseatic League. These include the enormous open square of Tuesday Market, fine churches, the chequerboard flint flushwork of Trinity Guildhall, the handsome little seventeenth-century Customs House under a lantern tower on the quay and a Hanseatic warehouse nearby – the only surviving example in Britain. The Fisher Fleet Basin still shelters shrimp, cockle and mussel boats.

▶ *☏ 01553 763044*
www.historic-uk.com/DestinationsUK/KingsLynn.htm

■ Skegness, Lincolnshire

'Skeggy' is Lincolnshire's premier seaside resort. The town offers a pier with lots of attractions, gardens, bowling alleys, amusement arcades and a fine sandy beach.

▶ *☏ 01754 899887* www.skegness.net

ISLANDS AND WATERWAYS

■ Humber Estuary

The River Humber's estuary is some 8 miles wide at its mouth, although the anteater snout of Spurn's long sand spit curves a good way across it. Inside the shelter of Spurn are

vast tidal mud flats and sandbanks, the haunt of wildfowl and seals.

▶ www.hull.ac.uk/coastalobs/ media/pdf/humberestuarysmp.pdf

■ Norfolk Broads

Norfolk Wildlife Trust's Hickling Broad and the National Trust's Horsey Mere are just two of the Norfolk Broads – flooded medieval peat diggings teeming with wildlife – accessible from the coast between Sea Palling and Winterton-on-Sea, Norfolk.

▶ *Hickling Broad* www.english-nature.org.uk
▶ *Horsey Mere* www.nationaltrust.org.uk

■ Scolt Head Island, Norfolk

Enormous sand dunes like shaggy hills, shingle to seaward and salt marsh to landward: Scolt Head Island is a unique and haunting National Trust reserve. Three species of tern breed here. There is a ferry from Burnham Overy Staithe.

▶ ⛴ *☏ 01485 210456*
▶ *☏ 01328 711866* www.english-nature.org.uk

■ The Wash

This huge square-sided estuary, on the boundary between Lincolnshire and Norfolk, has a wealth of geese, ducks and wildfowl in winter, and waders and seals in summer. Shrimping and shellfish boats nose through channels in the mud banks.

▶ www.washestuary.co.uk

SITES OF INTEREST

■ Admiral Nelson sites

Nelson's connections with Norfolk are many: his native village of Burnham Thorpe (see **Places to Visit**, left); the Hoste Arms in Burnham Market, where he often stayed; Holkham Park, where he went shooting; his old school (now Paxton Sixth Form College), at North Walsham; and Great Yarmouth, with its 'Nelson Column' and Nelson Museum.

▶ *☏ 01493 850698* www.nelson-museum.co.uk

■ Gibraltar Point, Lincolnshire

Gibraltar Point National Nature Reserve, south of Skegness, is the first port of call for countless migrating birds. Little terns breed and thousands of waders roost here. It is a beautiful spot, and the fine dunes, sand and marshes support many plant species.

▶ *☏ 01754 762677* www.lincstrust.org.uk/reserves/gib/index.php

■ Humber Estuary forts, Lincolnshire

Bull Sand Fort, a squat toad of a First World War stronghold founded on a sandbank in

The Humber Estuary to Great Yarmouth

COAST ON THE MOVE

the Humber Estuary, was built with its sister Haile Sand Fort in 1915 as a protection for shipping that gathered here to form convoys along the East Coast.

▶ www.cleethorpes-online.co.uk/forts.html

■ National Fishing Heritage Centre, Grimsby, Lincolnshire

Visitors can visit the fish market and a smokehouse, and learn of the fisherman's life from retired trawlermen at the National Fishing Heritage Centre at Alexandra Dock.

▶ ✆ 01472 323345
www.tlfe.org.uk/museums/heritagecentre

■ Pilgrim Fathers' memorial, Scotia Creek, Fishtoft, Lincolnshire

Scotia Creek runs into The Haven, the mouth of the River Witham, 3 miles downriver of Boston. A memorial column marks the spot where the Pilgrim Fathers were arrested in 1607 as they tried to flee the country,

▶ http://en.wikipedia.org/wiki/Pilgrim_Fathers_Memorial

NATURAL WORLD

■ Beaches

Lincolnshire's beaches run in an almost continuous 30-mile strip between the two national nature reserves of Gibraltar Point and Saltfleetby and Theddlethorpe Dunes (see page 168). Marsh is the main feature of North Norfolk; then wonderful beaches from Sheringham eastwards form a continuous strip of creamy-coloured sand as far as Great Yarmouth, a distance of nearly 40 miles.

▶ www.bbc.co.uk/lincolnshire/asop/places/beach_guide/index.shtml

■ Mud flats

Mud flats can harbour a million or more organisms in 10 square feet of mud. They are wildfowl's chief winter larder. You'll find wide flats in the Humber and Wash estuaries, and seaward of the North Norfolk marshes.

▶ www.geography-site.co.uk/pages/physical/coastal/mudflats.html

■ Salt marshes

There are large areas of salt marsh: along the south shore of the Humber Estuary, opposite Spurn Head and extending to Mablethorpe; all round the shores of the Wash except on the east; along the North Norfolk coast, from Holme-next-the-Sea to Cley-next-the-Sea and beyond – in all, nearly 100 miles of lonely, moody, bird-haunted marshes. Along the North Norfolk coast, towns and villages,

once coastal, lie marooned a mile or two inland, and wildfowl, rabbits, marsh plants and insects thrive in the lonely marshes.

▶ www.geography-site.co.uk/pages/physical/coastal/saltmarsh.html

■ Sand dunes

There are dunes at Saltfleetby and Theddlethorpe and at Gibraltar Point in Lincolnshire; also between Sea Palling and Winterton in Norfolk.

▶ www.bbc.co.uk/nature/animals/wildbritain/habitats/coastal/index.shtml?sanddunes#habs

■ Shingle spits

Shingle spits form when the offshore currents drag shingle pebbles in a long line and mould them into an ever-growing bar or bank in the sea. Vegetated shingle spits are rare in Britain, but Blakeney Point and Scolt Head Island are good examples (see **Places to Visit**, page 229).

▶ www.english-nature.org.uk/livingwiththesea/project_details/good_practice_guide/shingleCRR/shingleguide/home.htm

ACTIVITIES

■ Botany

Saltfleetby and Theddlethorpe Dunes National Nature Reserve in Lincolnshire is full of cowslips (April–May), pyramidal orchids (June–August), storksbill (April–September) and sea buckthorn (orange berries in autumn). At Gibraltar Point National Nature Reserve, further down the coast, the dunes support meadow saxifrage (April–June) and lady's bedstraw (June–September), the flatter sandy areas are rich in early forget-me-nots (April–May) and dove's-foot cranesbill (April–September), and the plants of the freshwater marshes include yellow rattle (May–September) and southern marsh orchid (June–July).

▶ www.jncc.gov.uk/protectedsites/sacselection/sac.asp?EUcode=UK0030270

■ Birdwatching

The Humber Estuary is one of the top five British estuaries for overwintering birds. In Lincolnshire, little terns breed and thousands of waders roost at Gibraltar Point. Hen harriers and owls prowl the marshes of the Wash, where the skies and vast mud flats are packed with overwintering geese and ducks. Snettisham Reserve in Norfolk sees spectacular numbers of dunlin and other

wading birds at high water; while Titchwell Marsh is world famous for marsh harriers, bearded tits, the blue-legged avocet and the elusive, booming bittern of the reed beds.

▶ *Humber and Lincolnshire* www.fatbirder.com/links_geo/europe/england_lincolnshire.html
▶ *The Wash* www.west-norfolk.gov.uk/Default.aspx?page=21453
▶ *Snettisham RSPB* ✆ 01485 542689
▶ *Titchwell Marsh RSPB* ✆ 01485 210779

■ Walking

Beach-walking is almost uninterrupted from Mablethorpe to Skegness in Lincolnshire. Seawall paths run round the Wash; then the Norfolk Coast Path takes you from Hunstanton to Cromer.

▶ www.ramblers.org.uk

■ Watersports

Sailing and windsurfing, and a little offshore jet-skiing, are very popular on the Norfolk coast. The Norfolk Broads see a small amount of water-skiing (restricted to certain times and areas of the rivers Waveney and Yare), but the main watersport activities here are sailing, canoeing, fishing and cruising.

▶ www.totaltravel.co.uk/travel/east-anglia/norfolk-broads/broads/directory/watersport

FIND OUT MORE

Alkborough Flats Project

The Alkborough Flats Project is a bold initiative to create around 1000 acres of new intertidal mud flats and salt marshes far up the tidal Humber.
www.english-nature.org.uk/about/teams/team_photo/alkborough.pdf

Clement Scott, journalist

London journalist Clement Scott (1841–1904) came to North Norfolk in 1883 to write for the *Daily Telegraph*. He named the area on the cliffs east of Cromer 'Poppyland', and created a huge late-Victorian tourist industry in the tiny farming villages of Overstrand and Sidestrand.
www.google.co.uk/search?hl=en&q=Poppyland&btnG=Search&meta

Horsey Windpump

Horsey Windpump (often called Horsey Windmill) was built in 1912 as a drainage pump; these days, beautifully restored, the five-storey pump is cared for by the National Trust.
www.aboutnorfolksuffolk.co.uk/125horseywindpump.htm

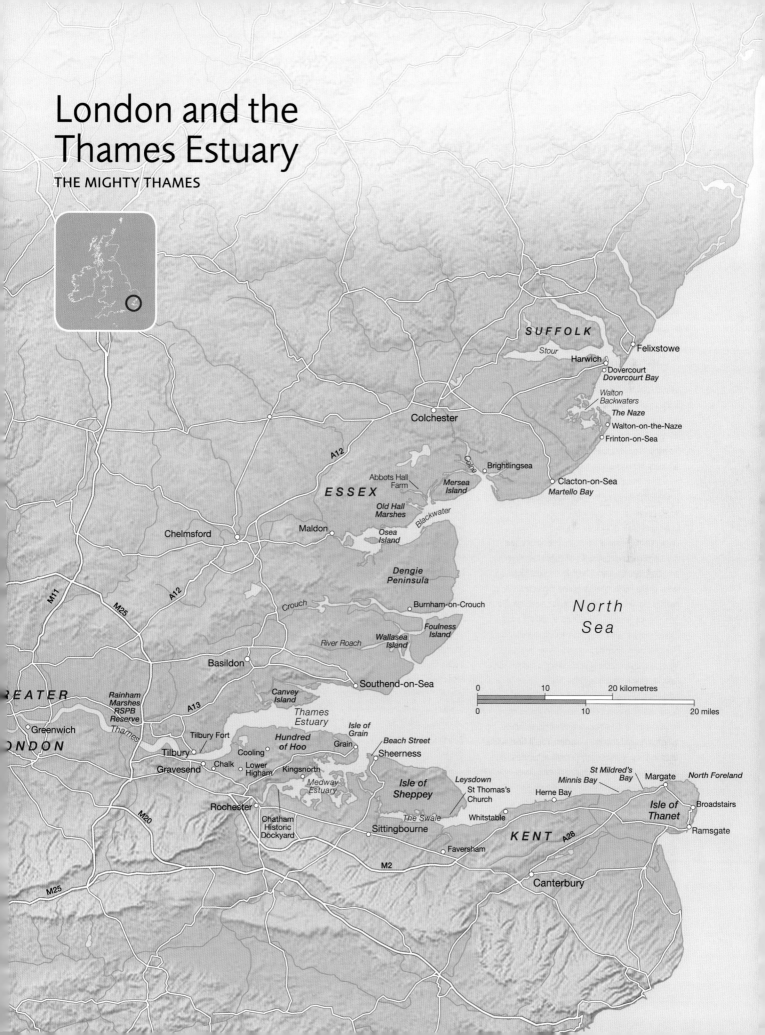

London and the Thames Estuary

THE MIGHTY THAMES

SUFFOLK

Stour
Harwich
Felixstowe
Dovercourt
Dovercourt Bay
Walton Backwaters
The Naze
Walton-on-the-Naze
Frinton-on-Sea

Colchester
Colne
Brightlingsea
Clacton-on-Sea
Martello Bay

ESSEX

Abbots Hall Farm
Mersea Island
Old Hall Marshes
Blackwater
Osea Island

Chelmsford
Maldon

Dengie Peninsula

Crouch
Burnham-on-Crouch

A12

M11
M25
A12

River Roach
Wallasea Island
Foulness Island

Basildon

Rainham Marshes RSPB Reserve
A13

Canvey Island

Southend-on-Sea

Thames Estuary

North Sea

Isle of Grain
Grain
Beach Street
Sheerness

GREATER LONDON

Greenwich

Thames

Tilbury Fort
Tilbury
Gravesend
Chalk
Cooling
Lower Higham
Kingsnorth
Hundred of Hoo
Medway Estuary

Rochester
Chatham Historic Dockyard

M20

Isle of Sheppey
Leysdown
St Thomas's Church
Whitstable
The Swale
Sittingbourne
Faversham

M2

M25

Minnis Bay
Herne Bay

St Mildred's Bay
Margate
North Foreland

Isle of Thanet
Broadstairs
Ramsgate

KENT
A28

Canterbury

0	10	20 kilometres
0	10	20 miles

PLACES TO VISIT

Broadstairs, Kent
Charles Dickens's favourite seaside resort (he stayed here many times, completing *David Copperfield*, *The Old Curiosity Shop* and several other books) is a pretty place of narrow roads and curious old houses, set attractively in the flint-banded chalk cliffs of the North Foreland. The Dickens House Museum is well worth a visit.
▶ ☏ 0870 264 6111
www.broadstairs.gov.uk
▶ *Dickens House Museum* ☏ 01843 861232
www.dickenshouse.co.uk

Clacton-on-Sea, Essex
Clacton is Essex's 'Fun Queen' of a seaside resort – brash and bouncy. The pier, built in 1877, is the focus of attention with its whirly rides, haunted house, rollercoaster and other fairground features. Several Martello Towers (Napoleonic Wars forts) stand along the coast here, including two at the Blue Flag beach of Martello Bay.
▶ ☏ 01255 423400 **www.clactontour.co.uk**
▶ **www.clactonpier.co.uk**

Harwich, Essex
The fascinating old town centre occupies the tip of the Harwich Peninsula. Narrow, winding streets and wide greens contain such delights as the Napoleonic Redoubt Fort, the Maritime Museum, a seventeenth-century crane operated by a treadmill, the world's oldest purpose-built cinema in the Electric Palace of 1911, and Trinity House's Buoy Yard, full of brightly painted buoys with evocative names. Neighbouring Dovercourt has a Blue Flag beach and rows of eccentrically decorated beach huts.
▶ ☏ 01255 506139 **www.harwich.net**

Maldon, Essex
Maldon is a charming old port on the River Blackwater. Its Hythe quay bustles with restored sailing barges, while round the corner the Maldon Crystal Salt company makes salt from evaporated seawater.
▶ ☏ 01621 856503 **www.maldon.co.uk**

Southend-on-Sea, Essex
There is some very handsome Regency and Victorian architecture in Southend, along with a Golden Mile-style seafront and the longest pleasure pier in the world at 2360 yards. The Thames at Southend has not quite made up its mind if it is an estuary or the open sea, but the resort offers no fewer than four beaches with Blue Flag status (see **Natural World**, opposite).
▶ ☏ 01702 215120 **www.southend.gov.uk**

Walton-on-the-Naze, Essex
An old-fashioned family resort with a child-friendly pier. Just north of the town rise the red-and-grey cliffs of the Naze, whose crumbly clay and sandstone regularly deposit fossil treasures on the beach, including the black T-shaped teeth of megalodon, a 40-foot-long giant shark.
▶ ☏ 01255 675542 (seasonal)
www.walton-on-the-naze.com

Whitstable, Kent
The most picturesque port on the north Kent coast, with a harbour full of fishing and coasting vessels and lined with fish and sail sheds. Whitstable's native oysters, long off the menu owing to disease and other adverse conditions, are back on sale again; you can sample them at the town's Oyster Festival in July.
▶ ☏ 01227 275482 **www.canterbury.co.uk/cgi-bin/buildpage.pl?mysql=333**
▶ *Whitstable Oyster Festival*
www.whitstableoysterfestival.co.uk

ISLANDS AND WATERWAYS

Foulness, Essex
Sited at the mouth of the Thames Estuary, Foulness is Essex's largest island. It has been perfectly preserved as a private enclave since 1915 by its owners, the Ministry of Defence.
▶ **www.stosyth.gov.uk/default.asp?calltype=foulnessmar01**

Isle of Sheppey, Kent
Sheerness is the UK's number one port for importing fresh produce – nearly a million tonnes a year, from lemons to kohlrabi. There is fine Georgian architecture in the old naval dockyard of Sheerness, splendid birdwatching on the Swale channel and the southern marshes, and the early Norman Church of St Thomas at the south-western corner. Two Blue Flag beaches are here, too (see **Natural World**, opposite).
▶ **http://tourism.swale.gov.uk/isleofsheppey.htm**

Isle of Thanet, Kent
The Isle of Thanet's bulbous nose of chalk that sticks out from Kent's north-east corner contains three neighbouring resorts of widely contrasting character – jolly and brassy Margate, quiet Broadstairs (see **Places to Visit**, left) and the faded Regency elegance of Ramsgate. The Saxon Shore Way footpath connects the three (see **Activities**, opposite).
▶ **www.tourism.thanet.gov.uk**

Medway Estuary, Kent
A long, winding estuary that is dotted with islands as it snakes its way slowly seaward from Chatham and Rochester. Old forts squat on some of the islands, creeks creep off to all points of the compass and the wildfowl-spotting is superb.
▶ **www.medwaypilots.co.uk/page2.htm**
▶ **http://en.wikipedia.org/wiki/River_Medway**

Mersea Island, Essex
Come to Mersea Island for sailing, a nice long 12-mile walk round the perimeter and to savour oysters at the Haward family's famed eatery, the Company Shed.
▶ **www.bbc.co.uk/dna/h2g2/classic/A810127**

SITES OF INTEREST

Abbotts Hall Farm, Essex
With the low-lying Essex coast under threat from rising sea levels, Essex Wildlife Trust has taken the initiative by buying the 700-acre arable farm of Abbotts Hall at Great Wigborough. Half is now being farmed in a wildlife-friendly way, while the sea is being allowed to flood the other half to create 300 acres of new salt marsh.
▶ ☏ 01621 862960 **www.essexwt.org.uk/Sites/Abbotts%20Hall.htm**

Chatham Historic Dockyard, Kent
Chatham Historic Dockyard, with its 47 buildings and sites listed as Ancient Monuments, houses many venerable ships and leaves a lasting impression of the work and atmosphere of a dockyard in the great age of sail.
▶ ☏ 01634 823800 **www.chdt.org.uk**

Great Expectations sites, Kent
The wide, flat grazing marshes of the Hundred of Hoo, lying north of the Medway Estuary, have been under threat of airport construction for decades – a threat now lifted. These marshes fascinated Charles Dickens, who grew up in nearby Chatham. The first part of *Great Expectations* is all set hereabouts, and with a little help from the Dickens House Museum in Broadstairs (see **Places to Visit**, top left) you can find Uncle

Pumblechook's shop in Rochester's High Street, Joe Gargery's forge in Chalk village, the marsh graveyards of St James's Church, Cooling, and St Mary's, Higham, and the old battery by the Thames.

■ Goddard's Pie House, Greenwich
Goddard's Pie House in Greenwich Church Street takes pride in serving traditional Cockney food, especially those two East End staples – pie-and-mash and jellied eels. So if you're on a spree down the shake and shiver and you're really Lee Marvin, do yourself a Cheesy Quaver and get into Goddards.
▶ ☎ *0208 293 9313* **www.pieshop.co.uk**

■ Rainham Marshes RSPB Reserve, Essex
Long neglected and misused as Ministry of Defence firing ranges and a freelance rubbish repository, Rainham Marshes and their neighbouring Wennington and Aveley Marshes are gaining appreciation as one of London's very few undeveloped landscapes – the largest area of wetland along the upper reaches of the Thames Estuary. Today Rainham Marshes is an RSPB reserve, good for wading birds (avocets, lapwings, ringed plovers and little egrets) and wetland plants, butterflies and insects. The area will be at the heart of the Thames Gateway development (see **Find Out More**, right).
▶ ☎ *01708 892900*
www.rspb.org.uk/reserves

■ Tilbury Fort, Essex
This is a treasure that has, amazingly, survived in its position between power stations and docks on the Essex shore. It is a perfectly preserved, star-shaped seventeenth-century fort built against the threat of a Dutch attack on London, with a fabulously elaborate carved stone watergate.
▶ ☎ *01375 858489* **www.english-heritage. org.uk/server.php?show=ConProperty.48**

NATURAL WORLD
■ Beaches
Essex's Blue Flag beaches include the following: Brightlingsea; Martello Bay (Clacton-on-Sea); Dovercourt Bay (Dovercourt, near Harwich); Jubilee, Shoebury Common, Shoeburyness East, Three Shells (all Southend-on-Sea). Kent's Blue Flag beaches include Minnis Bay (Birchington, near Margate); Viking Bay (Broadstairs); Leysdown (Isle of Sheppey);

Main Sands, Walpole Bay, Westbrook Bay (all Margate); Beach Street (Sheerness, Isle of Sheppey); St Mildred's Bay (Westgate).
▶ *Essex beaches* **www.essex-sunshine-coast. org.uk/Beaches.htm**
▶ *North Kent beaches* **www.tourism.thanet. gov.uk/pages/beach_index.aspx**

■ Cliffs
Down in Essex, the sand cliffs of the Naze near Walton yield prehistoric sharks' teeth. The Thanet promontory of Kent shows fine white chalk cliffs around Margate, Broadstairs and Ramsgate.
▶ *The Naze, Essex* **http://hometown.aol. co.uk/travelinhope/page5.html**
▶ *Thanet, Kent* **www.bbc.co.uk/kent/ content/articles/2005/06/24/coast05walks_ stage1.shtml**

■ Estuaries and rivers
The Essex coast fractures into a maze of estuaries and creeks, including the Colne from Colchester, the Blackwater and Crouch framing the Dengie Peninsula, and on the south the Roach creeping seaward from Rochford near Southend. The Medway is Kent's chief tributary to the Thames.
▶ *Essex estuaries* **www.jncc.gov.uk/ protectedsites/sacselection/SAC. asp?EUCode=UK0013690**
▶ *Medway Estuary* **http://www.medway- swale.org.uk/pages/esttext.htm**

■ Marshes
Essex has lost three-quarters of the 10,000 acres of salt marsh it possessed in 1980. But new schemes, such as Abbotts Hall Farm (see **Sites of Interest**, opposite) and the Wallasea Wetlands Creation Project, are reversing the decline. Kent's Medway Estuary (see above) has scores of small marsh islands.
▶ *Essex* **www.beenthere-donethat.org.uk/ essex/essexmarshes.html**
▶ *North Kent* **http://hostgate.co.uk/ northkentmarshes/index.htm**
www.bbc.co.uk/nature/animals/features/ 298feature1.shtml

ACTIVITIES
■ Birdwatching
Around 200,000 birds overwinter on the Thames Estuary and twice that number overwinter on the muddy rivers and sea margins of Essex and north Kent. Rainham Marshes RSPB Reserve, Essex, is superb for

breeding waders in summer (see **Sites of Interest**, left). The Swale channel, between the north Kent shore and the Isle of Sheppey, is excellent for curlews, redshanks, lapwings and grebes.
▶ ☎ *01767 680551* **www.rspb.org.uk**

■ Fossil-hunting
The crumbling Naze cliffs in north-east Essex (red crag, 1–2 million years old, on top of 50-million-year-old London clay) are packed with fossils. Children will love looking for fossil shells and may well find sharks' teeth.
▶ **www.walton.ukfossils.co.uk**

■ Walking
Sea-wall paths run along most of the Essex coast, and the Saxon Shore Way travels from Gravesend to Hastings (163 miles) along the margins of Kent. The Thames Path National Trail traverses London. *Walks in the Country near London* by Christopher Somerville (New Holland, 2003) describes several coastal circuits in Essex and Kent.
▶ *Thames Path National Trail*
www.nationaltrail.co.uk/thamespath

FIND OUT MORE

Maldon salt
Maldon Crystal sea salt is still made the traditional way, by boiling and evaporating seawater, in the town of Maldon on the Blackwater Estuary.
www.maldonsalt.co.uk/history

Prison hulks
Napoleonic prisoners-of-war were incarcerated in decommissioned ships of war, known as prison hulks, moored off the Kentish marshes. These hulks were also used to house British felons in appalling conditions in the Thames at Beckton, the Isle of Dogs, Woolwich and Deptford.
http://intolerablehulks.com/intro.html
www.portcities.org.uk/london/server/show/ ConNarrative.56/chapterId/414/Prison-hulks-on- the-River-Thames.html

Thames Gateway development
Plans are afoot to build an enormous number of houses (estimates vary between 200,000 and one million) together with their infrastructure along the Thames Estuary.
General **www.thamesgateway.gov.uk**
Essex **www.tgessex.co.uk**
Kent **www.thamesgateway-kent.org.uk**
London **www.thames-gateway.org.uk**

Index

REFERENCES TO THE GAZETTEER SECTION ARE IN BOLD
PICTURE REFERENCES ARE IN ITALICS

Acknowledgements

This book is dedicated to the memory of my father,
John Somerville (5 December 1917–16 November 2005),
who loved the coasts and seas of Britain.

BBC Books would like to thank the following for providing photographs and for permission to reproduce copyright material. While every effort has been made to trace and acknowledge copyright holders, we would like to apologize should there be any errors or omissions.

Key: a = above; b = below; c = centre; l = left; r = right; t = top
Abbreviations: Al = Alamy; BOV = Britainonview.com;
JH = Jason Hawkes Aerial Photography

p.1c Shutterstock/EML; pp.2–3 BOV/David Sellman; pp.4–5 JH; pp.6–7 JH; p.8l BOV/Philip Fenton; pp.10–11 BOV/Dennis Hardley; p.13l AL/Tim Ayers; pp.14–15 JH; p.16cr AL/Adrian Chinery; p.17 AL/Patrick Eden; pp.18–19 Corbis/Adam Woolfit; pp.20–1 BOV; pp.22–3 AL/Geoffrey Kidd; p.24br JH; p.24tr JH; pp.26–7 BOV/Gail Kelsall; p.28bl AL/David Hopson; p.29t JH; p.29crb AL/David Noble; pp.30–1 JH; p.32b AL/Keith Pritchard; p.33tr JH; pp.34–5 AL/Carol Dixon; p.36t AL/Michael Dutton; p.37tc AL/eye35.com; pp.38–9 BOV/Jill Swai; p.40tl AL/Robert Harding Picture Library Ltd/Firecrest Pictures; p.41cra AL/Arco Images; p.41crb AL/Oxford Picture Library/Chris Andrews; pp.42–3 AL/RIEGER Bertrand/Hemispheres Images; pp.44–5 JH; p.46bl AL/POPPERFOTO; p.46tr JH; p.48clb AL/Tim Cuff; p.49 BOV/David Hal; pp.50–1 AL/Peter Barritt; p.52tr BOV/V K Guy Ltd/Vic Guy; p.53tr AL/Cliff Whittem; pp.54–5 AL/Atmosphere Picture Library/Bob Croxford; pp.56–7 AL/The Photolibrary Wales; p.58r JH; p.59crb AL/POPPERFOTO; p.60cra BOV; p.60crb AL/Wild Places Photography/Chris Howes; p.61t AL/The Photolibrary Wales; p.62b BOV/Jean-Marc Teychenne; p.63t AL/David Lyons; pp.64–5 BOV/Jean Broo; pp.66–7 AL/Alan Novelli; p.68t AL/Simmons Aerofilms Ltd.; p.69clb JH; p.69tr AL/The Photolibrary Wales; pp.70–1 BOV/actionplus sports; p.72l JH; p.73ca AL/Terry Whittaker; p.73cr AL/POPPERFOTO; p.74t AL/Paul Glendell; p.75crb JH; pp.76–7 AL/scenicireland.com/Christopher Hill Photographic; p.78t AL/BL Images Ltd.; p.78bc AL/scenicireland.com/Christopher Hill Photographic; p.79bc AL/John-Mark Odero; p.80cla AL/POPPERFOTO; p.81t AL/Jon Arnold Images; p.81cb AL/nagelestock.com; pp.82–3 BOV/Martin Brent; p.84tr AL/Darryl Webb; p.85b Harrisonsphotos.com; pp.86–7 AL/David Noton Photography; pp.88–9 AL/Peter Adams Photography; pp.90–1 AL/Michael Diggin; pp.92–3 AL/Michael Diggin; p.94r JH; p.95tr AL/scenicireland.com/Christopher Hill Photographic; p.96 AL/Michael

Diggin; p.97cra AL/Arco Images; pp.98–9 AL/Tony Wright/
earthscapes; p.100t AL/Scenics & Science; p.101b AL/
Ashley Cooper; pp.102–3 AL/David Poole; p.104t AL/Homer
Sykes; p.105l BOV; p.106l BOV; p.107bl AL/eye35.com;
pp.108–9 BOV; p.110b AL/South West Images Scotland;
p.111t AL/South West Images Scotland; p.112r AL/
gkphotography; p.113cb AL/Alison Thompson; p.114ca AL/
Classic Image; p.115t AL/gkphotography; pp.116–7 AL/
Skyscan Photolibrary; pp.118–9 BOV/Colin Weston; p.121t
Shutterstock/Bill McKelvie; pp.122–3 AL/Barry Lewis; p.124t
BOV/Colin Weston; p.125b AL/Chris Joint; p.126bl AL/
David Tipling; p.127t AL/David Robertson/scot-image;
pp.128–9 BOV/Colin Weston; pp.130–1 BOV/Richard W
p.132bl AL/Tom Kidd; p.133r BOV; pp.134–5 AL/David
Tipling; p.136clb AL Doug Houghton; p.137l AL/Doug
Houghton; p.139t AL/gkphotography; pp.140–1 BOV/Helen
Harrison; pp.142–3 JH; p.144cla AL/Rolf Richardson;
p.145ca AL/Phodo; p.145b AL/Doug Houghton; pp.146–7
AL/Ian Paterson; p.148b AL/Doug Houghton; p.149t AL/
Colin Woodbridge; pp.150–1 JH; pp.152–3 AL/Martin
Beddall; p.154t AL/Adrian Harrison; p.155b BOV/Richard
W; p.156t BOV/Joe Cornish; p.157cra AL/Andy Marshall;
p.157crb AL/David Robinson/Snap2000 Images; p.158t
Shutterstock/Gary Dyson; p.159crb AL/POPPERFOTO;
pp.160–1 BOV/Joe Cornish; pp.162–3 AL/Chris Gomersall;
p.164t AL/David Moore; pp.166–7 AL/Terry Whittaker;
p.169t AL/Paul Glendell; p.169b BOV/Rob Edwards; p.170ca
BOV; p.170b BOV/Rob Edwards; p.171cl AL/Peter Garbett;
pp.172–3 AL/Brian Harris; pp.174–5 JH; pp.176–7b BOV/
Martin Knight; p.177tl JH; p.178b AL/Michael Jones; p.178tr
BOV; p.179r JH; p.180cra AL/Skyscan Photolibrary; p.181crb
AL/POPPERFOTO; p.181tr BOV/Rob Edwards; pp.182–3
AL/Richard Cooke; pp.184–5 BOV/V K Guy Ltd/Mike Guy.

This book is published to accompany the
television series entitled **COAST**, first broadcast
on BBC2 in 2006.

Executive Producer Gill Tierney
Series Producer Steve Evanson

Published by BBC Books

First published 2006
Reprinted 2006 (four times)
Main text copyright © Christopher Somerville 2006
The moral right of the author has been asserted.

ISBN-13: 978 0 563 49385 3
ISBN-10: 0 563 49385 2

Commissioning Editor Shirley Patton
Project Editors Polly Boyd and Sarah Reece
Editor Polly Boyd
Design and Picture Research Sharon Cluett at studiocactus
Picture Research Assistant Robert Walker at studiocactus
Cartographer Martin Darlison at Encompass Graphics
Production Controller David Brimble

Set in FoundrySans and Zapfino
Colour originated, printed and bound in Great Britain by
Butler & Tanner Ltd, Frome, England

For more information about this and other
BBC books, please visit our website at
www.bbcshop.com or telephone 08700 777 001.